THE ARTS BETRAYED

JOHN SMITH

UNIVERSE BOOKS · NEW YORK

First published in Great Britain 1978
by the Herbert Press Limited, 65 Belsize Lane, London NW3 5AU
First published in the United States of America 1978
by Universe Books, 381 Park Avenue South, New York, N.Y. 10016

Designed by Judith Allan
Printed and bound in Great Britain by W & J Mackay Limited

Library of Congress Catalog Card Number 78-56385
ISBN 0-87663-322-X

CONTENTS

ACKNOWLEDGEMENTS

This work includes many quotations, the original sources of which are acknowledged in the Notes. The author and publisher wish to acknowledge permission to include the following longer extracts from copyright material:

To Faber and Faber Ltd for extracts from *Gustav Mahler* by Donald Mitchell (new edition to be published 1979); to Oxford University Press for extracts from *Maurice Maeterlinck* by W. D. Hall, *Archetypal Patterns in Poetry* by Maud Bodkin, *On Science, Necessity, and the Love of God* by Simone Weil and the Introduction to *The Oxford Book of Modern Verse* by W. B. Yeats; to Miss Anne Yeats, M. B. Yeats and the Macmillan Company of London and Basingstoke for extracts from 'The Song of Wandering Aengus', 'Before the World was Made', 'The Second Coming' and the complete poem 'A Coat' by W. B. Yeats; to Cambridge University Press for extracts from *W. B. Yeats: His Poetry and Thought* by A. G. Stock; to George Allen & Unwin Ltd for material from John M. Synge's *Poems and Translations*; to Alfred A. Knopf Inc. for lines from 'A Song of Ch'ang-Kan' by Kiang Kang-Hu from *The Jade Mountain: A Chinese Anthology* translated by Witter Bynner; to Mr George Sassoon for lines from a poem by Siegfried Sassoon; to Curtis Brown Ltd, London, acting on behalf of Martin Esslin, and Doubleday & Co. Inc., New York, for an extract from *Brecht: A Choice of Evils* by Martin Esslin (© Martin Esslin 1962); to Harvard University Press for extracts from *A Composer's World* by Paul Hindemith; to Eyre Methuen Ltd for an extract from *The Messingkauf Dialogues* by Bertolt Brecht; to Eyre Methuen, London and Random House, New York for lines from *The Life of Galileo* (*Collected Plays*, vol. 5) by Bertolt Brecht translated by Wolfgang Sauerlander and Ralph Manheim; to Hutchinson & Co. for an extract from *Samuel Beckett* by Francis Doherty; to Hamish Hamilton Ltd and Mrs W. A. Bradley for extracts from *Nausea* by Jean-Paul Sartre (© Jean-Paul Sartre) translated by Lloyd Alexander copyright © 1962 Hamish Hamilton Ltd, London; and to the author, Jonathan Cape Ltd and The Viking Press for extracts from *Riders in the Chariot* by Patrick White (copyright © 1961 by Patrick White). 'Speech for Psyche in the Golden Book of Apuleius', 'A Virginal' and 'The Bath Tub' are reprinted by permission of Faber and Faber Ltd from *Collected Shorter Poems* by Ezra Pound and of New Directions, New York from Ezra Pound, *Personae*, copyright 1926 by Ezra Pound.

for

LESLIE MARTINDALE

PREFACE

The intention of this book is to show how, through their various media, certain artists, because of an innate temperamental affinity or the deliberate pursuit of a particular philosophy of art, develop in an extraordinarily similar manner.

While it is not a critique of modern art, by bringing into close juxtaposition the works of a number of important creative artists and considering them for the most part in a roughly chronological order, it does outline in little something of the way in which art has developed or declined during the first seventy years of the twentieth century. It also attempts to throw into relief the increasing dilemma of the artist in a time of social, economic, religious, moral and artistic uncertainty. The dilemma is hydra-headed, partaking of the perennial problem of the equating of content and form, the dichotomy of art and morality, and the unceasing conflict between tradition and experiment. Works such as T. S. Eliot's *Tradition and the Individual Talent*, or Ezra Pound's *Make it New*, Jacques Barzun's *Classic, Romantic and Modern* and Ernst Fischer's *The Necessity of Art* explore these themes at profound levels. For readers of such works this book is unnecessary. At the same time, while within the individual essays I have tried to convey something of the nature of the creations of the various artists, I have made no attempt to explore their work in depth. Ten, twenty or even thirty pages considering the life-work of a Schoenberg or a Picasso, a Yeats or a Proust, can obviously do nothing more than scratch the surface. But none of the figures referred to is lacking his own critical champion, whether it is George Painter for Proust, Will Grohmann for Klee, Jeffares for Yeats or Courthion for Rouault; it is to such volumes the reader is directed for analyses at length.

I believe there are, however, a growing number of general readers becoming aware of, and interested in, the major movements of the arts in our time. It is to such readers that this book is addressed. It makes no attempt to proffer judgements but is intended merely to stimulate reflections on the work and ideas, of some of the remarkable men who have, by their art, helped to create the bewildering world in which we live.

John Smith, Hove, January 1978

RILKE RODIN ROUAULT MAHLER

May thine own angel prove himself faithful and wise!

Thomas Mann, *Dr Faustus*.[1]

Nowhere is the seductive flower of sentimentality more likely to bloom than in the compost of decadent romanticism. What is surprising is not that so many artists of the turn of the century were tainted by its personal luxury but that they managed to avoid being destroyed by it. The surrounding pressures were formidable and not confined to the always vulnerable province of the arts. Arnold's intellectual quarrel, and Hopkins's love-hate relationship, with God were merely particular examples of a condition that hung like a suffocating cloud over the late-nineteenth-century landscape, offering as an earnest of future brilliance a present stifling humidity. Western society, feeding on the first succulent fruits of the Industrial Revolution, was already being disturbed by the ground suckers of an insidious Marxism. The Byronic man of action, perhaps the most admirable example of the committed romantic, was already an anachronism in a world in which the 'enemy' was power dressed up in the costume of international finance.

A new conception of man on earth needed a new conception of God in heaven. The Great Boyg against which Peer Gynt was to struggle was no more amorphous than the mysterious saviours of whom Madame Blavatsky was the popular mouthpiece and Rudolf Steiner soon to be the most eloquent interpreter. The conflicting state of present day moral and religious beliefs in relation to current political and social actions is apt to look thin and rather pathetic when set against a period dominated, or soon to be dominated, by such figures as Freud, Darwin, Jung, Shaw, Einstein, Schoenberg—for in Freud, Einstein and Schoenberg at least, the whole concept of a variable stability on which most of man's previous thinking had been based was undermined by the implications of relativity. But despite the development of the French Impressionist painters, and in music the gradually evolving manner of Debussy, the age was not yet ready for its most drastic shifts in style and ideas. The suns of Wordsworth,

Nietzsche and above all Wagner still controlled lesser planets within their vigorous magnetic fields. In spite of their different preoccupations it is to this world that artists like Rilke, Rouault and Mahler belong; artists who, however modern they may have seemed at the time, have about them qualities of nineteenth-century traditionalism which mark them clearly apart from more dramatic pioneers of modernism like Picasso, Schoenberg, Ezra Pound and James Joyce. The former are artists whose styles matured, deepened and expanded, but no crisis precipitated any drastic alteration in their conception of art. In each case they can be seen as isolated figures caught up in a spiritual and artistic struggle in which it is sometimes difficult for them to know whether they have not themselves become the god whose presence they perpetually seek. As Rilke writes in the second part of *The Book of Hours*, 'Who's living it, this life, God? Is it you?'[2] Which, though it has an explicit meaning in its context, points to an ambiguity that is to grow as the poet matures, and which is reflected in the later symphonies of Mahler, and certain of the more anguished Christ figures of Rouault. These artists occupy the last segment in the curve of nineteenth-century romanticism, for the first section is man in the shape of Prometheus rebelling against God, the second takes the shape of Shelley's Prometheus Unbound, conferring on free man the possibility of a utopian existence on earth, while the third is a Prometheus longing for a reunion with God even if, or perhaps because, such a reunion requires the agony of martyrdom. They exhibit few of the ethical concerns of an Ibsen, whose poetic realism is strong enough to anchor even his most extravagant excursions into symbolism; instead their work is imbued with a moral passion that at times reaches a pitch of fanaticism so extreme as to collapse into little more than subjective hysteria. We are a very long way indeed from the idea of the artist as servant or artisan. As Arnold Hauser says:

> The writers of the classical age wanted to amuse or instruct their readers or converse with them about their life. But since the advent of Romanticism, literature had developed from an entertainment and a discussion between the author and his public into a self-revelation and self-glorification of the author.[3]

But however grave their flaws, and whatever their ultimate place in the history of the arts, they were men of extraordinary dedication and daring, and for each of them, in the end, art became not so much a religious activity as religion itself. Such a development precipitated its own crisis, for: 'If poetry is made a substitute for religion, it is likely either to degenerate into moralistic discourse, or to break under the strain.'[4]

The poetry of Rainer Maria Rilke comes close to this collapse but is saved

mainly by his avoidance of evangelism. The poet's struggle with God is kept, for the most part, personal and interior; he avoids any temptation to convert the reader, even if his extravagant rhetoric does occasionally numb the mind into acquiescing in moral or religious dicta which are often shallow or tainted by a curious vulgarity. We can never be in doubt of his deep sincerity. His life was a long pilgrimage toward the *Duino Elegies* but there was no conversion on the road to Damascus, despite his near-breakdown after the strain of producing *New Poems*. He may have needed to struggle, and to wait for years for his revelation, but he was never in doubt as to the source from which it must come.

His first major claim to fame was a work in which ideas of chivalry, of redemption through love, filled the place of the revelation of God, but, despite its staggering success, *The Lay of the Love and Death of Cornet Christoph Rilke* falls, as does that hideously disturbing novel *The Notebook of Malte Laurids Brigge*, a little aside from the main preoccupation of his poetry. The former is an excellent example of that favourite genre of the period, the high-class literary romance set in remote or mediaeval times. It is seen in most of the artists of the period and had its brief but far-reaching apotheosis in the Pre-Raphaelite movement in England. This development was a curious mixture of hedonism and purity. The smell of incense is never far from the nostrils and the all-pervasive atmosphere of religious sensuality or moral sentimentality can only be taken in small doses. It is not surprising that the most successful work of its time, in the theatre, was Maeterlinck's *Pelléas and Mélisande*. Yeats, Swinburne, Mahler, Delius, Picasso, Schoenberg, Puvis de Chavannes, Richard Strauss, Pound, Debussy, all for a brief period—some for a considerable time—were fascinated by this possibility of an escape into a world of 'beauty', a world in which art could be self-sufficient and unsullied by the growing harshness of the real world. They were all in their formative years spiritual disciples of Mallarmé and the Symbolists, whose achievements, though they fall somewhat outside the scope of this book, are as fascinating as they are profound and more profound than is currently accepted. But the greatest art is made of reality, not fantasy, and as Yeats was to discover in his middle years, it is the hard realities which are finally more beautiful also.

But to return to Rilke. *The Lay of the Love and Death of Cornet Christoph Rilke* though written in 1899 was not published until 1906. Its success was instant, gratifying, but later somewhat embarrassing—since it was in a manner the poet quickly saw he could not continue to pursue. Certainly the public were electrified by it; for some received it almost like a drug, overwhelming the senses and making nonsense of any kind of critical detachment. Though it may seem now to be more gilt than gold, it does have about it a curious hypnotic, headlong quality; a mixture of mediaeval chivalry, virginal romance and Gothic terror. It breathes something of the air of *Des Knaben Wunderhorn*, which was to haunt

Mahler all his life and from which he was never quite to escape. Redemptive love, the shadow of *Tristan and Isolde*, falls over the whole creation, as it does over Maeterlinck's *Pelléas and Mélisande*, Yeats's *Wanderings of Oisin*, and the Jacobsen/Schoenberg *Gurrelieder*. Nothing is allowed to be explicit. It is no part of high romanticism to sharpen the edges of events. Like heraldic devices hung in a cobwebbed hall, individual colours stab the darkness, proffering the chiaroscuro effect of a Van Dyke warrior, or the dazzling tenor trumpet calls at the beginning of Mahler's Seventh Symphony. These are the glittering thrills that prick through the vague emotional denseness which is the groundwork of such pieces. The effect is always very sure, and Rilke's success was deserved:

> The turret-chamber is dark.
> But they shine into each other's faces with their smiling. They grope with their hands like the blind, each finding the other like a door. Almost like children afraid of the night, they cling close to each other. And yet they are not afraid. There is nothing there that is hostile to them: no yesterday, no tomorrow; for time has perished. And they blossom forth from its ruins.[5]

Rilke, who was always deeply interested in the visual arts, became the secretary of the great nineteenth-century sculptor Rodin, and by an extraordinary act of empathy he was able to enter into the sculptor's work so profoundly as to produce the two remarkable and perceptive *Rodin-Books*. In a way, to read them, especially the first, published in 1903, is almost like reading the poet's own autobiography: 'Rodin was solitary before he became famous. And Fame, when it came, made him if anything still more solitary.'[6]

Sculptor and poet shared an ever-increasing tendency to invest the world of the everyday with too heavy a weight of emotional anguish. There is scarcely a work of Rodin that escapes this dangerous subjectivity. It is what, above all, kept him from an early public acclaim; but it is also his major claim to originality, for before him no sculptor of comparable skill had stepped so far away from the Greek classical ideal. He is never able to achieve the emotional detachment of the earlier masters, but he avoids, through his excess of temperament that plunges him into the heart of the romantic world, the decorative elegance of late-eighteenth-century sculptors, which reflected the heroic ideal of the classical world long after that ideal had been defeated by the 'progress' of society. A hand, an arm, a face, a torso, are never merely physical properties, they are always imbued with some emotional overtone—the hand pleads, the arm declares, the face suffers, the torso struggles, but not necessarily against a visible enemy. The anguish is shown to be within; the figures are no longer of man in the shape of God, or in the shape of humans assuming the importance of

God. Man is shown as a human animal conscious of his extraordinary position between the spiritual and the animal kingdoms and suffering because of it. His defiance contains a longing for acceptance; his perversely human suffering resists but desires relief. He prays not for the forgiveness of past sins but in the full recognition that he is committed to sin. Like many great artists Rodin occasionally lapses into mawkish sentimentality and vulgarity, but he has about him a kind of flawed tragic grandness that catches up something of the nature of the age in which he lived and places him in a dominant position among the sculptors of his time. It is a quality that he shares with Balzac in human content and with Rilke in the spiritual undertow. These artists demand, as do Mahler and early Rouault, the emotional involvement of an audience, for much of their power is drawn from the identification of that audience with the condition expressed by the particular work of art, a demand that is rarely made by the greatest art of a classical period. To attempt to listen to a Mahler symphony with the detachment with which one may experience a Bach fugue would make nonsense of the nature of romanticism; nor can the spectator gaze at the imperious marching figure of Rodin's *John the Baptist* as he can at Michael-angelo's *David*, or read the *Duino Elegies* as though they were the *Georgics* of Vergil.

The spiritualization of nature which had been one of the most remarkable achievements of Goethe was not to be shrugged off in a mere hundred years, though as Ruskin observed, it led to a great deal of nonsensical thinking and to more impossible works of art. When the reaction set in, in the early years of the present century, it was so strong that it objectified nature almost out of any kind of rapport with the emotional condition of man. But the understanding of objects was very much a condition of the art of Rodin and Rilke. It was to reach its climax in Rilke's 'Ninth Duino Elegy', when the obsession became so great as to cause him to write, with a sort of fervent, despairing enthusiasm:

> . . . Are we, perhaps *here* just for saying: House
> Bridge, Fountain, Gate, Jug, Fruit tree, Window,—
> possibly: Pillar, Tower? . . . but for *saying*, remember,
> oh, for such saying as never the things themselves
> hoped so intensely to be.[1]

The weakness of romantic art lies precisely in investing things with more weight of meaning than they are able to bear. It is immaterial whether the thing in question is a human figure in the hands of a sculptor, a doll in the imagination of a poet, a theme of naïve exuberance in the musical fervour of a composer, or a clown or a prostitute emerging from the palette of a painter; too often a significance is being implied that a close scrutiny will reveal to be attached more to

the artist than to the object of his inspiration. To be able to give, to impose, is of fundamental importance to Rilke. He is above all a poet of questions and imperious demands. 'Who if I cried would hear me among the angelic orders?' Does he want an answer? Certainly he waits for the descent of the god in the form of inspiration, but he rarely wants to know the answer to the riddles he proposes. He is revealing on this count most persistently in his curious essay on dolls in which he shows how closely his archetypal figures resemble each other: doll, or angel, it scarcely matters which—as with Rouault, clown or Christ, it is often difficult to say. From the enormous deeps of his isolation Rilke is able to conceive that perhaps God's greatest and most magnificent claim to supremacy is his ability to remain silent:

> It was silent then, not deliberately, it was silent because that was its constant mode of evasion, because it was made of useless and entirely irresponsible material, was silent, and the idea did not occur to it to take some credit to itself on that score, although it could not but gain great importance thereby in a world in which Destiny, and even God Himself, have become famous above all because they answer us with silence.[8]

But despite this accepted silence of God, or perhaps because of it, the poet never doubted the power or importance of forces beyond the rational understanding of man. There was, it is true, a lack of orthodoxy in his beliefs but that it was necessary for him to be borne along within the embrace of God is never in doubt. What Jeffares writes of Yeats, 'He thought that wisdom could be found in the world only in some lonely mind communing with God'[9], might almost be an epitaph for Rilke, to whom it bears a most striking relevance. It is almost a paraphrase of many of the stanzas in *The Book of Hours*: 'For only solitaries shall behold the mysteries.'[10]

It is true that Rilke in *The Book of Hours* is, like Yeats, assuming a mask, and since the mask in the first part 'Of the Monastic Life' is that of a monk, the incidence of god or prayer images is naturally considerable, but it is still the voice of Rilke that is speaking.

> God speaks to a man but once, just before he makes him,
> then silently out of the night he takes him.
> But before each begins, these words he hears,
> hears these cloudlike words in his ears:
>
> Outsent by your sensibility,
> go wherever your longing's verge may be;
> give garb to me.

Grow behind all things burningly,
that the shadows of them, expandedly,
may always conceal me quite.

Take all as it comes, beauty and fright.
Only keep on: feeling's range is unbounded.
Let nothing part you from me.
Near is the land
called 'Life' by humanity.

By its gravity
You'll know you have found it.
Give me your hand."[11]

Rilke was not the first and we must hope he is not the last poet to pursue a pilgrimage in which the development of the art and the maturity of the life are so merged as to become almost indistinguishable. If at times the life seems too rarefied, the moral preoccupation too high, the tone too portentous, that is perhaps the price that is exacted for the luxury of this kind of obsession—for all obsessions, being self-indulgent, are luxurious.

But what is the nature of the 'god' or of those 'angels' by which he is obsessed? He seems, like Mahler, to have suffered the exaltation but to have been denied the vision. One wants at last to come to a concrete point, however disturbing, to hear that God revealed either looked just like an ordinary simple man or like something so extraordinary that the mind could never have imagined it. Instead, the final impact of the poems, even of the late ones, is muffled by the emotional weight overlaying the intellectual precision. Rilke confuses us not by assuming the inscrutability of God but by evasiveness, which is far more disturbing. Nevertheless the evasiveness is to be expected in art that derives its force from the moral and religious climate of a century that for the most part was concerned with asking 'why' questions or 'who' questions, rather than the more easily answered 'how' questions of the mid-twentieth century. It is necessary also to remind ourselves that evasiveness does not necessarily spring from lack of thought, just as we need to realize that romantic artists are not less intelligent than classical ones. We fall into a similar error when we deny any value to mysticism, thinking it to be self-induced. We need to ask ourselves whether there is any reason why it should not be. All activities require some training, some conditioning, for their proper realization and possibly the process of inducement of mystic states constitutes the craftmanship of the mystic. Undoubtedly the cultivation of thought is valuable; why should not the cultivation of emotional response, or states of apprehension, be equally significant?

15

The emphasis on feeling in the poetry of Rilke, the preponderance of emotive elements in the music of Mahler, are indications of the kind of artistic approach they share and not of a lack of rigour in their thought. Rilke shows an extreme interest in and understanding of many facets of art, and was especially perspicacious in his realization of the remarkable quality of people as diverse as Kafka, Proust, Valéry, Picasso and Rodin. If he had also written in the field of aesthetics he might well have produced work not unlike that of Paul Valéry, who despite his esteem as a clinical thinker, an incisive 'classical mind', also had a strong vein of decadent romanticism and shows in a poem like *The Young Fate* an almost perversely ornate manner of approach to an already highly romantic theme.

What Rilke was particularly skilful in avoiding was the belief that intellectual attainments are necessarily required for the production of works of art. He scrupulously separated the intellectual side of his being from the poetically creative one and unlike many great romantic poets poured his excess energy not into the production of extra-poetical works of professional literature but into the continual writing of private letters. This activity he pursued with obsessive devotion. The effect on the reader of these letters is twofold: an irritation at the arrogance of the man in his assumption of the role of 'poet'—and fascination at the insights which they reveal and the wealth of general comment on matters of art which they contain. He was perceptive enough to see when very young that 'destiny is precisely that which is not chosen.'[12] He made no attempt to control, for the purposes of a life of a man of letters, the direction of his activities. He played the most vigorous game known to the poet, which is for one player and consists in doing nothing. It is a game that requires supreme confidence. Proust, with whom Rilke has much in common, possessed a similar gift. It is dangerous, because one may be exposed as someone who waits in vain, having mistaken the vocation to which one dedicates a whole existence. God does not necessarily speak through the mouth of the man who appoints himself spokesman for the divine. Worse still he does not always reveal himself to those who most assiduously search. Earnestness of desire is no guarantee of the power to work miracles. But for Rilke, as for Rouault and Mahler, there was at least a partial revelation. Only partial because their obsessions were perhaps too extreme, too determined.

Already in *The Book of Hours* and *The Book of Images* the deliberate attachment to yearning is strong, and although in *New Poems* Rilke makes a fairly successful attempt to distance himself from his subjects, the best of the poems still have about them the air of a man desperately trying to penetrate the surface of the world, and the surface of himself, in order to release a meaning of more lasting validity than the destructible object itself—to penetrate to the reality of the name. In a sense perhaps the search is for death; not, of course *any* death, but the chosen death. He had always suspected that death, except through violent

catastrophe, could be manipulated, though few people accepted the gift: 'the desire to have a death of one's own is growing more and more rare.'[13] For Mahler the pursuit was toward a moment of martyrdom perpetually fended off; a luxury of fear. Rilke was more sure. He made himself ready with a dedicated calmness that was heroic in its magnitude. For him death itself was, after all, a work of art.

The expression of emotional states and the exploring of states of feeling are a partial denial of Pascal's famous axiom that the proper duty of man is to think well. His advice is not necessarily valuable to artists. If the trouble with romantic poetry is that it often avoids the dictates of reason, it also avoids the pitfalls of didacticism. When we complain of an excess of emotion in romantic art we should remember that if we are truthful to our own experience, our lives are made memorable not by the incidents in which we are involved but by the emotions those incidents arouse.

Rilke is concerned not so much to explore emotional states as to reveal, as Hopkins had tried to reveal in his particular Christian manner, the inner being of men and objects, not through scientific analysis but through intuition; to draw out from them the purpose of their nature. In order to do this Rilke gave himself up to his 'angels' with the dedication of the mystic. He willed himself to be a vessel through which revelation might pour. He believed he would be filled, and that when the time came he would spill over, giving back to the world, like a libation, that essence which in some mysterious way the world had secreted within him. Although at a superficial glance it might seem therefore that he was self-dedicated, that is not so. His stand was not so much for the glory of Rilke as for the glory of the poems which could only come into being through him. He was fortunate in finding a publisher who was prepared to wait with faith and encouragement for the great works of his later years, and who helped fend off the destructive nature of fame. That Rilke was aware of this danger is shown most clearly in *Brigge*: 'fame, that public destruction of one in the process of becoming, into whose building-ground the mob breaks, displacing his stones'.[14] He saw that it is as difficult to withstand success as it is to withstand failure. In this wisdom he was fortunate, more fortunate than Mahler, who suffered perhaps more than any composer of the time through the indifference or hostility of his audience.

There can be few more astonishing examples of an artist's patience than Rilke's ten-year pilgrimage toward the *Duino Elegies*. I say 'pilgrimage' because it does seem as if his life from the inception of the first elegy to the accepting of the tenth elegy was a journey of faith.

He knew that 'God' was always watching—watching, not hounding. He did

not flee either from the terror or the love, the weakness of Francis Thompson; he was not resigned to conflict, the despair and agony of Mahler. He was prepared to endure and to be modified. If God saw all and man was powerless to change God then the only thing to be done was to suffer the exposure and embrace the commands:

> ... for there's no place therein
> that does not see you. You must change your living.[15]

This was not an abdication of man's free will, quite the reverse. It was the exercise of the will to invite a personal destiny however terrible. Whatever the way in which life might be worked out, its very movement, direction and acceptance was the one supreme good. It was not that the pattern of a life merely made a particular and personal, therefore valuable, death, but also that the masterpiece, which was death itself, in its pursuance made life significant. It might have been better *not* to have to inhabit humanity;

> oh, why
> *have* to be human, and, shunning Destiny,
> long for Destiny? ...
> Not because happiness really
> exists, that precipitate profit of imminent loss.
> Not out of curiosity, not just to practice the heart,
> that could still be there in laurel ...
> But because being here is much, and because all this
> that's here, so fleeting, seems to require us and strangely
> concerns us. Us the most fleeting of all. Just once,
> everything, only for once. Once and no more. And we, too,
> once. And never again. But this
> having been once, though only once,
> having been once on earth—can it ever be cancelled?[16]

The things of the world strangely concern us. Why? What can we do for them? What can they do for us? Rilke's unswerving devotion was not to a poetry that might have the power to *interpret* the mystery of the world but to one which might summon the mystery itself into existence. His art and his philosophy are complex in the way that the writings of certain mediaeval mystics are complex. He renounces the progress man has made in the acquiring of knowledge and tries to penetrate to a deeper core of wisdom. This does not mean he is in any way 'old fashioned'. Far from it. His search is not dissimilar from that of Einstein and Freud. In the *Elegies* he refused to accept a system on which to

comment, preferring to give himself up to chaos and to build from that. It is a risky business. Just how great he might have been had he pursued a more standard course can be gauged from the supreme eloquence of the three big classical poems in *New Poems*: 'Tombs of the Hetæræ; 'Orpheus. Eurydice. Hermes'; and 'Alcestis'. The Orpheus poem in particular is a superb example of a great poet treating a classical subject with all the dignity of its ancient theme but also investing it with the shocking newness of a personal, modern vision. If it is a part of a poet's duty constantly to revitalize the most significant myths, then Rilke, with this poem alone, justifies his claim to greatness. The audacity with which he deprives Orpheus of his great cry of despair, giving it to Hermes instead with 'He has turned round!'—And to follow this with what is in its own way one of the most heart-stopping moments in modern literature: 'She took in nothing, and said softly: Who?'[17] is a formidable achievement. But it was only an achievement on the way to the greater structures of the *Elegies*.

These ten great poems are a demonstration of Rilke's belief in the possibility of virgin birth. Poetry if it is to be of any importance cannot be produced by a process of intercourse between thought and feeling any more than Christ could be born merely through the union of Joseph and Mary. The supreme being is rendered possible only through visitation. This is made plain at the outset of his writing life. The angels are solemn, silent and terrible. Speaking of Mary in *The Book of Hours* he sees that:

> . . . the angels, comforting no more,
> surround her alienly and terribly.[18]

The birth of beauty is like the birth of Christ. In the 'First Duino Elegy' he is aware of the alien nature of this presence, the danger and terror:

> For Beauty's nothing
> but beginning of Terror we're still just able to bear,
> and why we adore it so is because it serenely
> disdains to destroy us. Every angel is terrible.[19]

He is not content, though, to rest in the fulfilment of the birth. Nothing stays. Nothing is permanent. The angels are plural and each new birth makes possible a newer, more astonishing birth. It does not matter whether this is realized through simple or complex activities; though the angels only manifest to those whose acceptance of destiny discloses them to be tragic figures. Knowledge may come from experience; wisdom through suffering:

> Should not these oldest sufferings be finally growing
> Fruitfuller for us?[20]

Although already in the 'First Duino Elegy' he moves from a state of living to a condition of death he leaves the situation ambiguous. The idea of any kind of stability is as ruthlessly excluded as in the psychological explorations of Freud and the scientific discoveries of Einstein:

> Strange
> to see all that was once relation so loosely fluttering
> hither and thither in space.[21]

If the supreme achievement of man is to comprehend the unlimitedness of existence, something which the development of Western society and most of its philosophy had striven to prevent, then this could be achieved through feeling only:

> For we, when we feel, evaporate; oh we
> breathe ourselves out and away.[22]

It is an extreme example of the tragic joy of the romantic artist whose whole nature is set on transforming itself, breaking, however painfully, into a new consciousness of suffering. Hegel's *Philosophy of Art* might almost be a commentary on certain aspects of the *Duino Elegies*, for his use of the word 'soul' is precise, though he may not have been aware of his precision, for it is indeed 'soul' that the romantic exploits in art, as it is 'spirit' that imbues the highest flights of classical inspiration. Spirit descends from 'God' to fill the vessel of man; soul yearns upward toward a union with 'God'. Although Rilke wants to be filled it is the struggle with soul that he manifests in his writing, as Rodin made visible the same struggle in his finest sculptures.

The anguish which informs so much late romantic art springs from just this ambiguous station of man in the universe, and the ridicule so often heaped on it by artists of the mid-twentieth century is understandable though misguided. Rilke is aware of his problem, which is one of expression as well as one of inspiration. In *New Poems* he tried to rid himself of much of his earlier subjectivity though he was not altogether successful. *The Duino Elegies* accept the challenge of works of extreme subjectivity but within them they pursue and develop a rationale which admits the necessity for personal desire but includes the knowledge that the extreme bodying forth of this desire may be pointless. Who will it impress? Only those who share the condition of desire. The inferior, the unprepared will not understand; the superior will smile, tolerantly but knowingly.

As the *Elegies* progress, the modification of Rilke's vision, brought about by the collapse of the background against which he played out his formative years, is shown in a greater reference to the significance of things that exist in their own right. Things that are important not because of what we think about them, or because of any emotional effect they produce within us, but simply because they

are. He could not have anticipated a development in the arts in which things were to become absolute and dominant—as in Ponge or in Robbe-Grillet, or more decisively still in 'concrete-poetry', any more than Mahler could have foreseen the progress from Schoenberg through Webern to Cage or Stockhausen. But the seed was there:

> Praise this world to the Angel, not the untellable: you
> can't impress him with the splendour you've felt; in the cosmos
> where he more feelingly feels you're only a novice. So show him
> some simple thing, refashioned by age after age,
> till it lives in our hands and eyes as a part of ourselves.
> Tell him *things*.[23]

The sheer weight of dedicated suffering in Rilke is unnerving, and at times suspect. He is not unlike the 'Sixth Elegy':

> Fig tree, how long it's been full of meaning for me,
> the way you almost entirely omit to flower
> and into the early-resolute fruit
> uncelebratedly thrust your purest secret.[24]

What is astonishing is that the power did not drain from him nor the sap turn sour. He was suffering to reach joy—a joy known only to the mystic: a revelation of God himself. The elegies, which he carried like a child within him for ten years, were finally delivered at Muzot. The pain was shed. Did he feel blessed?

After the conditioned masterpieces the lightness of the *Sonnets to Orpheus* indicates that perhaps he suspected that a simpler song might, after all, be finer, more pure: 'An aimless breath. A stirring in the god. A breeze.'[25] Did he see, after the astonishing descent of the god, that he was mistaken in his obsession, that the greatest art requires order not only of structure but of vision? What is required is: 'Purest tension. Harmony of forces.'[26] Perhaps it is necessary to suffer in order to achieve a state of grace. In late-nineteenth-century art we can see a culmination of induced torment. Do we discover a 'harmony of forces'? Not in Rilke, for all his greatness. Not in Rodin, leaving unfinished his most ambitious work, *The Gate of Hell*.

Mahler was approaching the end of his tormented life when the aged Rodin cast his portrait. There may be no great significance in the fact that Rilke was Rodin's secretary and that Rodin made a bust of Mahler, but it is true that Rilke would have been the ideal poet to write Mahler's epitaph. Certainly they both display remarkably similar aspects of emotional instability. In their artistic endeavours they also show parallel desires and tendencies, admitting through

their work the allegiance they owe to the mainstream of the romantic tradition, a tradition ready for the drastic pruning that was shortly to be given it by such artists as Schoenberg, Webern, Picasso, Klee, Pound and Eliot. They share, also, a neurotic obsession with the idea of death and martyrdom. It might as easily have been about Rilke that Bruno Walter wrote: 'The mystery of death had always been in his mind and thoughts.'[27]

Mahler no less than Rilke was a man of considerable intellectual ability, but for the purpose of his art he was prepared to subdue that element of his being and allow almost excessive rein to his emotional nature. Like Rilke he wanted to be a god-creature on which great tunes were to be played, using reason only to condition the structure of his works. His astonishing skill as a conductor, his insight into the work of other composers seem at first sight to run counter to his personality as expressed in his own music. This, as we have seen, is a typical trait in the make-up of romantic artists. To penetrate with the intellect; to understand through the emotions. Perhaps Paul Valéry sums up the problem most succinctly in words that might as easily have been spoken by Rilke or Mahler or many artists of the time, poised throughout their lives on the brink of a similar decision:

> If I had to choose between the destiny of a man who knows how and why a certain thing is what we call 'beautiful' and the privilege of knowing what it means to *feel*, I believe I should choose the second, with the idea that if such knowledge were possible (and I rather fear that it is not even conceivable) it would soon lead me to all the secrets of art.[28]

Mahler's preliminary sorties in the field of art were of course subject to a discipline such as no writer can ever share: the mastering of the rudiments of music and the learning of an instrument. He was rare in the history of music in not exploiting the talent that first gave him an entry into a musical education. His remarkable gifts as a pianist were hardly ever realized during the years of his maturity. He excelled as a pianist when a student but later made little use of the piano, yet oddly enough, for a man who must have been one of the greatest conductors of all time, we have no record of his conducting a single concert during his years as a student in Vienna. What we can see in him, as we can in Rilke, is an earnestness, a high seriousness and an almost identical root structure already determining the course his art was to take. They are twins in their early love of the romantic heritage of the German language and in their discovery of a permanent and obsessive theme. Neither of them abandoned or outgrew the weaknesses and flaws of his early work; both by the curious alchemy of genius caught up these flaws and transformed them, if not into virtues, at least into excellences. They exploited their introverted passions as few artists have done,

and even in excess their works, when engaged at a deep level, overcome our criticism. But in Mahler especially the *longueurs* are many, the vulgarities sometimes scarcely endurable, the self-pity and torment distasteful.

The inability to hold himself in check is apparent from the beginning of Mahler's career as a composer. Of the early Piano Quartet Donald Mitchell writes: 'So far as they go, its little contrapuntal and variational ingenuities are—academically speaking—good work; but the patterns and formulas are relentlessly pressed home long after their interest *qua* invention has been exhausted.'[29]

He might as easily have been writing about the Ninth Symphony. It is easy to put this down merely to self-indulgence, but it goes deeper than that. Although the emotional weight of the Quartet is comparatively slight it already shows signs of that spiritual yearning which in later life is the major driving force behind his compositions. It was not a flaw peculiar to Mahler. The prototype of Mahler's Quartet is the Quartet of César Franck; its successor is the First Quartet of Schoenberg. Such are the vagaries of fashion that what we despise in Franck we admire in Schoenberg's early work; what we find vulgar in Tchaikovsky we applaud in Mahler.

That Mahler abandoned the piano is no less strange than that, almost alone among composers, he produced practically no small works; hardly anything done, as it were, on the side. What is more disappointing is that he never wrote an opera. After all, his career was made in the opera house, and he had toyed, as a student, with the idea of an opera, even going so far as to write a libretto. Yet he had to hand a work almost ideally suited to his talents and temperament. It could not have been an opera proper—a dramatic cantata perhaps in the manner of Schoenberg's *Gurrelieder*, but it had everything he needed. It is of course Rilke's *Lay of the Love and Death of Cornet Christoph Rilke*.

Mahler's first substantial work was the song cycle *Lieder eines fahrenden Gesellen*, but he followed this with the first major settings of songs from *Des Knaben Wunderhorn*. The last of the orchestrated versions was written in 1899, the year in which Rilke was composing his own romantic martial episode, and the bars of orchestral music before 'He beats the drum and wakens his dead brothers' are sufficient evidence of the closeness of imagination between poet and composer; the perhaps over-sweet, but lovely setting of 'Where the proud trumpets blow' again inhabits almost exactly the same emotional state as the tender moments of Rilke's small epic. Of course *Cornet* was not published until eight years later when Mahler was well embarked on his—quest for martyrdom?—no, that is too harsh. What then? His search for union with the infinite? After *Des Knaben Wunderhorn* he was rarely to exploit his talent for that gift of superb light music that is the especial province of Viennese composers. What waltzes we might have had; what operettas even! But no, the pressures were too great—

not external pressures, they are more easily countered. Not for Rilke the path of romantic novelist; not for Mahler the world of Reynaldo Hahn or Johann Strauss:

> . . . how he got tangled
> in ever-encroaching creepers of inner event,
> twisted to primitive patterns, to throttling
> growths, to bestial
> preying forms! How he gave himself up to it! Loved.
> Loved his interior world, his interior jungle,
> that primal forest within, on whose mute overthrownness,
> light-green, his heart stood.[30]

The significant word is 'loved'. What is distasteful in Mahler is not the suffering, which his slow movements express with a pathos unparallelled in music, but the suspicion that the suffering is induced and enjoyed. In the highest moment of inspiration he purges us with pity and terror; in his less exalted moments we recoil at the vision of a great musician indulging in masochistic self-flagellation. It is not altogether surprising that one of his most ardent admirers, Schoenberg, should have rebelled against this kind of psychological/musical exposure, while for so long sharing the same emotional condition. It is rare that we can listen to a note of music in the work of Mahler merely as a note of music; we are forced to listen to it with all the moral and religious overtones that had been accreting round the art since Beethoven's Ninth Symphony.

Writing to Debussy in 1899 after hearing a performance of Richard Strauss's *Thus Spake Zarathustra*, Pierre Louÿs pertinently observes: 'You must really hurry up and reform music because things really can't go on as they have been for the last fifteen years. We have got to the point where a chord cannot be resolved without pretending to resolve some problem of God himself.'[31]

The comment might well have embraced Mahler, though the problem of God would need extending to include the personal problems of Mahler.

In a world in which there was a great interplay between the arts, where painting was described in terms of music, music in terms of painting and both these transformed into subtleties of poetry, Mahler's symphonies required the language of philosophy, psychology and mysticism for their proper discussion. Wagner had created a musical language which was a substitute for all other expressions of man; a manner to which it was not enough, could not be enough to respond simply as music—as an art of man. (It is not insignificant that while music lovers merely *visit* Salzburg they make a *pilgrimage* to Bayreuth.) Mahler, though in so many ways his work derives from Berlioz, extends the neurotic element of Wagner. The folly of the will to martyrdom admirably expressed in

Eliot's *Murder in the Cathedral* is that the god for whom one is sacrificed can so easily be oneself. Only the unselfconscious can become true martyrs.

The intense religiosity of much of the music of Mahler is no doubt one of the reasons for its current popularity. It is such a relief after the surgical amorality of so much post-Schoenberg notespinning. Avoiding the degenerate chromatics of the symphony of César Franck and the overtly popular elements of the symphonies of Tchaikovsky, his music nevertheless is not dissimilar from theirs in its emotional aspects. He has in particular certain melodic traits close to those of Tchaikovsky, and though these are sometimes despised they are among his finest and most abiding gifts. His most dedicated champion, Bruno Walter, is surely right when he says: 'So the supreme value of Mahler's work was not in the novelty of its being intriguing, adventurous or bizarre, but rather in the fact that the novelty was transfused into music that is beautiful, inspired and profound; that it possesses the lasting values of high creative artistry, and a deeply significant humanity.'[32]

A critic like Paul Valéry would take exception to the use of words like 'beautiful' and 'profound' in this context and certainly the word 'beautiful' in a less ambiguous usage can be more reasonably applied to the music of Debussy. Nevertheless, we can certainly maintain that the finest works of Mahler are beautiful in the generally understood sense of the word, though rarely does he achieve a complete work in which the banal and the vulgar do not break in.

If Rilke's dolls, clowns and angels are all invested with a redeeming purity, Mahler's works are too often invested with a damaging vulgarity, which often seems deliberate and which is an example of a curious lack of intelligence on the part of this very remarkable composer. What he was unable to see was that vulgarity, sentimentality and banality consciously introduced into a work of art *must* have an additional ingredient of irony, satire, or wit, otherwise the effect will be merely vulgar, sentimental or banal. This error into which Mahler constantly fell is most brilliantly avoided by Béla Bartók, whose interjections of grotesque elements into even the most serious works is always calculated with precise effect; this can be most clearly seen in the Concerto for Orchestra or the Fifth String Quartet. It is the unyielding high seriousness which Mahler shares with Rilke that makes him unable to avoid sententiousness. In this he is a true romantic, the true heir of Wordsworth or Nietzsche, and certainly of Wagner. Seriousness, dedication, ecstasy, suffering. We shall see how, in art as in behaviour, the luxury of grief can swell into the relish of sadism, though by the middle of the twentieth century it was to find its most violent expression not in music but in literature and painting.

In his first six symphonies Mahler, like Rilke in *The Book of Hours* and *The Book*

of Images, was pursuing a single theme. Just as all the elements of the *Duino Elegies* are to be found in Rilke's early poems, even to the extent of similar images, lines, patterns of observation and revelation, so also in these first symphonies we can see the germs of the Eighth, Ninth, Tenth symphonies and of *The Song of the Earth*. It is interesting to note that just as Rilke felt it necessary in *New Poems* to attempt to distance himself from his subject matter, so also did Mahler in the long and enormously complex Seventh Symphony. In Rilke the result more than justifies the attempt. Not so in Mahler. The Seventh Symphony is perhaps the best work in the repertory through which to examine the weakness of the romantic conception of music in a period of its decadence. The shoring-up of structures which had already served their purpose in the symphonies of Beethoven and had been given remarkable after-life in the symphonies of Brahms is exposed in this gigantic symphony for what it is—a process of rescue rather than a process of creation. For all the weaknesses of Mahler's subjectivity the hollow rhetoric and posturing of much of the Seventh Symphony show that it is precisely that subjectivity which, in the long run, is his salvation. For all the structural magnificence of the work it collapses because of a lack of sustaining content. It collapses in a way that a weak concerto by Vivaldi cannot do, just as a high romantic poem collapses as an Elizabethan lyric cannot, or an Expressionist painting in a way denied to a Flemish primitive. In the later works of any history of art moving through a romantic phase, the power of the emotional content is not merely valuable, it is indispensable, for it is the emotional content that has the strongest claim on our interest. However much, in our more rational moments, we may rage against an art that by virtue of its emotional strength demands from us an excess of emotional response, we should be thankful that such an art has been possible and may well be possible again.

But the Seventh Symphony, despite the praise it has won from many critics, is surely for the most part of exceptional banality, and, like the banal in Rilke or Rodin, becomes more intolerable when we realize with what earnestness it was written down. It is not merely that the overall banality of the themes is so distressing but also that those 'tricks' of style which are so identifiable in Mahler are here remorselessly used for all the wrong ends. The work involves, as only a work of late romanticism can, a total self-deception, since it is produced out of a mood of self-indulgence. What is lost is the possibility of some admirable short works in, say, the Tchaikovsky ballet form; for much of the second movement is most fitted to such a lighthearted work. But for Mahler it was all or nothing, because in the long run his creative activity was perilously close to therapeutic activity. We are already in this work a long way from the conception of an artist as a man serving a stable community, as might a butcher, a baker or a candlestick-maker. In the Seventh Symphony we have the worse of two possible worlds,

for if it lacks the obsessiveness that marks certain of his other greater works, it is not greater for this, because, like it or not, that very obsessiveness is the bulwark against our criticism. Listening to this enormous ill-conception we can be excused if we smile somewhat ironically at the composer's supreme arrogance in rewriting the symphonies of Schumann and at his sardonic comments on the symphonies of Brahms. Well, perhaps the Seventh Symphony was necessary, since it cleared away much unwanted matter that might otherwise have clogged the infinitely more distinguished song symphony *The Song of the Earth*, the Ninth Symphony and the unfinished Tenth Symphony.

Few composers have had that astonishing gift of Mozart, who seems almost equally at home in all the forms of music; who can write with supreme confidence for piano, for violin, for orchestra, for the human voice. Not even Beethoven was quite so versatile, although he seemed to find at times a necessity for the concern that words have for the exploration of the condition of man. His Ninth Symphony has much to answer for. But it has much to take to its credit: few things more remarkable perhaps than the dedicated personal despair of Mahler's *The Song of the Earth*. After the Seventh Symphony with its long-winded meandering, its exploitation of effect after effect, *The Song of the Earth* opens with an upsurge of positive inspiration that leaves little doubt of its claim to being at least a possible masterpiece. It even manages to avoid the claims of symphony on the one hand and song cycle on the other and to exist as a new form in its own right. None of Mahler's other orchestral works which employ the human voice have such authority. Against all the odds, Mahler, in this work, comes very close to demonstrating what Coleridge has so finely written about works of art: 'No work of true genius dares want its appropriate form, neither indeed is there any danger of this.'

In his haunting song-symphony Mahler discovers his true genius, which undoubtedly has, to conclude Coleridge's observations, 'The power of acting creatively under laws of its own origination'.

How appropriate that it is *The Song of the Earth* and that it should be an enormous progress to a lament; the unbearable realization of the transience of human life. It is, as John Heath-Stubbs has written, 'in time of the unbearable tenderness of roses'. But roses are neither unbearable nor tender, only we make them so. The sentimentality which mars much of Wagner's *Parsifal* mars this work also.

The radiance, though, of that upward opening moment of exultation lurks even in the sombre mood of the long closing pages of resignation which for once are not despairing but accepting; accepting almost as the last 'Duino Elegy' accepts, as that sublime Sarah of Rouault smiles enigmatically in its own spiritual nirvana. But the 'almost' is important.

The choice of poems is particularly appropriate and fortunate. Chinese poetry translated into any European language has a strange quality of philosophical sadness. Intensely nostalgic, exceptionally refined, what could be more perfect for the swan song of a composer whose whole life seems to have been lived as a sort of love/fear relationship with the idea of death? In the event of course it was not his swan song at all. Hysterically afraid of committing his genius to the composition of a Ninth Symphony because Beethoven had died after that number, he interposed this work which is symphonic in proportions but to which he could avoid giving the exalted name of symphony. But in a way perhaps he was right after all, because when he came to write the next, which we rightly call the Ninth Symphony, it was to be his last, though Deryck Cooke has performed such an astonishing rescue operation on the unfinished Tenth that it becomes a fine completion of the cycle.

It is not difficult to imagine with what sympathy Mahler seized upon Li Tai-Po's 'Drinking Song of the Sadness of the Earth' for the opening of his work. 'Dark is life, dark is death.' The poet might have been addressing the composer directly. Rilke, for all his similarity to Mahler in weight and sonority, entered into the sadness of the world to release essential joy. Finally the *Duino Elegies* are affirmative statements. But for Mahler, always, the terror of death looms to prevent the full realization of the glory of existence.

> Look there, down there, in the moonlight, on the graves
> Squats a mad spectral figure!
> It is an ape! Hear how his howling
> Screams its way through the sweet fragrance of life.[33]

In fact *The Song of the Earth* is one of the few works of Mahler in which the howling of the ape is for much of the time kept out. The vulgarity which is his Achilles' heel is kept at bay throughout the greater part of the moving composition. He still cannot avoid those flattened intervals which cause such a tug at the heart; those scoops of sound which come close to being a mockery of the romantic composer's method of gaining effect and which we can hear in most bad Hollywood movies of more pretension than achievement. It is not for nothing that the imitative composers of romantic pop have drawn their work from the luxurious longing of composers like Tchaikovsky, Wagner, Mahler, *et al.* We may rightly say that it is hard luck on the composers if their style is diminished by the purveyors of popular romantic kitsch, but there must be an element of such kitsch in the original for it to be seized upon and exploited— Mahler has this in overwhelming measure, but so also has Wagner, and in philosophical spheres undoubtedly so has Nietzsche, so potent a force on Mahler in his formative years.

We have come a long way from Wordsworth and the first formulation of the romantic ideal. Whatever we may think of the poet's eventual tediousness, the moral rigidity, the humourless postures, he is an example of the necessity to see things whole. Self-pity was alien to him, self-torment impossible. What, he might well have said, does the world require of you if only a vicarious enjoyment of your suffering? Do we go into mental hospitals to enjoy the aberrations and despairs of the inmates, or stand at gravesides or by sickbeds to gain pleasure from another's grief?

What is distressing in Mahler is that he suffers; what is distasteful is the suspicion that he enjoys his suffering; but what is most damaging is the feeling that he exploits his suffering to win our sympathy. Nevertheless it must be admitted that it is this element in his music that accounts for much of the current adulation. His spectacular orchestration, his close-to-sentimental melodic lines make him a natural successor to Tchaikovsky, who, like Mahler, has a great deal more to offer than either of these.

The trouble is that the religiosity will keep breaking through and if it is entwined by the audacity of the mid-European artistic mind and the hyper-sensitivity of the Jew, the weaknesses are of the same kind that perhaps prevent Newman and Elgar, with their moral piety, from the highest achievement. Nowhere is this lack of classical decorum felt more keenly than in the huge adagio which closes the Ninth Symphony. True, there is the unfortunate feature of the expansive first subject's bearing so close a likeness to 'Abide with Me', but it is not *merely* a thematic problem. The shifts in tonality are less than in many other works of the period but they are of a particularly revealing kind; they continually decline. The extraordinary thing about Mahler is that he is not a forward-looking modern composer, nor is he, properly speaking, a settled traditionalist—as perhaps Bruckner was, or Sibelius was. Fundamentally he is regressive.

The more closely we examine the works of Mahler in the light of musical developments in the twentieth century the more firmly we shall discover them to be rooted inalienably in the tradition of the great German romantic composers. Despite his championship of such radical composers as Schoenberg and Berg he was never able, himself, to make that leap forward that would have made us think of him as a twentieth-century composer. Even a composer as saturated with the ideas of the Symbolists as Debussy, who, at first sight, seems so much the mystic or romantic of the *fin de siècle*, is modern in a way that Mahler not only is not but curiously never was. None of his works is in any way innovatory or original, if by original we mean a production stemming from a unique inspiration. There is nothing wrong in this. It has been said many times that Brahms

could be removed from the history of music and the effect would be minimal, but the removal of Berlioz would be of dramatic proportions. We do not, because this may be true, think any the less of the achievement of Brahms. Nor need we be concerned about that aspect of Mahler. What is fascinating is to observe in him a tendency on the part of romantic artists, choosing him as perhaps the most typical figure of the idealized artist placed just at a turning point of culture. It is not that he represents a composer perilously born out of his time or caught in a swing of taste and fashion; it is more dramatic than that. Richard Strauss, who shares his vulgarity, his pretentiousness but also his gift for superb melodic orchestration, shows how it was possible by facing both ways to escape the obsessive paranoia of Mahler. (This is not to imply that Strauss is a 'greater' composer.) It is doubtful whether Mahler could ever have realized not merely the sardonic overtones but the absolute rightness that drew Strauss to the pastiche of *Der Rosenkavalier*. The classical/romantic pleasure which the work provides is owing to the skill with which Strauss understands and uses, quite seriously, the particular convention; the modernity lies in the way in which, at the same time, he mocks it. Mahler would have seen small reason for the use of a soprano to play the part of Octavian and could never have allowed the moral ambiguity of the end. For all the lumpish humour brought, at great cost, into nearly all his music, nobody is likely to accuse Mahler of qualities of orthodox humour and certainly not of wit. He shares with Rilke a total high seriousness. The trouble with this lack is that it also usually precludes a real tenderness. Though Mahler was thoughtful, generous, kind, often unsparing in his work on other people's behalf, he is scarcely ever tender, and he is far too neurotic to relax without the relaxation's taking the shape of a melancholic nostalgia. One longs for that sense of normal humanity so appealing in Haydn, the delicious irreverence so captivating in Mozart, the sheer goodnatured warmth of Schubert, for whom music was sufficiently important not to be always obsessively 'serious'. But this would be to expect Mahler to escape from the condition of art within his particular formative years, and to think it possible for him to avoid the working out of psychological traits inherent in his being. As Krenek observed: 'A most peculiar attitude of hedonistic pessimism, joyful skepticism touching on morbid sophistication, became the dominant trait in Vienna's intellectual climate.'[34]

This is not merely a comment on Mahler as a person but a key to a proper understanding of much of the art of the time—sometimes extending well into the middle of our period for, as I have said, artists like Rilke, Mahler and Rouault only deepen in their approach to individual works, they show little development —their touch becomes surer but they do not venture outside the spiritual confines already clearly marked in their early creations.

The often-quoted element of 'morbid sophistication' is not the whole truth

about Mahler—if it were there would be less reason for considering him so passionately, as audiences undoubtedly do more than fifty years after his death. But it is a quality which he exploits to the full—in *Songs on the Death of Infants*, *The Song of the Earth*, the Ninth Symphony and the Tenth Symphony. Undoubtedly a streak of morbid sophistication attaches to areas of the poetry of Rilke and the painting of Rouault, but it is a reasonable flaw set beside the extraordinary achievement of each in his particular art form. Each has the tragic vision, each has a glimpse of glory, but Mahler more than the others is doomed to continual disillusion and suffering, whether self-induced or not. In the third section of the unfinished Tenth Symphony, over a particularly Mahleresque declining motif is written: 'O God, why hast thou forsaken me?'

'Art for you is serious, sober and, in its essence, religious. And everything you do will bear this stamp.'[35] The words might very well have been spoken by a perceptive literary critic to Rilke or by a teacher at the academy to Mahler; in fact they are the words of the great art teacher Gustave Moreau and refer, with precision and insight, to his most gifted pupil, Georges Rouault. Or again, from the same source: 'He was the kind who, in order to express himself through line and colour, is obliged to close his eyes, to replace sight by vision.'[36] Vision in this sense, though certainly imprecise and open to criticism (which was to come in great measure in the years leading up to the First World War) is perhaps the best word to use to describe a quality that does persist in the work of these three artists; seriousness is another; dedication also, and above all an extreme belief in the significance of what they were doing. Is a consciousness of the value of oneself as an artist a good thing?

Although his reaction was utterly different from Mahler's, Rouault shares, in his early life, similar despairs arising from rejection. What is noticeable in Rouault, as in Rilke, Mahler, and indeed in Rodin, is the way in which the progress of his work is indicated by his early paintings and drawings, and although his method of using paint undergoes a greater change than Mahler's use of orchestration, Rilke's vocabulary and formal structure, or Rodin's method of modelling, the themes are equally obsessive and of the same kind as those of the other artists. Art is indeed a manipulation of the spirit; a religious activity. What is especially notable in Rouault is the way in which he manages to avoid commonplace religio-moral overtones in his work. Like Rilke he is never evangelical. Indeed he shares to an astonishing degree that cast of mind which made Rilke speak of the silent nature of God or of dolls. It is amazing to discover along what parallel lines these three artists move and to see how they use images which have the same or very similar effects on audience, reader, or viewer. Rouault scarcely ever departs from three allied subjects: clowns, prostitutes, and

God (I include the Christ, King and Judge figures under the latter term). Essentially, like Rilke's, his work from the very beginning is a struggle toward the demonstration of the reality of the divine. While Rilke is desperately waiting for his 'angels', while Mahler is attempting to break through to an acceptance by God, Rouault, ruthlessly patient, is struggling to record his vision of the divine countenance.

His student work (judged by other than student standards) is close to sentimentality. How could he have discarded a century of classical treatment of religio-moral subjects? What makes even these student works fascinating in view of his development is the intense sense of tragedy which pervades them. They are shrouded in a darkness which is used for effects deeper, less calculated, than any orthodox student use of chiaroscuro effects. In a drawing like *The Kiss of Judas* (1895), one can see the pressure that will eventually force through those late Christ figures. Even these early works disturb. They do not exhibit sweetness and light. There is a kind of urgent bitterness in some, a desperate sadness in others, that is unnerving. Perhaps his rejection by the society to which he had given so much labour, and later the rejection by the larger public, gave him some reason to identify with a figure like Christ—the despised and cast out.

Society that had rejected him, as it had rejected Mahler (in his capacity as composer), was soon to round on him when he chose, with a vulgarity almost excessive, to display the series of paintings of prostitutes, for rarely has this aspect of the female been so brutally explored. What makes them so rewarding is the honesty with which they are presented. Here he is making a comment in the tradition of Daumier, not of the more shallow mockery of Picasso in a painting like *Les Demoiselles d'Avignon*. It is the very reality of these often near-obscene figures that makes them bearable. And as Pierre Courthion valuably discusses in his important book on the artist, the link between Christ and prostitution is a constant and abiding one, whether its overtones are of Mary Magdalen or of the Whore of Babylon. Courthion records an apposite event in relation to the *Prostitute at her Mirror* of 1906:

> This work recalls something Claudel told a friend and which he himself had been told by the priest who received him into the Catholic faith. A prostitute to whom this priest had just given the last sacraments said to him: 'Open the wardrobe and you will see what kept me from suicide.' What he saw was the statue of the Virgin Mary.[37]

A century which has seen the vulgarization of art, religion, morality, and most of the finer aspects of man's nature, has made obscene play with this 'good' prostitute idea. Rouault, though he is often too vulgar, too insistent on the sordid aspect of the theme, never exploits it. His comment is severe, savage, often

profound. The grossness and the mysticism are interestingly and obsessively entwined. He looks into the loneliness, despair or guilt of the characters he portrays; his concern is for them. He never offends, as Picasso frequently offends by using his subjects for his own ends, to flatter his personal vanity. The 'beauty' of these disturbing canvases lies precisely in their 'ugliness'. Despite the fact that he often relates his subjects to a particular place, a particular situation, he quite fails to indicate with any vividness the period of the work. There is nothing in his vision of the acid particularity of Lautrec, who manages to be accurate and satirical at the same time. No hint of real satire invades these early Rouault paintings. Only a deep concern for the universality of the conditions he portrays —for it is conditions that are his concern. All his work is concerned with making a spiritual statement. Like Mahler and Rilke he pursues, with gravity and occasional hysteria, a search for God.

The natural world is dark; it is a pit of blackness out of which light has to be conjured. Not for Rouault the white canvas on which beauties could be laid. Looking at his paintings, more deeply devouring than almost any other paintings of our time, we are never allowed to forget the heaviness, the density of man's being. He is of the earth; he is an animal. The prostitutes leer to seduce; the clowns are locked in their terrible tragedy, silent and unsmiling; the judges have iron bars stamped behind their eyes; the countenance of Christ is as enigmatic as a cat's or as savage as a tiger's. Only the ambiguous figures of Pierrot and Harlequin are allowed to indulge in the luxury of a fleeting grin, a tender reflective glance. They move, more elegantly than any of the women, through a slighter world partaking occasionally of the unsettling ambiguity of the homo- sexual world, but they serve to illuminate still more the terror and magnificence of the more sombre paintings. As his reputation grew, as his style developed, it seemed as if, like Rilke, he would never penetrate to the reality he knew to be hidden by the surfaces of the world; the beatific vision continued to elude him. His landscapes are all out of the Old Testament. Was he trying to create a New Testament Christ in the image of an ancient prophet? From being the only French 'German Expressionist' he pushed his style toward the manner, close to mannerism, of the makers of Russian icons, building up works in thick layers of paint, foreshadowing much later work of this kind by inferior artists. His excursions into satire have none of the superficial vulgarities of Mahler and none of the snobbishness of Rilke, nor are they so bitingly savage as are the more grotesque satires of Daumier or the pointed and vicious mockeries of Georg Grosz. Despite such deliberate uglinesses as can be found in some of the graphic work, in particular the drawings for *Ubu*, he is never fully successful in social comment or universal satire because he lacks any true violence of mind. He is too

sympathetic to castigate even those figures, like bankers, for whom he harbours most hatred. That is why even his most powerful statements in paint about the disgusting side of man's nature are never destructive. Perhaps the very fact that the world cast him aside for such a long time helped to build up that element of his character that desired spiritual and artistic wealth above all: 'The richness of the world, all artificial pleasures, have the taste of sickness and give off a smell of death in the face of certain spiritual possessions.'[38] So, despite sorties into the social situations of men and women, he became increasingly obsessed with trying to discover more and more about what man *is* and less and less about what he does. His own writings show, strangely, a somewhat jubilant cast of mind which can at first sight seem in contra-distinction to his essentially sombre paintings. But it must be remembered that while he was pointing out continually that all flesh is grass he was also perpetually reinforcing a belief in resurrection.

To find a painter of such intense dedication to the inner nature of man we perhaps need to turn back to Rembrandt, least 'attractive' of all the artists of his time. They share a lack of interest in the peripheral elements of man's world and both were utterly opposed to the material progress of the times in which they lived. Rouault saw with ever-deepening revulsion the growth of a society in which only lip-service was paid to the true needs of mankind. He loathed the increasing speed, the noise, the general 'admass' society. He saw it was as shallow as it was brilliant. This is not to say that he was only interested in what was profoundly important—the highest achievements of the greatest artists. On the contrary he had a great respect and liking for many so-called minor artists. He was honest himself. He valued honesty in others. He saw very plainly indeed (had his own experience not taught him to watch for such things?) how the meretricious can so easily be elevated to a position of rank and power. Developments in art during the last years of his life must have caused him considerable anguish, not because he could see men of no worth streaking ahead of him in fame—though he was by then a figure of international esteem—but because of the insult to art, to man's integrity, to the very fount of man's aspirations, which he believed to be entirely spiritual. For him nothing was of any significance except 'the ray of grace beneath which a man's heart is beating'.

In *The Family Reunion*, Agatha remarks, with a gravity that ought by now to have seared itself into the mind of its various producers but, alas, seems scarcely to have been heard by them at all: 'What we have written is not a story of detection,/Of crime and punishment, but of sin and expiation.'[39] It could stand as a comment on much of man's activity in the first half of the twentieth century. It could certainly stand at the head of the works of the three artists who have formed the main concern of this chapter. Mahler, Rilke and Rouault have

something of the character of the ancient Greeks, for whom art was a religious activity. None of them ever contemplates the pursuit of art as entertainment for the masses—though art as entertainment is a valuable contribution to the life of man. Nor do they confuse their aims or vary the direction in which, from the outset, they move. However 'difficult' they may have seemed to many when their works began to appear, indeed however difficult they may still be for many people, they show the romantic tradition in its final phase more clearly than any other artists of their time. If Mahler is of the nature of Beethoven and Brahms, Rilke is the heir of Goethe and Wordsworth and Rouault of Rembrandt. But romanticism in this late phase is concerned not with exploring man's search for a meaning in the world, but for an understanding of himself and for a realization of what lies beyond the surface of his being. For all their modernity these particular artists are in some way curiously old fashioned, and despite the fact that Rouault, for instance, did not die until 1958, I have placed them in this position because they exhibit more clearly than any other figures the especial preoccupation of the serious traditional artist at the end of the nineteenth century. Possibly they lack the touch that would have linked them directly with the future. Their beliefs, even their techniques, are perhaps more firmly related to the old than to the new world. If that is so then certainly the final fruit of the special kind of romanticism that budded in the last quarter of the eighteenth century and flowered so finely in the early years of the nineteenth was in these artists, rich and sustaining. It was perhaps all the more extraordinary for being delayed. Within the years of its development there was to grow up a plant no less exotic, but which put forth flowers of a very different kind, which indulged in a more tenuous mysticism, less sombre, but no less disquieting. It is not my purpose here to write about that extraordinary movement which we call 'Symbolist', but to look at one or two figures who are dominated by that movement and who make a bridge between the nineteenth and twentieth centuries.

It is essential to bear in mind that the chronology of the arts in historical epochs is never smooth or exact. So much depends, for instance, on the length of life of the dominant artists. Between 1860 and 1910 we can witness the birth, flowering and death, or the birth and flowering of a variety of artists of a quality perhaps as remarkable as in any comparable period of time. Not all of them do the same thing. For Mahler, for Rilke, for Rouault, the probing of man's spiritual dilemma is a positive, assertive occupation. But at precisely this time three figures in particular are making explorations in a highly different, much more feminine (which is not to be confused with effeminate) way. Two of these are now thought of as among the great figures in their particular arts; one, after a period of extreme popularity, is quite out of favour. Between them they illustrate a particularly civilized, perhaps too carefully refined period in art. This time the

attention shifts away from poet and painter to novelist and dramatist. From the crudities, if they are that, of the figures we have been pursuing let us for a moment look at the elegances (vulgarities, too, of a different kind) of Debussy, Maeterlinck, Proust.

MAETERLINCK DEBUSSY PROUST

For it was but a butterffy, a bright cream-licker, Hetæra Esmeralda, she charmed me with her touch, the milk-witch, and I followed after her into the twilit shadowy foliage that her transparent nakedness loveth, and where I caught her, who in flight is like a wind-blown petal, caught her and caressed with her, defying her warning, so did it befall. For as she charmed me, so she bewitched me and forgave me in love—so I was initiate, and the promise confirmed.

Thomas Mann, *Dr Faustus*.

Maeterlinck is perhaps the most spectacular example of the writer who is rocketed to fame overnight, who reaches a peak of international popularity in his late middle years and then, either because of his own declining inspiration or a change in literary tastes, or a combination of both, finds himself at the end of his life cast out or treated only as a mild curiosity.

With Emile Verhaeren, Maeterlinck was the most important figure in the astonishing artistic revival that took place in Belgium in the second half of the nineteenth century. In his earliest work he exhibits all the faults or sentimentality and self-indulgent mysticism that are the inevitable features of those periods in art in which the vision of the artist is focused on an idealized past. He was death-fixated but lacked the savage irony of Beddoes. He was reflective, eloquent but, somehow, tired. There was no saving eroticism in his languor and little sexual vitality in his passion. He sighed, he moved steadily toward a world further and further removed from the grim absurdity of everyday life. It is not inappropriate that the writer instrumental in launching his fame was Mallarmé, most pure, most removed, most perfect of the Symbolist poets.

The praise that Mirbeau lavished on Maeterlinck's first play now seems amazingly extravagant: 'In short, M. Maurice Maeterlinck has given us the work of this age most full of genius, and the most extraordinary and most simple as well, comparable and—shall I dare say it?—superior in beauty to what is most beautiful in Shakespeare.'[1]

But if the praise is hyperbolic it is not altogether to be wondered at. Symbolism in poetry had already arrived, was already established. The symbolist drama still had to be made. In Ireland, Yeats, it is true, was moving toward the symbolic gesture in his early 'Celtic' plays but what Mirbeau rightly saw in Maeterlinck's play was the possibility of a drama in which the characters might be thought of as abstract nouns rather than as persons of flesh and blood. It is not uninteresting to reflect in this connection that despite all its critical acclaim and the fact that it brought its author so forcibly to the notice of a large public throughout France and Belgium, this play, *The Princess Maleine*, has never been performed on the professional stage. For Maeterlinck the play was the first shoot toward his formulation of the presence of destiny. And as we have seen, destiny is precisely that which is not willed. Certainly the proposition that man is subject to forces outside himself was not new, but in Maeterlinck's early dramas the crude machinery of 'Fate' was replaced by a subtle apprehensiveness. He rightly saw that if destiny cannot be willed symbolism cannot be 'explained'.

He was not unique in his choice of themes. John Millington Synge, in Ireland, was shortly to produce in *Riders to the Sea* a situation, and a resolution, remarkably close to that of Maeterlinck's play *L'Intérieur*. More important because more closely woven, more 'abstract' is the hypnotically disturbing play *The Sightless*. It is spectacularly the play of 'no-happening' and when we smile comfortingly to ourselves in the knowledge of the rightness of our contemporary judgements and the folly of our predecessors we should perhaps look at this play in relation to one of the most celebrated dramas of the last twenty-five years—Beckett's *Waiting for Godot*. In a wood at night a group of blind men and women, together with a priest whose 'eyes, dumb and fixed, no longer gaze at the visible side of eternity' wait. For what? As in Godot nothing is explained, no action concluded. A significant part of the dramatic tension is provided by what is not there, what we shall never know. The opening is excellently precipitous:

FIRST BLIND MAN: Is he not coming yet?

SECOND BLIND MAN: You have waked me!

FIRST BLIND MAN: I was asleep too.

THIRD BLIND MAN: I was asleep too.

FIRST BLIND MAN: Is he not coming yet?

SECOND BLIND MAN: I hear nothing coming.

THIRD BLIND MAN: It must be about time to go back to the asylum.

FIRST BLIND MAN: We want to know where we are!

SECOND BLIND MAN: It has grown cold since he left.

FIRST BLIND MAN: We want to know where we are!

OLDEST BLIND MAN: Does any one know where we are?[2]

The whole burden of the play is dictated by the fact that, as in Godot, the characters *could* do something to extricate themselves from their predicament if they allowed reason to direct their actions, but *don't* do anything because 'destiny' paralyses their will to action. They wait, they hope, they despair. As in *Godot* the person they try to turn to—the Priest in the Maeterlinck, Pozzo in the Beckett—is blind. In *Godot* Lucky goes dumb also, in *The Sightless* the Priest dies, but remains on stage in the same position throughout. His presence is neither menacing nor horrific. He is merely there. The only positive action in both is the flowering of, or the falling of leaves from the trees. Both plays introduce an additional character who does not share the condition of the other persons in the drama—who presumably has some direct knowledge hidden from the ordinary man. Beckett uses a young boy who, in the final passages, when asked if he has seen Godot, and if he will come, says nothing that adds any dimension to the vagueness of the being called Godot:

VLADIMIR (*softly*): Has he a beard, Mr. Godot?
BOY: Yes, sir.
VLADIMIR: Fair or . . . (*he hesitates*) . . . or black?
BOY: I *think* its white, sir [my italics].
(*Silence.*)
VLADIMIR: Christ have mercy on us![3]

When the boy has gone Estragon and Vladimir continue to exist in their particular hell of inaction and indecision filled with hypnotic though desultory speculations about death. *The Sightless* relies for its effect on the same device. As the blind people hear what they believe to be footsteps coming nearer, the young blind woman lifts up her baby, the only sighted person among them:

THE YOUNG BLIND WOMAN: Step aside! Step aside! (*She lifts the child above the group of the sightless.*)
The footsteps have stopped right among us! . . .
THE OLDEST BLIND MAN: They are here! They are here in our midst!
THE YOUNG BLIND WOMAN: Who are you?
(*Silence.*)
THE OLDEST BLIND WOMAN: Have pity on us!
(*Silence. The child cries more desperately.*)[4]

However, the attempt to write drama in which all the characters are ciphers, who merely project the neurosis or mystic apprehension of their author, is a way of extreme narrowness leading, as is clearly observable in the later works of Beckett, over the brink of spoken drama altogether—only grunts or wordless actions are left. Maeterlinck saw the danger just in time but instead of turning his face against the genre as a whole was fortunate enough to discover a subject

in which, while the tragic theme was as elemental, as abstract as in any other symbolic play, it was carried forward by characters with just enough reality about them to demand our sympathy but not enough to break the fragile web of non-being in which all fairy tales and all symbolic works must be caught. At the first Paris performance the drama was performed behind a gauze curtain. 'It was hoped thereby to simulate the mysteriousness of the setting . . . blurring in shadow the outlines of reality.'[5] The play caused him a great deal of trouble and its subsequent career precipitated some of the silliest actions of his life, but perhaps, looking back on it even he might be astonished at its very remarkable power. Desperately out of fashion now, it is a work of extraordinary subtlety. If symbolist drama is a meaningful term then Maeterlinck has created within that medium its masterpiece. Written in 1892, it is, of course *Pelléas and Mélisande*.

It is surely no accident that, despite the mixed reception given to it by theatre critics, *Pelléas and Mélisande* attracted the attention of a great many musicians. Among those who wrote music inspired by it were Sibelius, Fauré, Schoenberg and Debussy. Since Debussy's opera is generally acknowledged to be a masterpiece, the play, in its operatic form, is unlikely to be forgotten. And since, despite Maeterlinck's severe criticism of the libretto, it follows the original text perhaps more faithfully than any other musical stage work, we can safely say that if the opera survives then the play survives. Where Debussy altered the play he did so for the most part to its advantage. The story has usually been described as a feminine *Tristan and Isolde* and there is some truth in that description. Both works are concerned with love and jealousy and the working out of a fate which the characters are powerless to avoid. Both are oblique in style and highly romantic; both are set in landscapes of gloom by the sea, and in each most of the action is interior—events hinted at rather than made explicit.

The terrible, smouldering wars of Strindberg and the shock tactics of Wedekind were to expose in the theatre what Freud had already exposed in the clinic and the study. Their relentless uncovering of guilt and the disastrous results attendant on the attempt to escape from, rather than to exorcise, that guilt, are firmly based in the sexual directives of man. What Klee, Berg and Synge saw with astonishing clarity was that this vital urge would be the foundation of the art of the immediate future. But the very power and the obsessive narrowness of Freud's explorations required, not an opposite, but a softer, more generalized face. It was supplied by Jung. In Maeterlinck's most successful plays, and *Pelléas and Mélisande* in particular, we see the Jungian hypothesis made for the first time possible in the theatre.

In *Pelléas* Maeterlinck says in effect: You do not know anything about the world you live in except that it is a forbidding wilderness. Occasionally you

suspect that somewhere outside there is light, air and freedom. Freedom from what? You cannot know what; if you did it would be easier to escape. You are aware of birth, though you may often wish you had not been born; you vaguely realize the continuous progress toward death. You are never able to understand another person, though occasionally in moments of unreason you inhabit states to which we give the names love, hate, jealousy, desire. Though you live in a vacuum other beings impinge, but they are equally lost and bewildered. If there is such a being as God and if you could become him you would have pity on the hearts of men.*

It was the inspiration of a poem by Mallarmé that produced the first un-questionable masterpiece of Debussy. It is appropriate that it should be a play by Mallarme's protégé that precipitated his only opera proper, an opera unique in its sensitivity. Although Debussy spent ten years on the writing of the work it was not a Flaubertian agony of composition. The major part of the score was finished quickly. However, force of circumstance hindered its completion. The result was that the first substantial music written for Maeterlinck's drama was the suite of incidental music by Gabriel Fauré which was played at the first London performance. Delightful as it is, Fauré's music reflects only the surface features of the play; its elegances are too innocent, its weight too insubstantial. It lies in direct contrast to the sombre gravitational pull of Schoenberg's enormous tone poem which misinterprets the play in a dangerously Wagnerian fashion. Listening to the Debussy opera it is as if we hear not a setting of the play but the play being rewritten in musical terms. Dramatist and composer shared a similar artistic ideal. For Maeterlinck the drama of closely related events pursued in a logical formal manner, with a mechanical plot, an overt schematic development—the traditional well-made play—was an impossibility. The pro-gress of his drama is indicated only by small fitful moments, specks which suddenly glint in the light, words which break into a silence and then sink again. The pebble thrown into the pond is visible for a brief time—the ripples expand into the eternity of silence. But this is not to suppose that the play has no structure or that the theme undergoes no development. What it does not do is allow the theme to become trapped by an argument that is capable of being pursued by the Cartesian method. The effect is of perpetual improvisation. It is precisely this ideal that is the driving force behind Debussy's music. It was a subtle development from the method of Wagner, a composer who both fascinated and repelled Debussy. The attempt to provide a Wagnerian analysis of Debussy's astonishingly lovely score has been undertaken very successfully but it would be

* 'If I were God I would have pity on the hearts of men.' Arkel in *Pelléas and Mélisande*.

a brave listener who could say with conviction that he was aware of the scheme in performance.

Debussy's aim was not so much to 'write an opera' as to body forth a dramatic text with a musical score, an aim pursued to its furthest extreme by the contemporary German composer Carl Orff. Debussy's first concern, already indicated by the early songs, was a respect for the nature of the language. One of the major stumbling blocks to an appreciation of *Pelléas* is the lack of an 'effective' 'operatic' vocal style. To experience an exact illustration of the difference between the ideal 'French' opera and an opera merely written in French it is only necessary to play side by side *Pelléas* and *Louise* by Gustave Charpentier, an opera deservedly popular at the turn of the century but since fallen into unwarranted neglect.

Although the major cause of the disruption between Debussy and Maeterlinck was the absolute refusal by Debussy to allow the part of Mélisande to be sung by Georgette Leblanc, a totally inadequate performer for such a difficult role, a subsidiary cause was Maeterlinck's belief that Debussy's changes in the text had mutilated the play. In fact Debussy's cuts, and they are few, help to push the play one stage further along the road to pure symbolism. He removes only those scenes in which an element of everyday reality, or of partial explanation, intrude. Unlike the play, which opens clumsily with a general scene for the servants, Debussy starts at once with the discovery of Mélisande weeping in the forest, and throughout the opera he removes scenes from the play in which the subsidiary characters intrude to give indications of what has happened or might happen. This is especially important in relation to the wounding of Mélisande. In the play, having been so enigmatic, so oblique in the great scene in which Pelléas and Mélisande are discovered in the garden by Golaud and in which Pelléas is killed, Maeterlinck introduces a dull and straightforward episode in which the servants talk about the event, are awed by it, convey to each other and the audience the news that Mélisande had been wounded and talk about the birth of a child. Debussy properly sees that this is a violation of the symbolist method and, while making very few changes to the garden scene or the final scene of the death of Mélisande, pushes this piece of theatrical machinery out of the way. Mélisande's death, therefore, and the birth of the child, on whom all fate now rests, are left without explanation or embroidery. This is in close relation to the musical deployment of the opera, for Debussy was concerned, not to remove the links between the themes, nor the actual structure of his harmonic pattern, but to submerge them so that they would be unnoticeable. It is in this quality that his originality lies and it is this that links him so strongly with a playwright of Maeterlinck's temperament, with the post-Cézanne era in painting (for though to call Debussy an 'Impressionist' would be limiting, it would be perverse to

pretend that his music is not often 'impressionistic'), and, among novelists, with Proust. Debussy's 'modernity' lies not in the fact that he abandoned the classical method of composition, that he replaced a particular and hallowed formal method with an untried and formless one, but in that he manipulated classical form differently. He does not say 'we should abandon harmony' but 'let us look at the nature of harmony—what do we mean by it?' as contemporary figures in the field of religion and ethics were concerned not to query the existence of God or to remove order from society but to examine the existing ideas and rearrange the elements into a pattern no less 'formal' but held together by different lines of tension. Their preoccupations were not unlike those of many of their distinguished contemporaries working within various scientific disciplines—though art, of course, has a significant advantage over science in that there are no 'absolute' artistic facts that can be discredited. They were attempting to replace a constant centre of gravity with a variable one. They were not saying nothing is constant, there is no centre, therefore things must fall apart, but that all things are at a centre; equally that the proposition of the world's being in a state of flux is not to be construed as an argument for a belief in chaos. But such is the nature of imitators that it does not take long for the misconceptions of the disciples to overlay the truths of the original genius. There is also the added exasperation that a truly remarkable work can be considered from diametrically opposed points of view, and it is often difficult to decide which is the more damaging, the misconception of those who criticize it for something which they *think* it lacks, or of those who criticize or praise it for what they *think* it contains. Debussy's work in general and *Pelléas* in particular suffer greatly in this respect.

One of the contributing features of an apparent weakening of the 'solidity' of the arts at the end of the nineteenth century was, in a sense, topographical—the social centre had changed. For a long time this led to bitterness and confusion. The astonishing upsurge in poetry and painting in England between 1780 and 1850 in which such major figures as Turner, Keats, Wordsworth, Shelley, Byron had played so significant a part, had declined in the face of a French movement that saw Cézanne, Manet, Monet, Degas, Mallarmé, Verlaine, Baudelaire, Rimbaud drawing more and more attention to France as the mother of Western culture. The rise of Debussy, and to a lesser extent Ravel, in a musical world that despite the astonishing genius of Berlioz had hitherto been almost exclusively dominated by Germany, added to this disquiet. It was not entirely a mistrust rising from artistic chauvinism, it was also that a particular nation used to its own tradition was unable to respond immediately to the newest works in a foreign tradition. In France four 'foreign' influences were nevertheless dominant, though perhaps in some ways misconstrued: Ruskin, Wagner, and Edgar Allan Poe and to a smaller degree the impact of the Oriental invasion, which included

exhibitions of prints by Hiroshige and Hokusai and the performances of the Javanese musicians at the great Paris exhibition of 1889. All these were important in that apparent 'blurring of the edges' against which subsequent artists like Mondrian, Brancusi, Schoenberg, Hindemith, Orwell, Camus were to rebel. If the distinction between dream and reality is removed how can we be certain of our own existence? If the moment alone is of importance, how can we formulate a philosophy which by its very formulation presupposes the importance of a before and after? If growth can only be organic, if there can no longer be a conscious 'development', is it possible for the will to exist at all?

What Rilke had conceived as destiny was the pattern of existence which, despite the will, conditioned individual man's development; what Maeterlinck proposed was a destiny within which man's development was contained. Similarly, Wagner shows an immensely complex body of musical themes implacably drawn toward a conclusion, as the pinnacles of Milan Cathedral draw together the determined Gothic structure of the building; the themes in *Pelléas* or the later works of Debussy are contained within the formal structure and are meaningless outside it, as are the proliferating motives of, say, Gaudi's Sagrada Familia in Barcelona. But it is Debussy, far more than Richard Strauss, or for that matter Mahler, who develops from Wagner, and it is no accident that the first years of the century produced a movement labelled 'Debussyism', in which the parallel figure of Marcel Proust played a significant part. The interrelation of the arts and philosophy at this time is perhaps most clearly reflected in the novelist/musical associations of Romain Rolland/Richard Strauss, Debussy/Proust, Thomas Mann/Schoenberg. To read Rolland's *John Christopher* is to see the ideal of a heroic composer, the epic man, explored and dismissed finally as impossible, as Richard Strauss indeed is *not* the Beethoven of our time. To read *Remembrance of Things Past* is to see the artist as the explorer of our world of momentary apprehension, even memory treated as an eternal 'now', but a now which is never entirely free and therefore never entirely satisfactory; to listen to *Jeux*, Debussy's most subtly fragmented score, is to experience most closely in 'classical' music, the feeling of continual improvisation, but which is not truly improvisation at all; the freedom is conditioned, after all by the score which exists. To read Thomas Mann's *Dr Faustus* is to see the intellectual artist creating a system in which the dogma is more important than the truth it may contain, as in the later works of Schoenberg the rigour of the law assumes precedence over what might be called 'artistic arbitration'.

It is not surprising therefore to find Richard Strauss irritated by *Pelléas and Mélisande* and criticizing the music of Debussy as that of a highly gifted but, in the last resort, dilettante composer. Beautiful, yes, but essentially negative. And since Rolland, for all his ardent pacifism, was a man wedded to the idea of the

importance of power, it is understandable that he also should find Debussy lacking in absolute significance. Strauss's criticism, when he heard the opera, was that it lacked any big scene, that it never escaped from the inhibition of its recitative, that he might just as well have been present at the performance of Maeterlinck's play. This is at once a mistaken critical attitude and a compliment. There is a sense in which Maeterlinck's play already possesses all the music Debussy subsequently wrote for it, just as there is a way in which Debussy's opera *is* the play written by the Belgian Symbolist. Despite the 'shocking' nature of *Salome, Elektra, Don Quixote, Thus Spake Zarathustra*, it is Debussy, not Strauss, who is strikingly modern. Strauss demanded an absolute authority for music; the text was required to be subservient to it; though it is surprising how often in his own operas the libretti by Hugo von Hofmannsthal are given most assiduously accurate readings and treated with remarkable fairness. Nevertheless he could not see, as is demonstrated by his praise of, say, Charpentier's *Louise*, that Debussy's opera is fundamentally melodic—it is melodic in essence. *Pelléas* is devoid of any arias, of any set pieces and is, in one sense, all recitative. But also it may be thought of as a set piece in itself—'vitrified improvisation'—in which what can be thought of as recitative is in reality one extended melodic line, the development spanning so great a period that its shape is for a long time impossible to perceive. In this it is an exact counterpart to the great novel of Marcel Proust in which the enormous flying arc of the 'story' was for a long time only partly appreciated by the public.

The success of *Pelléas and Mélisande* as a play speeded up for Maeterlinck the process of international fame which, as it developed, was for him finally corrupting. He was temperamentally vulnerable to flattery, and lived dangerously close to sentimentality in a way that Debussy was not and did not. In some respects he was more 'professional' in the worst sense of that word. When he moved away from the theatre to produce *The Life of the Bee*, which had an astonishing success, the tendency to provide writings for an adulatory public was accelerated. What is interesting is to see how in his plays he rejects all forms of human society, even to the extent of dehumanizing his characters, while in his books drawn from natural history it is society which he examines. There is a way in which, while writing plays which are essentially private, individual and feudal, he was engaged in his books in writing what might almost be taken as blueprints for the left-wing, social plays of Brecht. This progress away from the purity of the amoral play of *Pelléas* to the vastly successful but disastrously sententious and moralistic *Blue Bird* is a sad history. It is a path *almost* followed by Debussy, who was seduced away from various projects based on subjects by Edgar Allan Poe to setting the quasi-mystical rhetorical words of D'Annunzio, in that curious hybrid work *the Martyrdom of St Sebastian*.

Debussy, also, after *Pelléas* turns toward aspects of nature for his inspiration. His next most important work, which may perhaps be his most substantial orchestral success, is *La Mer*, a symphonic poem which in its substance comes closer to being a twentieth-century symphony than many works bearing that rather grandiose classical appellation. Despite the intensely impressionistic effect it creates in performance it is far from being 'impressionistic' in the usual way. There is nothing about it to link it with, say, such frankly descriptive works of lush orchestration as the tone poems of Respighi, or the least successful and most vulgar of the works of Richard Strauss, or the ecstatic extremes of Scriabin's tone poems. In its structure it is an exceptionally precise and strictly manipulated composition, and is as hermetic as the most pure of the poems of Mallarmé or as impersonal as the finest landscapes of Cézanne. While it can undoubtedly be considered the finest musical evocation of the sea ever written, there is also a sense in which it exists in a musical purity which has nothing to do with our ideas of the ocean. It is first and foremost a 'piece of music' and only secondly a piece of music called *La Mer*. It is perhaps this essential purity, this lack of extension into the world of the everyday, this exclusivity of devotion to the 'art' that causes so penetrating and original a critic as Ortega y Gasset to name Debussy as the originator, with Mallarmé, of a phase of art which he labels 'dehumanized'. He writes, with a conclusive dogmatism which leaves a great deal to be desired:

Music had to be relieved of private sentiments and purified in an exemplary objectification. This was the deed of Debussy. Owing to him, it has become possible to listen to music serenely, without swoons and tears. All the various developments in the art of music during these last decades move on the ground of the new ultra-worldly world conquered by the genius of Debussy. So decisive is the conversion of the subjective attitude into the objective that any subsequent differentiations appear comparatively negligible. Debussy dehumanized music, that is why he marks a new era in the art of music.[6]

It can certainly be said that Debussy reduced the passionate response of an audience, but the effect has not been total. It is significant for one development in music; not for all. If, as Ortega y Gasset writes in the same essay, the young cannot accept art which does not contain an element of irony, it is worth remembering that irony is not a replacement for passion or emotional response but only a modifying element. I suspect that what Ortega takes to be an ironic element in the music of Debussy is in fact an exceptionally civilized and well-tempered satire.

What is important in Debussy, and which is largely missing from the music

of his contemporary fellow musician Ravel, is a quality superbly demonstrated by Proust and by Monet: they produce works of art which are concerned with the 'perpetual now'. Debussy does not construct in *La Mer* or in *Iberia* or in any of the *Preludes* artefacts of a past that was, or a present that is. He shows us in a precisely fixed state what all moments are like. He does not recollect and tell us about his recollections. He rescues the past in such a way as to make it always present. So does Monet in his most luminous and ambitious works. He does not say 'this is a painting of waterlilies I *saw*', but rather, 'this is a painting of see-able waterlilies.' He removes the moment from time. So does Proust in his great novel. In one way the title *Remembrance of Things Past* can be said to be in-adequate, for what he is saying is not 'this is how things were in their reality', but 'any recollection of the past *is* the reality; the reality is always in the moment of recollection.' However remote he may seem at first, he is in this a true heir of that reviver of romanticism, Wordsworth, whose much-hated and much-loved poem beginning 'I wandered lonely as a cloud . . .' is, despite its destruction by the Eng. Lit. courses, a perfect statement of the value of the moment and the use of memory. With *La Mer* Debussy produces perhaps the first work in which by a method of constant forward movement, he achieves an effect of perfect stasis. He does this by submerging nearly all those elements which had been the mainstay of music for a hundred years, notably sonata form and demonstrably triadic harmony. I say *demonstrably* because he makes no attempt to abandon harmony or to call into being a different kind of harmony. He merely, by sleight of hand, as it were, conceals the harmonic structure. He is not unique in this respect. Although the method of continuous harmonic flux is only fitfully apparent in Delius's 'Paris: the Song of a Great City' of 1899, a work which has its nearest counterpart in the symphonic poems of Richard Strauss, the harmonic subtlety of *A Village Romeo and Juliet* of 1901–2 is not so far removed from *Pelléas and Mélisande,* and in his major works Delius was to pursue a line of development not unlike the development in the music of Debussy. Of course there are immense differences but there are astonishing similarities. Debussy, in his concealment of his harmonic structure, is like certain poets who when challenged as to why a poem does not rhyme point out with childlike glee that it does but that the rhyme words are carefully distributed within the body of the text and not flaunted in the orthodox places at the ends of lines. Even in his late works he still adheres to the underlying principles of nineteenth-century harmony. The effect of harmonic imprecision is created not by the rejection of tonality but by a constant shift of tonal centre and a proliferation of passing dissonances. It is *possible* that he might have found himself discarding harmony, though he is reported as being horrified by the idea, but in the event he died before taking such a major step. The deliberate overthrow of traditional tonality

together with the critical apparatus defending the action was to be the responsibility of Arnold Schoenberg; the first work in which we become electrifyingly aware of the challenge is his song cycle *Das Buch der Hängenden Gärten* of 1908.

Of equal importance, not merely because of its use in his own works but for its effect on later composers, notably Messiaen and Boulez, is Debussy's attitude to orchestration. The different geniuses of Wagner and Berlioz, even of Mahler and Richard Strauss, are certainly to be found expressing themselves through a vivid realization of the nature of that composite instrument the 'classical' orchestra. But even in his most scintillating and magical pieces Berlioz is still a long way from the discovery, by Debussy, of how to compose, as it were, *with* the orchestra. It was as if, in painterly terms, Debussy was the first composer to do away with drawing. In his orchestral works from *L'Après-midi d'un faune* on, the total conception is in terms not of the clothing of themes with the appropriate tone colours of individual instruments but of the themes being, in their conception, *of* the instruments. If it is true to say that in great works form, content and means of expression are one, then, at least within its own terms, *L'Après-midi* is a small masterpiece. There are few successful orchestral arrangements by other composers of works of Debussy and equally few successful arrangements of other people's works by him. The most successful small-scale orchestration is his arrangement of Erik Satie's *Trois Gymnopédies*.

It is perhaps surprising at first to find so exquisite a manipulator of large bodies of orchestral sound writing so much for the piano. But if Ortega y Gasset is correct then it is appropriate that Debussy should be drawn to this instrument which, despite the intensely romantic struggles of Beethoven, Schubert and, in particular, Chopin, can be more truly impersonal than any orchestra. Debussy's two books of *Preludes* and two books of *Etudes*, despite subsequent works like the *Ludus Tonalis* of Hindemith or the forty-eight preludes and fugues of Shostakovich, are still for the general concert-goer the culminating point of great music for the piano. They are set firmly in the tradition, more firmly than the *Iberia* of Albéniz, yet they are also startlingly modern. They lie in proper contrast to his surely misconceived attempt to set the *Martyrdom of Saint Sebastian*, and for a good reason. They are, as it were, 'amoral' and do not allow rein to Debussy's never quite submerged mystical tendencies. D'Annunzio's 'drama' exacerbates it. There is plenty of evidence of Debussy's interest in occultism and in this he was a true child of his age. He saw that the 'horrors' of Edgar Allan Poe were only the surface covering for explorations of profound areas of psychological disturbance. It is a small step from the merging of dream and reality to the interfusion of the 'seen' and 'unseen' worlds. *Pelléas* had been the most refined exploration of these intermingled worlds both for Maeterlinck and for Debussy, but, as both developed, the doom-laden tragic vision was partially replaced by senti-

mental moral considerations. The accusation often levelled at Maeterlinck that he was a decadent sadist is more appropriate in the false light of the *Blue Bird* than in the muted anguish of *Pelléas and Mélisande*, and it is a charge that might well be laid against Debussy in the luxurious music for the mystical eroticism of *Sebastian*. His choice of subject was not without precedent. It is a throwback to his early cantata *La Damoiselle élue*. But the early work has about it a great deal of the purity of the Pre-Raphaelite poem which was its inspiration, for the setting, no less than Dante Gabriel Rossetti's poem and painting, is sensuous but not erotic. At least there is little of the erotic decadence that one detects in Swinburne and which is certainly present in D'Annunzio's play. One suspects that it would not have taken much to plunge Debussy over the edge of sensuous ecstasy into a maelstrom of sexual eroticism. In this tendency he shows again how like Proust he is. Both loathed the dilettante in art yet both came close at times to being what they most despised. Both were curious combinations of extreme refinement and occasional astonishing vulgarity.

The rejection of work of a particular type of important artist by certain critics or by the public is not necessarily caused by bewilderment or shock. André Gide rejected *Remembrance of Things Past* because he was bored by it. And one can surely sympathize. With little indication of the purpose of the novel as a whole, any large section of it presented in manuscript might well seem tedious and misguided. The elegance of the writing would be apparent and the philosophical asides (though they are always more than that) would arouse interest, but the seeming lack of pace, of development, of orthodox structure would certainly be disquieting. At first sight *Remembrance of Things Past* can easily look like the dullest, longest of Victorian novels. In fact nothing could be further from the truth. If Maeterlinck's *Pelléas and Mélisande* is the first Symbolist work for the stage and Debussy's *L'Après-midi d'un faune* the first impressionistic tone poem in music, then Proust's novel is the first Impressionist painting in prose form. Even the title is significant. As Arnold Hauser writes:

> A continuous line can be traced from the Gothic to impressionism comparable to the line leading from late medieval economy to high capitalism, and modern man, who regards his whole existence as a struggle and a competition, who translates all being into motion and change, for whom experience of the world increasingly becomes *experience of time* [my italics] is the product of this bilateral, but fundamentally uniform development.[7]

Proust is not representative, in his person, of the modern man to whom Hauser refers but he is the writer who most significantly, though by the subtlest, most interior means, explores man's uncertainty in an increasingly uncertain

world. For nothing undermines certainty more drastically than a perpetual shift of focus. Eventually the only constant is the certainty of the impossibility of constancy. The medieval world order, in which, despite all inimical acts of God, the reality of his divine actuality was never in doubt, gave rise to disputations which were concerned with minutiae of the dogma, not with the reality of God himself; the gradual growth throughout the eighteenth century of a belief that man might well be of no less importance than God at least presumed an order in society. Indeed it created, as the growth of an expansionist economic system gathered strength, a hierarchical system within society which challenged the astonishing exactitude of the orders of angels and archangels. When Van Gogh painted his notorious *Yellow Chair* all such values received a shock from which they have not yet recovered; from which they may never recover. In painting one need only look at the extraordinary late canvases of Bonnard to see how powerfully Van Gogh's painting affected our sense of values. It is as if Bonnard were saying not 'objects are as important as human beings'—which is perfectly acceptable, but 'human beings are no more important than objects'—which is not. Proust fights a tremendous rearguard action against the significance of the *Yellow Chair* and perhaps does not see that he is using a method which is the direct result of it.

Compared with that of the majority of writers of his time Proust's conduct of his early literary life was at once precious and diffident. He was known in significant social-cum-artistic circles and admired by a handful of people for his very real elegance of style. But the circle was small and enclosed. It mirrors most appropriately the situation of Debussy before the first performance of *Pelléas and Mélisande*. But this should cause no surprise. It was necessary for Proust to gather and store so many sights, sounds and memories before he could embark on his major work, which is an enormous shoring-up of ruins. Like Chekov he does not observe the current scene and record it; 'realism' was far too 'vulgar' for both of them. He becomes within himself a microcosm of the society in which he exists and shows us that the world in which we live is not an absolute but is conditioned by our imaginative use of it. This is in its simplest form, perhaps, merely an extension of the idea that beauty lies in the eye of the beholder, but in Proust, as in Debussy, it is a notion driven to extremes. The technique of both of them indicates, in its constant shifts of emphasis, its perpetual questioning, its ambiguity toward tradition, its hesitations over dogmatic propositions, an early apprehension of one way in which the twentieth century has pursued the path toward a total permissiveness in Western man's behaviour. Both would have been shocked to discover the lengths to which certain artists have now gone.

Remembrance of Things Past is not the novel of total recall, despite the detective work of George D. Painter who in his admirable and exhaustive biography[8] is

able to relate practically every character and incident in the novel to people and happenings in Proust's life. Remarkable and valuable as Mr Painter's book is it is perhaps possible to criticize it for being precisely that book which Proust, as a truly creative genius, was sensible enough not to write.

Though many writers have commented on the passage toward the end of 'Overture', the first section of *Swann's Way*, in which the narrator, dipping the madeleine in his camomile tea, conjures up that complete life which he is to offer us in the pages of his great book, few seem to have been concerned to point out that this is only the event chosen to bring forth what had already been shown to be his intention. It takes the writer nearly twenty thousand words to get to this point, and for an artistically important reason. To have placed it earlier would have inclined the reader to believe the book a 'deliberate' exercise in memory, but this is precisely what Proust wishes to avoid. Early on he has carefully rejected this method:

> I feel that there is much to be said for the Celtic belief that the souls of those whom we have lost are held captive in some inferior being, in an animal, in a plant, in some inanimate object, and so effectively lost to us until the day (which to many never comes) when we happen to pass by the tree or to obtain possession of the object which forms their prison. Then they start and tremble, they call us by our name, and as soon as we have recognized their voice the spell is broken. We have delivered them: they have overcome death and return to share our life.
>
> And so it is with our own past. It is a labour in vain to attempt to re-capture it: all the efforts of the intellect must prove futile. The past is hidden somewhere outside the realm, beyond the reach of the intellect, in some material object (in the sensation which that material object will give us) which we do not suspect. And as for that object, it depends on chance whether we come upon it or not before we ourselves must die.[9]

If there is a way in which it is ever possible to divorce style from content then I think it is not inconceivable to discuss 'style' in Debussy and Proust and 'content' in Mahler and Rilke—though there are many points of similarity in the *Notebook of Malte Laurids Brigge* and *Remembrance of Things Past*. Despite the intense subjectivity of Debussy and Proust their work is, finally, more objective than that of Rilke and Mahler. To a large extent this may be due to a refine-ment, an excess of fastidiousness which was later to become dangerously effete in the minor figures of Bloomsbury; it may have something to do with national characteristics and the tradition of the arts in their respective countries. While composer and novelist, no less than Maeterlinck, that curious half-forgotten dramatist, might well have shuddered at the controversial pronouncements of

Marshall McLuhan, they all of them to some degree exhibit the partial, if dangerous, truth of his claim that 'the medium is the message', which is perhaps no more than a modern expression replacing 'the style is the man.' Certainly the style is Marcel Proust. He was constantly concerned that this should be understood. He wrote to Antoine Bibesco:

> My novel is not a work of ratiocination; its least elements have been supplied by my sensibility; first I perceived them in my own depths without understanding them, and I had as much trouble converting them into something intelligible as if they had been as foreign to the sphere of the intelligence as a motif in music.
>
> Style is in no way an embellishment, as certain people think, it is not even a question of technique; it is, like colour with certain painters, a quality of vision, a revelation of a private universe which each one of us sees and which is not seen by others. The pleasure an artist gives us is to make us know an additional universe.[10]

Perhaps more than any other writer of his time he did indeed reveal to us a universe hitherto scarcely known, or at best only fitfully explored.

> The dominion of the moment over permanence and continuity, the feeling that every phenomenon is a fleeting and never-to-be-repeated constellation, a wave gliding away on the river of time, the river into which 'one cannot step twice', is the simplest formula to which impressionism can be reduced. The whole method of impressionism, with all its artistic expedients and tricks, is bent, above all, on giving expression to this Heraclitean outlook and on stressing that reality is not a being but a becoming, not a condition but a process. Every impressionistic picture is the deposit of a moment in the perpetuum mobile of existence, the representation of a precarious, unstable balance in the play of contending forces. The impressionistic vision transforms nature into a process of growth and decay. Everything stable and coherent is dissolved into metamorphoses and assumes the character of the unfinished and fragmentary.[11]

This is perhaps the best concise statement of the nature of Impressionism, but needs, I think, an extension of the phrase 'the deposit of a moment'. For while nature is indeed a process of growth and decay, and the attempt of the Impressionists was to apply something of nature's technique; the supreme difference is that they could not prevent themselves from isolating and fixing the moment. They were not concerned with the uniqueness of a 1960 'happening' or with the unrepeatability of a supreme jazz improvisation.

Hauser's comment is directed toward the work of the painters of the time but it is very close to being a description of what Proust was achieving in his novel. His allegiances are the same as those of so many of the most 'sensitive' artists popular at the time: Ruskin, Turner, Oriental artists. He did not achieve his originality of method without some preliminary excursions. *Jean Santeuil* is an uneasy sketch in the traditional manner, and despite the philosophical insights and the exquisite passages of reflection and description in *Swann's Way*, that too is marred by the intrusion of traditional storytelling methods in a book in which the 'story line' was to be not a skeleton on which the flesh of the novelist's style was to be moulded, but no more and no less organically significant than that flesh. Proust's 'style' is finally the equivalent of Debussy's 'orchestral thinking'. From the beginning of *Within a Budding Grove*, the novel takes on the importance of 'the thing in itself', faltering only at the end when, perhaps because of his illness, Proust was compelled to hurry the downward curve by *telling* us too much, fearful that he might not have time to let things happen as leisurely and as surely as in the rest of the novel.

The complaint of so many people that in Maeterlinck's *Pelléas and Mélisande*, or in the music of Debussy, or in Proust's novel, nothing happens is astonishing when one considers the almost overwhelming amount of things actually going on. But these artists were all concerned with the essence of the happenings, not with the gross peripheral actuality of the actions themselves. It is perhaps paradoxical that in their attempt to show that the significance of things exists well below their surfaces they had to resort to methods which too often can seem nothing but surface. But this too is nature's way. Yeats clearly saw that 'Only God, my dear, / Could love you for yourself alone / And not your yellow hair.'[12]

Proust was permanently aware that man could not be divorced from his actions, that actions could not exist in isolation, and that the primary condition of life is time. The most remarkable feature of *Remembrance of Things Past* is that time is shown to exist in varying states simultaneously, for the past does recur in the present recollection of it just as the future can exist in moments of prefiguration. The characters in his masterpiece walk on adjacent moving staircases—as Dunne tried to show in another context in his *Experiment with Time*. Like Debussy, like Delius, like Maeterlinck, Proust abandons traditional development though without in any way subscribing to the belief that art can ever be arbitrary. He is as remote from the paste-ups of William Burroughs as Debussy is from the Indeterminist composers. The proliferation of images and the pursuit of ideas, is meticulously ordered, and is not to be thought of as a method of free association. He is in this respect a scrupulously scientific novelist of an exactitude in reference and inference probably unsurpassed. But these particularities are used in a quite different way from those employed by Proust's

forerunners in the novel. They are never merely the background *against* which an action is played; they are a complex of space within which significant events in time can be manifested and therefore witnessed. The most important of these events may often be the most irrational, or at least inexplicable, pursued by characters who are incapable of controlling their emotional states by their intelligences. The moment in the garden in *Pelléas and Mélisande* when Mélisande lets down her hair and Pelléas, entangling it on the thorns of the rose bushes, makes it impossible for them to avoid being discovered by Golaud, is an ideal example, in dramatic terms, of Proust's underlying interpretation of destiny— less hieratic and stern than that of Rilke, less conscious (if that is not a contradiction in terms) than that of Mahler, less symbolicaly explored than in most of Maeterlinck's work. *Remembrance of Things Past* is a book illuminated by the magnificent folly of the people within it. On the ebb and flow of its great tide, as time washes over and around and within the people so miraculously born within Proust's imagination, we see that it is perhaps in error and in accident that the beauties of living lie in simple terms,

> . . . people whose own hearts are not directly engaged, always regard unfortunate entanglements, disastrous marriages, as though we were free to choose the inspiration of our love, and do not take into account the exquisite mirage which love projects and which envelops so entirely and so uniquely the person with whom we are in love that the 'folly' with which a man is charged who marries his cook or the mistress of his best friend is as a rule the only poetical action that he performs in the course of his existence.[13]

But if it is a great novel of the folly of man and of society how does it differ from those other great works which belong to the realist school? Because finally it is a novel about a novel, a work of art about the creation of a work of art. It is in the distancing of the events that much of its greatness lies. Despite the long and fascinating passages of erotica, or of sadism, despite all those moments which George D. Painter shows conclusively to be drawn in large part from Proust's own experience and way of life, there is something about his use of them that is almost dispassionately pure. The presence of 'Marcel' is never the presence of Proust himself and indeed for a lot of the time in his passages about art and artists he is concerned to stress the fact that the finer the art the more the artist himself is under control and his personality effaced. As Howard Moss points out, 'Berma, particularly, is important because Marcel learns from her that great acting consists in the suppression of personality, not its exploitation.'[14]

Throughout the book, artists, homosexuals, politicians, dukes and duchesses dance their own exclusive steps unified only by their several exclusivities. If it

were possible for Proust to live for ever the dance could go on for ever, but it stops when time, finally, is regained. It could go on for ever because the cause, of which the elements in the novel are the effect, is never revealed; it is lost in time. We cannot know how these events began, therefore we cannot bring them to a properly detailed conclusion. Only the analytical and perhaps non-creative mind can do that. But for Maeterlinck whose Mélisande has no background, whose death has no cause, for Debussy whose *faune* is neither a part of nor not a part of reality, whose personification by the flute as tenuously exists as it so delicately emerges and disappears, knowledge, reason is an alien instrument.

> Don't complain about not having learned. *There is nothing to know.* Even what is called technique is not properly speaking knowledge, because it does not exist outside the mysterious association of our memory and the skill acquired by our own inventiveness when it comes in contact with words. Knowledge, in the sense of a thing that is all done outside ourselves and that can be learned as in the sciences, counts for nothing in art. On the contrary, it is when the scientific connections between words have disappeared from our minds and have taken on a life in which the elements are forgotten in a new individuality, that the technique, the skill that recognises their antipathies, humours their wishes, knows their beauty, conveys their forms, asserts their affinities, can begin.[15]

'The mysterious association of our memory and the skill acquired by our own inventiveness when it comes in contact with words.' The implication is surely that the production of a work of art is a reflective act. The perpetual present, in which the reader is to be ensnared, is to be brought about by the careful assemblage of fragments of the past. We are not to ask 'What will happen now?' but rather 'What has happened that is now about to be disclosed?' Our attention has to be kept from wandering, not through the method of classical storytelling in which the developing actions in the plot constitute the excitement; nor are we to be held by any engagement of the author in the moral predicament of his hero, which is the purposeful method of the romantic authors. Instead we have to be ensnared in the personality pattern of the author himself; we do not enter into the fictional world of the novel; rather the world of the novel infiltrates into us. The characters do not move within an environment which the author makes known to us. Our own environment is modified by the skill with which the author builds his chosen world within and around our own being. This can only be done by a method of extreme elaboration and suggestion. To read a work like Ruskin's *The Stones of Venice* is to feel that one has personally built that city with one's own hands. To read *Remembrance of Things Past* is to become a character

exploring a lifetime in the preparation of writing a novel. When at the end of the book Marcel is at last prepared to give up his life of idleness and begin some serious work, then so are we. We too, if we had the skill with words, might embark on *Remembrance of Things Past*.

But within this enormous complex of recorded scenes, psychological insights, philosophical discourses, lectures on art, asides on music, acting, literature, the weather, love, envy, everything that indeed is a surrounding area of sophisticated twentieth-century man, moves with brilliant decadence the figure of Monsieur de Charlus—the only character whose destiny concerns us as something being worked out. The darkly positive side of the novel lies in the vigour that is generated through the element of 'obscenity', for there can be little doubt that only the extreme difficulty of the novel from the point of view of the general public prevented it becoming the centre of a controversy as violent as that precipitated by Hardy's *Tess of the d'Urbervilles*, Lawrence's *Lady Chatterley's Lover*, or Joyce's *Ulysses*. For Proust, though he did not begin to publish his great book until 1913 and is in this respect slightly displaced in time, stands in his art ambiguously poised between the two worlds of the nineteenth and twentieth centuries. He also marries two features of present day writing, being on the one hand as fastidious, as nostalgic, as rarefied and at times as pure and as amoral as Virginia Woolf or Robbe-Grillet, while exhibiting an exploratory vigour and coarseness as vulgar and disturbing as that of Burroughs or Genet.

Indeed he marries them so well that one can sympathize with those critics who have said that *Remembrance of Things Past*, together with Joyce's *Ulysses* terminates the period of the novel. Is the activity of the novelists of the present day merely a decadent skirmishing over the corpse? Is the novel, like poetic drama, like the epic poem, like the symphony, an obsolete form?

Perhaps the last sentence of Proust's novel is the provocative suggestion for the future, not merely of the novel but of all the arts and of the sciences too.

> If, at least, time enough were allotted to me to accomplish my work, I would not fail to mark it with the seal of Time, the idea of which imposed itself upon me with so much force today, and I would therein describe men, if need be, as monsters occupying a place in Time infinitely more important than the restricted one reserved for them in space, a place, on the contrary, prolonged immeasurably since, simultaneously touching widely separated years and the distant periods they have lived through—between which so many days have ranged themselves—they stand like giants immersed in Time.[16]

In his masterpiece Proust does not quite succeed in doing this. He is perhaps

not 'experimental' enough. He was not consciously trying to be modern. He was in no way trying to write a kind of novel that had not been written before. There are no 'tricks' of style at all—in the sense that there are in the novels of Joyce or Beckett or even of Virginia Woolf. But he does see that a significant area of exploration for modern man must be the exploration not necessarily of time itself, but the *significance* of time. His novel is a kaleidoscope of events which are shown to exist entirely because of the shift of this unexplained element. In ordinary terms it may merely be a variant of 'never the time and the place and the loved one all together'. And it is time that is the unstable, cursable factor, for the place may well continue to exist and the loved one may also, but the possible moment of confluence may never arrive. What Proust *is* able to do is to create an enormous expanse through which time flows, but his technique, like Debussy's, tends to produce an effect of continual circling so that, fluid as their style is, it contains within itself, perhaps by its very excellence and perfection, its own isolation. It is in this curious imbalance between the chosen style and the effect on the reader that he shows his difference from the type of writer we most usually term romantic, as it is in the similar musical effect that we see how Debussy also avoids that term. As Jacques Barzun admirably points out: 'On the dramatic quality of romanticist art there is little disagreement. Whatever the medium, the romantic abounds in contrasts, oppositions, antitheses, strife, and color.'[17] These conditions all most certainly apply to the four powerful figures of Rouault, Mahler, Rilke, Rodin, in a way they equally certainly cannot apply to Maeterlinck, Debussy or Proust. It is surely ironic that in a novel like *Remembrance of Things Past* in which so many threads are in a constant process of interweaving, where the multiplicity of events of the most diverse kind is almost unparalleled in the novel, that the most common complaint should be that nothing ever happens. It is the sort of complaint levelled at Chekov's plays, *The Three Sisters* in particular, though it would be difficult to think of a modern drama more crowded with happenings. But of course the difficulty lies in the particular type of counterpointing of themes. It is most usually Bach, so abundant in melody, who is commonly supposed to be dry and unmelodious.

But Proust and Debussy and Maeterlinck have not only been savagely criticized for their lack of action and engagement, they have also been damned as being effete, as being 'escapist'—in the sense that they do not deal with the forward concerns of the time. Yet Proust, so impressionistic in manner, gives us perhaps the most engaged example of art in a novel of the time—a novel of aesthetic quality, that is—in his concern for Dreyfus. And it is Proust also, as we see from his letters, and from the exact enquiries of George Painter in his exhaustive biography, who, far from being the precious aesthete he is so often

taken for, is, indeed, a man of extreme moral concern. He suffers, as did the romantic authors before him, from the common misconception that only the 'classical' artist works, or considers anything but himself. This charge—in so far as it is levelled against the romantics—is magnificently refuted by Jacques Barzun in his outstanding work *Classic, Romantic and Modern*; it is time it was refuted once and for all in relation to Proust. One of the excellencies of his novel, indeed, is the way in which, through the medium of the impressionist manner he is able to convey so much of what has always been thought the province of the realist authors. He does not abandon the method of Flaubert and create a new method, any more than Debussy abandons the method of Wagner to create a new style; he extends and modifies, in this respect being properly Janus-faced. Although he is deeply concerned to state, at the end of his book, the *kind* of novel he wants to write, his eye is on the best way to communicate what *he believes to be the truth*. He does not desire an art which shall be utterly self-sufficient and, in consequence, possibly self-indulgent. For him the rules may be interpreted differently, but they are not to be discarded, neither are they to be replaced by a completely new set. His roots are too deeply embedded in the nineteenth century for that. Like Thomas Mann, like Debussy, like Yeats, like Bonnard, his influence is accidental, unconditioned. These artists stand equivocally in the panorama of the arts of our time, for from them it is possible to move backwards or forwards. They can, if the conceit is permissible, be wound down as well as wound up. The umbilical cord joining them to the artistic productions of the past two hundred years might have been stretched and tangled but it had not been cut.

A different type of man was required to strike the significant blow. Although each of the arts was to throw up a 'hero', it was the composer Schoenberg who, more than any other man, was to march boldly into the Gorgon's cave and with a perfect knowledge of that fabulous creature, strike off the head of romanticism, and with face held resolutely toward the future, release his companions from the terror of the past. But before approaching the work of that formidable and protean composer, let us glance briefly at two great artists of the twentieth century whose works can be seen perhaps as examples of an admirable balance between the old and the new worlds.

YEATS BARTÓK

And now the question is whether at the present stage of our consciousness, our knowledge, our sense of truth, this little game is still permissible, still intellectually possible, still to be taken seriously; whether the work as such, the construction, self-sufficing, harmonically complete in itself, still stands in any legitimate relation to the complete insecurity, problematic conditions, and lack of harmony of our social situation; whether all seeming, even the most beautiful, even precisely the beautiful has not today become a lie.

Thomas Mann, *Dr Faustus*.

W. B. Yeats is perhaps the best example in the world of modern letters of the dreamer as man of action, and the clash between these two aspects of his personality helps to make him one of the towering poets of the past hundred years. He is perhaps the last 'romantic', if by that phrase we can for the moment mean a man whose vision and ideals thrust upon him the necessity of action in the society within which he finds himself. He is also a pivotal figure of great significance in the development of art in our time, being on the one hand rooted to an exceptional degree in the traditions of his own country, a country retaining more features of the pre-Industrial Revolution years than almost any other in Europe, and on the other possessed of a forward-looking and probing mind and sensibility, fascinated by the development of the modern world but permanently sceptical of many of its so-called benefits. He is a poet of great insights and wisdoms, sometimes almost obsessively personal, but simultaneously a much-fêted, experienced, travelled, and no-nonsense man of letters. He escapes much of the enervating listlessness of so many poets of the turn of the century while avoiding the self-conscious stridency of many 'modernist' writers. Although, like Pound, he changes his style when he perceives that the methods of the nineteenth century are no longer acceptable to the serious artist, the change appears to be organic, a natural development from what has gone before, and not a violent and totally self-conscious break as seems to be the case with Pound. In this

respect he is close to the Hungarian composer Béla Bartók, whose later work is not in any doctrinaire sense different from his early compositions in the way that the late compositions of Schoenberg can be seen as the result of a conscious rejection of earlier methods and the deliberate formulation of a 'modern' style. Yeats is also able to bridge in the most subtle manner the worlds of pure symbolism as expressed in the work of Mallarmé and Maeterlinck with the world of 'imagism' as propounded by Ezra Pound and his circle. He has above all the quality of positive acceptance and hope, which distinguishes him from Rilke who is noble in the face of despair, or Mahler who is eloquently resigned, or Maeterlinck who postulates inevitable defeat. But as he leaves behind these qualities which inform so much art of the last part of the nineteenth century he sidesteps the impressionistic explorations of writers like Proust or composers like Debussy. He overplays neither his symbolic hand nor his contemporary and partly scientific one. Apart from anything else he is a poet who seems to glitter. He uses images of gold often in his poetry and there is, indeed, something golden about him. He is certainly the only poet of stature in the modern world who can both inhabit the gross world as it is and proclaim the existence of another world beyond and perhaps above our usually trivial concerns. This is not in any way to link him with a poet of Rilke's temperament. For Rilke nature was in a constant state of flux; the angels to which he cried were extensions of a growth process in which he himself was involved. He *could* become a tree; he *could* become an angel, though God himself would always remain silent and inscrutable. For Maeterlinck the condition beyond the world was a condition of disembodied morality. Rilke, like Mahler, like Rouault, as we have seen is to a large extent writing out of a desire for some unity with the divine; Maeterlinck displays a disquieting sense of unease about the unknown. But Yeats accepts, quite naturally, forces beyond and surrounding the world in which he lives his present life. This is understandable enough. For how could a man be Irish and a poet and not believe in fairies? He is in the great tradition. To think of Yeats is to think of Shakespeare and Blake and Keats. And come to think of it, they are golden too.

He is, of course, in his early work essentially Pre-Raphaelite, both in his choice of subjects and in his treatment of them. He was more fortunate than most of the Pre-Raphaelites, though, because he had no necessity to make an intellectual choice, or to adopt an attitude, when looking for his material. The poets and painters of the movement proper were for the most part living in a country in which the pagan world had for many years been utterly and irrevocably blanketed out by Christianity and Christian morality. Not so Yeats. Despite the perpetual feud between Protestant and Catholic which can make Ireland seem so religion-ridden a country, its pre-Christian past has in no way been obliterated:

The tradition in Ireland is that the gods were there before the Gaels came, that they fought for their possession of the country and at last came to terms and withdrew into the hills, leaving the surface of the land to the invaders. And before the gods there were darker powers, some of whom still survive. However that may be, the land is alive with spirits who are known and respected. Their deeds in different places are remembered; history trails away into myth and myth is projected forward into history. There are faery hills, green terraced mounds into which no farmer will drive a ploughshare. The fairies are seldom talked of, and most seldom by that name, for fear of drawing their attention to the speaker. They are the Good people, much in the way that the Greek Erinnyes were the Eumenides, or kindly ones, because disaster and madness were within their gift. But the people remember what they are—the dispossessed lords who ruled before Christ came.[1]

This historical and immediate background is of immense importance to Yeats and to our appreciation of him as poet and dramatist. Because of it he had, in his formative years, no need to invent symbols, or create a mythology. That is why of those poets deriving from the symbolist tradition he has from the beginning such a distinctive voice: the movement from waking reality to dream reality, from object as image to object as symbol was entirely natural. For Yeats the stepping into a world of myth or dream was not an escape or a rejection of actuality, for the world of commerce, politics and human affairs, and the world of Irish kings, fairies, and battles for men's souls were equally real. They both existed, quite naturally, and that was that. To these two worlds he added—or wanted to add—the third world of the created artefact.

But Ireland was not merely, at the turn of the century, a world of dying aristocratic centres, peasant poverty, ancient myth and modern agitations. It was a land, not racked by nightmare perhaps, but lapped in a very fitful sleep from which it was soon to awake into a period of nationalistic fervour. Yeats was therefore especially fortunate in being born when he was, for had he lived in the first part of the nineteenth century it is likely that he would have remained a poet of romantic dreaming, while had he been born in the twentieth century he might have been plunged too soon into the world of political struggle; he would have been less likely to have found intact the world of folklore and legend so central to his thinking and his art. Béla Bartók was similarly fortunate in this respect. A few years later and many of the traditional folk tunes he collected with such diligence would have been lost, and the political unrest in Hungary would have passed beyond the phase when an artist of his temperament could have become passionately and creatively involved.

The Wanderings of Oisin, published in 1889, shows a young poet in love with the idea of writing poetry. It is a mixture of the sensuous tactile imagery of Keats and the spiritual fervour of Shelley. Although a narrative poem, it lacks those qualities of forward movement, of action in the present, that are also lacking in most of the poetry of the Romantic Revival. Like Keats, especially, Yeats thought that the long poem was a place in which the reader could wander at his leisure, gently encountering beauties and pleasure on the way. What it needs is a little of Byron's flair for pace and movement. Nevertheless it shows considerable technical skill, and, despite Yeats's admitted tone-deafnesses, a rich musical and rhythmical quality. It is less matter-of-fact, less turgid than the poetry of Morris, and less artificial and slick than much of Swinburne, though of course it does not have the mature skill of these two poets. But already there are indications of a style that is soon to begin to modify, however unconsciously, the traditional stress patterns of the English four- or five-stress iambic line. Only seven lines from the opening we find this happening:

> The horsemen with their floating hair
> And bowls of barley, honey and wine.[2]

A lesser poet of his age might well have put another 'and' between 'barley' and 'honey'. Already, too, in this poem a basic feature of his thought and philosophy, both of life and art, is introduced. The first words of Niamh to Oisin are greatly significant: 'The hunting of heroes should be glad.' It was the ground of his life, a reflection about the heroic ideal. When he came as an old man to edit the *Oxford Book of Modern Verse* he excluded Wilfred Owen and other war poets because he believed that passive suffering was not the theme for poetry. The tragic heroes danced. He could not accept the dissillusionment of so many modern writers. He rejected images of horror, putting in their place the more vital and revitalizing images of terror, for beauty and terror are indivisible but beauty and horror are antipathetic. He believed also that the world could, to an extent, be conditioned by the imagination of the artist. Had not Shelley, after all, expounded many of the propositions of Karl Marx before that astonishing man put his thoughts down on paper? Even before the turn of the century it was possible for Yeats to see that the old order was changing; he still hoped, even to the end of his life, that the best elements of that old order could be saved. If they were not then what but chaos could ensue? And chaos was *trivial*. It was not idly, we may suppose, that he wrote '*Mere* anarchy is loosed upon the world.'[3]

Because his plays have never held the professional commercial stage for long, it is easy to overlook the fact that his imagination is very much a dramatic one, though its most dramatic elements are best seen in the lyrics rather than in

the stage works. But certainly clearer indication of the ground of his imagination can be seen in his first published play than in his first book of poems. *The Countess Cathleen* of 1892 shows at once two of his major themes or preoccupations —the devotion and sacrifice often given and made to the 'lower orders' by noble persons of rank, and the actuality of the spirit world, as well as the more personal theme of the artist as lover who rails against the forces that make his love unattainable. It is a remarkably cogent play. The forces are simple. The country folk are stricken by famine. Two merchants travel among them buying up their souls for money. The Countess sells her own soul to save her people but in the end it is shown that God takes heed of the motive, not the deed, and she is saved. The most immediately striking feature is that the agents of the devil are created as ordinary flesh and blood creatures and when they are disclosed for what they are cause no astonishment. There is no bewilderment at their being supernatural; the second important feature is the acceptance of a knowledge of man's past deeds and thoughts, whether good or ill. The knowledge of this, though it is annoying to the peasants, does not unduly surprise them. They take it for granted, as they take the devil for granted—though they are shocked and afraid when the good old woman, on receiving her soul's fee says 'God bless you, sir', and immediately screams in pain. Hell may be merited by many sins but the desperate agony is caused by the rejection of God.

The First Merchant in the play puts it simply and memorably: 'That name is like a fire to all damned souls.'[4]

There is of course nothing new about this: indeed one of its interests is that it shows a retention of the machinery and beliefs inherent in many of the plays of Shakespeare, and, of course, in Goethe. We shall see, later, how a particular originality was to be incorporated into subsequent plays which for the most part use the same dramatic technique.

His next play, *The Land of Heart's Desire*, reinforces Yeats's beliefs in a series of worlds, perhaps like palimpsests overlaying each other, certainly existing with their own individual logic and formulae. One of the features of our own world is exposed within the first speeches, for the girl Mary Bruin is reluctant to work, being a dreamer, half in faeryland. This may at first seem commonplace or trivial but it is not. When Father Hart asks her what she is reading she replies:

> How a Princess Edain,
> A daughter of a King of Ireland, heard
> A voice singing on a May Eve like this,
> And followed, half awake and half asleep,
> Until she came into the Land of Faery,
> Where nobody gets old and godly and grave,

> Where nobody gets old and crafty and wise,
> Where nobody gets old and bitter of tongue.[5]

and although Father Hart replies that: '. . . it was some wrecked angel, blind with tears, Who flattered Edain's heart with merry words'[6] there is the constant implication that with Christianity the world plunged into struggle and moral anxiety which the pagan world, for all its flaws, had not known. The amoral world of the fairies cannot abide the moral world of Christianity. The fairy child who tempts Mary shrieks when she sees the crucifix: 'What is that ugly thing on the black cross?'[7] For it is 'Our Blessed Lord' implying guilt in mankind and the necessity for the forgiveness of sins. When the crucifix is hidden the power of the priest is lost—he is powerless without the symbol, for in the symbol lies more strength than in his philosophizing, or his goodness. The crucifix becomes the thing for which it stands. This is a considerable difference from the traditional use of symbols in earlier poets and prose writers. The symbol is almost transformed into an image of power. It is the first step along the road to Yeats's desire for the fully created artefact that possesses a life more valuable, powerful and complete than the artist who made it. It is equally significant that when the fairy child successfully claims Mary and Mary dies it is not merely the 'spirit' that departs:

SHAWN:　She is dead!
BRIDGET:　Come from that image; body and soul are gone.[8]

What is left is a shell only. The dead, for Yeats, exist in a substantial state and not in an intellectually appreciated spirit form. In this respect he is like Beddoes, whose characters in *Death's Jest-Book*, though dead, live as flesh and blood characters in the underworld of graves, in Death's Kingdom. Although there is at first sight something rather naïve, or indeed capricious, about this idea, as Yeats's themes develop we can see that this is a fundamental conception and not a clever artistic attitude. He is not playing at make-believe. The *substance* of the beings feature in his work. In the statement by Bridget we can already see the line of thought that is going to provide the most thrilling, most electrifying moment in any of his plays. When the figure of the risen Christ enters into the upper room in the play *The Resurrection* of 1931, the Greek says:

> There is nothing here but a phantom, it has no flesh and blood. Because I know the truth I am not afraid. Look, I will touch it. It may be hard under my hand like a statue—I have heard of such things—or my hand may pass through it—but there is no flesh and blood. (*He goes slowly up to the figure and passes his hand over its side.*) The heart of a phantom is

beating! The heart of a phantom is beating! (*He screams. The figure of Christ crosses the stage and passes into the inner room.*) [9]

These moments in his plays and in his poems occur with such lack of fuss and such admirable simplicity that we are inclined to overlook not only their excellence in terms of artistic skill, but their audacious originality. No other poet writing in English, with the possible exception of Blake, confronts us with such an objective vision of worlds different from our own. This treatment of the other worlds—for there are perhaps a number of them—has bewildered many people, or confused them. Stephen Spender finds, for instance:

> In Yeats's thought, the greatness of the achievement of the creative will is to sacrifice tragic life on altars where the pure gold of idea or art or ritual is purged of the dross of actual living and becomes transformed, symbolic, artificial life. In order to do this and to justify it, a whole system of supernatural machinery is evoked. Yeats is serious (or means to be) when he declares that when he has left the human shape his soul will assume some predestined artificial pattern. And yet although we are sometimes convinced of his seriousness, he gives us less feeling of the supernatural than several who insist less on it: than Rimbaud or Eliot, or even than Lawrence when Lawrence writes his *Ship of Death*. [10]

But what Spender has done is to misunderstand Yeats's attitude to the supernatural. Yeats, as it were, objectifies it into existence and *removes* from it that which gives the word its usual overtones. Rilke, Lawrence, Rimbaud are all subjective in their attitude toward death and a possible hereafter; Yeats is coldly objective. It is the difference between being confronted by a 'ghost'—a something which is not, an abstraction, which causes shudders of apprehension—or being confronted by the 'living' figure of a 'dead' person—which is a concrete situation and can be more readily grasped, though it may be more terrifying. Yeats in fact brilliantly avoids the sentimentality so often inseparable from mysticism, without having to abandon mysticism itself. He saw that the true mystic has never preached of a never-never-land-of-heart's-desire but points out that the world as we know it burns forever in a divine fire. Yeats may have questioned the nature of the divinity but he never questioned the reality of the fire. Without being a scientist he did require more than most of the practising mystics of the time seemed able to give. When he came to London and fell under the spell of Madame Blavatsky his demand for a little practical demonstration of some of the tenets of the Theosophical Society made him unpopular among the members. He had an enormous admiration for Madame Blavatsky but finally found her teachings unacceptable. Again, though, he was fortunate in coming

into contact with persons for whom there were more things in life than were catered for either by orthodox Christians or orthodox atheists. He was at an age when influences go deep. He was never to forget the Indian monk Mohini Chatterjee who unlocked for him many eastern mysteries and gave a wider range of mystical, or supra-natural activity for his imagination to play upon, than the pagan mythology of Ireland. The second book of poems, *Crossways*, contains many verses on Indian themes which link it with some of his late work, Mohini Chatterjee being replaced by Shri Purohit Swami, with whom he translated the *Ten Principal Upanishads* and for whose translation of the *Bhagavad Gita* he wrote a preface. But more important than those poems are three lyrics, 'The Cloak, the Boat and the Shoes', 'To an Isle in the Water', and 'Down by the Salley Gardens'. They are important because in our sadly misguided age we lay so much stress on 'interest' that we too often overlook the profound importance of lyrical poetry, which cannot be paraphrased and which does not lend itself to intellectual discussion. But we need to remind ourselves that no artist of greatness has not produced at least some work that is accessible to a wide general audience. These lyrics by themselves would not perhaps indicate that Yeats was a great poet; but together with a few dozen more they would—and do. In all the thousands of words written about Yeats in recent years—examinations of his philosophy, expositions of his system of symbolism, discussions of his role in politics and the theatre, the tremendous fact of the sheer singing beauty of his lyrics is often obscured. Even Yeats himself might have been misled at times about what was truly significant in his work. But as A. G. Stock admirably points out, 'Often the truths that will govern a lifetime slip into the mind in just this unobtrusive way.'[11] There were indeed periods when Yeats came perilously close to mistaking his way, but he always recovered. He never *used* poetry for other ends than its own. This cannot be stated too forcibly. We must go to philosophers for philosophy, to mystics for mysticism, but to poets for poetry. Even T. S. Eliot could occasionally forget this, and one sometimes wonders if it is a thought that has ever occurred to some of our fiercest modern critics who often seem to demand from poetry everything but that which it really is. In *The Use of Poetry and the Use of Criticism* Eliot writes of Yeats:

> He was very much fascinated by self-induced trance states, calculated symbolism, mediums, theosophy, crystal-gazing, folklore and hobgoblins. Golden apples, archers, black pigs and such paraphernalia abounded. Often the verse has an hypnotic charm: but you cannot take heaven by magic, especially if you are, like Mr. Yeats, a very sane person.[12]

Although it is true that Eliot then goes on to praise the later Yeats as producing some of the most beautiful poetry in the language, he clearly does not

succumb to 'charm'. But I am not at all certain that heaven is not more nearly obtainable by magic than by ratiocination. In the early poem 'The Song of Wandering Aengus', which contains those suspect apples, he seems to me to be at least standing on the threshold:

> Though I am old with wandering
> Through hollow lands and hilly lands,
> I will find out where she has gone,
> And kiss her lips and take her hands;
> And pluck till time and times are done
> The silver apples of the moon,
> The golden apples of the sun. [13]

When the magic is at this level we should surely not complain.

Eliot is, of course writing from the standpoint of a man inheriting a tradition very different from that of Yeats, and also, in part, guilty of rejecting it—for his influences stem hardly at all from America but greatly from Europe. The significant word in his list of Yeatsian properties, and the key to his error, is 'folklore'. Yeats's magic stems far more from the stories of Ireland than from the esoteric paraphernalia of theosophy, valuable as that was. His 'magic' has none of the fragility of that of Walter de la Mare and is always well grounded in reality. Nor does he fall into the trap of confusing 'folk' poetry with 'art' poetry. He does not take over the traditional popular poems and ballads but creates poems of his own which contain features of that untutored style. He is able to be naïve and sophisticated at the same time. In these early poems, which are, as they should be, typically nineteenth century in manner, he shows already a melodic structure of his own; sometimes the melodies themselves are feeble, but they are never romantic paraphrases of secondhand material. His problem, as he grew older, was indeed quite the reverse of this. He had to discipline himself not to use his early romantic poems as the basis of his later, more severely classical ones. The influence of Pound and Eliot and T. E. Hulme has been so great in our time that occasionally it has been necessary to point out that they are as fallible in their judgements on art as other critics. But their comments and the comments of their disciples could often cause poets to scrutinize their poems and redraft them for all the wrong reasons. Both Herbert Read and Louis MacNeice, looking at Yeats's revision of his early poem 'The Sorrow of Love', came to the conclusion that the 1892 version is more satisfactory than the version printed in 1933. Herbert Read makes an important point:

My own (opinion) is definitely in favour of the earlier version. In spite of the romantic diction against which Yeats rightly reacted, I feel that it

produces a unity of effect which, romantic as it is, is superior in force to the more definite, more classical diction of the later version. For the truth is that the poem in essence and inception is irradically romantic and had better retain its romantic diction and imagery. As it is the new version has a patchy effect. The old suit may have been shabby, but it was of a good cut and an even tone; the patches of new classical cloth are too obvious and too disjointed.[14]

Although this remark is directed toward a particular poem it is relevant to a situation that is fundamental in any appraisal of the tendencies within the arts of our time: the general swing away from romanticism on the part of artists born when romanticism was at its most luxurious, 1870–1900. Stravinsky's modifications of the original scores of *The Firebird*, *The Rite of Spring* and *Petrushka* are an almost exact parallel of Yeats's action.

But it is equally important to realize that Yeats is not Ezra Pound. He does not decide to 'become modern'—he does not make an intellectual decision. His growing modernity, for good or ill, was conditioned to a large extent by his activities in the sphere of Irish affairs—in particular the Irish theatre. His romantic ardour was tempered by the sheer time- and energy-absorbing work of launching the Abbey Theatre and promoting the work of other Irish dramatists. It was necessary to 'think away' from his lyric tendencies; but in two figures of the Irish theatrical venture he found preoccupations that could not but strengthen the fabric of his own work; Lady Gregory was a mine of information on traditional folklore; John Millington Synge was a man who knew how the peasantry and common folk lived and behaved.

Yeats was acutely aware of his poetic destiny. The unsatisfactory collection of 1910, *The Green Helmet*, included two revealing poems, 'All Things Can Tempt Me' and 'The Fascination of What's Difficult'.

> All things can tempt me from this craft of verse:
> One time it was a woman's face, or worse—
> The seeming needs of my fool-driven land;
> Now nothing but comes readier to the hand
> Than this accustomed toil.[15]

> The fascination of what's difficult
> Has dried the sap out of my veins, and rent
> Spontaneous joy and natural content
> Out of my heart.[16]

Undoubtedly the choice of action embroiled his mind so as to give his poems little time to flower; but more significantly the concern with the new and more

vigorous style in poetry, though its long-term fruits were remarkable, prevented his immediate singing. The influence of Pound was in some ways valuable but possibly only because at the time of their meeting Yeats was already a mature artist with a well-stocked mind and a sure technique. Had he been ten or fifteen years younger he might well have been destroyed utterly. As it is he magnificently bridges within his own work the most dramatic styles of late-nineteenth-century and mid-twentieth-century poetry.

'Spontaneous joy': There is perhaps no phrase in Yeats more significant, for what distinguishes him from the majority of the poets of our time is this quality of joy. His whole artistic nature rebelled against the growing joylessness in art. He was concerned with the heroic and the holy and he diligently struggled to advance the dignity of man. He perceived that tragedy and joy were inseparable and in his greatest poems it is the marriage of these twin elements that is so distinctive. Where many artists (Pound is surely one, Schoenberg perhaps another) strive resolutely not to sink into mere imitation of a past style but fall into the error of imitating the future, Yeats, Janus-faced looked both ways. In 'A Coat', printed in *Responsibilities* (1914), he recognized that his early manner and indeed so much of what he had propagated of Irish mythology in his early days had been taken over by the poetic speculators ready to jump on the band-wagon. In 'A Coat' he exposed the imitators both for what they were doing and for their stupidity in doing it:

> I made my song a coat
> Covered with embroideries
> Out of old mythologies
> From heel to throat;
> But the fools caught it,
> Wore it in the world's eyes
> As though they'd wrought it.
> Song, let them take it,
> For there's more enterprise
> In walking naked.[17]

But what the others had not perceived was the dramatic nature of Yeats's lyrics, perhaps the most substantial individual feature of his work. Despite his involvement with the theatre he is not truly a dramatist—unless a future time, producing the kind of theatre his plays require, make them properly realizeable in chamber performance. Instead he pours dramatic emphasis into his lyrics, even the slightest of them. He is in this respect like Donne, who after Shakespeare is in some ways the most dramatic of the poets of the early seventeenth century

though he never wrote for the theatre. If 'The Ecstasy' is, as Donne puts it, a 'dialogue of one', so are the poems of Yeats. They are invariably conflicts between essence and experience. They are precisely poems of the human predicament; of man half-way between animal and angel. Yeats could not live on fairy tales alone; but nor could he live on the world of gross political or engaged action alone. Gesture was not enough; dream was not adequate. What was necessary was vision propelling man in a course of action made vivid and meaningful by an understanding of his situation in the universe. Death was essentially meaningful, therefore it was necessary to create it.

Folklore without philosophy declines into an old wives' tale; philosophy without experience is abstract hypothesis; mysticism devoid of scientific exploration is self-indulgence. But similarly, in the art of poetry, beautiful sound without meaning is emotional deception, meaning without beautiful sounds is intellectual speculation. In 1919 when he published *The Wild Swans at Coole* he had shaken off both the mists of his own Celtic twilight excursions and the preoccupation with things that were difficult. A new resonance is at once apparent. The title poem is neither a nineteenth-century nor a twentieth-century poem but merely a poem. Here we can see how he finds beauty in the use of a quite natural language. The 'poetic' element is never forced, neither does he attempt to make the poem explicit in the modern manner. It is realistic and symbolic at the same time. We need no gloss to appreciate it, merely its own words and structure. It is important that this should be stressed. Too many critics insist that for an understanding of Yeats it is necessary to have a reasonably intimate knowledge of his philosophy and the symbols he uses to purvey it. This, if it were true, would successfully remove him from the rank of the great poets. It is like saying that one cannot enjoy a meal without knowing the ingredients that went into it and the intentions of the chef. No. Poetry must be sufficient in itself, and Yeats's finest poems are purposeful fictions containing all the information necessary for their appreciation. *The Wild Swans at Coole* certainly is that. Without wishing to diminish the early poems, the gain simply in ease of diction in this book of 1919 is enormous. We have only to compare say the opening of 'The Lake Isle of Innisfree':

> I will arise and go now, and go to Innisfree,
> And a small cabin build there, of clay and wattles
> made:[18]

with that of 'The Wild Swans at Coole':

> The trees are in their autumn beauty,
> The woodland paths are dry,
> Under the October twilight the water

Mirrors a still sky;
Upon the brimming water among the stones
Are nine-and-fifty swans.[19]

Apart from the slightly poetic, 'nine-and-fifty' for 'fifty-nine' there is no sense of strain here, no indication that poetry is not the natural speech of the man. But it was a speech it had taken nearly fifty years to master; it was a slow growth. Those writers who are astonished at Yeats's ability to change his style and the direction of his verse in middle age are misconceiving the nature of his development. What has been happening is the gradual fusion of the two sides of his character. His poetry has at last created the poet. He has become the bird out of nature—the created artefact. In his early poems he was the dreamer; in the first poems of the twentieth century he was the observer, the commentator dealing in the commonplace realities made uncommon by his genius. In the poems from *Responsibilities* onwards he is the artist created by both these early persons. He does not elect to change his style; he elects to be a particular *poet* and that poet writes in his own style. As Pound created the figure of Hugh Selwyn Mauberley through which he was to write what are, paradoxically perhaps his most personal poems, so Yeats created Michael Robartes through whom he realizes his deepest self. He becomes, as it were, the archetypal poet, surrendering fancy for imagination and the everyday world for the eternal universe. He begins to remove himself from his own poems, a process that is to grow as he gets older. This is not an abdication from self but a discovery of the reality behind the impermanence of self. Out of the seeming comes the real. He begins to approximate to the requirements laid down by Maud Bodkin in *Archetypal Patterns in Poetry*:

> Gathering up our results into the form of an answer to the question proposed in this section, concerning the function of poetry, in which we feel the pattern we have called the rebirth archetype, we may say that all poetry, laying hold of the individual through the sensuous resources of language, communicates in some measure the experience of an emotional but supra-personal life; and that poetry in which we re-live, as such, a supra-personal experience though in terms of our own emotional resources, the tidal ebb toward death followed by life renewal, affords us a means of increased awareness, and of fuller expression and control, of our own lives in their secret and momentous obedience to universal rhythms.[20]

This is saying in purely critical terms what Yeats himself expresses in a personal way in his diary: 'I think all happiness in life depends on having the energy to assume the mask of some other self; that all joyous or creative life is a

rebirth as something not oneself—something created in a moment and perpetually renewed . . .'[21]

When Yeats creates his mask it is not because he decides to do so; he cannot avoid it. It is not a question of choice but of necessity. He has endured the passions of the world in the form of attachment to persons and to politics; he has ventured into the strange regions beyond the visible world through myth, fable and the teachings of the mystics. Now he sees that man can only be understood by someone at least attempting to understand God, and God can never be understood by someone who has no understanding of man. This activity of extending both ways requires the creation of the intermediary—the poet, who is both man and god, as the sybils were old women in caves as well as prophetic voices. What modifies man is more than the sum total of man's knowledge. The image out of nature he wishes to become is not a machine. There is no sense in which Yeats desires to be removed from consciousness or even supposes such a situation possible. Why should he wish, though, to take his form from anything which exists in nature? If it exists to that extent it is commonplace, since nothing in nature is unique. No, he wishes to become a being that is uniquely imagined, for imaginative truth is of a different order from the facts among which our bodies exist, and transcends them. He begins therefore, though as yet slowly, to remove himself, to become sybilline. For the time being he speaks through the mask of Robartes. It is this removal and the growth of an aristocratic attitude that causes many people to impute to him Fascist or if not that, wildly right-wing tendencies. This is a considerable error. He was concerned with the tradition that had produced the society in which we exist, not the small trappings of that society, but society as a condition of man in the permanent sense. He was aware that man cannot safeguard the future if he destroys the past. Man is not looking for something that only exists in future time, for perhaps nothing can *exist* in the future; man is always looking for the face he had *before* the world was made:

> If I make the lashes dark
> And the eyes more bright
> And the lips more scarlet,
> Or ask if all be right
> From mirror after mirror,
> No vanity's displayed:
> I'm looking for the face I had
> Before the world was made.[22]

Although in this poem and in many of the late lyrics both form and language are of extreme simplicity, the weight of philosophy behind what is said is enormous. He is, in these poems, less concerned with knowledge than with

wisdom. It is not too fanciful I think to link passages like this with certain esoteric and rare philosophies:

He (the Archetypal Man) who hath dominion over all mortals in the Cosmos, and over its irrational lives, bent His Face downwards through the Harmony of the Cosmos, breaking through its spheres, and showed to downward-borne Nature the beautiful Form of God. And when She beheld that fair Form, which can never satiate, and Him who possessed within himself every energy of the Seven Rulers, as well as of God's own Form, She rejoiced with love—for it was as though she saw the image of Man's fairest form upon the waters, and his Shadow upon the earth. But He, in His turn, beholding the form like unto Himself in the water, loved it and willed to dwell with it; and with the will came the act (energy), and so he vivified the form devoid of reason.[23]

Nor are the poems of political comment of a different philosophical order. It is only necessary to compare sections from, especially, the *Adams Cantos* of Pound with the Irish political poems of Yeats to see how Yeats is concerned with the total ideas governing man's actions whereas Pound is too often blinkered by the actions themselves. The most famous of the poems arising from the events of the Irish rebellion, 'Easter 1916', is remarkable for the way in which it combines statement of fact, extreme eloquence of language, and bodies forth in a most subtle way a philosophy which can make sense of the often senseless seeming struggles of men caught up in events and machines which are more powerful than they. The heroes, the small people, in the troubles of 1916 are vivified not so much by the actions in which they engage, the immediate struggle or its outcome, but by the passion with which they are filled; they are enlarged by the acceptance of their spiritual destiny and are 'changed utterly: a terrible beauty is born.' Terrible because beauty and terror are indivisible, and the actions are made beautiful by the transforming through human passion of an ordinary struggle to the majesty of an archetypal myth. This achievement of a body of poetry which enshrines events in mythological terms is of a particularly astonishing kind, for it required a process of 'making' alien to the usual method. Myths by their nature are those events in the past around which the process of time has not so much built an aura of significance as re-created processes from ordinary experience into processes in supra-ordinary experiences. Yeats was penetratingly accurate in realizing, for his own time, and out of his own temperament 'the knowledge that he must create a myth not out of legend but out of experience resolving into legend, out of friends, love, events in the raw; divine in this, inform this with, vital values, and ennoble them as timeless symbols promising wholeness that transformed Yeats from a soothsayer into a leader.'[24]

The growth of particular and observable events is an indication of enormous shifts in the spiritual life and movement of the universe. Few poets of our time have been able to step with such ease from plane to plane of experience and apprehension, and to have not only inspiration and vision but a plasticity of style that can body forth the ideas; it is no small step from the lucid simplicity and natural style of:

> I have met them at close of day
> Coming with vivid faces
> From counter or desk among grey
> Eighteenth-century houses. [25]

to the dense, charged, symbolism of 'The Second Coming', which must stand as among the most prophetic and disturbing poems of our time:

> Turning and turning in the widening gyre
> The falcon cannot hear the falconer;
> Things fall apart; the centre cannot hold;
> Mere anarchy is loosed upon the world,
> The blood-dimmed tide is loosed, and everywhere
> The ceremony of innocence is drowned;
> The best lack all conviction, while the worst
> Are full of passionate intensity. [26]

What is particularly noticeable here is that feature of Yeats's poetry too often neglected by critics but of first importance to the general reader: memorable lines; individual phrases of pungency and power, for undeniably, as with music, poetry, if it is to retain a hold upon the public for any length of time must have what can be thought of as melody, and Yeats possessed melody in abundance. In this quality he is perhaps richer than any other poet of his generation, out-stripping by far Pound, Eliot or Graves, whose powers lie in different facets of the art. But from the earliest poems, lines and phrases stand magical in their own right; they reverberate in the mind when the whole poem may be forgotten.

He was very conscious of this himself. Often bitter, angry, querulous, though rarely despairing, and most certainly at odds with the multitude in their communal vulgarity, he was concerned that his poetry should be for living, ordinary men in the real world. Despite his esoteric learning, his often childish playing about with the most spurious elements of the supernatural, his building up of an allegorical fable as complicated as the long poems of Blake, he was desirous of contributing to the age-old 'book of the people', thinking, with some justification that an age of art was passing away, as it must with the passing out,

the breaking up of two thousand years of philosophy. In 'Coole and Ballylee, 1931' he writes:

> We were the last romantics—chose for theme
> Traditional sanctity and loveliness;
> Whatever's written in what poets name
> The book of the people; whatever most can bless
> The mind of man or elevate a rhyme;
> But all is changed, that high horse riderless,
> Though mounted in that saddle Homer rode
> Where the swan drifts upon a darkening flood.[27]

He saw himself as the last of a great tradition in poetry, in action, in philosophical speculation. While he listened to the ideas of the young he perceived that for the most part an enormous gulf separated him from them. After the devastation of the 1914–18 war a generation was growing up with a different despair behind it, a different uncertainty in front. History had provided for its immediate background a European tragedy of already mythological proportions. He died a man honoured and revered, though ironically, while the poems of those younger rebels flourished, much of his own poetry was out of print. His life was dedicated in his art, indeed, to '. . . whatever most can bless/The mind of man.' An aim for which any man may be respected. But within the very luminosity of his vision lay a dark shadow anticipating the cruelty of the future. In his last book images of blood abound; it is as if the horror which he refused to allow into his poetry was striving to come to birth, as if his glorious angels were being beset by darker, grosser, more bloated forces. Before long 'the blood-dimmed tide' was to be loosed indeed, not only in human terms but in the world of art also. But before that happened we may hope that 'the last romantic' was indeed embrasured in 'the artifice of Eternity'.

I shall now make a few observations about the Bible and religion. Let's discuss it together . . .

Its odd that it says in the Bible, *God created mankind*, though it is really the other way around: mankind created God.

It's odd that it says in the Bible, *the body is mortal, the soul immortal* though the opposite is also true: the body (matter) is eternal, the soul (that is, the form of the body) transitory.

It's odd that the vocation of priest and actor are considered antithetical, when both priest and actor preach the same thing: fables.

I believe this: that in times of religious laxness, mankind is at its most dissolute, while in times of religious ascendancy, fanatical zealots arise.[28]

75

The words are not Yeats's but those of the young Béla Bartók, setting forth in a letter written before the turn of the century a part of his adolescent but exceptionally serious credo. For long considered extremely difficult, the music of Bartók has, since his death in 1945, become the most accessible to the 'ordinary', non-specialist listener of those contemporary composers generally labelled 'modernist'. There is a good reason for this, first the quality of the work itself, and second the fact that he can now be seen to stand in a similar position in the field of music to that of Yeats in poetry, bridging the worlds of nineteenth-century harmony and twentieth-century atonality through a steady growth pattern in his own style which escapes the intellectual decision that caused Schoenberg to break with tradition, a break made in poetry by Ezra Pound. Yeats and Bartók, despite their acceptance of the challenge of the modern world, took no radical theoretical decision in regard to style. That they did not do so was perhaps due to their involvement in the executant elements of their art, Bartók as pianist, Yeats as a man of the theatre, which prevented them from being pedagogues, as Pound, Schoenberg, and Klee were by virtue of their extra-creative activities. The pedagogical writings of Bartók lie in the province of piano teaching.

As Yeats's early absorption in Irish legend and folklore grew into an active though often misguided participation in the struggle for the emancipation of Ireland, so Bartók found himself from his childhood symptomatically Hungarian, though his birthplace—Nagyszentmiklós—is now in Romanian territory. It is this 'Hungarianness' which, like Yeats's Irishness, colours his life's work and helps him to avoid the dangers of being swamped on the one hand by the great German tradition in music or on the other by the growing 'universal' musical style. Apart from his superb gift of the gab, there is little in Shaw that distinguishes him as an Irish writer, but everything in Yeats points to his origin. Similarly, apart from one or two sophisticated and modified Hungarian rhythms, there is little in Liszt to proclaim him a Hungarian composer, while after a handful of early works there is a permanent and detectable national characteristic in the music of Bartók.

We have seen that Yeats's first substantial poem was based on a legend of Oisin, a great hero in Irish mythology, and that the style was one of extremely lush romanticism; so Bartók's first significant work was inspired by a figure from the immediate past in European history but who had in the few years since his death assumed an almost legendary importance in the minds of progressive young Hungarians. The work is the 'Kossuth' Symphony, the enormous symphonic poem in ten tableaux which celebrates in elaborate musical form the heroic struggle of Lajos Kossuth in his abortive attempts to free the Hungarian people from the dominance of the Hapsburg rulers. It is perhaps ironic that for the treatment of such a subject Bartók was not yet mature enough to create a

truly Hungarian composition. Scored for a huge orchestra, the work, though remarkable for a young man of twenty-two, is set inevitably in the mould of the tone poems of Liszt and Richard Strauss. Liszt was a natural influence on a man destined to be both pianist and composer and who shared the same nationality, and the all-pervading influence of Richard Strauss was, immediately after the turn of the century, almost as strong as that of Wagner had been twenty years before. The heroic tone of Bartók's work derives from the orchestral scores of Strauss which Bartók had studied avidly since first hearing, in 1902 in Budapest, a performance of *Thus Spake Zarathustra*. So greatly did he admire Strauss that he made a piano arrangement of *A Hero's Life* and was instrumental in introducing the work of Strauss to certain of his own Hungarian musical acquaintances. It is an odd situation, surely, when a composer from the dominating empire, celebrating the heroism of his own idols, helps both to form a style and set the seed of nationalistic fervour in the creative imagination of a composer from the subject country? But certainly this is the case, for the Strauss influence continues for a long time in the music of Bartók, gradually replacing that of Brahms, before being modified in turn by the innovations of Debussy and at a much later date by the composers of the pre-Bach era. But perhaps it is not so strange, for he may have been worried by this curious juxtaposition to the point where it was necessary to rebel against the cultural dominance of an alien tradition. He was not, of course, alone in this. Liszt, though never musically Hungarian in any true sense, had seen that, at least rhythmically, there were important and distinctive qualities to be found in traditional Hungarian folk songs and dances; so also had Ernst von Dohnányi. However, it was neither of these but Zoltán Kodály in whom Bartók was to find his greatest ally. What started out as a curious speculation as to the nature of traditional Hungarian music was to grow into a life's work, for Bartók almost single-handed can be said to have shored against oblivion all the known history of Hungarian traditional music. His enormous labours in this field are almost as valuable to the ethnologist as to the musician. For Bartók the labour was one of love and its very selflessness, perhaps, was to be repaid by a gift in kind. If it can be said that he has preserved Hungarian folk music, then it can equally certainly be said that Hungarian folk music 'created' Bartók, the composer. He is among the most striking examples of a composer whose ability to speak universally is determined by the strength of his nationalistic roots. He is not of course unique in this, for Glinka, Borodin and Mussorgsky had followed a similar path in Russia, and Bartók's Czech contemporary Leos Janáček was to do something of the kind, though less spectacularly, for Czech music, as was Villa-Lobos for that of Brazil.

It is important however to stress that Bartók was not narrowly nationalistic. As his interest in Hungarian folk music grew, it led him to a deep concern for

folk music in general and his researches into the subject took him as far distant as Turkey and North Africa, the North African experience having an effect on him as profound as, and not dissimilar to, the visit of Paul Klee to much the same area. For Bartók the concern was to find a way to the root of a tradition which had been overlaid by the sophisticated accretions of two centuries of the artefacts of an imposed culture. It is significant that one of the striking features he was to reclaim was rhythmical. This quality of primal vitality is of extreme importance and is the feature most lacking in over-ripe phases of any art form, as it is in most elderly societies where the reflective tendencies are uppermost and too often produce an enervating effect; we begin to find their artistic manifestation 'interesting' to the exclusion of more direct features, 'but interest alone does not give life to a movement and in the end it is the vitality of an art which secures its longevity . . .'[29] But it was not merely rhythmical energy and freedom that Bartók reclaimed from the peasant culture of Hungary and Romania, but a melodic cadence that escaped the clichés that had overtaken the Western music of so many composers of the post-Beethoven era. He was not able to make use of these discoveries for a long time, any more than Yeats was able to use the simpler diction of the Irish peasantry until well after the turn of the century. Bartók, like Yeats, indeed like Schoenberg, Picasso, Stravinsky and Pound, is firstly a romantic in the generalized nineteenth-century sense of the word. This was to be expected in 'Kossuth' which, remarkable as it is in its execution, is entirely adolescent in its conception. But we might have expected a rather less orthodox approach in the Rhapsody for piano and orchestra which he entered for the Rubinstein prize. That it failed to win is surprising, for it is a masterly work in its own traditional way and one would have thought quite unexceptionable in its manner. It is a full-scale near-concerto in the style of Liszt and Brahms, calling for much bravura playing on the part of the soloist, a deliberate feature because the young composer was also competing for the piano prize (which he also failed to win), and considerable virtuosity in the orchestral parts. It has few of Bartók's fingerprints, unlike the easily identifiable early works of Mahler, which are clearly tied to their composer. Only the two short moments toward the end of the Hungarian dance-like middle section, where there is a tinge of that sardonic melancholy which is to become a feature of his personal style, indicate the composer. He seems all set in this work to be the Hungarian Shostakovich.

But despite the immaturity of this work in the light of Bartók's later compositions, it is of especial interest for it demonstrates the dilemma in which music found itself at the turn of the century. It shows a young man of immense talent producing a self-sufficient work in a manner that is at once perfectly acceptable and impossible; it shows with astonishing clarity how the needle, as it were, had got stuck in the groove. While it is imitative it is not an imitation; it is a fully

created work by a sincere composer; it demonstrates how possible it might have been for music to go on and on like this, in an endless variation of the rhapsodic style, tuneful, comfortable, lush, *civilized*. Equally it shows how the manner is already worn out. It does not so much speak in someone else's language as in the language of the dead. It is a book that had already been written, a painting already painted.

The works produced between 1904 and 1909 show comparatively little development in style from the 'Kossuth' Symphony and the Rhapsody no. 1, despite the growing 'modernity' in the music of many of Bartók's most significant contemporaries. What is most remarkable, in view of his later compositions, is the apparent predilection for works for large orchestra—the two Dance Suites and the *Two Portraits*. Equally surprising is the fact that after the initial success of 'Kossuth' Bartók's encouragement from performing societies was small, which must to some extent be the reason for his deflecting his creative gifts into the field of the solo piano and the string quartet. His first serious study of Hungarian folk music was beginning to have an effect, not so much on the music produced at this time as on the musical mind that was to produce major works in a later period. The first absolutely confident work is the First String Quartet of 1908 which more than either the Quartet of Debussy or that of Ravel, beautiful as they are, or Schoenberg's no. 1, astonishing as that is, shows the young Bartók the true heir of Beethoven in this exceptionally rigorous category. While being demonstrably of our own time it seems, in its first movement at least, to lead directly from those grave spiritual explorations of the late Beethoven masterpieces. He does not create that new French Impressionist world of Ravel, nor does he attempt to sum up the history of quartet writing as does the young and ambitious Schoenberg; more surprisingly the work owes little to Debussy. He exhibits a gravity of musical thought in this work that should at once have proclaimed him a major composer. The conspicuous difference between it and the early works is in the ambiguity of its tonality, for it cannot be said to live within any set key, nor can it be thought of as an 'atonal' work. All his life Bartók was to produce just such nicely balanced compositions, assuming a richly rewarding stance between the impossible late-nineteenth-century manner and the impossibly new. The two sides of his young musical personality are shown most clearly in the two piano works written at about the same time as the First Quartet: the collection entitled *For Children* and the *Two Elegies*. The former are clear, classical and direct, showing the influence of his exploration of Hungarian and Slovakian folk music, while the latter are extravagant highly complicated exercises in the sophisticated manner of Western concert music; they show, inevitably, some influence of Debussy who was replacing Strauss as the dominant

79

musical master. But that influence was to be shown more directly in the *Deux Images* for orchestra where musical impressionism is carried further than in any other of Bartók's symphonic scores. The significant work of the period however, and the one most closely tied to Debussy, is the opera *Duke Bluebeard's Castle*. Although the libretto is by a Hungarian friend of Bartók this strengthens the link with Debussy, for Béla Balázs' libretto is a reworking of Maeterlinck's play *Ariadne and Bluebeard* (which Dukas had used for his opera of that name), an unwisely neglected musical drama that should be retrieved from its obscurity, as should many of Maeterlinck's plays. Bartók's *Bluebeard* shows very clearly indeed, as do the ballets *The Miraculous Mandarin* and the *Wooden Prince*, the composer's deep absorption in symbolism, an absorption as profound as that of Yeats or Arthur Symons or Maeterlinck himself. Indeed Balázs' libretto is of an implacable symbolic obscurity that far outdoes Maeterlinck's original. *Bluebeard* is a singularly perverse stage work, having no overt dramatic action, and the rarity of its appearances in the theatre is perhaps not to be wondered at, but at the same time it is an electrifyingly dramatic work from the purely musical point of view. Debussy, though following Maeterlinck almost word for word in *Pelléas*, removes the two scenes which deal with the opening of the great doors of the castle; but for Bartók the opening of the doors of Bluebeard's castle forms the musico-dramatic structure of the work. What the two operas have in common is the oppressive atmosphere of gloom. For Judith as for Mélisande all is dark, and each desires light with an obsessive though already despairing passion. Both plays and therefore both operas are about the impossibility of happiness. We move from one darkness, one despair, to another. Perhaps they demonstrate something of the dilemma of Sisyphus, who in Camus's essay is happy when he realizes the impossibility of happiness. Freedom comes from the acceptance of captivity.

Everything that Bartók learned from Strauss and which was reinforced by the influence of Debussy is in this short masterpiece. It is one of a number of extraordinary one-act operas of true quality in the operatic repertoire of the twentieth century, from the exquisitely comic and tender *L'Enfant et les sortilèges* of Ravel to the near-psychotic dramatic scena *Erwartung* of Schoenberg, or *Oedipus Rex* by Stravinsky. What many of these works have in common is quite outstanding orchestral textures, the voice being a part of an orchestral tapestry and used in a fashion quite alien to that of Verdi or Puccini or Tchaikovsky, or even of Richard Strauss, yet also very different from the manner of Wagner. Bartók was immediately rebuffed by the authorities when he submitted this work for a prize to be given by the Budapest Commission of Fine Art and it had to wait seven years for its first performance. Like Schoenberg, like Mahler, like Berg, Bartók was to find it difficult to *hear* his works and only through hearing his music can a young composer learn to modify mistakes in scoring. Not that

Bluebeard suffers in this respect. It is among the most vividly orchestrated works in the operatic repertoire. As Judith insists on the opening of each of the dungeon doors in turn, the orchestra is required to paint for the audience what is disclosed to her sight. Bartók achieves this effect with quite terrifying skill, exploiting in these brief interludes the kaleidoscopic effects of a large instrumental ensemble. In this opera, as in Debussy's *Pelléas*, it is what is suggested that is so powerful rather than what is actually witnessed. The text avoids concreteness. Judith's questions are turned aside by Bluebeard until he can escape answering them no longer; the answers are contained in the orchestral passages accompanying the opening of each door. But although there is an aspect of the drama which supposes that for Bluebeard reality exists in the memory of the past, since he finds it perpetually impossible to discover a mode of present existence satisfying to him, and because he is fated always to be destructive of the present, there is also the fact of the reality, in flesh and blood, of the wives who appear in all their radiant beauty when Judith demands the opening of the seventh and last door. These wives, though they do not sing, are clearly neither memories nor phantoms. They are tangible as the dead are tangible in the plays of Yeats. Yeats and Bartók both seem to have had a glimpse of the possibility that time is misconceived by Kant as an operation of objects in horizontal procession and that in its true nature it is a permanent state discoverable, as it were, vertically, in depth. What makes the opera difficult for most popular audiences however is not its static nature, but the problem, also inherent in such works as *Pelléas and Mélisande*, *Oedipus Rex*, *Moses and Aaron* and Szymanowski's *King Roger*, of the necessity for the public to see the characters as symbols rather than as ordinary living creatures of flesh and blood. It is not a new problem. *The Marriage of Figaro* and *Don Giovanni* hold the stage more easily than *The Magic Flute* for the same reason. Not even the impact of the plays of Brecht or of Beckett has significantly broken down the desire of most theatre- and opera-goers for the conflict between individual characters with whom he can identify. Janáček, Puccini, Richard Strauss all offer this simplest of attractions—even Berg's Wozzeck and Marie exist in a world the average man might encounter.

Obsessive as is the *theme* of *Bluebeard* it is not musically among the most obsessive *scores* of Bartók. It is almost his last essay in a traditional romantic style, for despite the influence of Debussy, and despite the exact use of the Hungarian language, it is still heavily dominated by the great German tradition. A work of quite different calibre and type, written in the same year, 1911, is infinitely more revealing as to the subsequent development his music was to undergo; it is the brief piano piece expressively entitled *Allegro barbaro*. In this short work Bartók takes the vital step which is to transform him from a nineteenth-century to a twentieth-century composer. Although in his major works

Stravinsky precedes Bartók in the protean impact of his rhythmic discoveries, this tight and implacable solo of Bartók is in some ways the germ of that development. Nothing in Schoenberg or Debussy or Albéniz or Ravel up to that time has about it the rigidly controlled, tightly leashed violence of this work. Into the refined world of the concert hall Bartók introduced the traditional dance fervour of the Hungarian people, freed from the civilizing refinement of Liszt. Bartók was not here adapting the folk music of middle Europe any more than Yeats or Synge were to adapt the stories or method of speech of the Irish peasantry; like them he was creating from his knowledge, his awareness of the roots, an autonomous work within the genre, purified by his genius but not bastardized by his sophistication. As with Yeats, we must appreciate that this was indeed a growth, a refinement of intuitive sensibility, not the product of a conscious change of aesthetic. Before Bartók's next significant work Stravinsky was to compose *The Rite of Spring*.

If Schoenberg is largely responsible for freeing twentieth-century harmony from the constraint of the key system, then Bartók and Stravinsky can be said to have released modern music from the over-rigid rhythmical devices of the classical and romantic schools. Undoubtedly Bartók was aware of the primitive vigour but sophisticated manipulation of Stravinsky's *Petrushka* and *The Rite of Spring*, as can be clearly seen in the opening of his most viciously dissonant and rhythmically disturbing work, the ballet *The Miraculous Mandarin*. The source is nevertheless the *Allegro barbaro* and the String Quartet no. 2. To compare the development between the First and Second Quartets of Schoenberg and those of Bartók is at once to see how Schoenberg is being directed by his intellect in contradistinction to Bartók's intuitive development. For all its dissonances the Bartók Second Quartet is demonstrably related directly through his own First Quartet to the world of Beethoven and Haydn. The first movement is his first absolutely grave and mature work, combining at once a sense of the assurance of tradition and the calm vision of a possible new order. The third and last movement, as ineluctably desolate as anything in the late works of Beethoven, is at once a restatement of the classical virtues and an introduction to that world of real Hungarian lament already hinted at in the Dirges for piano. The vital element is however the startlingly disruptive second movement, a Scherzo of contained savagery and mordant wit, that with lesser technique might well have broken the quartet form. The bite, the barbarity is all the more disturbing because it is in a chamber-music form of the most refined good manners. The full explosion is reserved for what is perhaps his most controversial work, the erotic ballet that still awaits a production worthy of the music—*The Miraculous Mandarin*.

Despite its compulsive fascination this ballet, not because of the eroticism of its theme which so amusingly shocked one of the most prurient societies in history, is one of the most positively repellent of modern scores. Perhaps because its musical characterization is so honest and convincing, it is the more difficult to abide. There is none of the self-indulgent sensuality of Strauss in *Der Rosenkavalier*, nor the tolerant and rather soft connivance of Berg in *Lulu*, nor the ironic permissiveness of Shostakovich in *Katerina Ismailova*. The libretto by Lengyel, which is peopled only by a prostitute, three callow and brutal thugs and a 'miraculous mandarin' whose actions are as vicious as his death and person are mysterious, inspired Bartók to create musical personages of a power and reality far removed from the cyphers of *Bluebeard* or *The Wooden Prince*. Not even the full fury of the climax of Stravinsky's *Rite* quite matches the deliberate brutality and extraordinary frenzy of this savage and bitter score. The viciousness is inherent in the vision. Not only was the barbarous element taking hold on Bartók, so also was a desire, perhaps unconscious, to indulge in complexities of structure and musical syntax far in excess of any of his previous works. 'The fascination of what's difficult'—Bartók was pushing his musical problems to extremes. Miraculously he was solving them in a masterly way. These works were certainly far from the conventional idea of 'beauty'.

It is not surprising that a composer of great daring and originality like Delius, with his refined and mystical loveliness, should have raged at the 'ugliness' of the music of Bartók. He could not see, as many people could not see at the time, how intensely and profoundly beautiful these complex works were. The most difficult is undoubtedly the Third String Quartet of 1927. It is the most crucial in his development as a 'modern' composer and moves him closer than any of his previous compositions to the extreme position of Schoenberg and Webern. This work and the two violin sonatas, though Bartók always thought of them as being in particular keys, come as close to 'atonality' as anything in his œuvre. The Quartet is extremely compressed. Much has been made of the 'motivic' element in Bartók's work—Halsey Stevens is particularly anxious to deny to Bartók the use of 'themes', preferring to read all the 'themes' as fragmentary motives.[30] But these fragments are surely developed in such a way as to become 'themes'—they are, for instance, conditioned by the structure of the works to cohere in a way that, say, the far looser and more disjointed fragments of melody in the quartets of Janáček rarely do. Even in so rarefied a work as the Third Quartet it is more possible to hold a continuously developing phrase in the mind than it is in either of Janáček's two excellent quartets. But the Bartók work, especially when placed in relation to the next quartet, throws dramatically into relief his growing artistic problem. To have accepted the system of thinking advocated by Ezra Pound, Yeats would almost certainly have found it necessary

to slough off all traces of his earlier romanticism; this fortunately he was unable to do. He was incapable of accepting a dogma so extreme, and in the end his lyric impulse held its own against the rigour of Pound's intellectual directions and observances. Schoenberg was never Bartók's mentor but we can see in the tonal ambiguity of the Third Quartet a musical mind being very severely strained by the claims of an analytical genius as all-powerful as that of Schoenberg and his disciples. For the first time in Bartok the rhythmical vigour plays a secondary role to the harmonic treatment which is both fluid and exact—though this is not to overlook the rhythmic excitement of many of its parts. Bartók's love of passing dissonances is almost reversed in this work where it is the harmonies that seem to be passing through a musical time span in which dissonance is the norm. Dissonance is not, however, to be read as ugliness, or unappealing sound. The fewer dissonances contained in the First Piano Concerto of the same year are far more disturbing because their absorption in the overall harmonic scheme of the work is less skilfully managed. What is shown most clearly in this chamber work is, however, the concern for 'arch' form that was to be among the major fields of stylistic and structural exploration for the remainder of Bartók's life. In this obsession he is not unlike Berg, the difference being that Bartók's own musical growth process required less overt formalization than Berg's. A significant difference can be seen in the composers' markings in the scores of their respective violin concertos. Bartók meticulously directs the dynamics and scrupulously orders the time sequence—giving a playing speed that is perhaps unattainably fast—but he does not indicate the position of the climax as does Berg in his own gravely beautiful work. For Bartók the rhythmical impetus would always make the growth to the climax inevitable and its position obvious. This is an indication of a difference in kind, not a comparison of excellences, and certainly no criticism of Berg.

What is astonishing and gratifying in the major works of Bartók is the way in which the growing tendency toward the solving of formal difficulties of the most extreme kind heightens rather than diminishes the emotional effect. Like Yeats in his later poems, Bartók uses his growing technical skill not for its own sake but in order to express his deepest personal concerns. By being extremely disciplined he avoids the excesses of emotionalism so often the downfall of romantic composers, but at the same time he manages to escape being trapped in the formal pattern-making which is the fate of those artists who hold too intellectual and arid a conception of the classical ideal.

He does not indulge in the games and satirical frolics of many of the composers of the 1920s. Nevertheless Bartók's gravity is not portentous. He was, as Yeats so magnificently was, able to smile, able to laugh, to celebrate and to enjoy. His works abound in exquisite ironies. Musical jokes occur with the same

delightful surprise and freshness as those to be savoured in Haydn and Mozart. The superbly placed 'out of key phrase' for the first violin in the last movement of the Fifth String Quartet, the use of deflating ritardandos in the Violin Concerto and the Concerto for Orchestra, some of the particularly extravagant absences of harmonic or thematic rapport between the instruments in the two violin sonatas, the delicately poised classical commentary that imbues the finale of the Divertimento for Strings are ample evidence of this gentle and wise humour.

His lack of success in the theatre kept him away from works involving any major forces of the human voice until 1930 when he produced the seriously undervalued *Cantata profana* which in retrospect can be seen as the first sign of that drawing away from expressive dissonance or tonal ambiguity toward a reasonably close approximation of traditional nineteenth-century harmony. He makes no apology for this. At no time does he find it necessary, as Schoenberg often did, to comment on his works or to distinguish between the levels or intentions of his compositions.

Once a symbolist, always a symbolist—at least for Bartók. The choice of text for this large-scale work is as intriguing as his previous choices, for although the emotional overtones and undertones are less disturbing, they are no less intellectually fascinating. It is a crystalline and exceptionally open and 'pure' work. The main themes owe much to those of the magnificent Fourth Quartet and are to provide a great deal of the material for the Concerto for Orchestra. The folk, or rather Hungarian aspect of his earlier works is much to the fore and there is a considerable pentatonic element. The intervals, especially in the tenor's vocal line, are always surprising but rarely shocking. The *Cantata* admirably demonstrates the continuing possibility for a composer of the most modern inclinations to produce on a large scale a harmonically and rhythmically traditional work without in any way resorting to artistic compromise. Possibly its text, which deals with the question of individual choice and the desirability of freedom, was significant to Bartók, as a similar theme was to Schoenberg in his opera *Moses and Aaron*; Bartók's resolution of the challenge is more complete than Schoenberg's but the plane on which the choice needed to be made was less extreme. Bartók, for all his audacity, was for the most part admirably level-headed and demonstrates the virtues, in art as in life, of the Buddhist ideal of the 'middle way'.

This classical decorum, however, is rudely disrupted by the first movement of the next major work, the Second Piano Concerto, with its scoring entirely concentrated in the wind, brass and percussion, the felicities of the strings held back for the subsequent movement. Despite the popularity of the Third Piano Concerto, with its Bach-like balance and refined elegance, there is some reason

for thinking the Second Concerto his finest essay in this medium. The second movement is especially fine with its superb dialogue between piano and percussion which lends it the air of being Beethoven's Fourth adapted to modern times and its introduction for the first time in an orchestral score of that mysterious element graphically described as 'night music'. The somewhat disquieting quality is its rather savage aggressiveness. Listening to the more powerful orchestral music of Bartók one cannot help feeling sometimes that he finds it necessary to demonstrate his masculinity—or perhaps, because so large a part of his output was for small combinations of instruments, that the larger vision and the ability to contend with it was not denied him. After this work, throughout the 1930s, he was to pursue a path of growing simplicity of expression. If it ·is possible to consider a poem like Yeats's 'The Second Coming' to be one of the great statements in the poetry of our time by virtue of its prophetic utterance and the assurance of its style, then we may legitimately claim the same responsible position for Bartók's Music for Strings, Percussion and Celesta of 1936. It is difficult to think of a work in the chamber orchestral repertoire of the last fifty years more likely to hold a place of historical significance. Few contrapuntal exercises since those of the Beethoven quartets are so profoundly moving as the first section of this work. The choice of two string groups is perhaps significant, for the work has about it the air of a gravely important discussion. It unfolds like a platonic dialogue and is utterly devoid of rhetoric. The emotional intensity is as great as anything in Yeats but the argument is as lucid as that of Paul Valéry.

Toward the end of his life Yeats records his turning away from the disputations of his own time, finding more profound qualities in the words of certain earlier writers. This was not an opting out of current engagement but an attempt to temper modern opinions, still untried historically, with the views of major figures whose worth seemed to have been guaranteed by the passage of time. So Bartók became more and more engaged by the musical ideals and observances of certain early composers, composers often far from the usual run. The effects of this exploration cannot be thoroughly approved, for despite the fervent advocacy of certain writers—notably Halsey Stevens—the late works of Bartók do show a slackening of inspiration, a reworking of material already superbly handled. This criticism does not apply to the Sonata for Two Pianos and Percussion nor the lightweight but utterly delightful Divertimento for Strings. But the Third Piano Concerto, the unfinished Viola Concerto and the Concerto for Orchestra—even, in part, the beautifully controlled and moving Sixth String Quartet have less originality and are less eloquent and significant than their immediate predecessors.

Perhaps the most fortunate factor in the development of Yeats was the fact that not only did he discover his own voice but he also found his audience. Alas,

Bartók, whose voice when found was of a quality rare in modern times, never in his lifetime found his audience. It was not until the success of the Concerto for Orchestra, in many aspects his least typical work, that he was assured of a truly world-wide public. Even the Dance Suite of 1923, though frequently played to much applause, never won him a large general following. He suffered, like Schoenberg, though with less justice, from a positive lack of public response and there can be little doubt this caused a withdrawal, an introspection, which in turn made certain of his works even less accessible. When the public did begin to applaud his music it was almost too late. He had found asylum in America, as had Toch, Schoenberg, Hindemith and many others, but despite the magnanimity of certain musical foundations there, he never discovered the freedom from financial worry that might have released even more fine works. When he died he was a disappointed man. Odd that so few years after his death his quartets are played more frequently than those of any of his contemporaries, perhaps more even than those of Brahms or Mendelssohn. Too traditional in some ways to become a spectacularly controversial figure and too modern to be generally accepted and played during his lifetime, he suffered neglect, contempt, the patronage of smaller figures and the particular harrassment of the sensitive artist caught in the violent trap of Europe in a constant state of uncertainty and war.

Without deeply affecting the general development of modern music and leaving no school of ardent disciples, he achieved an extraordinary victory over the dominance of the German musical tradition. Despite the nationalistic flavour and fervour of Sibelius and Janáček, their music is never utterly independent of their Austro-German masters. Bartók forged from the peasant music of Hungary and Romania a classical and austere language. This he did with an assurance never achieved by Liszt. A whole new range of rhythmical experience and excitement was brought from the simplest of musical men into the sophisticated concert halls of the Western world. The peasant dances and songs of his country and its neighbours are now available to all.

When he celebrated the great Hungarian rebel Kossuth in his early symphonic poem he was telling a story of heroic defeat. From the assiduous tending of his traditional musical roots, Bartók in his mature works forged a style as absolute as that of any of the great German classical and romantic masters. It is no small achievement.

SCHOENBERG BERG KLEE WEBERN

'Do you consider love the strongest emotion?' he asked.
'Do you know of a stronger?'
'Yes, interest.'

Thomas Mann, Dr Faustus.

However modern or obscure the artists so far considered may have seemed, and perhaps still do seem, to certain sections of the general public, none of them was intellectually committed to the idea of 'modernism' that was to become so strong a principle of many major writers, painters and musicians once the twentieth century got under way. We cannot see in their work a moment at which they resolved a problem relating to the *idea* of art, as opposed to the resolution of the problems inherent in the work of art in process of being created. Mallarmé it is true had constructed an aesthetic within the framework of which most of his work had been produced, but the most drastic shifts were made by the composers of the Viennese school, Schoenberg, Berg, and Webern, by the painters Klee, Mondrian and Picasso, by the two American poets Ezra Pound and T. S. Eliot, and by the Irish novelist James Joyce. An immense shift was also made by Stravinsky, but for the moment it is necessary to look at one of the most radical artists of our time, the extraordinary composer and pedagogue Arnold Schoenberg. Controversy has raged perpetually around this man; however, his protagonists have won at least the present phase of the battle. He is now confidently acclaimed by the most vocal and powerful group of critics as the greatest composer of the twentieth century, a giant against whom all other contenders look ridiculously small. Has he not reformed the entire conception of music? Has he not successfully put in the place of an outworn convention a system not only remarkable in its own right but even more important from the point of view of future developments? And has he not composed the most significant musical works of our time?

A certain mild scepticism might be felt by the public at large when confronted by claims so rash as these, a public more often than not utterly be-

wildered by Schoenberg's music. The old cry that everything 'modern' is always misunderstood by the general public at its early performances is not a proper argument in the case of most of the works of Schoenberg. It is worth remembering that late works like the Clarinet Quintet of Brahms and the Sixth Symphony of Tchaikovsky were firmly established in the public's affections within ten years of their first performances. It is more than half a century since the first works of Schoenberg's 'modern' period were first heard and the majority of willing music-lovers who are not professional musicians still find them exceptionally difficult and as often as not consider them downright ugly. I am not making a qualitative statement here—merely a statement of fact. These same people will normally be found to enjoy a great deal of the music of Elgar, Sibelius, Ravel, Debussy, Shostakovich, even, to a certain extent, Bartók. I doubt whether their reaction is conditioned by prejudice—many of them will certainly admit to a liking for Schoenberg's *Verklärte Nacht*. We need therefore to look at the nature of the change in Schoenberg's music around the years 1905–6.

Brahms's rejection of Hugo Wolf and his half-hearted response to Mahler, except as an indication of personal vanity, remain puzzles we are unlikely to solve. It should come as no surprise, however, to find Mahler being such an ardent champion of Berg and Schoenberg. Schoenberg's early work is saturated in the influence of Wagner and, through Wagner, of Mahler. It is a matter for real astonishment to consider, against a background almost devoid of true musical training, the fantastic achievement of this young Viennese Jewish composer. Not even the young Berlioz was as precocious. It was as if Schoenberg had listened to all the works in the classical and romantic repertoire and by some process of alchemy had transformed what he heard into an understanding of traditional technique. For how else can one explain the maturity, in their chosen style, of works like the First String Quartet (the one included in the canon; not the recently discovered 'lost' quartet), the string sextet *Verklärte Nacht*, the symphonic poem *Pelléas and Mélisande* or the first part of the *Gurre-lieder*?

Take the First Quartet. Has there ever been a work by so young a composer of such proportions or intensity and, on the whole, of such quality? It is as if he had decided to produce a synthesis of all previous quartet writing, making, in a way, the works of the past redundant, offering in their place his own enormous and, in many ways, splendid composition. The sheer energy of it is overwhelming enough but the way in which he solves technical problems that might defeat an old master is equally formidable. It shows, nevertheless, how firmly he was still caught up in the seductive manner of the late romantics. For all his insight into the thickness of the instrumental and orchestral works of Brahms, he was

not able yet to refine his own style. He had made an intellectual attempt in the choice of the string quartet form, most pure of all classical forms and from this purist point of view therefore a step forward from what is still his most readily accessible and certainly his most popular work—*Verklärte Nacht*. Just how caught up he was in the prevailing over-ripe romanticism of the end of the nineteenth century is clearly seen in the very decision to write a work of this kind. In some ways it is an innovation, for although many composers, most notably Richard Strauss, had written large-scale orchestral works tied to a literary theme, and in which attempts were made, often successfully, to mirror exactly in sound specific moments in a literary text, this had rarely previously been attempted in a work of chamber music proportions. (The violin sonatas of Biber are a notable exception.) Schoenberg could scarcely have chosen a more sentimental theme for his work. Romantic love, in symbolic or actual form, offers many pitfalls even to the most experienced writers, and Richard Dehmel, the author of the novel containing the poem 'set' by Schoenberg, lacks Maeterlinck's skill as shown in *Pelléas and Mélisande*. Dehmel's poem records, in a slightly embarrassing way, a moment when, walking with her lover at night through a wood, a woman discloses that she is to bear a child, but the child is not his. After some mental anguish the man replies that the circumstances of the conception do not matter, the child will become theirs through the transforming power of their love for each other. The symbolic and mystical overtones are very strong; there is practically no distancing of the situation so as to form the kind of classic strength that Rilke, say, or even Yeats might have achieved. Nevertheless the poem gripped Schoenberg's imagination at a very deep level, forcing out of him, as Maeterlinck's play forced out of Debussy, a work of great beauty and power. The sheer weight of emotional emphasis, coupled with the proliferation of the thematic development, break the form of the sextet down, and on the whole the version for string orchestra made by the composer some seventeen years later more properly bodies forth his intention. What is immediately apparent, though, is what was even more obvious in the *Gurrelieder* begun the following year, that in Schoenberg the fruit of romanticism was, if not already over-ripe, certainly as mature as it could be. No emotional impact is avoided; not even Mahler could surpass the extreme subjective anguish of the sextet and all the first part of his enormous cantata. If the First Quartet was all the classical examples rolled together, then the *Gurrelieder* was the apotheosis of *Tristan and Isolde*. And how desperately earnest it all was! Magnificent yes, often thrilling, but at the same time overbearing in its hothouse atmosphere. It is amazing, in these great structures, to find so little sense of strain. This was to be much more noticeable in the rather ill-conceived tone poem based on Maeterlinck's *Pelléas*, which seems to be essentially too dense and earnest for its subject. But how

revealing it is that fifty years later he found it necessary to point out that the use of the trombone glissandi was the first time such a demand had been made of the instrument! Certainly, like many of the Viennese school, he was not one to hide his light under a bushel. The effect however is of small significance and has none of the importance of certain effects of sound, such as those employed in the last section of the First Quartet or the final stages of the *Gurrelieder*. The morbid introspection which is a particular characteristic of this enormous and on the whole unsympathetic work links it to those morbidly hypnotic and haunted paintings which he was to execute soon after. Perhaps the writing of it was especially useful in bringing about the first sign of his revolt against such decadent romantic preoccupations. Music, is, after all, music; it is not painting, neither is it literature. Nor is it, despite Xenakis and certain other notorious composers of recent years, a branch of mathematics. Did Schoenberg, avoiding the first of these traps, possibly come close to falling into the other? From an excessive sensuality did he become too exlusively clinical? If the early work is too much of the body, is the later work too much of the mind? In common with so many artists of the last part of the nineteenth century he found it necessary, in his own words 'to express every character and mood in a broad manner'.[1] He was aware of what this entailed from the purely technical point of view: 'every idea had to be developed and elaborated by derivatives and repetitions which were mostly bare of variation—in order not to hide the connection.'[2]

What is puzzling about his early compositions is why they were thought so difficult. It is perhaps one more example of the arbitrariness of the response, even of a cultivated public, to new works of art. The bewilderment that greeted the first performances of Schoenberg's First Quartet and *Verklärte Nacht* seems all the more astonishing when we consider the acclaim accorded to the string quartets of Debussy and Ravel. The structure and the sound effects of the Schoenberg pieces are firmly, almost too firmly, grounded in the high German musical tradition, whereas the freedom of structure and strangeness of sound especially in the Ravel quartet were in many ways startlingly new. But it was, as a whole, 'delightfully' new, not 'shockingly' new.

The last work of the first period is the classically beautiful Chamber Symphony, op. 9, no. 1. It is, in Schoenberg's work, innovatory in two respects. It replaces the monster orchestra of his own *Pelléas and Mélisande* and the *Gurrelieder* with a company of fifteen solo instruments. The grandiose is replaced by the modest, the elaborate by the concise. We see here in his music the first work to rebel against nineteenth-century musical custom. Difficulties set in at once, almost entirely caused by the compressed nature of the work; the poor listener has no time to sit back and rest. It is essential for him to be alert at every moment for the forward movement is swift and almost implacable. Certainly there is

recapitulation, certainly towards the end there is considerable romantic sweetness, but there is rarely a second chance to catch or reflect on what has gone before. Here the act of listening begins to approach the act of composition. Looked at from this point in time it seems comparatively innocuous, but it is the first sign of the discontent with traditional methods that was soon to precipitate the rethinking of the function of music and the first startling fruits of which, in all their severe desolation and bleakness, are the Three Pieces for piano, op. 11. Although for Schoenberg, as for Pound the operation was of a reclamatory nature, this original thinking has had far-reaching, perhaps in some ways disastrous results.

We are at the beginning of the calculated overthrow of the past, or rather of that past which had been the Western tradition since 1700. A statement made in defence of his Bach orchestrations shows clearly what Schoenberg's intentions were in his musical pilgrimage:

> Our modern conception of music demanded clarification of the *motivic* procedures in both horizontal and vertical dimensions. That is we do not find it sufficient to rely on the immanent effect of a contrapuntal structure that is taken for granted, but we want to be aware of this counterpoint in the form of motivic relationship.[3]

A cry for truth? Laudable. But as Eliot was to observe in *Murder in the Cathedral*: 'Human kind cannot bear very much reality.'

'Clarification', 'motivic relationship'. These are significant keys not only to the music of Schoenberg but to a movement in art that was soon to play havoc with received ideas. For Paul Klee, whose student work had been of great strength in the orthodox manner, who could have blossomed into a naturalistic painter of great range and power, the problem was the same. 'For me it is very necessary to begin with minutiae, but it is also a handicap. I want to be as though newborn, knowing absolutely nothing about Europe; ignoring facts and fashions, to be almost primitive. Then I want to do something very modest, to work out by myself a tiny, formal motif . . .'[4] What has happened to the sureness, the godlike nature of late-nineteenth-century romanticism? Surely the edifice built up with such labour, such love, such skill was not to be knocked down? Soon quite ordinary people would start to question the very structure of society, the accepted forms of behaviour, even God himself! The process of fragmentation had begun. Had not Darwin already sent a shudder through settled societies, forcing them to look into themselves to see what they were? Had not Freud thrown overboard accepted reasons, vague, embracing and usually false, for man's behaviour, and started to build from a thick fog of precariously based

religio-moral conceptions, small evidences drawn from particular experiences and explorations? Had not Einstein questioned the very nature of the universe? In terms of the art of music, Schoenberg's Three Pieces for piano, op.11, do just that. Could things ever be the same again?

The immediate impact of these piano works was, of course, small in so far as the general public were concerned. They were not of a scale or of a kind to cause the public outcry that was shortly to greet the first performance of Stravinsky's *Rite of Spring*. In some ways they were less startling than Bartók's *Allegro barbaro*. Their significance lies in their effect not so much upon the public of the time as on the composer himself. With them he proclaimed the right to step out of his orthodox environment and create an environment of his own. It was a claim that had been made slightly earlier in painting, especially by Klee and by Picasso. It was a step of profound consequence. It was a step that requires us to look at the accepted idea of environment as it relates to the creative artist, for the change is more subtle than merely a change *within* the environment; it is a change of the very nature of that environment. The piano pieces, more even than the enormously complex Five Pieces for Orchestra do not exist within the environment of the time; they proclaim the discovery by a major artist that art can have, perhaps must have, the environment of the imagination of the artist and need have no other. This is a radical development. It is a development that challenges not merely existing values but the whole concept of the reality of values. We can no longer say how does this compare; because there is nothing of a kind against which a comparison can be made. Excellent as such radical rethinking might be, it is not without its accompanying dangers, as Paul Valéry was acutely aware: 'A consequence of the modern preoccupation with genius was that everyone felt obliged to invent his own technique.'[5]

That these works were forced from Schoenberg because of the expanding and proliferating nature of romantic music cannot be denied. Donald Mitchell[6] makes a great deal of the idea that the very freedom of the artist in the nineteenth century produced the new disciplines of Schoenberg. But he fails to consider that in order to counter looseness or freedom, or indeed excess, it is not essential to produce new kinds of rigidity. It is sometimes possible to restore original or traditional disciplines. Composers of the nature of Janáček, or even Béla Bartók, were more inclined to do this than was Schoenberg; Thomas Mann and Lawrence more drawn to that method than was James Joyce; Bonnard and Hardy, than Picasso or Pound. With other apologists of the Schoenberg method Mitchell fails to see that the twelve note method[7] was not, to use his own words 'a recall to established order', but was in fact a call to a new, unexperienced order. He points out that we dislike what we fear but he does not expand this into the more apposite truth that we fear what we do not understand. This fear

can sometimes become sublimated into a form of worship. If God is inscrutable what can we have but faith?

More important is the fact that, in the case of Schoenberg, it was not so much that he had to bring order into a musical style that was in general becoming more and more excessive; he had to bring a new order into his own work, which was in danger of being more excessive than that of any other composer. It was not that he needed to recall to reason the extravagances of Reger, Mahler, Richard Strauss, but his own. Was he not even then emerging from the most luxurious indulgence of them all, the *Gurrelieder*, compared with which even Mahler's 'Symphony of a Thousand' appears comparatively ordinary? Coming immediately after the Five Pieces for Orchestra and the *Gurrelieder*, the most noticeable difference of these piano pieces lies in their conceptual nature. They are gnomic but they are not miniatures—however small they may seem compared with the big orchestral works (in terms of length the second piece lasts eleven minutes)—any more than are those small heroic nudes of Picasso which at times seem to be among his most monumental works. They reject absolutely all previous notions of what music for the piano should be like as, in turn, do the piano works of Pierre Boulez. The tradition of romantic composition for the keyboard raised to such expressive heights by Chopin, brilliantly extended by Liszt and to be brought to a dazzling conclusion by Debussy, is attacked in an almost callously brutal way by Schoenberg. It is a splendidly rewarding and illuminating experience to play these works between, say, the *Iberia* suite of Albéniz (completed in 1908) Ravel's *Gaspard de la nuit* (also 1908) and the two books of *Preludes* by Debussy. Only once toward the close of the second piece does Schoenberg pay any homage to the post-Lisztian transcendental school, and when he does it seems a curiously unconvincing passage. What is noticeable is the feeling that the instrument is a means to an end—that he has no concern for it as such. It is used because it is there; as later his contempt for the purely human elements in writing for the voice becomes more and more noticeable. What is significant is the extension of his movement first toward a pure, liberated 'atonality' which in turn was to develop into the twelve note method. This had been foreshadowed, perhaps in a more disturbing way, but not in such a purposeful and extended manner, in the last movement of the Second String Quartet. The fruits, so far as piano music is concerned, can be seen in the Webernesque Six Little Piano Pieces, op.19. It is as if by 1908 Schoenberg could no longer endure the slow, often beautiful death of the romantic notion of art, but had to help to kill it. That the tradition was at its last gasp he believed with an intensity, sometimes an arrogance, that is almost totally forbidding. Of course he always considered himself a 'romantic' composer but his was to be the live romanticism of the future, not the dying romanticism of the past.

In 1910, writing to the President of the Academy of Music and the Fine Arts in Vienna offering himself as a lecturer in composition, he states with a breath-taking audacity:

> I influence only those who are inclined that way from the start, whereas those who are constitutionally immune to my art (—untalented) remain so and develop the way they would have developed in any case. Only, they will know a bit more. Secondly it will not be possible to prevent the young and gifted from emulating my style. *For in ten years every talented composer* will be writing this way, regardless of whether he has learned it directly from me or only from my works.[8]

This is surely a bit steep. To say that if a composer fails to emulate oneself he has no talent is to act God with a vengeance. On the other hand it has to be acknow-ledged that his influence has been progressively pervasive and his statement was in that respect undoubtedly prophetic. He was of course fortunate in having in his circle two men of staggering talent who did absorb his teaching and write in his manner—Alban Berg and Anton von Webern. It is important also to remember that while Vienna was often pretty cavalier in its treatment of him—indeed of all three men—he was nevertheless fortunate in being a Viennese composer, for undoubtedly the world finds it difficult to ignore what goes on in that city, saturated as it is with such a sumptuous past of music and music-making.

Historically speaking there are few cases of an artist's announcing a change within his particular art form as far-reaching as that made by Schoenberg. Gluck's reform of opera does not in any way encroach upon the nature of com-position or of the traditional structure of dramatic literature. The nearest thing is Bach's reforming of the tuning of the clavier to permit of the modulation through all the possible keys without offence to the ear of the listener, but even this was born of practical considerations rather than a development in aesthetics. The consequences were enormous because without the 'well-tempered clavier' the music of the romantic period and subsequently the music against which Schoenberg was to make his stand would scarcely have been possible. Bach's innovation and Schoenberg's later theories stand closely linked therefore. Bach was freeing the composer from the artificial restriction of his inspiration by the impossibility of continual modulation; Schoenberg is formulating a system which prevents the abuse of the possibility of unceasing modulation.

But at what a cost is Schoenberg's reform bought! Added to the growing complexity in the actual performance of music is an intellectual difficulty as great as any in the field of science or mathematics. In the realm of piano music the difficulty of playing Brahms or Liszt is more a question of manipulation than

anything else as it is also in the work of later composers like Busoni and Ravel. The problems are mechanical—will the fingers perform the necessary technical feats? But in the orchestral works of Schoenberg, Berg and Webern the demands on the players are of especial difficulty not because of the mechanical brilliance of the works but because of the extreme problems of aesthetics. The question is not so much 'how do I play what I understand?' as 'how can I understand what I am asked to play?' One can sympathize with the musicians rehearsing for the first performance of Schoenberg's Five Pieces for Orchestra, to whom Henry Wood is reported to have said (and how rightly), 'stick it, gentlemen, this is nothing to what you will be playing in fifty years' time.'

Not only does Schoenberg modify the method of composition in 1908, he also introduces a variation of the use of the voice in vocal works which has been of equally far-reaching consequence. In the last section of the *Gurrelieder*, begun in 1901, the use of speech-song, a method of declamation in which the performer speaks at a fluctuating but given pitch, and must abide by the composer's notation, is used to remarkably atmospheric effect. The extension of this technique in *Pierrot lunaire* is more audacious but not always without an aspect of the ludicrous. The hallucinatory poems by Albert Giraud are made even more rarefied and arty by the combination of a vocal line 'spoken' precariously by a high female voice above an instrumental ensemble which seems to eschew, for the most part, any orthodox or traditional melodic or harmonic structure. The result is bizarre rather than satisfying or profound and too often the 'new' method of composition does fall into the error of mistaking originality, cleverness, for profundity. If the flaw in Mahler's character is that he seems humourless, how much more is this true of Schoenberg. And this is not to imply that humour is a necessary ingredient in music. One cannot help smiling at Paul Klee's comment after hearing this *Pierrot lunaire* 'Burst, you stuffed shirt: your knell is ringing.'[9]

Perhaps Schoenberg's personal struggles allowed little time or inclination for the relief of laughter, for while many people have reflected with astonishment and distress on the way in which he was treated during those years in Vienna, so that his day to day existence was often precarious, the real terror was the war that was surely going on in his artistic being. He was, after all, producing within the space of five years scores which on the one hand are as romantically charged and psychologically disturbed as anything in the history of music and on the other not only formulating his aesthetic—to be published as the *Theory of Harmony*— but writing the first of those severely pure works which point the way to his subsequent development. His expressed desire was to write for small combinations of instruments, as in the Chamber Symphony, no. 1, but between 1908 and 1912 he was to write works as enormous as the Five Pieces for Orchestra and the monodrama *Erwartung* and pieces as refined and 'classical' as the Second String

Quartet, the Three Pieces for piano, op.11 and the Six Little Piano Pieces, op.19, to say nothing of that strangely hypnotic, almost unsingable setting of Maeterlinck's *Herzgewächse* and the bizarre *Pierrot lunaire*. It seems at times as if in the final years of romanticism Prospero had played his final and most horrible trick, merging the quicksilver spirit of Ariel with the body of Caliban and then offered the resulting monster an invitation to the dance.

I shall not go so far as to say, with Joseph de Maistre, that whatever restricts a man strengthens him. Perhaps de Maistre forgot that shoes can be too tight. But speaking of the arts, he would no doubt reply that tight shoes would make us invent new dances.'[10] After 1914 the new dances were indeed strange, not only those to the music of Schoenberg but to that of Berg and Webern as well, though nothing in the intellectual development of Berg could extinguish the essential nature of his romantic and lyrical soul. Without Schoenberg's lofty intelligence and almost godlike prescience, Berg was nevertheless able to absorb a great deal of the teaching of his master, though the Viennese tradition was never abandoned, merely overlaid. Like Schoenberg he was very much a child of his time. How luxuriously melodic are those beautiful *Seven Early Songs* written between 1905 and 1908. It is not merely youth that makes them so appealing, it is that without being grossly imitative they inhabit the world of accepted nineteenth-century German *Lieder* as expressed in vocal music from Schumann to Wolf. They have a home. Perhaps Berg was fortunate, from the purely lyrical point of view, in never straying entirely away from the modifying sensibility of Debussy, in contrast to Schoenberg whose idiom, after the Debussy-influenced Five Pieces for Orchestra becomes almost aggressively alien to that of the French composer. It is sensible too, to recall that Berg's early inspiration was allied very strongly to the human voice, so that he was compelled to consider whether a vocal line could physically be achieved. There is nothing in early Berg as outrageously difficult as the soprano part of , say, *Herzgewächse*. He was, in a way that Schoenberg was not, a natural songwriter.

> What I have achieved with these two [pupils] in particular could so easily be convincing. One [Alban Berg] is an extraordinarily gifted composer. But the state he was in when he came to see me was such that his imagination could not work on anything but *Lieder*. Even the piano accompaniments to them were song-like in style. He was absolutely incapable of writing an instrumental movement or inventing an instrumental theme. You can hardly imagine the lengths I went to in order to remove this defect in his talent.[11]

Fortunately Schoenberg did not, in expanding Berg's talents, destroy this inborn

lyric gift which far more than anything else makes him such a rewarding composer. Berg adds nothing to the forward development of music that Schoenberg has not already outlined, if not actually brought about. He accepts the Schoenberg doctrine and is quite happy to work within it, often carrying the formal preoccupations to extravagant lengths. It is as if he sensed that he was really a true heir of the nineteenth-century romantic composers and had to cover this up by a series of elaborate subterfuges.

What Berg does see very clearly is that there is about to be an enormous breakdown of the moral attitudes and preoccupations of artists. He sees that the old order of society is changing and that there is a growing modification of man's acceptance of certain dogmas. He welcomes this change especially as it affects drama and literature and finds a surprising spiritual ally in the painter Paul Klee, who in a diary entry of 1898 writes succinctly: 'Force demands forceful expression. Obscenity as expression of fullness and fertility.' Both sensed the growth of a movement toward 'obscenity', towards the permissiveness of the present time.

> And now for Literature: Wedekind—the really new direction—the emphasis on the sensual in modern works!! This trait is at work in all new art. And I believe it is a good thing. At last we have come to the realization that sensuality is not a weakness, does not mean a surrender to one's own will. Rather is it an immense strength that lies within us—the pivot of all being and thinking. (Yes all thinking!) In this I am declaring firmly and certainly the great importance of sensuality for everything spiritual. Only through the understanding of sensuality, only through a fundamental insight into the depths of mankind (shouldn't it rather be called the 'heights of mankind'?) can one arrive at a real idea of the human psyche.[12]

It is possible that, without the strict discipline imposed by Schoenberg, Berg would have become so obsessed with the idea of the liberating power of the sensual that he would have developed into a sort of twentieth-century César Franck. As it was he tempered his sensuous lyricism with severe classical restraint, thereby gaining a gravity that might well have been dissipated by luxury. Or did it perhaps hold him back from a rich flowering which always seems to be hinted at but which never quite comes about? How strange it is that this composer who never quite fulfils our expectations should have been so drawn to works which in themselves are unresolved.

When Debussy set Maeterlinck's *Pelléas and Mélisande* he turned a beautiful and moving play into an operatic masterpiece. Few people would go so far as to say that Büchner's *Wozzeck* is an entirely successful play; yet out of that incomplete and very disorganized fragment Berg makes what must be considered

one of the greatest musical stage works of the twentieth century. The very elements in it which make it not quite acceptable to good orthodox Schoenbergians, elements of sentiment, and nineteenth-century melodic traits, are the very ones which have helped to keep it so firmly on the world's operatic stages. Compared with the more exalted *Moses and Aaron* of Schoenberg it is almost naïvely old fashioned, but the significant difference is that it makes us concerned for the persons in the drama. We respond to Berg's humanity in a way that we find it difficult to respond to Schoenberg. For Schoenberg has the defect of all self-appointed gods (however remarkable); he seems to care more for himself than for anything else. A figure of less radical significance, such as Berg, escapes this sin of pride. Both Paul Valéry and Thomas Mann saw how the pursuit of an aesthetic could result in a certain brutalizing element both in an artist's thinking and in the society conditioned by such thinking. Schoenberg's greater aesthetic purity is for this reason perhaps more dangerous than Berg's more adolescent excesses. One ought perhaps to ask oneself constantly whether the orgy scene in Schoenberg's unfinished opera is the responsibility of Moses or of Aaron. Schoenberg's aesthetic points, or might be thought to point, toward an ominous future indeed, whereas Berg's examples perhaps extend no further than the excesses of the present. What these contemporary concerns are can be seen in the moral indignation and hopelessness of *Wozzeck* and the moral licence and permissiveness in the unfinished opera *Lulu*. The power of Wedekind's experiments in the theatre and the perceptive honesty of Berg's early remarks about them can be seen vividly in this obsessive dovetailing and setting of *Pandora's Box* and *Earth Spirit*.

But Berg's significance is a dual one, for not only did he produce works of individual beauty and importance, he was also a major figure in the dissemination of Schoenberg's musical theories. Together Berg and Webern by embracing the teaching of Schoenberg in a quite fantastically wholesale way and by their perpetual advocacy of his theories, helped them to assume a dominance and importance far greater, in musical circles, than those deriving from the music of Debussy, or Bartók, or Stravinsky.

But despite the severity of his thought and the power of his mature compositions, Schoenberg (and Berg with him) extend the boundaries of the world we know. They do not penetrate to a world hitherto beyond our knowledge, a world that seems to have an existence parallel to, but not partaking of our waking human existence. This is the world of Anton von Webern and the painter Paul Klee.

'My faces are truer than real ones.'[13] Already at the age of twenty when he wrote these words Klee was discovering within himself a tendency, perhaps

somewhat strange for a painter, to disregard the surface of things; not so much a desire to penetrate the essence as a passion to realize and release the spirituality of the object painted. No great painter has been content merely to record the visible aspect of the subject of the work being painted, but before Klee it is difficult to recall one who has tried with such concentration to expose what might be thought of as the spiritual world lying within and beyond the world of orthodox appearances. Although his work is narrower in range, his skill less staggering than that of Picasso or Matisse, this gentle, retiring and fastidious Swiss painter causes us to rethink the nature of painting in a way that is more terrifying than that of those more powerful figures. Both Picasso and Matisse take the world of painting as they find it and either build from that position or break it down and rebuild from the scattered pieces. Klee dismisses it and attempts to create a world of art in which no historic landmarks survive at all. He does this quite consciously, though his decision may have been an intellectualizing of an emotional state.

The first great etchings from 1903–5 are hieratic: sardonic figures leer out at us from a hermetic legendary world, irreverent and unnerving. Elements of the Art Nouveau style are contorted into images that seem to come from a mythical cosmos untinged by any morality. The technical skill is as disquieting as the structures it bodies forth.

He began to paint on glass, twenty-six pictures in all. It was as if, aware of the barrier of air dividing him from a direct knowledge of a world beyond but concerned with our own, he needed to work his way through the glass window. First he had to make the barrier tangible. He had to paint on the very air itself; by making the invisible barrier visible he might be able to capture the shapes of the beings which inhabited that world. The intensity of his gaze, that we can see in all the photographs of him, was always directed toward the interior nature of the object he wished to paint, or through the surface of the everyday reality that surrounded him into a supra-reality that revealed itself as a world of disturbing gaity. As he moved further and further away from normal representation, the curve of his development took him well outside the orthodox province of those contemporary artists who were starting to build up their own world of pure abstraction. He became perhaps the most isolated painter of the twentieth century, taking no part in the expanding world of the successful modern masters, difficult for the public to accept since they could see only the 'childishness' of his paintings, and awkward for the critical art world who for a long time could find small place for so individual a miniaturist. Like Webern he was thrown more and more on the resources of his own special vision, though Webern at least had Berg and Schoenberg as powerful figures in the background. Though Klee's work is often grotesque it is never disquieting in the way that, say, the visionary

paintings of Schoenberg are, though both artists give some evidence of passing through deeply psychotic states. The combination of childlikeness and mystical experience in Klee's work is well realized in Sidney Keyes's poem with its appropriate opening:

> The short-faced goblins with their heavy feet
> Trampled your dreams, their spatulate
> Fingers have torn the tracery of your wisdom:
> But childlike you would not cry out, transforming
> Your enemies to little angry phantoms
> In clarity of vision exorcised.

And with its curiously shocking but penetrating conclusion:

> And so they stirred the shallows till the sky
> Flew blue in shards and thought sank even deeper,
> Where crouched your passion's residue confined:
> The evil centre of a child's clear mind.[14]

Klee was a constantly anxious man, surrounding himself with beautiful and strange objects of the natural world, regarding them with minute attention, talking with them we may suppose, always trying to discover the stone-life, the seed-life, the shell-life, the flower-life of whatever it might be before him. Later when he taught at the Bauhaus he was somewhat notorious for the vigour with which he pursued the idea of absolute fidelity to representation when dealing with his pupils. Not before they had mastered the smallest nuances both in understanding of the object to be drawn and the technical requirements for such drawing would he allow any hint of the kind of 'distortion' which characterized his own work. For he never moved away from the fundamental ground of his inspiration: 'The world was my subject, even though it was not the visible world.'[15] And although he is a most painterly painter he usually interpreted the invisible world in a very dramatic way. Even in his most 'contentless' pictures there is an element of drama; he creates the environment through which he is to move. In an early diary entry he mentions sketching out a dramatic work which was a miniature scheme for the fall of man and his redemption. The scenes were called: '1. The Dancing Eve, 2. The Suffering of Men, 3. The Evil One and Men, 4. The Use of Violence, 5. The Liberating Hero, 6. The Poet, 7. Execution and Resurrection'.[16] He enacted this drama in his own paintings and to some extent in his pedagogical writings and his poems. It was an exercise of great privacy, of intense self-communing—so private in fact that it helped to bring about a shift in our whole relationship to art, as does the achievement of Webern in the field of music. We can no longer be content to relate the works of

the artist to the condition of his time or to the work of other artists. The paintings of almost any artist up to the time of Klee are to a large extent capable of being evaluated in relation to other painters of the same epoch. But from the time when Klee freed himself from the classical manner of the early etchings and the Art Nouveau influences in certain of his drawings and watercolours, it is necessary for us to relate the work only to the total world of Klee's art. It is possible looking at a painting by, say, David, or Goya or Rembrandt or Monet, to compare and discuss their merits. But to look at a painting like Klee's *One Who Understands* and expect to make any useful comparison between that and a work by Rouault, Bonnard, Picasso or Matisse is impossible, the gulf is too wide, the environment too remote and unlike. Klee requires us first to enter his own world. If we are not prepared to do this then we can neither understand nor treasure his achievement. And we cannot do this by reading his fascinating but dangerously wayward pedagogical works. They are useless if we expect them to provide us with much of a clue to the paintings themselves. More likely than not they will merely allow us to draw completely false ideas about the nature of painting in general. It is fairly safe to say that the more people take notice of what Klee has to say about art and the more they attempt to model their style on his example the worse they become. He is too idiosyncratic to allow of useful imitation. He is a genius of the kind of William Blake, who also built up a world for us to enter to our terror and joy.

Will Grohmann in his exhaustive study of Klee reproduces three very interesting and possibly significant drawings made by Klee in 1884 and 1885 when the artist was six or seven years old. They do not differ so very greatly from ordinary children's paintings, except that they seem somehow more refined, more self-contained, more conscious, and *Picture with a Hare* uses certain shapes that are to recur throughout Klee's life in his drawing of animals. What is fascinating is that in later years, when he had already painted such fine 'academic' works as *The Artist's Sister*, he should have chosen to return to his childish and perhaps intuitive scribbles rather than to build on the assurance of the mature 'art-school' portrait. It is perhaps all the more surprising in view of the fact that the portrait coincides more or less with a period of travel in which he became acquainted with many of the world's great masterpieces as well as works by 'minor' figures who gave him intense pleasure. Paintings by Corot which he saw in Geneva appealed to him enormously. He commented on their beauty. He saw with growing clarity that it was a beauty which he must scrupulously avoid imitating, for it was a part of that great treasure-house of European art which needed to be rejected if a world of different beauty was to come to birth. His rejection was not like that of Picasso. There is in Klee no equivalent to the

hideously mocking *Les Demoiselles d'Avignon* in which man's attitude to art and women as things of sublime beauty is disgustingly affronted. Klee does not make an intellectual and moral stand from the point of view of a sophisticated adult. He does not want his own work to be compared with that of others. He merely retreats from the field and begins slowly and painstakingly to build up a system of painting from what are almost personal first principles. It is because of this that he calls into question, in a fashion more dramatically than any other painter, the idea of judgement within accepted scales of values. The environment of Klee's paintings is the world of Klee's mind—nothing else.

The dual aspect of the work of his formative period—that of graphic artist and that of painter—is significant, for he was especially attracted to the Impressionists, who by virtue of their extreme emphasis on colour are the least easily reproduceable in any black and white medium, whereas his most rigorous graphic training was as an etcher, a method concerned very positively with line and linear structure; painting, although it is so rigid an art form, seems in the works of the Impressionists to be free, fluid and evanescent. Similarly in his musical tastes (for he was a fine amateur violinist) Klee was constantly proclaiming the greatness and purity of Mozart while finding the score of *Pelléas et Mélisande* of supreme beauty. The refinement of line; the enchantment of colour. Both of these had been the core of the inspiration of countless artists before him. But Klee wanted to use line and colour to produce works that would have no reference to any kind of classical or romantic past. He constantly returns to this obsessive concern with being modern. 'I have now reached the point where I can look over the great art of antiquity and its Renaissance. But for myself, I cannot find any artistic connection with our own times. And to want to create something outside of one's own age strikes me as suspect.'[17]

Something else was also becoming increasingly suspect — mere technical efficiency. Of course for someone as technically accomplished as Klee it was perhaps too easy to dismiss this side of art, though he did not in any way dismiss the necessity for the artist to master his craft. He criticized those artists who put it to use in an uncreative way. He wrote of the Impressionists: 'The fragmentariness which is typical of so many Impressionist works is a consequence of their fidelity to inspiration. Where it ends, the work must stop too. And so the Impressionist actually has become more human than the sheer materialist. The notion of sober, practical craft ceases to be valid at any cost.'[18] One begins to wonder how it was possible for Klee to record thoughts which so often seem to run counter to the practice of his painting and drawing. Klee's work is rarely fragmentary. It perhaps avoids being so by virtue of its scale. In order to be an artist showing no trace of the glory of post-Renaissance art it was necessary to avoid engaging in the proudly heroic and often large-scale subjects which are a

part of that tradition. Instead of the enormous paraphernalia of a Delacroix he was to use the smallest means: a few scratches on paper; a few pure colours laid side by side in the simplest, least pretentious manner. Was this not what Webern, most austere of the Viennese school of composers, was about to do in his own severe and essentially 'private' musical compositions?

The bringing together of the names of Klee and Webern is far from new, for the affinities are so striking. Wilfrid Mellers makes an interesting comparison in his excellent book on modern music:

> The spontaneous affinity between Webern and the oriental and medieval mind in part explains why, when he began to write serial music, he tended to employ the row in a spirit different from Schoenberg's. For Schoenberg the row was a refuge from chaos; the pressure of harmonic and tonal tension was so extreme that it had to be released into linearity. Webern, though highly wrought in nerves and senses, could live in and on his nerves in relative passivity; the explosive figurations that intermittently erupt in his music do not ultimately affect its radiance, nor even its serenity. This may be precisely what the music is 'about': the music effects the catharsis of hypernervosity, in the same way as does Klee's meticulous, childlike, yet complex quasi-oriental calligraphy. Webern can do this because, although rooted in humanist tradition, he was by nature a mystic: which is what Schoenberg frustratedly sought to be.[19]

Certainly both Klee and Webern leaned heavily on Goethe in his humanitarian aspect and in his penetrating late mysticism. But equally they both saw virtues in the 'emptiness' of certain oriental philosophies. Meller's suggests that Webern's orchestration of Bach's Ricercare is 'a still more hermetic version of the 'abstract' rite of Bach's *Art of Fugue*. It is a religious piece, in that it seeks a haven of quiet within the mind: not a public affirmation of faith, but a private meditation wherein the contrapuntal unity is the oneness of God.'[20] This recalls Klee's 'I seek a place for myself only with God.'

'"Abstract" rite' and 'private meditation' are indeed significant phrases that inalienably link Webern with the Swiss painter. Both artists combine these two somewhat disparate elements; the '"abstract" rite' side of their preoccupations is demonstrated by the extreme precision and classical purity of so much of their work; the 'private meditation' joins them in the refinement of their literary preoccupations, for both are essentially concerned with 'subject' matter. The bulk of Webern's music consists of settings either for chorus or solo voice of texts which are both sensuous and mystical and nearly all Klee's paintings are extremely personal explorations of what might be called the spiritual essences of

natural phenomena. Both employ methods far removed from those of the great nineteenth-century artists, or artists still dominated by the major styles of that fecund century. If Yeats's golden bird could have been created the artist might well have been a supreme Fabergé, and its song would have imitated the melismatic loveliness of Richard Strauss. I think if one could twist the handle of Klee's exquisitely amusing *The Twittering Machine* those curious birds would sing the enchantments of Webern.

Despite their posthumous fame the rarefied delights of both these men will perhaps remain unshared for a good many years by the majority of people; yet both knew only too well what the public found acceptable. Webern's compositions are dominated first by Wagner, then by Brahms, then by Debussy, though he escaped entirely the giganticism of the first. Even the Passacaglia, op.1 of 1908 only lasts for about ten minutes and the Piano Quintet—most purely Brahmsian, though with certain moments reminiscent of early Schoenberg—only twelve minutes. Webern, like Klee had some difficulty in shrugging away the nineteenth century. When he did escape he did so more decisively than Schoenberg, as Klee did more decisively than Picasso. The gain is enormous but the loss is also considerable. The mature style of Webern, like that of Klee, needs to be considered strictly within its own self-imposed sphere of reference. The environment is that of one man in his own spirituality, or musicality. No longer is there the possibility of a reference to general experience. Webern's problems were his own and the answers came dangerously close to being as private as the questions. For all his philosophical awareness, for all his use of quasi-pantheistic texts, he is coming very dangerously close to 'art for art's sake'. The necessity to communicate at a level that was possible for any substantial number of people who were not professional musicians was no longer a consideration. Can minds communicating so exclusively with God also communicate with man? Klee's development as a painter and Webern's as a composer offer this as a serious challenge for us to consider in relation to the development of certain kinds of twentieth-century art.

Webern's predicament is clearly shown not in his fairly rapid rejection of the late-nineteenth-century style as demonstrated by the early Piano Quintet, but in the conflict between the texts and the music in nearly all his vocal compositions. Early Richard Strauss, early Schoenberg, early Delius, early Sibelius, early Stravinsky, and indeed early Webern, lean dramatically toward the Dionysiac aspect of art. Many of these composers move in their later works toward the Apollonian principle, and in purely formal musical language none is more Apollonian than Webern himself, yet as his musical method became more mathematical, more pure, his chosen texts became more emotional, more pantheistic, more sensuous in spite of or perhaps because of their mysticism.

Despite the spareness of the music—in quantity—in Debussy's *Martyrdom of St Sebastian*, there is a correspondence between the language and mood of D'Annunzio's erotic text and the sounds created by Debussy for its accompaniment. This is emphatically not the case in the vocal works of Webern, where certain of the texts might well have been set in a fashion not far removed from Debussy's setting of 'The Blessed Damozel' but are in fact treated in a far less emotional manner. It is as if at one and the same time Webern felt the necessity to communicate with man yet write for God; his texts are nothing if not shared—they are far removed from the abstraction of René Char's *Le Marteau sans Maître* so brilliantly realized in Boulez's setting—and yet the musical structures which body them forth are of an almost unsurpassedly cerebral kind. Despite the fact that in the later works the personal pronoun is less in evidence, there is a constant sense of the necessity of the sharing of experience and there is a recurrent emphasis on certain emotive words that is utterly disparate from the emphases in the orchestral structure. In this respect Webern is totally different from Berg or Schoenberg, for in the early songs of these two composers there is a considerable residue of the effect gained by the style of the great nineteenth-century song-writers, and although in their late works a different musical method is employed, the emotional effect is not altogether dissimilar. There may be a world of difference between the harmonic structure of the *Seven Early Songs* of Berg and the songs of Wolf, but there is no essential difference between the way in which the meaning of the words is conveyed. Similarly the world of Schoenberg's early songs and *Das Buch der hängenden Gärten* or even *Moses and Aaron* is related in the emotional emphasis that is given to what is being sung in relation to its accompanying piano or orchestral structure.

Webern is, of course, one of the very few significant composers to be a musicologist, aware to an extraordinary degree of the progress of musical history and the role played by music in various societies. Perhaps because of this he was able to see for what a short space of time the dominant 'classic/romantic' musical idiom of the Western world had existed. But although he was a musicologist he was not, as Schoenberg was, a pedagogue, and despite the radical modernity of his music it is not conceptualized as is Schoenberg's. For the most part his harmony is not so much strange in what it does as disturbing in what it does not do; and his melodic structure seems more complicated than it is merely because of the disposition of the line between the instruments performing it and not because it so outrageously differs from previous melodic lines.

Neither Klee nor Webern abandons the idea that man and God exist in some kind of juxtaposition, but they express their belief in a manner sufficiently personal to make previous methods *seem* totally different. Much of the fascination and greatness of their work lies in this strangely private manner. In their art they

express not total intellect as does Mondrian, nor the social conscience of Hindemith or Brecht. Mondrian is the arch anti-humanist painter of our time: his first works in the abstract medium are remarkably early in relation to the late fruits they have born; Hindemith's desired humanism is surprisingly late in view of the dominant years of humanism. But Klee and Webern are neither humanist nor anti-humanist; they are, perhaps, caught in a strange limbo somewhere in the middle.

In spite of the effect, over a few years, made by the music of Webern, there is no great evidence to suggest that his music will be permanently influential (which is not to say that it will not be permanently enjoyed) and among the truly remarkable painters of our time there is little likelihood of any significant development stemming from Klee. Their rites are private, mysterious and obscure. If art, as Quintilian observed, originates from experience, the proper enjoyment of art may well depend on the possibility of the experience of the art-lover's being reasonably related to that of the artist. If the works of Klee and Webern arise from experience, their expression transforms that experience beyond the likelihood of a similar transformation in the mind of the non-artist. The more private the symbol employed in any ritual the less possible it is for the majority to understand and benefit by the rite, unless they are to accept the idea of all art as magic and succumb to its un-reason. The more remote any art becomes from the realities that surround us, or from the religio-philosophical order of the dominant tradition, the more necessary it is for observers and participants to have faith in its rightness; reason cannot be enough.

Both Webern and Klee made a valiant but perhaps misguided attempt to solve the problem of newness by offering small and refined answers to the complex and strange questions they asked. At the end of the nineteenth century, when the interested public was conditioned not so much to art as to the demonstrably highly wrought and all-embracing artefact, to be asked, as Klee asked them, to 'go for a walk with a line' was an impossible demand. Klee was expecting the public to enter not merely into the work of art but into the process of its creation. Children, of course, are constantly accepting such demands from parents and teachers. Adults however take unkindly to being treated as children; they also have a difficulty to overcome—they have to unlearn so much before they can start on their new adventure. Webern not only took away the traditional harmonic structure, he appeared to take harmony away altogether; worse, he refined his melodic structure in such a way as to seem to have abandoned melody also. Had he compensated for this by offering an intense rhythmic drive—as for instance does Carl Orff—he might have won more ready support. Yet both, by the dramatic nature of their work, seem to want to communicate. Had Webern without a text asked for the repetition of one note for five minutes

à la Erik Satik, the public might have been less baffled; but the settings of the *Five Sacred Songs*, op. 15, with such words as:

> Get up, dear children,
> the morning star, resplendent as a hero
> hath risen and is shining brightly
> O'er the whole wide world.

present a dichotomy of styles that too often precipitates the question 'why like *that*?' A totally blank canvas can be dismissed, or admired, with little difficulty, but—humour aside—one can understand the remark overheard while looking at *Landscape with Yellow Birds* 'I do wish that bird wasn't upside down. It quite worries me.' Birds after all do not walk about upside down, especially if they also appear to be under water! When no dramatic element is involved, in Webern's purely instrumental works or Klee's non-programmatic paintings, the difficulty inheres as much in the scale of the works as in their nature. Klee's paintings are as prismatically beautiful as a butterfly's wing, but in art we, for so long, have been used so much more; Webern's brief sound patterns are like a short burst of the dawn chorus of birds. Into such alien worlds how far can the non-specialist human being hope to follow?

POUND

Neither was there any doubt that we should have to become very much
more barbaric to be capable of culture again.

Thomas Mann, *Dr Faustus*.

'Hardly a week after Swinburne's death, Pound's second volume of poems,
Personae, appeared, the first of many to be published in England, and this can
now be seen as the beginning of a new period in English and American Litera-
ture.'[1] But it is not to Swinburne but to William Morris because of his medieval-
ism, and to Browning because of his men and women, that early Pound is
closest. Before he decided, as Klee decided, to be 'absolutely modern', he was an
excellent example of the artist in love with the pre Industrial Revolution world.
His first book is an astonishing example of poetic self-indulgence, for it cannot
even be excused on the grounds of youthfulness. He was, after all, twenty-three
years old when *A Lume Spento* came out. It is an obstinately archaic and precious
collection, the falseness of many of the poems themselves made less endurable by
the air of superiority that pervades the book. It is not however an imitative book.
It does not echo the rhythmical facility or the erotic luxury of Swinburne, nor
does it engage in the melancholy of Dowson. The poems in it are far less 'modern'
than the best of Meredith or Morris, and show little of the rough vigour of
Masefield, whose use of the 'low' style in the early years of the century has been
sadly overlooked and undervalued. When Pound decided to change his style, in
some ways to do in English for poetry what Schoenberg did for music, he was
not striking out entirely on his own. It is, perhaps surprisingly, neither Pound
nor T. S. Eliot but the Irish dramatist John Millington Synge, in the preface to
his *Poems* of 1908, who first comments on the necessity for a change of style in
verse.

> In these days poetry is usually a flower of evil or good, but it is the
> timber of poetry that wears most surely, and there is no timber that has
> not strong roots among the clay and worms. Even if we grant that
> exalted poetry can be kept successful by itself, the strong things of life are

needed in poetry also, to show that what is exalted, or tender, is not made by feeble blood. It may almost be said that before verse can be human again it must learn to be brutal.[2]

Indeed Synge and Yeats like Pound were concerned with a holy past, with the mysterious soul of man, man as a spiritual being, before they came to grips with man as an animal. It was Synge, not Pound, who criticized Yeats for being too much in love with the enchanting otherworld of Celtic mythology. Certainly Pound helped to strengthen Yeats's diction, but he made no conquest of Yeats's inner being.

A Lume Spento and *A Quinzaine for this Yule* are mainly interesting for us now because they are by Ezra Pound. Who could have supposed that such resolutely archaic poems were to be the preliminary skirmish of the man whose critical ideas and subsequent writing were to have such an effect on English and American poetry? A short list of titles of individual poems from these collections is all that is required to indicate the perversely remote inspiration: 'Villonaud for this Yule, 'Na Audiart', 'Aube of the West Dawn', 'Oltre La Torré: Rolando', and a few plucked-out lines will convey the general temper and style:

Toward the Noel that morte saison
(*Christ make the shepherds' homage dear*!)
Then when the grey wolves everychone
Drink of the winds their chill small-beer
And lap o' the snows food's gueredon.[3]

When svelte the dawn reflected in the west,
As did the sky slip off her robes of night.[4]

What is faintly disturbing is not that Pound should have written like this but that he should have approved—for he was never an unconscious writer. One wonders just how remorselessly he might have treated a collection of precisely this kind written by another poet. Of course even in these early collections there are harder, more 'modern' lines, just as in the later poems there are surprising pockets of nineteenth-century rhetorical verse; the change, shown in *Personae*, is startling. But the poems do betray, as do his early letters and critical writings, an unfortunate tendency to assume a dogmatic position as guardian of culture; to say, as Schoenberg indeed said, that art is a serious and important matter and must be protected against the depredations of the second-rate. It is sometimes necessary to reply 'agreed, but are you so certain that your own opinions are unassailable, and that all your own works are first-rate.' The assumption of godhead is a dangerous manoeuvre. It is always wise to remind ourselves of what in the twentieth century which is so rich in pundits we too often forget, that not

all excellent art is the product of artists of high, serious intent. Helen Waddell in the notes to her *Mediaeval Latin Lyrics*, quotes Tacitus' remark that Petronius Arbiter 'loitered into fame'.

If the more traditional followers of Tennyson were merely being 'old fashioned', Pound was being deliberately archaic. But interesting as his attitude toward history was, the overall effect of most of these early poems is not of a remote past being brought vividly alive in the present but of the present making the ancient world seem as if it was *always* 'archaic'. And when his attention wavered the poems became as vaguely sentimental as those produced by that body of minor poetizing Englishmen on whom he was always so ready to pour his scorn. Like many pedagogues he could not see that his own creative ability often fell far short, not merely of achieving the standard he demanded from others, but also of producing the desired *kind* of work. For all his critical rigour his life's work shows a curious inability to decide in what way it is possible to be 'truly modern'. Often he mistakes the passing slang of the time for the true language of the twentieth century and equally, by scrupulous attention to the originals, succeeds in ossifying the poetry of the past. One suspects too much examination altogether. The omnivorous reading, the magpie-like collecting of every kind of evidence, the continual polemics, the political/economic side of his nature eat into those areas of silence which are perhaps necessary if, among the babble of voices, the small voice of—what? inspiration?—may be heard. He was always, possibly, too concerned to write a major work. Already, while these early poems were forming, he was preparing for *The Cantos*. But before glancing at Pound's astonishing, magnificent, exasperating, impossible, boring, sometimes beautiful and certainly intriguing work, it is necessary to look at the volume that most clearly shows the deliberate break with the past. For it was Pound, in the English language, who rebelled most strongly against the prevailing style, opposing to the soft aura of Symbolism with its insistence on essences beyond observable reality, the hard-edged realism of recognizable surfaces, in the form of imagism, though he was not properly speaking an 'Imagist'.

After *A Lume Spento* and *A Quinzaine for this Yule* Pound's use of language became harder, his ideas more incisive. It is as if he had progressed from reverie to direct inspection—and this is certainly in keeping with his aim of treating the material of the contemporary world with respect for its private actuality; not to overlay it with what might well be outworn subjective significance. His eyes were wide open; perhaps too wide open: 'Whereas James Joyce drew much of his material from reverie at night, or Proust used the early morning imagination to recover the past, Pound seems concerned with full daylight, like a man talking to himself at mid-day.'[5]

This revolt against blurred outlines required not merely a new way of looking at things but a new way of using language. What Schoenberg saw as a necessity was to break away from the ever-increasing harmonic permissiveness and abuse of modulation in the work of the late-nineteenth-century composers; what Pound saw as a necessity was the breaking of the luxurious stranglehold of the English pentameter—the all-embracing, all-smothering nature of blank verse. He perceived in writers as varied as Tennyson, Swinburne, Arthur Symons, even Browning, that the blank verse style too often bred a facility of manner which in turn induced an indolence of thought. It was necessary to reform the rhythmical and harmonic structure of English poetry if the poet was to begin to tackle the harshnesses or ironies or abuses and confusions of the modern world. Despite a very positive youthful arrogance he was not, of course, pitting himself against the major figures. He is at pains to write, in a very different context: 'Only the mediocrity of a given time can drive the more intelligent men of that time to "break with tradition".'[6]

The change is not made as dramatically as we now like to think. There is still a tone of high 'romance' about many of the poems up to 1912. The voice is not yet entirely Pound's, though perhaps Pound really has no 'personal voice'. The most famous, most rightly praised poem in *Personae* is 'Sestina: Altaforte', but for all its audacity it is clearly bred directly from the dramatic monologues of Browning. Nevertheless the power is undeniable:

> Damn it all! all this our South stinks peace,
> You whoreson dog, Papiols, come! Let's to music!
> I have no life save when the swords clash.
> But ah! when I see the standards gold, vair,
> > purple, opposing
> And the broad fields beneath them turn crimson,
> Then howls my heart nigh mad with rejoicing.[7]

At least this breaks away from the enervating mood of nostalgic melancholy so prevalent in the poetry of many English poets writing at the turn of the century, though the language is scarcely the dry, hard language of the common man. Of course the setting and the burden of the poem are 'romantic', but even allowing for this the manner is a great deal more artificial and, 'poetic', than that of, say, Wordsworth, or even the best poems of Matthew Arnold. And this style persists throughout most of the poems:
'Speech for Psyche in the Golden Book of Apuleius'

> All night, and as the wind lieth among
> The cypress trees, he lay,

Nor held me to save as air that brusheth by one
Close, and as the petals of flowers in falling
Waver and seem not drawn to earth, so he
Seemed over me to hover light as leaves
And closer me than air,
And music flowing through me seemed to open
Mine eyes upon new colours.
O winds, what wind can match the weight of him![8]

Synge might well have complained that the language here is still too beautiful, but although it is as yet only tentative, the modification of the blank verse line is already indicated. Some of Pound's most excellent stylistic virtues are hinted at, notably the tender falling cadence, not merely of individual lines but of the poem as a whole. There is less 'perfume' despite the conceits, than in the work of Arthur Symons, a poet much admired by Pound and who excellently demonstrates the condition of English Symbolist poetry of the preceding years. Nothing more clearly shows the elegance with which this lyrical style of Pound can be deployed than the love sonnet entitled 'A Virginal' from the collection *Ripostes* of 1912. That book contains the jaw-breaking translation from the Anglo-Saxon 'The Seafarer' and the exquisitely modulated fragment 'The Return', but both of those point, however differently, toward what is to come. 'A Virginal' is a complete statement arising out of the full command of an already mastered method:

No, no! Go from me, I have left her lately.
I will not spoil my sheath with lesser brightness,
For my surrounding air hath a new lightness;
Slight are her arms, yet they have bound me straitly
And left me cloaked as with a gauze of æther;
As sweet leaves; as with subtle clearness.
Oh I have picked up magic in her nearness
To sheathe me half in half the things that sheathe her.
No, no! Go from me. I have still the flavour,
Soft as spring wind that's come from birchen bowers,
Green come the shoots, aye April in the branches,
As winter's wound with her sleight hand she staunches,
Hath of the trees a likeness of the savour:
As white their bark, so white this lady's hours.[9]

This is almost pure Tudor, and none the worse for that. There is more than one echo of Wyatt, 'And she me caught in her arms long and small', for instance, and

other poets of the sixteenth century. Cadence is perfectly modulated; despite
subtle ambiguities of rhythm the line still flows. 'The Return' breaks the
pattern, especially in the extreme lightness of its conclusion:

> Haie! Haie!
> These were the swift to harry;
> These the keen-scented;
> These were the souls of blood.
> Slow on the leash,
> pallid the leash-men![10]

This is undoubtedly a purposeful move toward the finding of a contemporary
style, for Pound, more than Eliot or Yeats, was especially concerned with this
problem, though in the end, with less conscious searching perhaps willing less but
discovering more, we find greater absolute inner identity in a poet like Hardy;
certainly we do in Yeats. But Eliot is right, surely, when he comments: 'Through-
out the work of Pound there is what we might call a steady effort toward the
synthetic construction of a style of speech.'[11]

It is appropriate that Pound should have spent so much of his time and
energy on translation, for there is perhaps no literary activity that can more
directly cause a poet to make choices in method and style. To pit oneself against
another with a view to making that other accessible to a wide public necessitates
a continual watch upon one's own method of presentation. The translator needs
to say, what was the original author trying to communicate, what is the vision
behind the words; he also is required to discover how to represent that thought
in (in Pound's case) a different century and in a different language. His concern
must be the particular temper of his own speech. However brilliant it may be,
translation cannot be a totally inspirational activity. The translator cannot
produce while in a state of trance, which is Robert Graves's requisite condition
for the production of true poetry. The intellect needs to be at work, sifting,
weighing, refining, in a way that does not occur in the primary stage of original
composition. The confrontation of a work in one language allows the element of
choice as to how to bring it across into another tongue. The poems in *Lustra*,
which come between *Ripostes* and the first major translations from the Chinese,
use a firmer no-nonsense language than Pound's early poems. They replace
romantic pastiche with modern pastiche, for they are still, in one sense, surely
'mock'. They exhibit an extreme sophistication; they are altogether too know-
all, though for some people, in particular Robert Graves, the 'know-all' often did
not 'know' enough; he was merely pretentious, merely showing off:

Literary internationalism—the incorporation of foreign tongues and

atmospheres—is another method of civilising and enlarging poetry. French is the most common language introduced to this end, with Italian and Spanish closely following. Mr. Eliot not only makes free use of French side by side with English: he has written poems entirely in French. An even greater enlargement is made by a cultivation of the more remote classics. Some poets are able to maintain a sense of balance and dignity in this, if only because they are good scholars; but not so Mr. Ezra Pound. In a single volume of his, *Lustra*, occur literary references to Greek, Latin, Spanish, Italian, Provençal and Chinese literature—several of these incorrectly quoted.[12]

This is an appropriate comment on much poetry of the period but Robert Graves is chiding Pound a bit too severely. For the poems in *Lustra* are for the most part poems of irony. They are not poems of real situations but ironies related to fashionable situations. Pound shares with D. H. Lawrence a desire to shock the bourgeoisie, and at the same time a sneaking desire, one suspects, to be admired by the very people he claims to despise. The excellencies of so many of the acid observations of Pound's short squibs in *Lustra* and Lawrence's in *Pansies* are of an entertaining but undergraduate type. There is a slight air of prancing condescension about many of them despite their skill and in spite of the pleasure many of them undoubtedly give the reader.

> As a bathtub lined with white porcelain,
> When the hot water gives out or goes tepid,
> So is the slow cooling of our chivalrous passion,
> Oh my much praised but-not-altogether-satisfactory lady.[13]

In this volume the approach to a throw-away unimpassioned style is pursued with admirable tenacity. Layer after layer of poetic eloquence is shed; but the style cannot be read as straightforward, for the triviality of much of the subject matter demands an irony of tone. The language is still masked, as the poet is still masked, by the character he has chosen to assume. He is able to throw away a lot of lines but the reader is often made only too aware that they are being thrown away, the act is just a bit too transparent. But the refinement of the language is a significant move in the right direction and is seen in its excellence in the next volume, *Cathay*.

Eliot again provides the clue: 'As for *Cathay*, it must be pointed out that Pound is the inventor of Chinese poetry for our time.'[14] Inventor is the significant word, for Pound has often invented, or at least apprehended, much of a poetry that he did not understand, for he is not a Chinese or Japanese scholar. Of course Eliot's phrase is unintentionally dismissive of a translator of the stature of

Arthur Waley, who certainly conveys to the Western reader a possible and acceptable world that seems recognizably 'Chinese', and Waley has the advantage of a deep knowledge of his originals very different from Pound's inspired guess-work. The translations of Witter Bynner, also, deserve more attention, though they lack the incisiveness of Pound and reflect something of the flavour of nineteenth-century English lyric diction. Nevertheless it is worth comparing the opening of 'A Song of Ch'ang-Kan' by Witter Bynner:

> My hair had hardly covered my forehead.
> I was picking flowers, playing by my door,
> When you, my lover, on a bamboo horse,
> Came trotting in circles and throwing green plums.[15]

with Pound's opening of 'The River-Merchant's Wife: A Letter'.

> While my hair was still cut straight across my forehead
> I played about the front gate, pulling flowers.
> You came by on bamboo stilts, playing horse,
> You walked about my seat, playing with blue plums.[16]

The poems in *Cathay* are based on the papers of Fenollosa, left in some disorder at his death. But although they are translations arising from another man's primary excavations, they are properly to be thought of as translations by Ezra Pound; and they are the first of his poems to show clearly his particular voice, the eloquently modulated, civilized and uncontentious voice before it became drowned in the clamour of *The Cantos*. However remarkable they may be, it is necessary to keep a sense of proportion and not to praise them as if they were original, or astonishingly different from the work of other translators.

As a translator the poet puts on another man's clothes, assumes a mask, speaks with a voice that imitates another voice. Pound has written his life in his poems but as often as not in another person's syllables. Perhaps none of the voices has been more gravely eloquent than that used for the poems in *Cathay*. The slight playfulness, the melancholy, the exceptionally 'civilized' nature of the originals, coupled with their provenance, so remote as to have given them a certain facelessness, all these things are a great advantage compared with translations from the more accessible world of medieval Europe. Chinese poetry as a whole, and early Chinese poetry in particular, seems to come from a past barely connected with our own. Problems of tone are therefore less exacting and perilous. There is a sense in which in his translations from European languages one is always conscious of Mr Pound the poet and pedagogue stepping daintily or blundering about among the word gardens. He is always visible, like a tourist. He most nearly effaces himself in *Cathay* and the poems are better for the

effacement. Among the finer qualities of these translations is the unselfconscious ordinariness of the language.

It has been forcefully said by Donald Davie that to call these translations 'masks' is to miss the point: 'If *Cathay*, if "The Seafarer", if "Planh for the Young English King" were indeed nothing but masks for Pound we should not value them so highly as we do.'[17] though Davie seems to accept that *Hugh Selwyn Mauberley* is a mask for the author, and values highly that much admired and discussed poem. Certainly it would seem as if Pound found it necessary to move from persona to persona exhausting one voice after another until he settled down to concentrate on the huge project in which he could be a hundred different personae all at the same time. All those people! They had to be there. T. S. Eliot indicates the necessity: 'Technically, these influences [Browning, Yeats, Swinburne, Morris] were all good; for they combine to insist upon the importance of verse as speech . . .' The point has been extended by many people; succinctly in 'Ezra Pound', by Allen Tate. 'The secret of his form is this: conversation. The *Cantos* are talk, talk, talk; not by anyone in particular to anyone else in particular; they are just rambling talk.'[19] The significant phrase here, or so it seems to me, is 'talk; not by anyone in particular'. Pound is a poet lost among his own fictions.

'Certainty engenders repose.' I take the phrase from the last of the *Cantos*, but who has achieved certainty and who has entered into repose? Certainly not Ezra Pound. His life-work was a continual voyage remarkable for some exquisite landfalls but more noticeable for the storms and the wreckage. The opening is set luxuriously fair: 'And then went down to the ship,/Set keel to breakers, forth on the godly sea . . .' but between it and the closing line, 'You in the dinghey (piccioletta) astern there!'[20] it is possible to observe the self-destruction and calamity of a man who might have been the finest poet of our time. Something went wrong. There can be few major works in history—major in scope and attempt, that is—so disastrous as this enormous compilation of words, words, words; for finally the reader is more aware of the words than the thoughts and opinions they are meant to convey. For Ezra Pound, in so far as the 'common reader' is concerned poetry may be defined as 'that which gets lost in *The Cantos*'. To say this is to lay oneself open to much abuse, perhaps to much deserved abuse. Why should one suppose that the author of this enormous work is, or ever has been, interested in 'the common reader'? The reply must be that any work of such overall didacticism in its widest sense must rely on communication if it is to succeed. Though Pound expressed himself as loathing didacticism in poetry and hoped to avoid it, for the most part communication is smothered in the poet's own, and in other people's quoted, words.

Already in the early poems we have seen the tendency toward cultural arrogance. As we proceed through the strange terrain that is Pound's poetic life we find the references more and more remote and esoteric, the obsessions more acute, the tolerances less in evidence; and we see in these tendencies the danger hinted at by Thomas Mann—the progress toward Fascism. That Fascist element in Pound may indeed be innocent of any malevolence, but innocence of intent is not always an excuse. What we see also is that throughout the work, when it is not being so obscure as to be almost unintelligible except to the most erudite academic, or too hectoring or vulgar to be acceptable to any but the most uncritical admirer, it lapses into a poetry of a melancholy nostalgia that, often romantically beautiful, is certainly lacking in the vigorous clarity and modernity that Pound himself seems always to have required of others. If to criticize the work for its ugliness, its obsessive obscurantism, its ludicrous opinions, is to be wildly short of an appreciation of its stature, then so also is it damaging to praise it to the public at large for those passages of traditional beauty, for they are not the ground of *The Cantos* but small gardens flowering in a vast wilderness. It is not that one rebels against its difficulty. People indeed will go to extreme lengths to overcome difficulties in practically every human activity once their interest has been aroused. Even societies eschewing the complexity of the arts during the last fifty years acknowledge that mere difficulty is not the problem. A poet like Andrei Voznesensky, writing for an audience of Russian youth, and in the context of a society whose artistic development has as yet avoided many of the extreme phenomena of Western art, has said, when asked who his readers were: 'Above all, I should say, our young technical intelligentsia. There are millions of them in Russia now. Many of them work on sputniks and other complicated machines, and they want poetry to be complicated, too. They have no use for rhymed editorials.'[21] But there is a difference between technical complications and the extreme allusiveness of a work like *The Cantos*.

It can be argued, of course, that only a mind as remarkable as Pound's is in any position to criticize his work. Not only might that be argued, I suspect that it is indeed held very firmly by certain people; and for Pound one can perhaps supply the appropriate figure in most of the other branches of the arts. It is one of the insidious evils in our view of the arts in our time. For if art is not for the people who is it for? This is not a plea for an art of ease readily understood by the 'average man'. There is a case to be put forward that all great art is 'difficult', that it requires patience and dedication for its proper appreciation; but the difficulty, I suspect, in such cases, is not the difficulty of particular knowledge, but of profound understanding.

Of course Ezra Pound, an American expatriate, was deliberately setting himself the task of writing 'universal' poetry; his style and preoccupations are

non-nationalistic, as is the music of Schoenberg. It is a style in which the elements of a particular tradition rooted in a national culture have been deliberately discarded. What is surprising in the result is that the universal style so often seems less universally acceptable than many more obsessively narrow traditional manners. The majority of people can respond more readily to the less extreme departures from tradition of a poet like Eliot, or to the more nationally dictated music of Bartók. For Pound, right from the start, English poetry was pretty well written off. Only one or two poets after Chaucer were admitted to his affections. His chief concerns were French and Italian poets and, slightly later, the poets of China and Japan—though Japan only peripherally as he became more and more embedded in the philosophy of Confucius and the manner of early Chinese poetry. This would seem to be rather extraordinary in a man whose own work is in English. English. Yes, well . . . There can be little complaint, within the context of modern literature, at finding oneself reading, even in the middle of a supposedly English poem, a pretty hefty fragment in French, and only a partial complaint if this is followed by an equally long passage in Italian or German. But once the international element goes further than this we need to pause and reconsider. Desirable as a command of languages is, there is a limit to the number of people who can read many languages with the attention and minute understanding that is required for the appreciation of poetry. It is not enough merely to get along with the words; if that were so then we would never need more than ordinary translations of the classics. It may sometimes seem necessary, reading Pound, to modify the excellent observation of Michael Roberts: 'primarily poetry is an exploration of the possibilities of language'[22] to 'languages'. In technical prose, dealing with specific subjects, it is enough perhaps for every man to be his own translator. But not in poetry. No more than in music it is sufficient for every man to be his own interpreter. No doubt Pound was aware of the difficulty, but was not able to overcome it. In his essay on 'How to Read' he describes 'three "kinds of poetry"':[23] melopœia, phanopœia, logopœia, pointing out that the first cannot properly be translated but can be appreciated by a 'foreigner with a sensitive ear', which presumably explains his refraining from translating much foreign matter embedded in his poems; that the second can certainly be translated since it is almost impossible to destroy, which makes one wonder why he does not translate many passages of this kind throughout *The Cantos*; that the third is impossible to translate, by which I take it that the reader has to be able to think directly in the language concerned—a gift few possess in more than three languages, and scarcely any, I venture, in the early forms of any language. Pound, simply, expects too much. The problem is exacerbated when problems of intricate reference are included as well. I quote, not quite at random, from the close of 'Canto C':

Gardner, A.G.

 Aug. 1. 1914

 also specific

Beauclerc the first norman duke who could read,

Half the land, and slaves or how much

 belonged to the temples

as Julian noticed ('Apostate')

2 million died for investiture,

 Rome; Autun; Poictiers; Benevento

 crosse (+) et l'anneau (O)

 1075; '77; '78; 87

 et le prépuce at Puy en Vellay

'To avoid other views' said Herbert (De Veritate)

 'their first consideration'

 come in subjecto

lisses

 amoureuses

 a tenir

EX OUSIAS . . . HYPOSTASIN

III, 5,3 PERI EROTAS

 ||| hieron

nous to ariston autou

 as light into water compenetrans

that is pathema

 ouk asphistatai'

 thus Plotinus

 per plura diafana

neither weighed out nor hindered;

 aloof.

 1 Jan '58[24]

I need to rush, not to defend the passage, but to admit that it is of course always easy to jibe; as easy in this instance as it is to jibe at those weaknesses of sentimentality or traditional cliché-ridden passages in poets of smaller stature. But the fact is that *The Cantos* is riddled with passages like the above, passages which do not only require concern for themselves but concern for the effect they have had and still have on certain areas of English and American poetry. If these passages of obscure reference were surrounded by, or if they surrounded, passages of great lyric fervour, one could indeed make many excuses. Alas, too often they run before and after sections which are either misguided quotes from depres-

singly dull political figures or harangues about the evils of capitalism. For
Pound's *Cantos* constitute not only one man's vision of the world through its
history and present condition but one man's dictatorial notion of how to put it
right. The trouble is that the vision is too often blurred and the cure for the evil
of doubtful efficacy. In his introduction to *Ripostes* Pound wrote, when the first
Cantos were in the making but before they had been published: 'The essential
thing in a poet is that he build us his world.'[25] It is impossible to tell with what
deliberation he chose his words, but certainly 'build' is significant. Pound indeed
does just that. He builds: consciously, wilfully, and with an energy almost
unsurpassed. He is indefatigable. But the world he has built, for all its astonishing
structures, finally seems to lack purpose. Which is odd when one considers that
Pound, as a man and as 'a man of letters' always seemed so purposeful. The
currents and eddies surely drove his odyssey into strange waters. As Joyce's
Ulysses foundered in the sargasso sea which is *Finnegans Wake*, so Pound's
Homeric voyage—for *The Cantos* begins with the odyssey—founders not on
Circe's isle, to which he goes all too infrequently, but between the Scylla and
Charybdis of intellectual pretension and emotional hysteria.

But to go back to the beginning, to 'Canto I' of what has always been *The
Cantos*—as one might in despair of some astonishing modern play refer to it as
The Acts, it being impossible to give the work as a whole a title. To enter into
those first pages is to enter into a world offering munificent beauties and wisdoms.
The nagging suspicion that the long poem is an impossibility in the twentieth
century looks as if it might prove wrong after all. The implication is heroic.
Pound is as imperious in his use of language as Milton is in the opening lines of
Paradise Lost; it is both rhetorical and elusive. There is even a way in which it
can be thought of as old fashioned. The style is of necessity almost 'eloquent',
though why does not immediately become apparent. The first shock, a gentle
one, and a very obviously contrived one, opens 'Canto II'. For the juxtaposition
of the first line with the last line of the preceding 'Canto I' are guaranteed to
make the reader prick up his ears.

> ... thou with dark eyelids
> Bearing the golden bough of Argicida: so that:

> Hang it all, Robert Browning,
> there can be but the one 'Sordello'.[26]

The shock is effective as all shocks are, but is not properly justified by what
follows, for as yet the poem gives small hint of breaking wildly out of the
classical mould. The lines are for the most part mellifluous, the argument
minimal, the images disturbing in their somewhat gross way, for Pound, long

before Eliot, knew how to titillate our fear of the animal threat by heavily anti-human images:

> And, out of nothing, a breathing,
> hot breath on my ankles,
> Beasts like shadows in glass,
> a furred tail upon nothingness.
> Lynx-purr, and heathery smell of beasts,
> where tar smell had been,
> Sniff and pad-foot of beasts,
> eye-glitter out of black air.
> The sky overshot, dry with no tempest,
> Sniff and pad-foot of beasts,
> fur brushing my knee-skin,
> Rustle of airy sheaths,
> dry forms in the *æther*.[27]

Many years later T. S. Eliot was to make good use of this passage, and other similar passages, in the choruses of *Murder in the Cathedral*. But if the images are disquieting they are not horror images as they are in the work of Eliot, a far more fastidious man and poet. They are here in contrast to the sea images brought by the boy who has the 'god' in him, taken aboard at Naxos. 'He has a god in him.' So the poem is about the high qualities, about the men with a god in them, or of loyalty, integrity, spiritual heroism, self-less-ness in men or women great in 'self'. 'My Cid rode up to Burgos' so that 'no man speak to, feed, help Ruy Diaz.'[28] It is to be a poem then of the ceaseless battering of antagonisms in history, of everything holy, sacred, true, broken down, and of the very beauty of virtue redeeming all:

> And she went toward the window and cast her down,
> 'All the while, the while, swallows crying:
> Ityn!
> 'It is Cabestan's heart in the dish.'
> 'It is Cabestan's heart in the dish?
> 'No other taste shall change this.'
> And she went through the window,
> the slim white stone bar
> Making a double arch;
> Firm even fingers held to the firm pale stone:
> Swung for a moment,
> and the wind out of Rhodez
> Caught in the full of her sleeve.[29]

It is this attitude, the characteristic of direct action from the purest motive, that is the initiating theme of *The Cantos* and from it all variations are castigated in degree. It is not in any sense that Pound writes against the barbarians breaking down civilization, for he would query with an exact ferociousness what we mean by those two words. No; what he is clear about is the value of actions which are undertaken with no thought of gain. The action sufficient in itself and the growth of social structures which make such actions more and more difficult is one of the major elements in the argument of *The Cantos*. He is always recalling those moments of the past which contain some essential 'beauty' or 'goodness', not necessarily definable, and setting them against the treachery of modern societies. 'These fragments I have shelved,' he says, as, Eliot says at the close of *The Waste Land*. And the fragments are as heroic in action as the surrounding chaos is gross and squalid in manoeuvre. The first thirty of *The Cantos* pursue this theme with reasonable clarity and, allusive as they are, and elusive as is their meaning, they do not go as wildly off the rails as many of the later sections. But it is interesting to note that when they do it is in those stanzas where Pound is coping with contemporary events and where he is using a style that is deliberately forward-looking and 'up to date'. For the most part he is defeated in the one area where his intention is most determined. He falls down when the poem tries to become 'the poem for our time'.

As a fragment of a projected long poem the first thirty *Cantos*—make fascinating reading, but as the successive volumes appeared something of that interest waned. How long can a 'non-epic' poem go on, written in so kaleidoscopic a manner? How long can the reader go on giving the ambitious author the benefit of the doubt? For doubt there certainly is, and it is not dispelled by the *Jefferson Cantos* that make up the next instalment. There is much to be said for the juxtaposition of great moments in history and small personal items, and for the exploration of the general though seemingly minute particulars, but the pursuit of an argument through such prosaic means and with such uninteresting material as in these *Cantos* induces the worst state possible for a reader, which is not bewilderment, anger, amusement, or contempt even, but sheer boredom. They are concerned, in their most considerable layers, with what is to become one of the most obsessive and finally damaging subjects of this poem and indeed of much else that Pound has written: money, its proper use (as Pound sees it) and its improper use by all capitalist states. It is true that he also in these *Cantos* shows, through quotation—and most of this book is made up of extremely boring quotations—how standards would seem to be in a constant state of decline; but he does little himself to remedy things. Or does he? Donald Davie remarks that at the end of 'Canto XXXV' there are lines 'which can sustain comparison with Eliot's "Coriolan"',[30] to which indeed they appear to be related:

The firemen's torchlight procession,
Firemen's torchlight procession,
Science as a principle of political action.
Firemen's torchlight procession!

'The exclamation mark', Davie adds, 'does an amusing amount of work.' Indeed!

Where the boredom is broken the sense becomes almost impenetrable, for at once we are plunged into a version of Cavalcanti's 'Donna me Prega' which might for all the meaning it conveys almost as well have been left in the original. Certainly it moves the intellect to explore, but hardly stirs the emotions to engage. It is strange that in an attempt to get closer to the original Pound should make a poem more dense than the earlier versions previously published. Even so the lighting upon some poetry, veiled, elusive, not understood, is a relief among so much misdirected learning. For we see in these and in the next group preceding the *Pisan Cantos* the sad spectacle of a man whose very knowledge is steadily leading him toward a final ignorance.

We can perhaps admit that it may profit a man little to have read all the major works of world literature and exposed himself to all the masterpieces of the art or philosophies of the world if it has no effect on his sensibility or his behaviour. I do not mean here to comment on whether Pound was a Fascist or not, or a traitor or not, or anything else of that kind. But he certainly seems both in actions and in many opinions to be silly and misguided. This is not a cheap sneer at a man of extraordinary gifts and courage as well as unusual generosity. It is a serious concern. For Pound's thesis both in his critical writings and in his poems is that art is valuable not because it *entertains*, a word he constantly scorns, but because it instructs man how to live. How else should we put our house in order except by learning from the insights, apprehensions and wisdoms of the artists whose works remain accessible to us from the ruins of the past? But of course Pound does not mean any artist we may in our own poor folly consider great—but only those he chooses for us. Alas, so many of them are admitted as too remote for our capacity to understand that we know we shall have to pass them by. Grateful as we must be at his discovery of Arnaut Daniel there is a certain frost on our joy when we read:

The twenty-three students of Provençal and the seven people seriously interested in the technic and aesthetic of verse may communicate with me in person. I give here only enough to illustrate the points of the razo, that is to say as much as, and probably more than, the general reader can be bothered with. The translations are a makeshift; it is not to be expected that I can do in ten years what it took two hundred troubadours a century and a half to accomplish; for the full understanding of Arnaut's system of

echoes and blending there is no substitute for the original . . .[31]

One is even becoming afraid to smile. As *The Cantos* wears on and the humiliated reader is worn down, one begins to suspect that God, or the god who looks after the purity of the arts, really should count Pride as a deadly sin.

Throughout those of *The Cantos* which deal with aspects of Chinese history and which are ominous warnings of the speculations on the Chinese lettered character which is to take up so much of *Rock-Drill*, there is much that is elegant —though when it is so its mood, as has been previously noted, is melancholic and in a declining mode. It is also not especially heightened in its poetic rhythms, though it escapes the prose flatness of so much of the American or modern European sections. Before the oft-quoted lines beginning 'What thou lovest well remains . . .' and containing the cry that one desperately wishes he had heeded many years before: 'Pull down thy vanity,/I say pull down,' there are mellifluous passages, but for the most part the matter excludes the interest of all but the most ardent disciples or those already deeply concerned and know-ledgeable about the historical situations he surveys. And it is difficult not to reflect that perhaps if a man did study long enough to relate Pound's references and collate them so that he *could* benefit as Pound must surely have hoped *one* man might benefit, by the time he had done so history would have changed so that in his later circumstances he would not require the knowledge. For if society, at least in the West, aided by the scientists and the biologists continues to develop as it seems set to develop, brains remarkable enough to unravel Pound's enigmatic edifice of words will surely have something better to do.

There is an excellent story related by Arthur Koestler in *The Act of Creation*.[32] He tells how a little girl when asked what she thought was the most beautiful thing she had seen in the Greenwich Art Museum replied: 'Nelson's shirt'. When asked what was so beautiful about it, she explained: 'That shirt with blood on it was jolly nice. Fancy real blood on a real shirt which belonged to somebody really historic.' Pound, I think, would have approved her comment. How sad it is that progressively we come to see how this immediacy, this *actuality* of experi-ence is the major element that is missing from so much of his work. For when he made the shift from symbolism to imagism as he did, he overlooked one thing, and ignored his own excellent advice:

I believe that the proper and perfect symbol is the natural object, that if a man use 'symbols' he must so use them that their symbolic function does not obtrude; so that *a* sense, and the poetic quality of the passage, is not lost to those who do not understand the symbol as such, to whom, for instance, a hawk is a hawk.[33]

Certainly he does not allow his symbols to overlay the natural object (neither as a matter of fact does Maeterlinck in his best work) but in a way he does something worse; he overlays the object with his opinion of the object. We are never left with the thing itself; somewhere along the line Pound gets in the way.

Pound's first important poem, 'Sestina: Altaforte', is a battle-song. He said of it himself, while admitting its excellence: 'Technically it is one of my best, though a poem on such a theme (War: the clash of swords) could never be very important.' But there is a sense in which all his later work has been produced at war. The clash of opinions is more deafening than the battering together of medieval weapons. Eventually he got caught up in a war-machine of actuality and found it more brutal than he might have imagined it could be. For the courage of his constant engagement we can do nothing but admire him. Folly or not. But if art is to speak to man, then Pound shares with Schoenberg the grave flaw of being, in so many of his works, more inscrutable than God. This is one of the major crises in the development of art in our time. Rarely have we seen the propagation of aesthetic dogmas so severe, opinions so intractable, areas of knowledge so exclusive. Faced with the problem of which goddess to choose Pound eschewed the blandishments of Venus. As far as we can follow him we are bound to pay homage, out of respect for his sheer learning, for his searching out of originals, even for some of his irascibility, certainly for his opening up of new territory, though that has dangers too, and for his tireless encouragement of others. But where, where, for pity's sake are the songs?

CHAPTER 6

STRAVINSKY ELIOT PICASSO

Society demands to be excited, challenged, torn in sunder for and against; it is grateful for that as for nothing else, for the diversion and the turmoil qui fournit le sujet for caricatures in the papers and endless, endless chatter. The way to fame, in Paris, leads through notoriety—at a proper première people jump up several times during the evening and yell "Insulte! Impudence! Bouffonerie ignominieuse!" while six or seven initiates, Erik Satie, a few surréalistes, Virgil Thomson, shout from the loges: 'Quelle précision! Quel esprit! C'est divin! C'est suprême! Bravo! Bravo!

Thomas Mann, Dr Faustus.

The frontispiece of Eric Walter White's excellent book *Stravinsky, The Composer and his Works* is a photograph of the composer taken in the offices of Faber and Faber Ltd, with a bust of T. S. Eliot in the background, while in the course of his exhaustive work the author comments on Stravinsky's friendship with Picasso and the similarities between their work. Certainly these three men form in the minds of the majority of people the triumvirate that is synonymous with 'Modern Art'. Ask the average person what he thinks of modern painting and he will invariably answer as if you had said 'Picasso'. Ask him about music and he is likely to reply as if you had particularized Stravinsky. Perhaps the only poet whose name he remembers at all (except Dylan Thomas, for very different reasons) is T. S. Eliot. Each of these men has caused an outcry, a violent controversy at some point in his career; each has been thought of as an arch-rebel or an *enfant terrible*, yet each of them enjoys the reputation, almost, of a classic. Of course not one of them was ever as strikingly avant-garde as Pound, or Duchamp, or Schoenberg. Perhaps this is the reason for the outcry. Their various 'shocking' works were violating a convention and were therefore comprehensible in a way that more extreme works were not. More interesting though than the shocks is their development which is so similar and so significant in relation to the development of art in our time.

Because of the staggering success of the first performance of *The Firebird* we are apt to fall into the delusion that Stravinsky was some kind of original genius springing fully armed from the forehead of Zeus. That is not the case. His earliest attempts, not at composition but at arrangement, had been contemptuously dismissed by Glazunov, and even Rimsky-Korsakov was some time in coming round to the belief that the young Stravinsky was exceptionally talented. It is perhaps to Rimsky-Korsakov however that Stravinsky owes his quite astonishing virtuosity as an orchestrator and his early love of the sumptuous and exotic. What is perhaps surprising, since his father was an accomplished opera singer, and since Stravinsky must have heard more opera than any other kind of music, is that he produced so little himself in that genre.

It was that astonishing man for all seasons Serge Diaghilev who first saw and fostered the young Russian composer's genius. In 1908 when he heard Stravinsky's *Fireworks* he was actively looking for a composer for the season of opera and ballet he was planning to launch in Paris. Stravinsky was at work on the score of *The Nightingale*, but put it aside in order to compose his first major work for Diaghilev, the ballet which is still one of his most popular compositions, *The Firebird*. In 1910 after the first performance he found himself famous overnight, as famous as Dubussy after *Pelléas and Mélisande*, and Debussy was among the first to congratulate the composer. Although *The Firebird*, especially in the 'Dance of Katchei', bewildered some listeners at early performances, especially concert performances, there is little in it that is much more disturbing than the most exotic works of Rimsky-Korsakov, or Scriabin, and nothing remotely as difficult either rhythmically or aurally as Webern's, Berg's or Schoenberg's orchestral pieces which had already numbed smaller audiences of the period. There is however a distinguishable feature that is soon to become unmistakably Stravinskian, a negative feature possibly, but none the less significant for that. *The Firebird* may be romantic in the tradition of Tchaikovsky and Rimsky-Korsakov, but it is not nostalgic and it contains no elements that might seem to be, in musical terms, moralistic. All in all it is a pretty straightforward, nononsense score, fairly traditional in its conception, astonishingly mature in its execution. Even the following ballet *Petrushka*, though its more complex rhythms and greater overt vulgarity of sound is demonstrably more 'modern', still keeps fairly comfortably within the harmonic and structural limits of classical music. An important aspect of it, the choice not so much of theme as the characters who were to inhabit the theme, will be shown more significantly when we turn to the paintings of Picasso. There is little in it, as music, that is as new as the end of *Tristan*, or *Pelléas*, or *Gurrelieder*. The catastrophic shock comes with the third and greatest of the Diaghilev ballets, *The Rite of Spring*.

The uproar at the first performance of this ballet has now become a legend

and like most legends is constantly embroidered in the telling, so that at times the actions of the audience would seem to have been more riotous than those of the performers. The disturbance was not, however, violent enough to stop the dancing or the playing through of the work. We have to keep in mind the fact that in artistic circles before the First World War *claques* were more in evidence than they are today, as well as to recall that the subsequent performances were triumphantly successful. *The Rite of Spring* was not so persistently attacked as for instance, Synge's enchantingly inoffensive drama *The Playboy of the Western World*. Certainly, though, a misconception surrounds most attempts at producing this work and in the conducting of it by so many conductors who seem to misconstrue the nature of its energy. From Stravinsky's great score—one of his greatest—the mistake has been made of confusing energy with violence. *The Rite of Spring* is not in essence a violent score at all; but the beginning of a cult of violence can be seen to germinate within it. Perhaps poor Nijinsky was more to blame than we care to admit. It is necessary to remind ourselves that although the rites are pagan they are still religious; they are just not Christian, that is all.

Much of the viciousness that seems to come from this work is often introduced by conductors whose sole aim seems to be to stun the audience with noise and who overlook the fact that all the emotive words in the scenario—'earthly joy', 'celestial triumph', 'sacred kiss', 'mystic terror', 'solemn moment'—are an explicit denial of this approach. It is an ordered and highly complex ritual; not an act of hooliganism. It is especially significant that performances conducted by Stravinsky himself made the score almost as luminous as one by Mozart. But the idea dies hard of Stravinsky as some kind of violent bad boy of music. It may well be that subconsciously he detected that by pursuing the path opened up by *The Rite of Spring* he might get caught up in the same misconception himself. Instead, apart from one other major work, *The Wedding*, and the rather less significant *Symphony in Three Movements*, he abandoned the more dangerously frenetic elements of the score and developed its most fertile ingredient—its supreme rhythmic vitality.

Listened to now with more than fifty years of concert performances behind it, and able as we are to appraise it in some kind of perspective, its significance can be seen to lie in its positive features. It is a work of proclamation. Both *The Firebird* which preceded it and *The Nightingale* which was completed after it are still tied to the musical world of the past. Despite the extreme modernity of the musical language of Schoenberg and Berg their works of the same period, also to some extent carry with them the emotional residue of late-nineteenth-century artistic anguish, not yet utterly free from the spectre of Wagner. *The Rite of Spring*, for all its expressionistic nature, seems to exist in a world free at last of moral anxieties. If the early works of Debussy and Ravel, like those of Monet

and Cézanne, somehow bring the light of day into the excessively dark rooms of 'high' art, so Stravinsky in his art seems to be allowing man to step out of his personal neurosis into a less subjective and therefore less disturbing world. Stravinsky is perhaps the only major composer of our time to do this so early in his career. It is something which Schoenberg and Berg never achieved (they doubtless did not want to) nor Bartók until his latest works, and Webern only spasmodically. Because of this Stravinsky may well be seen, in the future, to have been essentially more 'modern' than any of the Viennese school. It is *The Rite of Spring* that allows him to make this step, for it is a single necessary plunge into expressionism from which he emerges purified, as it were, and ready to begin a new series of initiations towards his second ritual. *The Rite of Spring* is a ritual of Dionysiac fervour in which the sacrificial victim is Stravinsky himself as a musician dominated by the history of Russia and the music of the Russian nineteenth century. Unlike most sacrificial victims, real or imagined, Stravinsky, phoenix-like, rose from his own ashes to start the long process toward the sacrifice to Apollo[1] finally accomplished in his ballet *Apollo Musagetes*. He was helped in this, rescued one might say, by a terrifying circumstance—the real sacrificial orgy of the First World War.

The sheer hedonistic luxury in which the arts were indulging was cruelly destroyed by the economic problems created by this first modern European collapse. Nero might have fiddled while Rome burned, but the devastation of the old Europe between 1914 and 1918 was too enormous to allow of any development in the extravagant direction toward which a certain group of artists was moving. It pruned the proliferation of that remarkable man Diaghilev.

In our concern for the movements and phases of the arts in the middle of the twentieth century we are inclined to forget just how much closer similar movements were to their full realization immediately prior to and just after the outbreak of the First World War. Apart from the development in electronic means for achieving certain ends, we do little now that had not already been done by such men as Scriabin, whose uniting of music and colour in such works as *Poem of Ecstasy* and *Poem of Fire* was nothing if not psychedelic, or Satie whose ideas of the combination of music, silence (in an extended sense) arbitrary noise, and repetition, are remarkable demonstrations of an urge toward purposelessness as extraordinary as anything happening at the moment; or Diaghilev in his creation of the Debussy-D'Annunzio *Martyrdom of St Sebastian*, which was to bring together dance, poetry, music and the visual arts in a total theatrical experience that makes the extravagance of many of our current productions or 'happenings' look quite puritanical.

Such elaborate spectacles cost money and demand that many remarkable figures should be able to get together in reasonably settled conditions for lengthy

periods. The war prevented this. The dream was to be shattered by the waking nightmare. After the cathartic experience of *The Rite of Spring*, therefore, Stravinsky found himself leaning toward a thinner, perhaps more classical manner: out of a precocious artistic adolescence was to sprout the no less precocious rational man of middle years. It was definitely not a case of all passion spent, rather a realization that the intellect has passions no less demanding than the emotions. But just as *The Rite of Spring* would not have occurred without *The Firebird*, *Petrushka*, and *The Nightingale*, so the great works of his middle period were not arrived at without a number of small steps. The first of these is *Reynard*. The shift way from spontaneous emotions towards considered attitudes is clearly shown in this fascinating but rarely performed work. Although the basis of *The Firebird* is a fairy story the emotional framework is not far removed from reality. The persons in the drama may be remote from ordinary man but their emotions are seen to be the same. However elaborate the manipulation of these states might be, they are clearly love, jealousy, despair, elation. In *Petrushka* which, significantly like Schoenberg's *Pierrot lunaire*, deals with a clown or puppet, the engagement of the audience is through emotional states which they share with the personages exhibited on the stage. The Moor, the Blackamoor, Columbine and poor Petruska himself suffer like us—they are real too, they inhabit the world of Leoncavallo's *Pagliacci*, where Pulcinello is only disguised as a clown, being, after all, a human being, who shares the condition of everyman. As the prologue expresses it: 'We all are men, like you, for gladness or sorrow.' Similarly Picasso's clowns and acrobats in the painting of his Blue and Rose periods reflect our melancholy and pander to our nostalgia. The characters in *Reynard* never engage our emotions in this way. They are deliberately seen from the outside. They are actors in disguise and what is more they are in the guise of animals and fowls. The music becomes sharper; the focus more exact, the rhythms stricter, less capable of being interpreted with any freedom by conductor or performers. The works up to and including *The Rite of Spring* have all been intuitive, instinctual, despite the astonishing controlling craftmanship; the main line of Stravinsky's development from *Reynard* is rational and anti-intuitive, until the third phase of his development which is toward a religiously inspired and devotional music.

As an expatriate, choosing France as his home, he perhaps found it necessary to manufacture a mode of living and a method of composition. He became from *Reynard* onwards a self-conscious twentieth-century artist faced with a choice of various possible styles, and finding it necessary to adopt an attitude. Despite the religious development in his later years, the attitude was of a highly intelligent but uncommited observer. The gain in purity and formal precision is enormous, but the loss of—dare one say it—humanity is disheartening. *The Soldier's Tale*

which bears a family resemblance to *Reynard* and has a text by the same writer, C. F. Ramuz, is among his most brilliant scores, witty, sardonic, but only intermittently moving. This is not to imply that works of art are necessarily inferior if they do not engage the emotions; it is possible for the intellect to be engaged also! In *Reynard* and in *The Soldier's Tale* the intellect is teased and delighted but not *modified*. We have to wait for *The Wedding* (actually an earlier work but not performed until 1923) before we reach a work equivalent in authority and power to *The Rite of Spring*, which in some ways it resembles. It is significant that in *The Wedding*, despite the fragmentary nature of its text, which is a mixture of banal clichés and unrelated phrases as well as simple Russian folk poems, and the almost overwhelming percussiveness of its score, we become involved in a work in which identifiable characters exist.

Originally conceived in 1914, it was to have been composed for orchestral forces of the size of those employed in *The Rite of Spring*. By the 1920s not only had Stravinsky reformed his ideas about music but he was in no position to be able to command the use of such a luxurious medium as a truly gigantic symphony orchestra. He therefore scaled the musical idea down, though he scarcely made the problems of performance any more simple. Indeed it is the most perverse scoring one can imagine from the performing point of view, though aesthetically it is triumphantly successful. It foreshadows in a most striking way many of the works of the leading composers of the years immediately following the Second World War. Also, in the fragmentary nature of its text which deliberately avoids continuity, it can be seen as an ancestor of many vocal works of recent years, few of which are any match for its greatness. What makes it so riveting is almost precisely what is the dominant achievement of *The Rite*, namely its rhythmical vigour and excitement. Less expansive than that primitive ballet, it seems to jerk the listener into an intense consciousness of the actual moment more than any of Stravinsky's later scores. It is an ambiguous work, on the one hand rooted in an orthodox and mundane human happening, on the other hand inhabiting the realm of the highest formal art. Despite the length of time between its inception and completion it is not broken-backed like *The Nightingale*, but it does show Stravinsky torn between the Dionysiac elements of his early works and the Apollonian nature of his later scores. Apollo was to be the victor in the struggle; the battlefield is perhaps Stravinsky's greatest work and certainly among the most authoritative scores of our time, the hieratic opera *Oedipus Rex*.

Stravinsky is nothing if not cavalier in his attitude toward convention. His masterpieces include a ballet, *The Rite of Spring*, which cannot be adequately danced, a cantata/dance-drama, *The Wedding*, that in a normal theatre requires

the importation of no less than four grand pianos, a dramatic-musical narrative, *The Soldier's Tale,* that requires no stage, and in *Oedipus Rex* an opera that is to be sung in Latin and to be performed on a stage but with as little dramatic action as possible. It is astonishing how successfully he overcomes all these self-imposed difficulties. One sometimes wonders, though, what Gluck or Mozart or Verdi might have thought of the oddities of twentieth-century opera composers who require singers to play the roles of tables, chairs, clocks, frogs, etc. (Ravel, '*L'Enfant et les sortilèges*), or have only one character (Schoenberg, *Erwartung*), or two characters who converse while the scenery and orchestral music carry the weight of dramatic action (Bartók, *Duke Bluebeard's Castle*), or in which the total vocal music is extended recitative (Debussy, *Pelléas and Mélisande*), or the characters are deliberately deployed as in an oratorio and sing in a dead language (Stravinsky, *Oedipus Rex*). Why if Stravinsky wanted to write a prophetic tragedy for our time did he choose an archaic story, and why, having chosen such a theme, did he need to go through such elaborately sophisticated motions as to have a classical Greek tragedy re-written by that sophisticated and audaciously modern Frenchman Jean Cocteau, and then have the French in turn translated into formal and hieratic Latin? Yet the outcome is for the most part, magnificent.

Apart from the opera-buffa *Mavra* and the ballet *Pulcinella* based on music by Pergolesi, nearly all the music between *The Soldier's Tale* and *Oedpis Rex* is instrumental—one superb work, the Symphonies for Wind Instruments and one grand if slightly less exalted piece, the Piano Concerto. The move toward an instrumental purity was growing but with *Oedipus Rex* the stage was set for the two opposing forces of Dionysiac inspiration and Apollonian control. After it only in the Symphony in Three Movements were the savage forces to be released again, and by that time their terrors and powers had been severely tamed.

There is a truth contained in Siegfried Sassoon's poem:

> The Audience pricks an intellectual Ear . . .
> *Stravinsky . . . Quite the Concert of the year!*
>
> Forgetting now that none-so-distant date
> When they (or folk facsimilar in state
> Of mind) first heard with hisses—hoots—guffaws
> This abstract Symphony . . .
>
> This matter is most indelicate indeed!
> Yet one perceives no symptom of stampede
> The Stalls remain unruffled . . .

> In the Grand Circle one observes no sign
> Of riot: peace prevails along the line.
> And in the Gallery, cargoed to capacity
> No tremor bodes eruptions and alarms.[2]

The music is nevertheless experienced 'along the blood', as is appropriate in a dance ritual in which a victim is chosen to be sacrificed for the good of others; the fact that the rite is a religious one does not alter this power. The victim is not us but someone other who may have done nothing to avoid the sacrifice, may have acquiesced in it, but has not acted upon himself. The drama arises from the realization that man is both victim and victor. It is the drama of the road to the crucifixion in contra-distinction to the path toward the death of Buddha. *The Rite of Spring* is mysterious and magical and the sacrifice it celebrates is necessary only within the superstitious structure of the society performing it; but a little of its power to affect us lies in the fact that despite our contemporary world of scientific marvels we are still a very short step away from our superstitious past.

The sacrifice in *Oedipus Rex* is of a much more sophisticated order and Stravinsky was brilliantly inspired when he chose to treat it in such an aloof manner. The predicament in which the people of Thebes find themselves is real —the city is being decimated by the plague. They require a saviour but they do not arbitrarily pluck out one of their own number for sacrifice. They need to know the cause of their plight and then rid themselves of that cause. When Oedipus realizes that he is the rottenness within the city he performs his own sacrifice. But he does not die, and he says farewell to the city bearing the good wishes of the people.

Cocteau's original libretto did not please Stravinsky at all—but then neither did Gide's text for *Persephone* nearly ten years later—but one particular element of Cocteau's conception still survives. The various sections of the opera are introduced by a speaker in evening dress who sets the scene by giving a short explanation of the situation in very laconic French. Although Stravinsky disliked this and it has infuriated many critics, it does perform a very important function in that it helps to create yet a further distance between the world of the audience who can identify with the narrator and the world of the acted drama.

Oedipus is not the first of Stravinsky's neo-classical works but it is the most important in relation to his development. Eric Walter White comments with musical authority, but without total conviction, that the world from which this work springs is not eighteenth but nineteenth century:

> If outside influences are to be looked for, they will be found, not in
> eighteenth century composers like Pergolesi or Handel or Bach—not even

in Beethoven—but in nineteenth century Italian opera. Jocasta's great aria has been not inappropriately described as sounding 'like the finest milk of Verdi curdled into cheese.'[3]

But there is surely nothing Verdian, in the operatic sense, in the work as a whole. Neither is there anything to remind us of Gluck. The oratorio-like nature of the work does bear considerable affinities, however, to the major Passions of Bach, and indeed the whole gravity of the Stravinsky work, handled with a passion that is restrained by the vigorous formal treatment, is certainly reminiscent of Bach.

The significant moment, from the stylistic point of view, comes not within the body of the opera proper but in the final tableau. At the very place where it was possible for Stravinsky to stun us with an emotional climax, he declines. The opera has built up implacably to this moment. Oedipus has delivered himself of his statement that all sin is his: 'I was born of whom it was sin to be born; I lay with whom it was sin to lie; I slew whom it was sin to slay. The truth has dawned.'

This is followed by the Speaker, who interposes a brief and highly civilized description of what is happening off-stage:

And now you are going to hear the famous monologue, 'Dead is the sacred head of Jocasta', in which the messenger tells of Jocasta's end. He can barely open his mouth. The chorus take over his function, and help him to tell how the Queen has hanged herself and how Oedipus has put out his eyes with her golden brooch.

Then follows the epilogue.

The King has been caught. He wishes to show himself to everyone—unclean beast, committer of incest and parricide, madman.

They drive him away with great kindness. Farewell poor Oedipus, farewell. We loved you once.

Stravinsky's decision is taken at this point. To catch up the drama in a 'romantic' or expressionist manner, to unleash all the power of the style of *The Rite of Spring*, or to take the leap that would commit him to the classical style? He chooses the latter. Far from shattering his audience at this point he dismisses all thought of directly emotive musical means and introduces the scene with music that might easily have found a place in an opera by Rameau or Lully, though perhaps the genesis is the epilogue to Mozart's *Don Giovanni*. The effect is striking. It places the audience in the position of the gods—able to observe and to understand but not requiring emotional involvement. The distancing,

begun by the choice of subject, deepened by the use of Latin, is completed by the remoteness of the musical setting. We are placed in a privileged position vastly removed from the time in which the tragedy is played out. Man's immediate agony is rejected in favour of the possible joy that comes from the acceptance of an eternity in which transcendent truth may produce a 'peace which passeth all understanding'.

Apart from certain minor and often very lively works, the compositions which follow *Oedipus* are of a crystalline beauty that is sometimes so pure as to be enervating. The immediate successor, in some ways his most perfect score, is the homage to the god he has chosen to worship: *Apollo Musagetes*.

Stravinsky is not alone in his successive sacrifices. To a remarkable degree similar developments and resolutions can be seen in the works of Picasso and T. S. Eliot. Before considering the music of Stravinsky's post *Oedpius Rex* years, let us examine the shifts of emphasis that have occurred in the poetry of T. S. Eliot.

Despite the Russian element which persists throughout most of Stravinsky's career, there can be little doubt that had he stayed in Russia he would have developed differently. The cosmopolitan flavour of much of his middle-period work would have been less strong, the Parisian characteristics, the elegance and eloquence, would have been less noticeable. He is a Russian and the Russian voice is always there but the lungs are full of the air of foreign places, the language gradually replaced by French. Eliot, too, suffers from this removal from the country of his origin. He was, after all, an American of some cultural background, of some social distinction; he was shaped physically by the American continent. He chose however to reject America and to live in England, eventually to become a pillar of a great English publishing house, Faber and Faber, but for his *choice* of intellectual and poetic background, he went neither to America nor to England but to France. He had read while at Harvard Arthur Symons's *The Symbolist Movement in Literature* and from that reading was drawn particularly to explore the poetry of Laforgue. 'On the incentive Symons provided, Eliot went, in December 1908, or New Year 1909, to Schoenhof's and ordered the three volumes of Laforgue, which he thinks he may have been the first man in the United States to possess.'[4]

Laforgue, then Rimbaud—to some extent Mallarmé—these with Dante form the fertile ground of Eliot's imagination far more than any American or English poets, though Poe is always there in the background. What is noticeable however about his first book, *Prufrock and Other Observations*, is not so much the debt to the Symbolists as the rather melancholy and declining romantic beauty of the majority of the poems. However unpoetic they might have seemed on

publication, there is little that is deeply shocking or new. Just as *The Firebird* and *Petrushka* were mild compared to some of the experimental scores of Berg and Schoenberg, so *Prufrock* is less complex, less jarring than much in late Browning, or even in the savagely low style of Masefield's *The Widow in the Bye Street*. It is astonishing, looking at these poems now, to think that the young author of them should have been considered so dangerously progressive. Like *The Firebird*, like most of Picasso's paintings from the blue and rose periods, the all-pervading atmosphere is one of a seductively contrived nostalgia. Evening mists, yellow fog, October nights, midnight fantasies, elderly men and women sighing for lost youth. The tendency toward self-pity or enervating languor is only saved by the high artifice of the style. The voice is an adopted voice; poetry is to be pursued from an awareness of it as an art. Unlike Yeats or Hardy or indeed Housman, whose early poems were perhaps romantic but honest dreams and delusions, those of Eliot and Pound are calculated and to some extent self-conscious deceptions. The hard poetry of experience was being written by the war poets like Owen, Sassoon and Rosenberg. Eliot's confrontation with his deeper subconscious disturbance comes in 1922 with *The Waste Land*. Like *The Rite of Spring* it is primitive and ritualistic. It is perhaps not utterly without significance that the poem opens with a shocking but appropriate section about spring. Eliot's ritual, like Stravinsky's, is only superficially brutal; in its essence it is mysterious, religious, and grave.

After the poems of the *Prufrock* volume, which were for the most part romantic and expansive, those of the 1920 volume, *Poems*, were strict, spare, satirical and intellectually narrow. *The Waste Land* shows Eliot demonstrating a remarkable gain in craftsmanship and control, as well as being in a demonstrably personal voice. As *The Rite of Spring* is not a symphony yet seems to be of symphonic proportions and grandeur, so *The Waste Land* is not an epic yet is of epic scope. It struggles to make available to poetry an extreme range of material not usually found in the art, at least not in the work of English writers. Like *The Rite of Spring* it is a landmark in twentieth century art. Powerful as it is there are many disadvantages in the method used by Eliot and weaknesses in its overall structure. Too much, in the end, may have been left unsaid, or left to be said in critical essays or by others in the thousands of words already written about the poem. For Eliot is seen to have been a most assiduous propagator of ideas which help to uphold his own poetic practice, as Helen Gardner has very astutely noted: 'Mr Eliot's first volume of poems was published more than thirty years ago, and he has by now created the taste by which he is enjoyed.'[5] As Pound was lucky in Eliot so Eliot was lucky in Pound. They were undoubtedly a formidable pair.

What is stunning about *The Waste Land* is the sheer skill of its linguistic manipulation. Indeed the style is so assured that it is often difficult to disregard

it sufficiently to examine certain features of the thematic structure that, once startled from their hiding place, are less admirable. In 'The Burial of the Dead', for instance, despite the hypnotic quality there is a shift of narrative focus that is not sufficiently integrated, and there are many fascinating allusions which might well be thought wilful. Too many people have enjoyed exploring, with the aid of Eliot's own notes, the paraphernalia surrounding the quotations without perhaps asking why some of the quotations should be there. The two fragments from *Tristan and Isolde* for instance might with no especial diminution of the direction of the poem have been other quotations, or even if they *are* absolutely required cannot be properly appreciated by a reader unaware of their original context. Allusiveness of reference is a besetting sin in much modern poetry and in *The Waste Land* the allusion is too often to the overtones of the passage rather than the passage itself. We need, I think, to know Act Two of Tristan in order to make any real sense of the quotations from Acts One and Three. There is also a sense of irritation in having as a separate and supposedly significant part 'Death by Water', given utterly different overtones from those it has in French as the final verse of 'Dans le Restaurant'. Some of the links we try to forge when reading the poem may however be unnecessary or even ridiculous, for Eliot has warned the reader a number of times not to look too hard for what might never have been intended to be there; 'And finally, there is the difficulty caused by the author's having left out something which the reader is used to finding; so that the reader, bewildered, gropes about for what is absent, and puzzles his head for a kind of "meaning" which is not there, and is not meant to be there.'[6]

The element of nostalgia still persists but a significant dramatic tenor is introduced—indeed in some ways *The Waste Land* is more successful from the dramatic point of view than any of Eliot's stage plays. The ritual, which is a sacrificial one, as well as being a ritual of exorcism, is deliberately rendered unnerving by the introduction of off-stage of figures who forbode disaster. The unease is heightened by the references both to Elizabethan terror and Gothic horror. There is also an equally unsettling sense of superiority in the tone, that firmly keeps the reader in his place. We are conscious *first* of the poet's attitude, second of his subject. Prufrock remarks:

> No! I am not Prince Hamlet, nor was meant to be;
> Am an attendant Lord, one that will do
> To swell a progress, start a scene or two,
> Advise the prince; no doubt, an easy tool,
> Deferential, glad to be of use,
> Politic, cautious, and meticulous,
> Full of high sentence, but a bit obtuse . . .[7]

He comes close to denoting the stance of Eliot himself, who is always superbly disengaged. Despite this, in *The Waste Land* perhaps for the first and last time in a non-stage work, Eliot does involve the *reader* in the powerful undertow of his ritual. He uses means as sophisticated and complex as, perhaps even more complex than Stravinsky's. The poem as a whole is greater than the sum of its parts and the primitive vigour is finally not smothered by the intellectual pretension. *The Rite of Spring* toward the end very nearly collapses under the problems of its own rhythmical complexities, and *The Waste Land* nearly suffocates under its plethora of reference and allusion; but the internal power of the sacrificial ritual is strong enough to save it. In some ways still the most difficult of his scores, *The Rite of Spring* is undoubtedly the most popular work of Stravinsky; so too *The Waste Land*, though much more 'modern' than much of Eliot's later work, still has the strongest pull. It is curious that it should most nearly fulfil the function, so desired by Eliot, of appealing to a large audience: 'I believe that the poet naturally prefers to write for as large and miscellaneous an audience as possible, and that it is the half-educated and ill-educated, rather than the uneducated, who stand in his way. I myself should like an audience which could neither read nor write.'[8]

The statement is somewhat perverse, for it is surely only artistic work of direct experience that can appeal in such a way and to such an audience. No totally unsophisticated audience could be expected to get very much out of large areas of *The Four Quartets*, *The Waste Land*, *Ash Wednesday* and *The Family Reunion*. Eliot is here perhaps subconsciously playing his superiority game, for most people *are* half-educated or ill-educated, very few are totally uneducated or well-educated. Besides, poetry or drama which springs from an attitude requires some sympathy with or antagonism to that attitude; demands some knowledge of the situation from which the attitude springs or to which it is directed. Eliot's later poetry, like Stravinsky's music after *Oedipus Rex*, cannot be appreciated without some considerable intellectual activity. The move away from direct speech must inevitably result in an appeal to a more specialist audience. The sophistication of *The Waste Land* is enormous but the primitive ground is strong enough to counter it, so that read aloud it can have a powerful effect upon the emotions; whether the effect is meaningful is open to doubt.

Certainly within the development of Eliot the concluding moments of *The Waste Land* are of severe consequence. In *The Rite of Spring* Stravinsky exorcised the Russian past—apart from the residue of works like *The Wedding* or the Symphony in Three Movements; in *The Waste Land* Eliot exorcises the European dramatic-poet past. Both poet and composer emerge purified, to some extent, of the gross matter that they have been carrying with them. Unlike Schoenberg and Pound they do not wish to reject. Neither Schoenberg's Five Pieces for

Orchestra or *Erwartung* nor Pound's early *Cantos* are in any way sacrificial or ritualistic. Eliot's interest is specific: 'These fragments I have shored against my ruins.' This is the acknowledgment of the sacrifice and the retention of the experience. 'Why then I'le fit you. Heironymo's mad againe.' This is the acceptance of the continuance of the person toward a new sacrifice in a different cause. 'Datta, Dayadhvam, Damyata' (Give, Sympathize, Control).' This is the step from direct to indirect action, and might be equally well expressed, 'to offer, to understand, to manipulate or order'. Then 'Shantih. Shantih, Shantih', which as 'The peace which passeth all understanding' points toward the 'passionless' desire for the ineffable irradiation of grace. It is not surprising from such a conclusion that Eliot should have chosen the theme of martyrdom for his first full length stage play.

Before *Murder in the Cathedral,* however, we have *Sweeney Agonistes,* a drama in camera, like Stravinsky's *Reynard* or *The Soldier's Tale.* Here the mood is at once lighter but with a biting and satirical edge. *Sweeney* is a burlesque only made intellectually pretentious by its two descriptions 'Fragments of an Aristophanic Melodrama' and 'Fragment of an Agon' and the twin, heavily charged quotations from the Choephoroi and St John of the Cross, both only partly relevant to the action of this brief fragment of drama but the first later to be the substantial subject matter of *The Family Reunion* and the second to be the ground from which *Ash Wednesday* grew. Brilliant as *Sweeney* is, it is in a style that is defeated not so much by the inability of Eliot as by the realization that other people do this sort of thing better. Perhaps Eliot abandoned it because of this realization. When he got to the last chorus, 'When you're alone in the middle of the night and you wake in a sweat and a hell of a fright', did he perhaps feel not the 'sad ghost of Coleridge'[9] but the happy ghost of W. S. Gilbert beckoning from the shades?

Unable, or unwilling, or both, to write another *Waste Land,* it was necessary to make a second choice, to move toward a new kind of sacrifice. Helen Gardner is specific in dealing with the development: 'The change in Mr Eliot's poetry cannot be discussed without reference to the fact that the author of *Ash Wednesday* is a Christian while the author of *The Waste Land* was not.'[10] Miss Gardner is however far too penetrating a critic not to qualify that statement and perhaps her qualification removes some of its force, for she points out that Eliot by his conversion is only attaching himself to that to which willingly or unwillingly he was always moving toward. He had no Pauline conversion—or at least no detectable one. Dealing from the first in mysteries, he does no more than follow the usual procedure for 'The Christian only gives the mystery a name when he speaks of grace.'[11] *Ash Wednesday* may be for Eliot the sacrifice to Christianity — though the images from the sensual world are abundant—but it is also the first

ritual in his sacrifice to Apollo. Though Eliot was never sufficiently emotionally involved to be considered altogether Dionysiac, he pays homage in *The Waste Land* to Dionysiac principles. He has no intention, however, of going mad. Like Stravinsky and Picasso he was always going to be firmly in control of his passions. Later he was to say, perhaps with regret, 'Not for me the ecstasy'. There is some accuracy in his self portrait in *Five-Finger Exercises*. Indeed much of Eliot's nature and limitations as a poet can be found in these seemingly slight pieces.

It is not certain however if Eliot was denied ecstasy or whether he denied it to himself. Between *The Waste Land* and *Ash Wednesday* Eliot glimpses a world (or a person, or both) about whom it might have been possible to rejoice. There is no rejoicing before and during the *Waste Land* and at the beginning of *Ash Wednesday* we are told of renunciation, of a moment of joy that did not last. Such natural joy, perhaps such 'natural tears' was not to come again:

> Because I cannot hope to turn again
> Consequently I rejoice, having to construct something
> Upon which to rejoice[12]

What he constructed was an art reflective of, and a character absorbed in, 'The idea of a Christian society'.

Ash Wednesday was purgative of the mockery and cynicism of the past as well as dismissive of the stylistic violence of *The Waste Land*; something of the spirituality of the one and the vigour of the other are brought together in *Murder in the Cathedral*, a play of many flaws but of astonishing resilience. Again the similarity with Stravinsky is marked: like *Oedipus Rex*, Eliot's play is hieratic in style and static in its dramatic deployment. The weight is taken by the chorus to whom is given some of Eliot's most magnificent poetry. The action moves through a series of set pieces which are almost formal arias. Just as Stravinsky/ Cocteau bring the archaic and the modern into close juxtaposition, so also does Eliot, causing the political haranguing by the four Knights in part two to be spoken in an ironic prose—almost imitation Shaw—which very nearly dislocates the play. For the choruses he leans heavily on certain elements to be found in Pound's early *Cantos* but the work is on the whole blessedly free of the excessive use of quotation which occasionally makes one long for an *original* line of quality and memorableness. He shines too often at second hand.

Part One of *Murder in the Cathedral* and the choruses of part two are the last examples of Eliot's emotive style; that style from which he might perhaps have expected an uncultured audience to sustain an emotional shock. From then on, like Stravinsky, he chooses the path of formal beauty and emotional tranquillity, devising a manner closer to the eighteenth century than to the Elizabethans or to the nineteenth-century poets he had hitherto emulated. We are aware up to

Murder in the Cathedral of Eliot's modernity; so, we may suppose, was he, — as aware as Cousin Nancy. Did he question the whole nature of modernity in the light of his growing preoccupation with Christian ideology? Did he, did Stravinsky, see that a choice between licence and limitation needed to be made? Did they find it *emotionally* easier to choose the formal classical diction of their later works? Did they find it less of a struggle to acknowledge art as a dance? Was it an avoidance of the final battle?

It was a commission from Diaghilev that drew forth from Stravinsky his first three major works and gave him direct experience in working for the theatre; it was a commission from the Elizabeth Sprague Coolidge Foundation that produced the first of his neo-classical ballets, *Apollo Musagetes*. In his *Chronicle* he points out how in this work he wanted to explore the possibilities of similarity, harmony and order and to eschew violent effects of contrast and variety. Purity and simplicity of effect were the aim, which is not the same as simplicity of method. His first consideration was to choose a theme that could be carried through without a 'story line' and without characters; dance itself was to be significant. Next, for purity of musical line, by using a classical string orchestra he avoided the extravagant textures afforded by the orchestral resources of his early works, and thirdly he gave first place in the composition of the score to the principle of melody, whereas in his previous works rhythm is of paramount importance. The score is lucid, elegant, controlled, engaging the intellect far more deeply than it stirs the emotions. It is an aloof score and Balanchine's choreography appropriately mirrors the temper of the music. Admirable though the work is both as dance and music, it can be somewhat enervating in performance, being almost too godlike in its remoteness and serenity. It placed Stravinsky in an even more perilous position than the violences of *The Rite of Spring*. He was in danger of being dubbed regressive in a way that a composer like Hindemith with a score like *Nobilissima Visione* was not, for Hindemith seemed naturally to have grown to his style whereas Stravinsky seemed to have conditioned his. The reputation of Eliot was shaken in almost precisely the same way by the publication of *Ash Wednesday*.

Although, as we have seen, both Eliot and Stravinsky had always written with a gravity of purpose that might be considered religious, the specifically Christian commitment, coming in Eliot after *Ash Wednesday* and with Stravinsky after *Apollo* causes a drastic shift of emphasis in their styles. After *Apollo* the next major work of Stravinsky is the Symphony of Psalms, a work in which the contrapuntal elements so conspicuous in the ballet are developed to an even greater degree. As in *Oedipus Rex*, the text is sung in Latin so as to reduce still further any direct appeal to the emotions of the listener. Its austerity makes it as

private as any ritual in a closed monastic order. Like much of the music that follows, it contains a slight element of portentousness. The musical pronouncements of Stravinsky, after *Apollo*, like the poetic/dramatic productions of Eliot after *Murder in the Cathedral*, have about them a slight air of godlike prescience that their actual quality might not for long sustain. Wilfried Mellers sees the Symphony of Psalms as essentially lyrical, and comments: 'That work, which is certainly among the two or three supreme masterpieces of the twentieth century, is a revelation of God's love because the creator attains, in the last movement, to the love of God. In comparison, Stravinsky's later works seem to be in love with the idea of God, rather than with God himself.'[13] This, though it is in some ways as portentous as some of the works themselves, contains perhaps a grain of truth. Out of the artistic struggles of their youth both Eliot and Stravinsky reached a point where they seemed to find it necessary to embrace 'God' rather than struggle to find him.

In Eliot it is as if from identifying with Becket in *Murder in the Cathedral* and thus achieving martyrdom he accepted a purgation period in the character of Harry in *The Family Reunion* before emerging purified (or canonized) as Reilly in *The Cocktail Party*, thence to speak as from a position of privilege and wisdom. Speaking as one who did not know he was more able to hold our attention than when making pronouncements from a platform of assumed omniscience. Both Eliot and Stravinsky arrived at a point where they conquered chaos and restored order, but it was perhaps an order unsatisfactory for the distinctly disordered world in which we live; for it was an order drawn from a past but only uneasily inhabiting the present.

It is ironic that at a time when its whole national fabric was in decay, Spain should have produced the man who, in a society generally antipathic to the artist, has dominated the twentieth century like a god. The name of Picasso is known to millions who have never set foot inside an art gallery or consciously viewed any of his works. Picasso, whether we like it or not, *is* modern art.

Like Eliot and Stravinsky he emerges first as a romantic, startling because of his brilliance rather than his immediate originality. The earliest works, before the famous Blue and Rose periods, are rather disquietingly reflective of the Parisian world of Toulouse-Lautrec but lack the adult understanding of that master; too often Picasso's early satires are not satires on a profoundly realized reality but are brilliant glosses on another man's original observations. The bewildering thing is that so young a man should be able to use paint in such a mature way. The struggle for mastery of technique that occupies the majority of men for the greater part of their working life seems alien to this astonishing Catalan artist who seems almost to have been born with the knowledge of how

to paint. But while admitting this remarkable gift we may wonder whether, in the larger view, Picasso has ever discovered the one theme for his painting that would have been the major justification for his supreme talent, as Milton did in *Paradise Lost*, Beethoven in the late quartets, Wordsworth in *The Prelude*, Proust in *Remembrance of Things Past*, Tolstoy in *War and Peace*.

The first paintings to have about them the inescapable signature of Picasso are those malancholic and somewhat sentimental pictures of the Blue period— beggars, grieving women, exiles. They are touching but not real, for the beggars have not known poverty nor experienced rejection or deprivation; neither have the women known the agony of loss, their tears have been silent, they have not howled out their grief nor are they resigned to their desolation. The wanderers and *saltimbanques* of the Rose period move from nowhere into nowhere. They bring no past trailing its rags behind them and they gaze toward no future; their exile is nostalgia. During these years—1900–1906—Picasso seems first to observe, then to imagine. He does not strike through into the world of the unseen, unknown, as does Klee, nor struggle through into the heart of tragic reality as does Rouault. If in his later painting he is to savage the idealization of women, in his early work he idealizes some of the disparate conditions of man in his role of outcast.

Compared with the late paintings of Cézanne or the contemporary paintings of Klee or Rouault, Picasso's early works are surprisingly old fashioned and imitative. If those Parisian scenes lack the personal vision as well as the obsessive commitment to the subject that we find in Toulouse-Lautrec, they are also deficient in that element of sardonic bitterness so noticeable in Daumier. When he begins the series of Blue paintings his main contribution is a quality of calm, of stillness that relates him to certain mannerist painters and prevents him from becoming an orthodox Post-Impressionist. What these paintings lack is intellectual vigour and classical authority. It is not surprising that these works together with those of the Rose period should be sought after either in the original or in print form for they are essentially bourgeois—indeed Picasso, Stravinsky and late Eliot perhaps owe their universal acclaim to this fact that while the public calls them 'modern' they are to a large extent providers of pleasure to the new bourgeoisie. This is an attempt not to diminish the importance of their work, but to indicate its temper.

The major growth, in artistic skill, between the Blue and Rose periods lies not in any freedom in the application of paint, but in greater structural strength, for Picasso shows especially in his *saltimbanques* series (so admired by Rilke) his astonishing gift for filling a canvas so as to activate the space around the form into a vibrant life of its own. But why the flight into these subjects, these half-real, half-created characters? Perhaps years of social realism had exhausted the

possibility of treating nineteenth-century man, and twentieth-century man had not yet emerged as a being capable of being understood and portrayed. The paintings seem to inhabit a half-way stage between gallery paintings and theatrical décor, and it is not surprising that Diaghilev should have commissioned Picasso to work for him—though ironically not for Stravinsky's *Petrushka*. The theatricality of these works is acknowledged, though possibly subconsciously, by Pierre Daix and Georges Boudaille: '. . . in *The Saltimbanques* Picasso has chosen models he can dispose exactly as he wishes to, to whom he can give the expression he has decided on, as if he were both author and director of the play and they were actors.'[14] Picasso's break with this style is decisive; as decisive as Schoenberg's break with nineteenth-century harmony. *Les Demoiselles d'Avignon* throws much more than a pot of paint in the face of the public; it is a jeer at everything man had hitherto held sacred in the name of 'reverence' to art and to women. Rouault's ugly prostitutes are for all their disgusting grossness painted with a curious desperate love that redeems their ugliness. *Les Demoiselles d'Avignon* is a picture of calculated simian ugliness. It is a landmark in twentieth-century art, which does not necessarily make it a great or even a desirable painting. The painting with which it should be compared is the magisterial and classical *Portrait of Madame Casals*, not because the one is a 'better' picture than the other but merely to see the world that was rejected and the world that was offered in its place. This juxtaposition of paintings within the work of an individual painter is revelatory of one significant change not merely in the art of Picasso but in art in the last fifty years.

To a large extent the paintings of the Dutch period and the paintings done at Gosol in Catalonia are an attempt to penetrate through the classical to the primitive, not in order to produce 'primitive' paintings but to invest his sophisticated paintings which were in danger of becoming too sweet and sentimental with some cruder primitive vigour. Stripped of the hypnotic effect of the perpetual adulation afforded to practically every scribble of Picasso, so famous a painting as the *La Toilette* of 1906 is seen to be scarcely less sentimental than Holman Hunt's *King Cophetua and the Beggar Maid*. The vigour Picasso was perhaps searching to release had nothing to do with 'animation', for the distortions which become more and more acute in his nude paintings of this period result in an immobility that is almost stupefying; the women are not merely 'monumental' but monuments. He does not at this period so much reject women as turn them into men: their limbs become thicker, their muscles monstrously powerful, their stance squat and ignoble. It is as if Picasso in order to show man how gross and bestial he had become needed to make his most savage onslaught on the last remaining 'idea' of beauty. The dramatically powerful portrait of Gertrude Stein—is authoritative and convincing because the subject matter and

the painter's method are well matched. But not all women, thank God are like Gertrude Stein.

Picasso was not the first, to break violently with the world of the Impressionists and Post-Impressionists. Before leaving for Gosol he had seen and been impressed by the 'scandalous' exhibition of the Fauves. When he came back to France he was a more dangerous beast than any he had left behind.

'The change which had just taken place in Picasso's painting through contact with the rough realities of the high Catalan mountain was not only aesthetic but philosophical in the widest sense. Painting is a way of understanding. It reaches out not only to appearances, but to the physical truth of the world.'[15] This is well said, but whether Picasso is the artist who has discovered and portrayed this physical truth of the world is open to doubt. Even if he is, it is somewhat ominous, that word 'physical'—does it exclude the 'spiritual' truth of the world? Certainly Picasso was on the brink of showing us a new way of looking at the world. Newer even than that of Cézanne. Cézanne died in 1906 having bequeathed to the world a late painting still the subject of much controversy. When Picasso saw this painting, *The Bathers*, he was still only twenty-five. Behind him lay a body of work that might be the envy of a painter at the end of his life. Before him lay the years of the first half of the twentieth century which he was to dominate like a god. He knew that what was needed for him was to make the final leap into those years, to discard the nineteenth century for ever. Cézanne's career ends with *The Bathers*. Picasso's new life, for good or ill, begins with his derivation from that painting, of his own mocking canvas *Les Demoiselles d'Avignon*.

Was this the beginning of a period of schizophrenia? Ehrenzweig hints at this possibility though he stops short of making any precise accusation: 'The greatest modern painter, Picasso, did attack conscious sensibilities in an outright deliberate manner. His cubist experiments come perilously near to schizophrenic fragmentation and its self-destructive attacks on the ego. The schizophrenic literally attacks his own language function and capacity for image making.'[16] The possibility of some deep psychological disturbance having precipitated Picasso's Cubist paintings is given weight if we look carefully at the faces of many of the portraits of the Gosol period. In the paintings of the Blue and Rose periods it is noticeable that the eyes are invariably utterly expressionless or are allowed to show only the smallest emotional engagement. In the Gosol pictures the eyes are either obsessive or destroyed. Especially interesting are those portraits where the left eye is practically gouged out; a black hole painted with a savagery that borders on dementia. Between 1890 and 1915 Picasso shows an astonishing development—in terms of portraiture—from naturalism, through romanticized suffering, classical disengagement, grotesque distortion, mutilation, total destruction.

Les Demoiselles d'Avignon is not a 'Cubist' work but it contains the seeds of Cubism, that startling development of style which has been seen in certain quarters as the true 'new' language of painting, notably by Donald Mitchell.[17] But in practice the technique of the Cubist painters, like the method of the twelve-tone composers, is too rigid and narrow to become a permanent style, through undoubtedly it helped to free certain artists from the constraint of orthodox realism, Impressionism, Expressionism or pure abstraction. Picasso's Cubist paintings are more interesting than they are satisfying. They lack the aristocratic calm of Braque's paintings in this style and are curiously devoid of resonance in the sheer painterly qualities. They avoid the grotesque ugliness of the preceding paintings but do not contain the vibrant life of those works that were to succeed them. Often, too, they are betrayed by a lack of absolute courage. The famous portrait of Vollard, for instance, is given substance as a portrait by those simplified strokes outlining the salient features of eyes, nose and mouth; take them away and the work becomes a total abstraction, but with them in they show only too clearly that the 'portrait' element is an overlaying of the Cubist structure. More purely 'Cubist' works by Gris, Braque, Severini show how dangerously close such a style comes to being style for style's sake and how easy it is for that to descend to being mere decoration. Indeed the pursuit of decoration in the guise of high art is among the more distressing characteristics of the twentieth century.

The debt owed to Debussy by so many composers of our time is mirrored in painting by the debt owed to Cézanne. Both musician and painter were attempting much the same thing in their respective media, the liberation of volume from density. Picasso's growth from Cézanne and his move toward Cubism can be seen clearly in the *Portrait of Pallarés* of 1909, especially when placed side by side with the *Vollard* portrait of the following year, and in the *Three Women* of 1908. In this last canvas the savagely satirical grotesqueness of *Les Demoiselles d'Avignon* is modified by the greater complexity not so much of the 'form' as of the planes of the picture; the interest is allowed to focus more on the areas of colour with smaller emphasis on the delineation of particular areas of subject matter, an aspect of Picasso's work at this period that links him more strongly with Schoenberg than with Stravinsky.

But where the genius of Debussy and Cézanne, rebelling perhaps against the harmonic thickness of Brahms on the one hand or the dense paint of Courbet on the other, did allow light and air to flow into and through their works, Schoenberg and Picasso while helping to liberate form from some of its traditional turgidity produced a momentary deadness, a turgidity in sound and colour. This is especially noticeable in many of Picasso's early Cubist pictures; the colour

lacks variation, the pigment itself is devoid of vibrancy. Momentarily the astonishingly alive substance of oil paint ceases to sing. Of course there are exceptions, notably the light tones and exhilarating freshness of *Girl with a Mandolin* of 1910.

If one of the most significant achievements of Cubism was the production of painted space, then it follows that an immediate problem arises. Space in painting up to 1909 was the area in which subject and object disported themselves. In Cubism subject and object became dissolved to the point where they and the space were one and indistinguishable; it was therefore necessary once again to refill that space; the question arose, 'what with'. Both Picasso and Braque were too committed to the idea of an art moving forward into the future to resort to solutions comparable with those of 'classical' or 'romantic' artists. Their search brought them to the same conclusion, first the incorporation of elements which, secondary to painting, are primary to literature and music—letters and notes; then to the incorporation of objects, in actuality, not in representation, from the world of man's general activity. It is somewhat ironic that having driven the world of everyday appearances out of their canvases, or having distorted it to such a degree as to make it unrecognizable to most viewers, they should want to incorporate the artefacts themselves from this destroyed world: tickets, tobacco packets, etc. Fragments shored against their ruin.

Collage developed from Braque's *trompe l'œil* nail, his decorative imitation of wood, cloth, marble, etc., but, above all, the use of collage exploded the false dignity of the painter's skill, and exposed the hitherto buried conflicts between industrial society and the painter with his solitary craft. Leonardo, Raphael, Delacroix, all were on an equal footing with other craftsmen, manually preparing their own colours and canvases. But the development of industry, standardisation and mass production, the spread of photographs and colour reproductions, all these things now confronted the secret processes of painters—their alchemy. Collage was one way of taking up the challenge. Picasso and Braque came forward and presented themselves stripped of all magic, displaying their works, their materials and their craftsmanship simultaneously, abandoning all secrets of workmanship, all mystifying techniques, to be judged purely on their responsibility as organisers of reality.[18]

If the introduction of 'collage' and 'assemblage' exploded the *false* dignity of the painter's skill, then perhaps that was no bad thing. But there is little reason to suppose that the dignity of a painter in the exercise of his craft need be insincere, or that the development of art need in any way invalidate the methods, practices and achievements of another age or that produced by a different kind

of society. Picasso in his paintings rarely made use of collage, and then only for a short period of time, exploring the possibility of assemblage more radically in his sculptures. What he did immediately after the formulation of Cubism was to imitate in paint some of the effects that can be gained by the use of collage. Two of his most appealing paintings of this kind are *The Three Musicians* and *The Three Masked Musicians*, both of 1921. Nothing more clearly shows the instability of his stylistic development than an examination of these paintings side by side with *Three Women at the Fountain* of the same year. On the one hand we have a style of painting closely related to the decorative arts of the theatre and on the other a return to the heavy, monumental figure painting of the Gosol period. Throughout the 1920s Picasso exhibits many of the characteristics of Stravinsky and Eliot in his faltering between widely disparate styles, uncertain whether to move forward to a light, almost entertaining manner or to a more disturbing and committed one. This dilemma is reflected in those paintings which are throw-backs to the elegance of the acrobats of the Rose period, combining some of the pure pattern features of Cubism with an almost nineteenth-century naturalism in portraiture. What seems lacking is any purposeful philosophical background out of which truly major paintings might grow; there seems to be an almost total lack of connection between mind as agent or director and hand as instrument or contriver. It may well be true that painting is, in the long run, only about painting and that it is heresy to introduce such words as philosophy or morality. Picasso himself has made too many gnomic statements about painting in general and his own work in particular to attempt to pin him down on such a topic, but he has often stressed the importance of the hand as an instrument working almost under its own compulsion, or, paradoxically, under the compulsion of the canvas which requires, demands almost, that its potential picture be realized. 'Painting is manual; it is physical. You find in the materials with your hands. You have a blank piece of canvas. The picture is already there. You scrape for it. It's like digging potatoes.'[19]

In the same interview he admits that his paintings do not come from his head, from his brain. They are not thought by him; indeed they are not his at all. They occur when the creator of them inhabits him. Confronted by so much of his seemingly irresponsible nonsense we may be forgiven for sometimes wondering if he was not often 'possessed' be very mischievous and destructive spirits rather than illuminated by the wise gods. The sheer audacity of the paintings, the dazzling brilliance of the skill are never in doubt, but the result of his cleverness is too often wickedly superficial. This danger is most skilfully avoided in the graphic work, where the realization of particular texts has usually been acutely successful. The paintings continue to indicate problems not unrelated to schizophrenia but give little evidence of a strong spiritual struggle or awareness;

certainly there is little suggestion of any moral crisis. Despite his voluntary exile from Spain, very few of the major political problems of the century seem to have disturbed him. There is of course no reason why they should, but it is perhaps strange that the horrors of the great war impinge so lightly on his work. There is no equivalent, in Picasso's work, of the great masterpiece of Rouault: *Miserere*.

The one major event from the outside world which did shock him was of course the bombing of the small Spanish town of Guernica. His painting on this theme, by which the world at large now remembers the town and the event, is undoubtedly the most famous 'war' painting of our time. Yet it still has about it a little too much of the decorative quality that is so much in evidence in the still lives of the Cubist and post-Cubist phase. It is, for all its mastery, for all its 'shocking' qualities, a painting of artistic disengagement. It is too hygienic in its effect to convey carnage or wanton brutality; the subject seems to have gone through too fine a filter of sophistication. While it is too swiftly, almost carelessly executed, to be called 'painterly', it also seems too contrived to be an abrupt passionate statement, just as the twin canvases *War* and *Peace* of 1952 seem too purely decorative.

This sophistication has been seen by such a perceptive and sympathetic critic as Herbert Read as an element of grace; 'The great canvas is flooded with pity and terror, but over it all is imposed that nameless grace which arises from their cathartic equilibrium.'[20] There is a sense however in which this carthartic element fails to convince. A true catharsis is produced by the power possessed by a work of art to take us through the experience, by proxy, and allow us to emerge purged and momentarily purified on the other side; to suffer the experience of death without dying. *Guernica* seems finally to lack the emotional power to do this, while at the same time being devoid of that curiously disquieting yet calm acceptance of suffering which shines out from certain classical works and reduces our intellectual rage. This ambivalent attitude toward 'romantic' and 'classical' art is, of course, as fundamental to the work of Picasso as it is to that of Eliot and Stravinsky.

In another essay Read attempts, in somewhat grandiose terms, to elevate these stylistic problems to a search for a truth hitherto unattainable by romantic artists.

Picasso has passed beyond the extremes of any previously-known romanticism; more and more he has tended to fuse, not only all the elements of plastic expression, but everything material and immaterial—spirit and matter, myth and science, the dream and the reality. After exploiting abstract art, the pure tectonics of form and colour, he moved to the opposite pole and created *surrealisme*, a form of art that denies 'art', that

seeks only the naked heart, the unknown, the uncreated, the dreaded Minotaur in the dark labyrinth of the unconscious mind.[21]

The 'tectonics of form' are perhaps too evident in *Guernica*. There is first the separation of the rectangle into two equal squares of night and day, then the separation of two almost equal perpendicular rectangles to flank a large central square, and above all the almost perfect triangle which encloses the main elements of the painting. These formal devices go a long way to reducing the emotive aspects of the theme and add to the unreality that is fostered by the distortion of the purely figurative elements. We cannot imagine a work like Delacroix's *Raft of the Medusa* as anything other than a painting. Does that add to or detract from its power? It is possible to conceive *Guernica* as a stunning backcloth to some modern ballet of protest. Equally we may wonder does that add to or detract from its stature? it is to a large extent the decorative features and elements of distortion which militate against the emotional power that should inform a painting of the type of *Guernica*. What Wilfred Owen said about his own tragic war poems, 'the poetry is in the pity', is not translated by Picasso into what might be its proper equivalent, 'the painting is in the suffering.' There is just too much sophistication. It would be idle to pretend that Picasso is not the most astonishing painter of our time, but all too often his works seem to be the manipulation of human beings as toys animated by the audacious skill of his brushstrokes. Where these toys are prancing and joyful, mysterious and fanciful, they can produce a sense of infectious delight. But when Picasso gives way to his more spiteful tendencies, doubts begin to creep in. The destruction of animated toys is not, in the long run, a particularly moving spectacle.

Guernica stands in the same relation to Picasso's paintings as does *Murder in the Cathedral* to T. S. Eliot's poetry and drama and *Oedipus Rex* to the music of Stravinsky. After these works, apart from a few exercises in a different manner, the productions of poet, painter and composer become less full of emotional anxiety and often take their inspiration from works of an earlier time: Eliot goes to the Greek dramatists or to the Christian apologists; Stravinsky to such composers as Pergolesi, Tchaikovsky and Gabrieli; Picasso to Poussin, Manet, Velazquez. In a great many of the works there is a feeling of contrivance replacing primal creative energy. To a large extent they are glosses on other artists' experiences; conscious play comes more frequently to the fore. These later works cannot perhaps be called imitations but they are often reflections. Occasionally they are in contradiction to the avowed intentions and desires of the artist concerned.

In Eliot's case, for instance, there can be small possibility of a theatre-going

audience of our own time being unable either to read or to write or of being either non-educated or well educated. And unless they are very well educated indeed what can they be expected to make of such idiotic language (from the point of view of direct communication in a theatre) as that in Harry's speech in *The Family Reunion*:

> What I see
> May be one dream or another; if there is nothing else
> The most real is what I fear. The bright colour fades
> Together with the unrecapturable emotion
> The glow upon the world that never found its object;
> And the eye adjusts itself to a twilight
> Where the dead stone is seen to be batrachian,
> The aphyllous branch ophidian.[22]

Nevertheless we can see in *The Family Reunion* a distinct and laudable attempt to drag poetic drama into the twentieth century, even though paradoxically the foundation of the play is remotely classical. For all its difficulty it is Eliot's most considerable theatrical achievement. In the subsequent works for the stage he adds nothing that has not already been explored to some extent in this tightly knit play. The level of the writing is remarkably consistent. The loosening of the rhythmical tension in the later plays, reaching its weakest point in *The Elder Statesman*, demands a compensating dramatic structure that is sadly lacking, or a revelation of character which is almost totally absent. The achieving of a satisfactory equilibrium between formal structure, rhythmical propulsion and spiritual content is confined after *The Family Reunion* to the last three of the *Four Quartets*.

The Family Reunion is a very open-ended play. We are never quite certain what has happened, still less certain what will happen. It is this very questioning element that makes it a finer play than its successors. It also contains at least one fully realized character in the person of Agatha. In its formal precision it is as hieratic as a novel by Ivy Compton-Burnett, which it greatly resembles in theme and content and in its unyielding allegiance to a rapidly vanishing English class system. The play has about it the excitement of the artist grappling with a theme slightly too big for him. The later plays are more comfortably manipulated; Eliot seems to have abandoned the struggle. They become like pale imitations of the already enfeebled stage works of Henry James. The sheer emotive vigour of early Eliot has been lost in the somewhat querulous pomposity of Christian certainty. Even the intellectual vigour which informs so much of his youthful criticism seems to have disappeared so that, notwithstanding some cogent passages of social comment, books like *Notes toward the Definition of Culture* appear more suited to a quietly polite discussion in a country vicarage than to the hard

debate of a significant public meeting. Eliot however was never an *either/or* writer; he had a third remarkable quality—the quality of deep spiritual insight and philosophical reflection. If *The Waste Land* towers above most poetic productions of the 1920s then the *Four Quartets* is the major achievement in poetry of the 1940s. It stands in relation to *The Waste Land* as *Persephone* stands in relation to Stravinsky's *Rite of Spring*.

Stravinsky's *Persephone* begins where Debussy's *The Martyrdom of St Sebastian* leaves off. It is a throwback to Diaghilev's conception of total theatre, using singers, orchestra, speaker, mime and ballet. Stravinsky—perhaps typically—disliked the libretto provided by André Gide and conspicuously and wilfully ignored Gide's not altogether ludicrous suggestion that the role of Pluto should be given to a basso profundo. The work is essentially homophonic, often mellifluously beautiful, and contains small indications of the primitive energy of his earlier works. Stravinsky seems to be moving toward the equilibrium of Eliot in the *Four Quartets*. Were they both, in their own way, producing a criticism of the headlong dissonances of the modern movement which they had been so conspicious in fostering, as Picasso in his carefree fauns and piping shepherds was seemingly stepping back into a more generous, less guilt-ridden, happier world? Certainly none of these three artists ever again became caught up in a positive, forward-looking, essentially vigorous style—with the possible exception of Stravinsky in the Symphony in Three Movements. The interesting fact, not to be overlooked, is that the public who had found the early works so disturbing, so ugly, so dissonant, failed to embrace with any very marked fervour these newer, less jagged works. Perhaps the very purity of the *Four Quartets*, the eighteenth-century insouciance of the mellifluous Stravinsky, the amoral innocence of Picasso seemed somehow untrue at the deeper levels of the artists' consciousness. Only Eliot's *Four Quartets* can stand rigorous examination and emerge undiminished in stature. Not so the subsequent plays, not so Stravinsky's *The Rake's Progress*, not so Picasso's variations on Velazquez's *Las Meninas*.

After the *Four Quartets* Eliot produced little poetry. The language of the plays becomes steadily more prosaic and the rhythms more pedestrian. The energy has leaked away. Picasso, ebullient as ever up to his death, seemed to reflect something of the care-less-ness so aptly suggested in Auden's poem 'Anthem for St Cecilia's Day':

> O dear white children casual as birds,
> Playing among the ruined languages,
> So small beside their large confusing words,
> So gay against the greater silences
> Of dreadful things you did . . .

Stravinsky, moving away from both the savage rhythms of *The Rite of Spring* and the serene elegances of *Apollo Musagetes* offered in *Agon, Threni* and subsequent scores compositions that seem to hover uncertainly round the periphery of the worlds of Webern and Schoenberg. Was there, in their particular kind of esoteric modernism, something finally inimical to the production of what they each deeply longed to produce—a body of work of epic proportions, capable of standing four-square amid the great masterpieces of the past? Would a less élitist idea of art have served their intentions more generously? It seems unlikely when we consider the different excellences, but also grave shortcomings, of two other major artists of our time, who eschewed the idea of art for art's sake: the composer Paul Hindemith and the poet/dramatist Bertolt Brecht.

CHAPTER 7

BRECHT HINDEMITH

Tell me, what do think about greatness? I find there is something un-
comfortable about facing it eye to eye—it is a test of courage—can one
really look it in the eye? You can't stand it, you give way.

Thomas Mann, *Dr Faustus*.

Despite their incursions into spheres of activity where they were directly
addressing a public, Eliot, Stravinsky and Picasso belong to that class of artist
for whom purity of artistic endeavour remains a high ideal. The attempt to
please, or to accommodate their work to the demands of performers or public, is
only intermittently apparent despite the fact that, in the event, many of their
works have pleased a very large public indeed. Also, in spite of their leanings in
later years toward periods of art where the artist was a servant of his patron and
the society dominated by that particular patron, the bulk of their work sub-
scribes much more closely to the artistic ideal of the post-romantic movement
where the creations of the artist seen progressively more private and self-
sufficient. In those works in which they do appear spasmodically to take some
notice of the public at large they are paradoxically often less successful in
capturing that public and invariably less successful in producing works of the
highest quality. If they are defeated in that particular sense they are also
defeated in their various attempts to discover a means by which the idea of the
epic might be revivified and made new in our time. It is difficult indeed to
discover within the generally recognized framework of the so called 'modern
movement' any artists who managed to sustain the epic style or create within
their chosen form of 'modernity' works of the weight and gravity of the major
classical periods. The most successful works of this kind are seen to be produced
by those artists most firmly rooted in tradition and less experimental in their
style. Thomas Mann is perhaps the major novelist of this type and Sibelius and
Shostakovich representative composers. Despite the scale and magnificence of
Prokofiev's *War and Peace* or *The Flaming Angel* they perhaps are finally less
successful than his satirical, less ambitious opera *The Love for Three Oranges*,

while the profoundly moving operas of Janáček, fine as they are, lack the final turn of intellectual rigour and strength.

The two artists most purposefully to pursue within a self-evidently twentieth-century style something of the classical ideal are the composer Paul Hindemith and the poet-playwright Bertolt Brecht. Despite the very formidable difficulties inherent in the successful performance of their work, both were especially concerned with the use of art as an instrument for the possible betterment of society. Their general political and intellectual attitudes could scarcely be further apart, however. The young Hindemith seemed to be possessed of an almost excessive virtuosity. He had nearly all the qualities that one finds among classical composers. He was possessed of the ability to enter into practically every kind of music-making and apart from being something of a virtuoso performer on his chosen instrument, the viola, he was capable of playing, and playing well, most of the instruments of the orchestra. In this he perhaps resembles a figure like Telemann, who was of the opinion that a composer needed to be able to play the instruments for which he composed as otherwise he would be unable to write for them in the most appropriate manner. Telemann's general involvement in the musical life of his time and his constant flood of works for different groups of performers, often within the amateur field, also closely resembles the main characteristics of the young Hindemith. As a German composer Hindemith might seem at first to be ideally placed to create the major classically orientated works of our time but it may be that his very background was inhibiting. Bence Szabolcsi has an interesting point to make in respect of the development of melody.

It was primarily East European music that emerged first from impressionism, then from expressionist experiment, and finally from the style-play of Neo-Classicism. In their own way, all three trends represented a flight from reality, a taking refuge in one corner of the world; yet they all brought lasting results, already apparent in the new world language that was forming. Expressionism preferred melodies which were dramatic, ejaculatory or fragmentary; Neo-Classical objectivity needed the play of 'self-propelling' Baroque type melodies; but at the hands of East European composers both trends characteristically join forces with some form of folk melody. In Stravinsky they turn into equalised, litany-like fragments of melody (*Sacre du Printemps* and *Les Noces*); in Bartók's concerto texture (particularly the *1st and 2nd piano concertos*) the clattering rhythms of Bach's *Brandenburgs* meet up with the typical devices of the Balkans and the Near East—the asymmetrical forms of Rumanian, Bulgarian, Arabic or Turcoman music. In the broad melodies of Khachaturian's concertos they are

absorbed into the folk-rhythms of Russian and Armenian dances. Whether or not this was the intention, this is the world of East and West, a new synthesis. It affects rhythm and melody alike, its diatonic and chromatic style throws a bridge across continents.[1]

Indeed Bartók, Janáček, Vaughan-Williams, Villa-Lobos, De Falla were chanelling into the structures of the great classical German period something of the individual folk element of their own countries, and this produced, by a strange fusion of opposites, works that seem to grow out of the tradition and extend it rather than to be too firmly encapsulated within it, stultified by a lack of fresh air. Hindemith's development as a composer suffers from his constantly being brought back to variations within a tradition already perilously close to exhaustion. He is most successful when he imports elements from Eastern melodic styles as in the Third Quartet, which seems very much closer in spirit to Béla Bartók than to the more generally accepted image of Hindemith. It would be wrong to ascribe this to any direct influence of Bartók since the quartet was written in 1922, when Bartók had composed only two of his six great quartets. But in the melancholy and beautifully expressive first movement of the Hindemith we are aware of melodic influences which seem to flow in from Eastern Europe, though the world of Reger and Mahler may not be too far away.

The lives of Brecht and Hindemith are of much the same length and run through much the same period, and the development of their art as it expresses their moral and philosophical preoccupations is remarkably similar. Perhaps this is most clearly noticeable in the move from Brecht's play *Baal* and Hindemith's opera *Cardillac* to *The Life of Galileo*, which is perhaps the most important play of Brecht, and *Mathis der Maler*, which must certainly be the most important large-scale work of Hindemith. In these works Brecht and Hindemith are particularly exploring the temptations and moral predicaments which face creative men. The protagonist of each of the early dramas is a man of comparatively small worth and not a historical figure. The problems therefore of their chosen life-style and their actions and the way in which they face or abandon their moral challenges are of personal significance only. *Cardillac* is an infinitely better and more mature opera then *Baal* is a play, but they both show stylistic features which are of especial interest when one considers the development of their creators' talents.

Baal is essentially the work of a young man. It is pre-eminently the work of a young revolutionary student. It was written when Brecht was only twenty, and it is interesting to see how in its hysteria and romanticism it exhibits most of those elements of drama which Brecht most vigorously criticized in others and which he was later at pains to reject. It is succinctly described by Martin Esslin

His play, Baal, also tells the story of a poet, an anti-social outsider who seduces women, throws them to the dogs afterwards, and finally murders his best friend in a fit of homosexual jealousy reminiscent of Verlaine's attack on Rimbaud. The play is preceded by an orgiastic ballad in the style of *The Legend of the Dead Soldier*. *Baal* is a wild and extravagant effusion in the tradition of Buchner's *Woyseck*, episodic and disjointed but carried along by a torrent of powerful images that unmistakably bear the marks of genius.[2]

It is indeed not the action itself but the extraordinary vitality of the language that makes the play more than a silly excursion into the realm of updated nineteenth-century melodrama. The language cloaks the rather pointless development (if development there is) and undoubtedly shaky structure. The enormous part given to Baal, which makes the playing of it a punishing vocal and emotional feat, obscures the real lack of characterization.

The first version of Hindemith's *Cardillac* was not written until 1927, by which time the composer had already produced four string quartets, the two viola sonatas, and nearly all of the works collectively entitled by the composer 'Kammermusik', that is to say the series of seven 'concertos'. It is fascinating to listen to *Cardillac* after these works. The overall effect of the style is one of high romanticism far removed from the severely classical, often Bach-like nature of the instrumental works. Like Brecht, Hindemith was producing a work which exhibits many of those musical features to which he was most forcefully opposed. The character of Baal is that of a man whose final concern is only for his art and, similarly, Cardillac is a creator for whom the created object is more significant and desirable than anything else in the world. Cardillac himself is a goldsmith who is doubly avaricious. He sells his creations for extravagant sums of money but then is prepared to murder the purchasers in order to retrieve the objects which he feels to be an inalienable part of himself and which would be in some way debased and spoiled if possessed by a second person. Like the play of *Baal*, *Cardillac* is written in the form of fairly loosely connected scenes, and although there are many exquisite moments of tenderness they are most effective where the musical burden is carried by the orchestra and not by the singers, for the characterization is not particularly convincing. The major moments of the opera come in those scenes in which the chorus express their disquiet at their apprehension that there is a condition of evil at large in their world. Their unease at something which they cannot control infects the audience as the extreme anti-bourgeois hysteria of an outsider like Baal disturbs the average law-abiding citizen. Though Brecht and Hindemith both demanded intellectual and emotional control and were committed to reason, in Baal and Cardillac they

chose to portray characters driven by an emotional instability which in the end brings about their own destruction.

It is curious then that it is these two artists who, at least in theory, were particularly committed to the idea that art was possessed of a function more important than the realization of its own excellence. Neither Brecht nor Hindemith was in any way an ivory tower artist, though both became sadly pedagogical in their later years. Just as Hindemith played in jazz bands, in night clubs, in chamber ensembles, appeared as soloist and conductor and generally lived the hectic life of an all-round musician, so Brecht, instead of retiring into solitude to produce his plays, worked always within the theatre itself, arguing, directing, designing, and being what is most generally called 'a total man of the theatre'. Neither of them has quite recovered from the misconceptions arising from the tag phrases pinned on them in their early careers. To think of Brecht is to think of the 'Verfremdungseffekt' the 'alienation effect', to think of Hindemith is to think of 'Gebrauchsmusik'. As late as 1951 in the preface to his book *A Composer's World* Hindemith admits to still being dogged by that old tag.

Let me show you how harrassing a situation may arise out of this ostensible incorrigibility of former statements. A quarter of a century ago, in a discussion with German choral conductors, I pointed out the danger of an esoteric isolationism in music by using the term Gebrauchmusik. Apart from the ugliness of the word—in German it is as hideous as its English equivalent, workaday music, music for use, utility music, and similar verbal beauties—nobody found anything remarkable in it, since quite obviously music for which no use can be found, that is to say useless music, is not entitled to public consideration anyway and consequently the gebrauch is taken for granted. Whatever else I had written or said at that time remained deservedly unknown. . . . The slogan *Gebrauchsmusik* hit me wherever I went, it had grown to be as abundant, useless, and disturbing as thousands of dandelions in a lawn.[3]

Brecht, also, especially in *The Messingkauf Dialogues*, goes to some lengths to explain that the popular conception of what the 'alienation effect' is all about is far from accurate. It was used as an attitude toward the theatre, in relation to modern drama, and was not put forward as a 'method'. Both 'Verfremdungs-effeckt' and 'Gebrauchsmusik' are related to the general philosophies of the playwright and composer; they do not relate to a formal system, as do the principles of Cubism on the one hand and the twelve-tone system of Schoenberg on the other.

The alienation effect is largely the concern of the performer, not the audience. It consists mainly in a manner of acting which reduces the identification with one

heroic or tragic character—in a way it is an anti-star system and produces a social relevance even in those plays seemingly furthest removed from the concept of socialism.

The new theatre appeals to social man because man has helped himself in a social way technically, scientifically and politically. It exposes any given type together with his way of behaving, so as to throw light on his social motivations; he can only be grasped if they are mastered. Individuals remain individual, but become a social phenomenon; their passions and also their fates become a social concern. The individual's position in society loses its God-given quality and becomes the centre of attention. The A-effect is a social exposure.[4]

The 'concertante' element in Hindemith's works is surely based on much the same principle.

In the confused world of Berlin—indeed middle Europe as a whole—during the 1920s it is scarcely surprising that artists made use of a form of savage satire. Both Brecht and Hindemith made considerable excursions into this field, though within the arts it is perhaps the painter Georg Grosz who is the supreme manipulator of this form of invective. In Hindemith and Brecht the satire is perhaps a little too jolly. Hindemith's opera *News of the Day* mocks at the moral standards of the well-heeled private citizen by inverting all the usual celebration rituals. Adultery, divorce and permissiveness riotously take the place of marriage, faithfulness and romantic love. And it is not merely the text that inverts the situations but the musical devices, which make great play with variations on and perversions of those musical elements usually connected with the traditional moral situations. Brecht's *Threepenny Opera*, like *The Rise and Fall of the City of Mahagonny*, underscores the corruption of officialdom. But if *The Threepenny Opera* is the work that for a long time was the most popular of Brecht's compositions it is undoubtedly more by reason of the haunting musical score by Kurt Weill than because of Brecht's words.*

Despite the international success of some of the large-scale works, it is within the smaller and more intimate productions that the finest inspiration of these two artists is poured out during the 1920s, the poems of Brecht and the chamber music of Hindemith—in particular the seven concertos by the latter beginning with the Chamber Music no. 1 of 1922 and closing with the Concerto for Organ and Orchestra of 1928. In these works we not only see the astonishing

* Indeed I am aware that for many people it is the composer Kurt Weill who would seem the musician closest to Brecht, since he produced music for so much of the poet's work, music which is usually astonishingly appropriate and successful. But in spite of this he does not seem to me to be fundamentally of the same creative cast of mind.

contrapuntal brilliance of the German composer but we are also aware of his abundant good humour. If his jokes are sometimes a little heavy they usually have a point, and there is about these works the sheer joyousness of music-making that is so often sadly lacking in the works of the followers of Schoenberg. But the vitality and good humour do lead the composer sometimes perilously close to a manner of jovial banality which is saved only by the dexterity and technical virtuosity of his craftmanship. These scores are 'absolute' in much the same way as are the concertos of the Baroque period, and perhaps because of that they escape some of the high moral seriousness that is to become increasingly apparent in Hindemith's later compositions. This preoccupation with the morality of the artist is shown in its most elaborate form in the opera *Mathis der Maler*, just as the major predicament of the artist or scientist is shown at its richest in Brecht's drama *The Life of Galileo*.

We see once again in these two large-scale works an almost exact parallel between the two artists, both in the choice of subject matter and the method of dealing with it. From the exploration of the totally selfish acts of the artists or craftsmen in *Baal* and *Cardillac* we now see Brecht tackling the moral dilemma of Galileo confronted with the choice of expediency or death and the painter Mathis (Grünewald) concerned during the Peasants' Revolt with the problem of the role of the artist within a society in a ferment—whether to concentrate on his art or become personally and actively engaged with the social struggle.

In choosing these subjects for exercises in the epic style they both perhaps fall into the error of selecting themes which are properly those of secondary epic as opposed to primary epic. In this they highlight the fact that for the twentieth century the tragic hero is not acceptable. Both Mathis and Galileo for different reasons and with a different degree of integrity reject the decisions that would annihilate them but which would enlarge their stature. In the choice of these models they mirror fairly clearly their own personal moral and artistic predicaments. In the case of Hindemith the choice of Mathis is surely that of the artist wanting to go out into the populace and experience, suffer and rejoice with them—to enter into the body politic and help to refine it—but who because the times are inimical to the success of such an action is finally forced to retreat to his studio in the hope that perhaps his art alone, or his ideas about art, will ultimately perform the miracle which he could not in person. Brecht, one of the most expedient of men, chooses the scientist Galileo who rejects death (martyr-dom?) partly because he values his own life and flesh very greatly but also because he realizes that by the expediency of the moment there is a possibility of his work's having a greater chance of success in the future.

Despite the undoubted stature of *Mathis der Maler* and the *Life of Galileo* the two works are flawed in a similar way, and the flaw is related entirely to the

artist's concept of his role in the modern world. The expository element in both works holds the audience at bay for too long. In *Galileo* the opening scenes, though comparatively short, can nevertheless seem much like a very long, boring lesson in elementary astronomy and in spite of the skittishness, the wide-eyed hypnotized admiration of the young boy as Galileo explains the movements of the heavenly bodies can seem as sentimental as that classical Victorian stock sentimental picture *The Boyhood of Raleigh*. This kind of effect in the theatre is managed far more successfully by Bernard Shaw, not because he is a better dramatist than Brecht but because he is a wittier lecturer.

Brecht is really distrustful of the powerful effects of individual charisma which seduces reason, but he is very concerned for 'empathy'. This empathy can be achieved without the necessity for the audience to abandon its critical or reflective qualities. Or can it? In the West at least it would seem that it can do so only very fitfully, for in recent years the so-called director's theatre, or producer's theatre, or designer's theatre, or even writer's theatre have still lacked that power over the audience which the actor's theatre had. The playwright coming closest to Brecht's ideal would, perhaps strangely enough, seem to be Chekov, in whose plays the audience can almost seem to become a part of the lives of the characters on the stage without being dominated by them. The conflict, or argument, between the ideal theatre of Brecht and the ideal classical theatre is that between reason and faith. It is perhaps in this respect that Hindemith and Brecht as they develop gradually part company, for Brecht sees the growth of reason as necessary to *replace* man's reliance upon faith, whereas Hindemith would seem to believe that in a subtle way the development of reason *enhances* an understanding of faith.

Reason, as Brecht points out in *Galileo*, is related to proof:

SAGREDO: So that there are only stars there!—And where then is God!

GALILEO: What do you mean?

SAGREDO: God! Where is God?

GALILEO *angrily*: Not there! Any more than he could be found on earth, if there were beings up there and they were to seek him here!

SAGREDO: Then where *is* God?

GALILEO: Am I a theologian? I'm a mathematician.

SAGREDO: First and foremost, you are a man. And I ask you, where is God in your universe?

GALILEO: In us or nowhere.

SAGREDO *shouting*: As the heretic Giordano said?

GALILEO: As the heretic Giordano said.

SAGREDO: That was why he was burnt! Not ten years ago!

GALILEO: Because he could prove nothing. Because he only stated it.—
Signora Sarti!

SAGREDO: Galileo, I have always regarded you as a shrewd man. For
seventeen years in Padua and for three years in Pisa you
patiently instructed hundreds of pupils in the Ptolemaic
system which the Church supports and the Scriptures, on
which the Church is founded, confirm. You thought it untrue,
like Copernicus, but you taught it.

GALILEO: Because I could *prove* nothing.

SAGREDO *incredulously*: And you believe that makes a difference?

GALILEO: All the difference in the world! Look here, Sagredo. I believe
in mankind, and that means I believe in its commonsense.
Without that belief I should not have the strength to get up
from my bed in the morning.

SAGREDO: Then I will tell you something. I do *not* believe in it. Forty
years among men has consistently taught me that they are not
amendable to commonsense. Show them the red tail of a comet,
fill them with black terror, and they will all come running out
of their houses and break their legs. But tell them one sensible
proposition, and support it with seven reasons, and they will
simply laugh in your face.

GALILEO: That is untrue—and a slander. I cannot understand how you,
believing such a thing, can yet love science. Only the dead are
no longer moved by reason.[5]

This being so, proof is related to demonstration. If I say my proposition is
reasonable and then am asked for proof then I have to become involved in a
demonstration. Brecht's plays, as one would expect, are therefore magnificent
in demonstrations, as are the plays of Shaw. Their essential relevance to
twentieth-century culture lies in their accepting the importance of the 'how'
questions and to some extent their disregard of the 'why' questions. It is perhaps
for this very reason that it was essential for Brecht to choose a character like
Galileo in preference to a man like Giordano Bruno because even though Bruno
suffered the tragic consequence of holding to his beliefs he could not prove them
to the satisfaction of his inquisitors. Galileo on the other hand by neat demon-
stration could. He not only could but did say 'this is how it works.' He was then
able to be expedient and avoid death at the hands of the Church by the exercise
of his cunning. He recanted in the knowledge that what had been demonstrated
could not forever be ignored; that knowledge cannot be unwound. Both Galileo's
predicament and his resolution of it closely resemble the political predicament

and its solution in Brecht's last years of life. Historically this is a dubious proposition because a good deal of knowledge does seem to have been unwound, but for the purpose of Brecht's plays and, in particular, *Galileo*, it is more than adequate.

Brecht's propositions are also propositions toward harmony and order, though the harmony and order is to be many-faceted and capable of shifting its centre. It is not to be an imposed harmony and order differing from that of the past only by the distinction of a new set of rules. This is equally true of the preoccupations, in music, of Paul Hindemith, and it is fascinating that the second of the big operas should be *Die Harmonie der Welt*, which is based on the life of another astronomer, Keppler. This has not held the stage and like *Mathis der Maler* is mostly known through the symphony drawn from it. Of these operas of our time which initially became widely known through suites or symphonies made from them—*Wozzeck*, *Mathis der Maler*, and *Die Harmonie der Welt*—only the first has established itself on the world operatic stages. There is some reason for this. Metaphysical arguments, intellectual discussions, or any overt attempt to solve moral or ethical problems, seem to fit uncertainly within this curiously ambiguous art form. Those operas which succeed most—of which perhaps the classic example is Mozart's *Marriage of Figaro*—do so because the process of the argument seems to arise naturally from the characters who body it forth. But in *Mathis der Maler* the people appear to be there merely as mouthpieces for the ideas of the author, and to that extent we are the less compelled by it. In the opera house our reasons are engaged but our emotions are rarely disturbed, so that the true power of the work really impinges upon us only in the big set pieces, where we are suddenly swept along by a broad stream which seems to mingle the intellectual and emotional problems, or in those moments of gentleness where ethical considerations are forgotten and a purely human and simple situation is presented. In those moments Hindemith's melodic gift is beautifully capable of realizing his lyrical inspiration. The dramatic effect in *Mathis* of the scene of the Temptation of St Anthony which inspires some of Hindemith's most compelling music is mirrored in *The Life of Galileo* by that astonishing scene in which Pope Urban VIII has received the Cardinal Inquisitor and, during the Audience, is being robed. For through this brilliant tableau we become aware of the pomp and paraphernalia of the Church of the time in relation to the possibility of a scientific future and, more important, the fragility of a man's life. It is the more significant in that it is a major scene in which Galileo does not appear but over which his presence hangs with something of that power that perhaps Brecht would wish to disown.

Galileo like *Mathis der Maler* moves closer to the possibility of modern epic than a work like Brecht's *Mother Courage*, if only because the range of ideas

explored within it is greater and because it has about it a certain heroic element that is lacking in the more popular war play.

But *Mother Courage* once again shows us that its major effect is achieved at these moments when Brecht's desire for an 'alienated' audience is least strong. The more we become absorbed by and identify with Mother Courage herself the more power the play has to move us. Similarly in *The Caucasian Chalk Circle*; the tedium of the argument becomes more bearable at those moments when we suddenly feel emotionally engaged by the problems, suffering or joy, of the people on the stage.

In the West the gulf between the artisan and the artist has perhaps grown too wide to be bridged within the work of one or two figures, however major and important they may be. There is in Eastern countries considerably less distinction between the fine and the applied arts. Brecht, who was deeply influenced by the art of 'alien' cultures, very clearly sensed this and to a great extent was attempting to restore something of this balance without merely retreating into a mock-eighteenth-century style. He saw indeed, as he expressed tersely in the *Messingkauf Dialogues*, that 'nothing is irrelevant to society and its affairs.' But the removal of God or the removal of the tragic hero requires something significant to be put in their place. The most enlightened committee or hierarchy of mortals does not seem to be a satisfactory replacement as yet for 'God', however inscrutable or unsatisfactory we may find 'him' to be. Nor does expedient man seem to be a satisfactory alternative to the flawed tragic hero.

In spite of the 'remoteness' of much of the work of Eliot, Picasso, and Stravinsky, there is in a great deal of it a considerable emotional undertow which still seems to be an element required by the public. In the works of Brecht and Hindemith there is a shying away from this but what is put in its place is not so much an appealing and delightful exuberance as a kind of rather contrived jollification. There is a slight air of condescension. This continuing desire on the part of audiences for an emotionally charged form of artistic expression is demonstrated in the extraordinary growth of interest in the symphonies of Mahler and in the rather belated revival of interest in the powerful, anxiety-ridden plays of Eugene O'Neill. What is unnerving is the spectacle of a considerable audience willing not merely to share the emotional hysteria of those artists but to wish to suffer the flagellant neurotic excesses of more recent but not less powerful figures.

GIACOMETTI BECKETT BACON

This is what I think: that an untruth of a kind that enhances power holds its own against any ineffectively virtuous truth. And I mean too that creative genius-giving disease, disease that rides on high horse over all hindrances, and springs with drunken daring from peak to peak, is a thousand times dearer to life then plodding healthiness. I have never heard anything stupider than that from disease only disease can come. Life is not scrupulous—by morals it sets not a fart. It takes the reckless product of disease, feeds on and digests it, and as soon as it takes it to itself it is health. Before the fact of fitness for life, my good man, all distinction of disease and health falls away. A whole host and generation of youth, receptive, sound to the core, flings itself on the work of the morbid genius made genius by disease: admires it, praises it, exalts it, carries it away, assimilates it unto itself and makes it over to culture . . .

Thomas Mann, *Dr Faustus*.

If, to adapt George Orwell's classic remark, inside every fat artist there is a thin artist clamouring to get out, then nowhere is the truth of this more clearly demonstrated than in the work of the sculptor Giacometti and the novelist/playwright Samuel Beckett. Both also illustrate in their different ways the nihilistic nature of T. S. Eliot's *hollow men*, for whom the world indeed ends not with a bang but a whimper. With the possible exception of Paul Klee, Alberto Giacometti is the most famous Swiss artist, and like Klee he did not find the full flowering of his genius until he had left his own country and settled abroad. It was in Paris too, where Giacometti lived in the final years of his life, that Beckett, expatriate Irishman, grew to discover his mature lean style; a style which like that of the later Giacometti, moves so far away from the gross substance of his earlier work as to become almost nothingness.

Whether or not the family background and early life of an artist is of any particular importance in his subsequent development is open to question, but certainly Giacometti is somewhat unusual in coming from a family already

possessed of two remarkable artists, his father Giovanni and Giovanni's second cousin Augusto, as well as Alberto's brothers Diego and Bruno who where both possessed of considerable artistic gifts. It was also a well-to-do family and there was no pressure on Alberto to attempt to make a living. Like Mendelssohn he overcame his good fortune and in spite of such a benevolent providence came, if late in life, to be hailed by many discerning critics as one of the most remarkable sculptors of the twentieth century.

The influences and styles helping to shape Giacometti's work are brilliantly shown in the series of small monochrome illustrations at the end of Reinhold Hohl's book on the artist. Undoubtedly the two most important figures among his early allegiances were Cézanne and Hodler. In discarding Hodler, Giacometti began the diet that was to slim down the fatness of much late German romanticism and release the thin refined man of the Parisian intellectual ideal. But Giacometti's final rejection of post-Hellenic art, and his growing admiration for the art of certain primitive cultures, stimulates a very different development from that of Cézanne whose work shows a constant refinement upon, and draws most of its inspiration from, the great classical masters of Europe.

Giacometti was an astonishingly precocious painter—in his use of watercolour perhaps as astonishing as any artist of our time; there are early paintings and drawings which show a mastery as great, almost, in their different media and styles, as that of the young Picasso. The manner of Cézanne, especially Cézanne's realization of trees in a landscape, is remarkably well caught. But unlike Cézanne Giacometti was to develop first and foremost into a sculptor and not primarily into a painter, and for a long time in his middle years it seems as if he got lost amongst the exceedingly powerful influences of Arp, Brancusi, Lipchitz, Duchamp, *et al*. However effective the work of these artists may have been in developing the manipulative powers of Giacometti they seem to have left very little residual effect, for his late work relates much more closely to the early portrait head of his mother and to other naturalistic sculptures produced between 1914 and 1920 than to the abstract sculptures produced between 1925 and 1940. What is surprising, perhaps, is to see not less in the late attenuated sculptures than in the powerful, emotional, early heads, the influence of the humanist sculptural tradition as so magnificently exemplified in the work of Auguste Rodin. What seems to be the major benefit from the years Giacometti spent in producing totally abstract works is his ability to create tension within the space of the objects displayed before the viewer. If Henry Moore is the first great master to invest the holes in a piece of sculpture with a power indistinguishable from the power of the solid object, then Giacometti is the first artist of genius to establish a similar mysterious value within the spaces that separate his standing or walking figures. Rodin's groups of figures for all their cumulative

power do not charge the spaces between them with the significance of the multiple sculptures of the modern Swiss artist.

It may seem totally heretical to suggest of so dedicated an artist that during that period when he became involved with Surrealism and abstract art there is a strange air of the dilettante about the work he produced. There seems to be an element of choice about his style that is rarely detected in work of the first order. The various standing figures of men and women produced between 1926 and 1927 in the manner of Archipenko have undoubtedly an authority of style and structure but seem to lack the compulsive passion of the work of Archipenko himself. Nor does the extraordinary *The Table*, for all its shock tactics and its deliberate quotations from the work of so many of Giacometti's friends, create the *frisson* of the most successfully unnerving paintings of René Magritte. There is a sense in which it can be said that for so many artists between 1910 and 1930, whether in the field of the novel, the poem, painting, sculpture or music, the intellectual idea too often got in the way of the actuality of the work being produced. It was not until the 1940s that the Giacometti who is instantly recognizable as Giacometti and no one else started to make his first appearance, in particular in the drawings and sketches for future sculpture.

It is easy reading Samuel Beckett's *How It Is* to wish indeed that this were how it was not; or watching *Come and Go* fervently to wish that so brilliant an author had not come to this going point. The growth, or decline, from the early Beckett of *More Pricks than Kicks* to the almost non-existence of the latest works is a fascinating example of a writer feeding incestuously on his work and seeming to be wilfully blind to the debilitating effect of such obsessive exclusiveness.

More Pricks than Kicks was published in 1934 and unlike most of the later works of this author was composed in English. Comparatively little attention was paid to it at the time and when it went out of print it remained so until 1970, long after Beckett had become internationally famous with the play *Waiting for Godot*. Like the novels *Murphy* and *Watt* and indeed like *Waiting for Godot* itself, *More Pricks than Kicks* has much grace and above all an abundant humour, qualities which get rarer and rarer in Beckett's later and more perverse works. Of course it may be that the curious Mr Beckett may consider the more recent pieces to be comedy of a kind. It is Erskine in *Watt* who has much that is relevant to say about laughter, indicating very early on in the author's work just what might be in store:

Of all the laughs that strictly speaking are not laughs, but modes of ululation, only three I think need detain us, I mean the bitter, the hollow and the mirthless. They correspond to successive, how shall I say succes-

sive . . . suc . . . successive excoriations of the understanding, and the
passage from the one to the other is the passage from the lesser to the
greater, from the lower to the higher, from the outer to the inner, from
the gross to the fine, from the matter to the form. That laugh that now is
mirthless once was hollow, the laugh that once was hollow once was
bitter. And the laugh that once was bitter? Eyewater, Mr. Watt, eyewater.
But do not let us waste *any more time* with that, Mr. Watt. No. Where
were we. The bitter, the hollow and—haw! haw—the mirthless. The bitter
laugh laughs at that which is not good, it is the ethical laugh. The hollow
laughs at that which is not true, it is the intellectual laugh. Not good!
Not true! Well, well. But the mirthless laugh is the dianoetic laugh, down
the snout—haw!—so. It is the laugh of laughs, the *risus purus*, the laugh
laughing at the laugh, the beholding, the saluting of the highest joke, in a
word the laugh that laughs—silence please—at that which is unhappy.[1]

Note the important exhortation in the significant place, 'silence please'. Mr
Beckett is never anything if not in earnest and his mirthless laughter wheezes
through the arid dust of his most recent work.

More Pricks than Kicks, though in some ways more of a collection of episodes
than a novel proper, is written in a fairly traditional manner as far as language is
concerned and it makes comparatively few demands on the reader. There is
plenty of flesh on the bones. Life, though often gross, still has something to
commend it, and in this way it is not unlike Joyce's *Dubliners*, for both of them
can be read for enjoyment without the niggling consideration as to whether or
not they are 'literature'. Significance has not yet raised its ugly head. Indeed the
very first experience suffered by Belacqua, who is the main character in the
book, mirrors only too well that of the common reader faced with the im-
penetrable stream-of-consciousness prose of which the last short novel of Beckett
is made up.

The forthcoming humour of *More Pricks than Kicks* is beautifully pointed by
the opening:

It was morning and Belacqua was stuck in the first of the canti in the moon.
He was so bogged that he could move neither backward nor forward.
Blissful Beatrice was there, Dante also, and she explained the spots on the
moon to him. She showed him in the first place where he was at fault, then
she put up her own explanation. She had it from God, therefore he could
rely on its being accurate in every particular. All he had to do was to
follow her step by step. Part one, the refutation, was plain sailing. She
made her point clearly, she said what she had to say without fuss or loss of
time. But part two, the demonstration, was so dense that Belacqua could

not make head or tail of it. The disproof, the reproof, that was patent. But then came the proof, a rapid shorthand of the real facts, and Belacqua was bogged indeed. Bored also, impatient to get on to Piccarda. Still he pored over the enigma, he would not concede himself conquered, he would understand at least the meanings of the words, the order in which they were spoken and the nature of the satisfaction that they conferred on the misinformed poet, so that when they were ended he was refreshed and could raise his heavy head, intending to return thanks and make formal retraction of his old opinion.

He was still running his brain against this impenetrable passage when he heard midday strike. At once he switched his mind off its task. He scooped his fingers under the book and shovelled it back till it lay wholly on his palms. The Divine Comedy face upward on the lectern of his palms. Thus disposed he raised it under his nose and there he slammed it shut. He held it aloft for a time, squinting at it angrily, pressing the boards inwards with the heels of his hands. Then he laid it aside.[2]

But at least at the end of Belacqua's studies he would have gone, with much excitement and pleasure mixed with certain tracts of boredom, through a huge masterpiece worthy of his labours, whereas it is possible to suspect that the labour required to comprehend the meaning and purpose of *How It Is* is hardly justified. Almost immediately after putting aside the volume of Dante we come across the action of Belacqua making toast, which almost seems to be the story in little of Beckett's attitude to art as expressed through his lifetime of writing. Belacqua abominates underdone toast (soggy romanticism?) 'If there was one thing he abominated more than another it was to feel his teeth meet in a bathos of pith and dough.' He cuts the bread. 'He laid his cheek against the soft of the bread, it was spongy and warm, alive. But he would very soon take that plush feel off it, by God but he would very quickly take that fat white look off its face.' The toast is not merely to be brown and crisp, it is to be practically charred to a cinder. 'When the first candidate was done, which was only when it was black through and through, it changed places with its comrade, so that now it in its turn lay on top, done to a dead end, black and smoking, waiting till as much could be said of the other.' But even in this early work, written with elaborate gusto and we may suppose enjoyed enormously by its author, there is too great an evidence of artifice. During those episodes which are not of the best quality there is a tedious air of stylistic manipulation. It is as if the author, like a conjuror in a bad patch in a juggling act with all the balls in the air at once, has difficulty in not falling flat on his face and making a fool of himself. This of course may be said to be a rather prevalent condition where many Irish writers

are concerned. It is curious that while they are talking more than anyone else they are usually bitterly complaining that other people will go on so. In *More Pricks than Kicks* Beckett, in his early works more riotous in words than most writers since Joyce, again perhaps foreshadows his later development when he says 'Who shall silence them, at last? Who shall circumcise their lips from speaking, at last?'

There is still a great deal of fatness and exhuberant comedy—though it is more often a sad comedy, almost a tragic comedy—in Beckett's second full-length prose work, *Murphy*, which was published four years later in 1938. Joyce is still very much to the fore, not so much in the language itself as in the character drawing. The structure of the novel is clearer, the comedy arises out of the situations rather than overlaying it and there is a much more satisfactory sense of purpose throughout the work. It is not formally as powerful as it could be for there is a certain discrepancy between the weight of the beginning and that of the end, but it is a rich and full book and contains much profound insight into character and behaviour. Too often, though, the reader is exasperated by the author's nudge at his witticisms, the wink at his cleverness:

> Miss Counihan sat on Wylie's knees, *not* in Wynn's Hotel lest an action for libel should lie, and oyster kisses passed between them. Wylie did not often kiss, but when he did it was a serious matter. He was not one of those lugubrious persons who insist on removing the clapper from the bell of passion. A kiss from Wylie was like a breve tied, in a long slow amorous phrase, over bars' times its equivalent in demi-semiquavers. Miss Counihan had never enjoyed anything quite so much as this slow-motion osmosis of love's spittle.
>
> The above passage is carefully calculated to deprave the cultivated reader.[3]

Of course to remove the asides by the omniscient and omnipresent author would be to destroy a large area of the pleasure given by the book and reduce the author's purpose, but it is sometimes a bit too much of a bad thing. If the scene of Murphy's sojourn in the Magdalen Mercy Mental Seat is rather too drawn-out, the concluding pages of this black comedy are shockingly well contrived. The false conventional beauty of grief and respect for the dead play no part in Beckett's sardonic mind and the contemptuous humour of Murphy's own wish that his ashes should be thrown down the lavatory pan in a well-known theatre and flushed away while an important incident was going on, is turned the more sour by the actuality in which the bag of ashes having been carried into a pub is finally split open in a brawl and trampled amongst the sawdust, beer and vomit.

The first twenty-five pages of *Watt* make up perhaps the most brilliantly

sustained comic scene in the whole of Beckett, but the first long paragraph given to Mr Spiro is an ominous murmuration of voices, not spoken by Spiro but heard by Watt during Spiro's speech. The first sign of those endless repetitions which must inevitably force the average reader over the edge of enjoyment into the abyss of boredom. To read them thoroughly is pointless. Not to read them thoroughly makes the writing of them pointless.

In Lucky's famous speech in *Waiting for Godot* the repetition spoken on the stage rises into a form of hypnotic incantation and is unnervingly effective, but in the novels those areas in which the author catalogues names or repeats instructions are merely deadening. They lack the movement and swell to a purpose which is the redeeming feature of such similar devices within the greater works of James Joyce, and they exhibit a sad and, in the end, pathetic paranoia. In nearly all cases what might have been vigorous is turned to a sort of whining self-pity by Beckett's constant obsession with his excremental vision of life.

An ordure, from beginning to end. And yet, when I sat for Fellowship, but for the boil on my bottom . . . The rest, an ordure. The Tuesday scowls, the Wednesday growls, the Thursday curses, the Friday howls, the Saturday snores, the Sunday yawns, the Monday morns, the Monday morns. The whacks, the moans, the cracks, the groans, the welts, the squeaks, the belts, the shrieks, the pricks, the prayers, the kicks, the tears, the skelps, and the yelps. And the poor old lousy old earth, my earth and my father's and my mother's and my father's father's and my mother's mother's and my father's mother's and my mother's father's and my father's mother's father's and my mother's father's mother's and my father's mother's mother's and my mother's father's father's and my father's father's mother's and my mother's mother's father's and my father's father's father's and my mother's mother's mother's and other people's fathers' and mothers' and fathers' fathers' and mothers' mothers' and fathers' mothers' and mothers' fathers' and fathers' mothers' fathers' and mothers' fathers' mothers' and fathers' mothers' mothers' and mothers' fathers' fathers' and fathers' fathers' mothers' and mothers' mothers' fathers' and fathers' fathers' fathers' and mothers' mothers' mothers'. An excrement.[4]

In his highly personal and to a large extent perverse essay on Proust he writes, 'Tragedy is not concerned with human justice. Tragedy is the statement of an expiation, but not the miserable expiation of a codified breach of a local arrangement, organised by the knaves for the fools. The tragic figure represents the expiation of original sin, of the original and eternal sin of him and all his

'socii malorum', the sin of having been born.'[5] But tragedy requires conflict as comedy requires action, whether physical, intellectual or both, and it is conflict and action that Beckett discards so drastically in his later work.

To read the novels and plays of Beckett as individual self-sufficient works is a mistake, for they are a continuous and developing panorama in the manner of Proust's *Remembrance of Things Past*; but whereas Proust for all his neurotic melancholy celebrates the varied flow of life in all its creative and forceful nature, Beckett's huge prose work is a long day's dying: a dying without struggle but with much complaint. In all the most direct passages the dominant image is that of the dunghill: 'but its a change of muck. And if all muck is the same muck that doesn't matter, it's good to have a change of muck, to move from one heap to another one from time to time, fluttering you might say, like a butterfly, as if you were ephemeral.'[6]

But in the end the reader is perhaps forced to the speculation that the weakness of Beckett lies in a misconception of the dungheap, which is after all a breeding ground out of which, not only the squalors but also the beauties of the world can grow. What he offers finally is not the useful, fructifying energy of dung but the sterility of vomit.

Molloy, from which that paragraph is taken, is perhaps the most successful and wide-ranging of the prose works of Beckett, being in the form of an enormous wave-swell of language perhaps more extraordinary because it is the first of his books to be written in French. We see also more clearly in *Molloy* than in the earlier novels that Beckett's philosophical concern is with the horror of a continuous existence; an existence which may not be entirely personal. The persisting being might merge, change and re-emerge into and out of other persisting beings. In the paragraph quoted above it will be noticed that he says 'fluttering you might say, like a butterfly, *as if you were emphemeral*'. Alas no, we are all, says Beckett in this modern version of Dante's *Divine Comedy*, perpetually crawling round and round one or other of the circles of hell. It is very difficult to conceive the possibility of Beckett's writing a concluding heaven.

Francis Doherty in his book on Beckett prefaces the chapter on *Molloy*, *Malone Dies* and *The 'Unnamable'*—which he very appropriately calls 'Moribunds in their courses'—with this comment dealing with Beckett's literary purpose.

What Beckett traces in the course of this trilogy of novels is the search for self, a hunt for identity by writers through writing. By choosing characters who all pursue a meaning for their existence and who can be seen in states of decay and asylum from the ordinary world, Beckett more and more closely approaches the problem of the writer who uses writing in order to avoid the eventually inevitable task of facing himself. But facing oneself, if

one's existence is only that of a writer of stories, is facing that which will constantly escape definition when all the stories are taken away.

The trilogy is a gradual approach towards the problems of the nature of the self, the nature of language, the nature of creation. All provisional answers must be discarded, all provisional foundations dismantled.[7]

It is possible to wonder whether in fact Beckett ever will face himself and indeed whether he ever will face life as it is, for the existence about which he writes is of such spectacular limitation as to be, in the last resort, almost a deception. His work exhibits remarkably well the progress that so much art and literature has taken since the eighteenth century—which might be called a progress from public conscience to private neurosis. To enter fully into Beckett's world is to inhabit a peculiarly nauseating neurosis that has none of the shock of drama nor the trauma of tragedy but the self-destruction of perpetual sickness. Its extraordinary power and fascination is at one and the same time perhaps a major achievement and a major disaster; its popularity a curious comment on the artistic desires of modern man.

Despite growing critical attention with the publication of each of the prose works and in particular the trilogy of *Molloy*, *Malone Dies* and the *Unnamable*, it is of course not for his novels that Beckett has become a figure known to the world at large but for his plays; this despite the fact that by comparison with the fiction the plays are perhaps in some way peripheral, with the obvious exception of the work that made his name internationally famous, *Waiting for Godot*. In spite of all the linguistic experiments and of the growth of a personal voice and personality in the novels, it was not until the bodying forth on the stage of those jocular tragedians who people *Waiting for Godot* that Beckett as an immediately identifiable figure took shape in the public mind. When Vladimir and Estragon come on to the stage at the beginning of that short poetic drama the hitherto narrowly circumscribed artistic world of Beckett becomes a general possession. Similarly when all the variations upon the forms of Archipenko, Arp, Magritte, etc., have been explored, it is through those strange pipe-cleaner figures, those pin-headed enigmatic personages, that the known Giacometti reaches out to us.

Giacometti's two significant stylistic developments are the removal of colour and the removal, as it were, of flesh; those qualities in a man's life which relate most positively to any kind of pleasurable existence in the world in which he exists. Let us look at the removal of colour first. Why should a painter wish to take away that element which seems to be of the very nature of painting? After all Giacometti was not saying that he wanted to stop painting and take up drawing (though in fact he did a great many very fine drawings) but he was saying that

he really wanted to paint without colour—he wanted greyness. But for Giacometti the greyness was not the abandonment of colour but the realization of the colours within the grey: 'I had to eliminate one colour after another, no—one colour after another dropped out, and what remained? Gray! Gray! Gray! My experience is that the colour that I feel, that I see, that I want to reproduce—you understand?—means life itself to me; and that I totally destroy it when I deliberately put another colour instead.'[8] Nevertheless for the observer, whatever the intention of the artist, the colour has been drained away. Because of this lack of colour there is a deadness about the later paintings of Giacometti; a deadness, not a lack of vigour. No matter who the models may be, there is a curious sense in which Giacometti seems to have burnt through their living beings and charred them so that what we see, though remarkable in likeness, powerful in stance and vigorous in emanation, seems to arise from their dead selves. They have about them something of that quality of living death which we see in Egyptian mummies, or in those two famous lovers forever exposed by the destruction of Pompeii. Similarly in the sculptures. Pitted, scarred, as if scraped by some excoriating wind they are existences after the holocaust. But like the characters and the philosophical ideas of Albert Camus they are erect, purposeful, and undefeated—or perhaps they are defeated but will never admit it. The eyes, which for Giacometti were the most important part of the head, and whose gaze he was at such pains to capture, stare through us. They do not meet our gaze with understanding nor do they let us communicate with them. They are the unblinking eyes of the characters in Sartre's *Huis Clos* who were deprived of the possibility of ever blinking and thus enjoying those thousands of tiny moments of sleep which our eyelids thankfully provide merely through their ordinary natural responses. Giacometti's figures never sleep; Giacometti's figures do not see the world; Giacometti's figures pour out of the great tunnel of blackness from which they stare the shock and terror which their experience of death has grafted eternally upon them. Without colour and without flesh. Perhaps one of the most disquieting personal comments by an artist is that made by Giacometti after his operation in 1963 for stomach cancer. Unlike most people suffering from cancer or fearing that they might suffer from cancer, he made no secret of it and indeed was not distressed by it. 'I'll tell you—really and truly, it was cancer. And the strange thing is—as a sickness I always wanted to have this one.' It is easy to say that there is a terrible and terrifying honesty about that remark—it is perhaps right to say that it is the remark of an honest and fearless man. I believe it is equally possible to say that it is a perverse remark and a self-indulgent one. The process of cancer is insidious and grows from such very tiny beginnings; the result is terrible, painful and emaciating. Giacometti suffered all this without complaint and in some way, as we have seen, welcomed the experience. Does the

progress of this disease not mirror the process of his art in his last phase? After all, those tall, emaciated, striding figures battling against the lacerations of existence, grow from the minute figures which Giacometti sculpted soon after the war and which were so small that he was able to carry them about in a match-box. Over and over and over again he worked with these tiny pebbles of clay producing little figures like fully fashioned germs of the giant cancer that was to destroy him and which was to become visible in the late sculptures.

But is it altogether meaningless or without purpose to ask if this is all that we should expect of the artist? Can this intense subjectivity generate a power great enough to produce works which thrust beyond their maker and exist and endure longer than the period in which such anxieties, such disease complexes, persist? For we have to accept that such works are the product not merely of the indi-vidual's innate sensibility but of that nature acted upon by the processes of society, and both Beckett and Giacometti have been desperately concerned with the problems of loneliness. Toward the end of his life Giacometti lived almost hermetically sealed within his room, gathering around him the kind of dust that one seems to detect has gathered and overlaid those figures in his paintings and drawings. The life of Beckett, in so far as we are permitted to know it, seems to be conditioned by a desire to remove itself from any contact with the healthy world outside. For we err surely if we believe that this world in which we live is totally ill; the illness, the disease, battens upon it but it is not an inalienable condition of it, and there is a sense in which artists like Beckett and Giacometti connive in the work of depredation on the human spirit and the body politic of mankind when they produce works of the kind that are so much praised at the moment. It is all too easy for us to laugh and perhaps to sneer at the work of certain nineteenth-century painters whose sentimental vision would make us believe that the world is a beautiful and rosy place and who obscure the terror of much of our lives behind a delicate gauze of artifice and make-believe. But just as their rosy world is not whole, so it is necessary for us to say that the hideous world that is created for us by such artists as Beckett or the emaciated and terrifying world painted or sculpted by Giacometti is also not whole, and we need sometimes to question their value as well as the quality of their art in relation to the philosophy which they seem to wish to disseminate.

It is quite a large step from those Rodinesque humanistic sculptures of Giacometti to the variations on Surrealist themes with which he played in the twenties and thirties and it is an even bigger step from those delightful games to the severe striding figures of his late men and women. It is interesting to note that most of the important works are male figures; the fecundity of the female form is for the most part avoided. The steps are huge and meaningful and the later figures are infinitely more important than the elegant sculptural tribalistic

games of the Surrealist phase, but we have to remind ourselves that the loneliness of individual man may be conditioned by man himself and may be in many cases a condition to which, perversely, he may aspire, rather than succumb. We might say that the abstract artefacts produced by mid-period Giacometti or the derivations from tribal customs remote from our own times—totems without purpose—have helped to *foster* loneliness, being all too often masturbatory playthings for the alienated human being locked within the sculptural inflexibility of his own skeleton. Giacometti appears to struggle against this condition almost in spite of himself. Perhaps to free oneself from loneliness the eyes which so fascinated Giacometti in the visage of man are more significant than the mouth, that orifice which fascinates with ever-increasing nauseous isolation the astonishing enigmatic writer who is Samuel Beckett.

From *Waiting for Godot* loneliness, and the babble of words which so often after years of appalling silence comes from the condition of loneliness, is the overriding theme of the works of Beckett. Godot is an eloquent, declining, beautiful prose poem for four characters on a stage. Its humour and its tragedy are enjoyable as well as bearable because Vladimir, Estragon, Lucky and Pozzo have not yet made that pact which will seal them forever into the horror of accepting horror and futility. Though they are incapable of decisions, they are foolish, they are lamentable, they might even be heroic; sometimes they are violent and they come close to being tragic but they do not yet whine.

Giacometti's identification with the creations of Beckett stretches back for a long time and is exceptional in its obsessiveness. At times their work seems to be linked almost as closely as the libretti of Hofmannsthal to the music of Richard Strauss. The public collaboration was most palpably demonstrated with the production of *Waiting for Godot* at the Odeon Theatre in Paris in 1963 when Giacometti was responsible for the stage set. It is not too fanciful to say that Giacometti was giving an environment to Beckett in gratitude for the characters that Beckett had provided for the sculptor. But although it is to Beckett that Giacometti's sculpture is so closely related, there is a tempering figure who adds an extraordinary dimension that is lacking in Beckett, and that is the existentialist philosopher Albert Camus. Camus infiltrates that redeeming essence of heroism which radiates from Giacometti's sculpture and which is totally absent from the characters of Beckett. It may be said that whereas Giacometti's figures may often appear to inhabit hell, Beckett's characters are inalienably *of* it, and partake of its very nature.

By the mid-1940s both Giacometti and Beckett had moved away from earlier Surrealist preoccupations and were developing their mature style, which is of an intense subjectivity. Finally, in both cases, this subjectivity becomes so obsessive as to amount to the exploitation of a purely personal and excessively narrow

private neurosis. As in Beckett's novels, so in the plays. The characters become more obsessive, more filled with self-disgust and more hysterical. It is tempting to say that they almost become more insane, for Beckett's world is one of such nausea and isolation as to appear almost to be an asylum in which his characters not only exist but in which they wish to exist. But at least in *Waiting for Godot* a melancholic humour and a sense of there being a world outside the area in which the characters wait, gives the play both in the philosophy (or the lack of philosophy) expressed by the characters, and the action (or the lack of action) undertaken by them, a greater sense of artistic reality. Although in *Waiting for Godot* neither Vladimir nor Estragon ever makes any of the choices that are open to them—to move away, to change their lives, to develop their characters—at least they do accept the fact that there is the possibility of action, of making a decision. There is a greater sensation of pace in the writing of the dialogue, which in consequence sets up more reverberations in the mind of the observer than do the succeeding plays with their narrower limits and their exhibition of a more disgusting and inescapable personal neurosis.

In the more extreme works of Beckett we see a creative writer attempting to make happen in a fictional present something of what is proposed by a reflective philosopher, especially those philosophers who put forward the idea that to attempt to make sense of the universe and man's existence within it is automatically a senseless occupation. But the philosopher, if he is proposing a philosophy of despair, is not himself partaking of that despair, whereas it would seem that Beckett enters into the despair and almost makes it tangible. The proposition is not 'this is how it might be' or even 'this is how it is, because I am telling you so' but the terrible, and at the same time futile, 'this is how it is.' Full stop. Beckett and Giacometti have been desperately concerned with man's loneliness; they have apprehended that progressively alienating tendency and have reflected it, but with such force and with such absolute determination that they seem to subscribe to its value rather than to oppose its viciousness. Beckett's characters are rarely whole. They have lost the use of their limbs, or their limbs have been amputated, or they are blind or deaf. They suffer in their own excrement, or they are merely breathing and pulsating plasma. If they do not exhibit physical castration and deformity they suffer a deformity in their inner beings by some mis-direction in the past, some chance not taken, some horror endured but which sears them too deeply ever to be forgotten or redeemed. Even their names are ugly and are spat out at us. There must be no sunshine, there must be no laughter; essentially there must be no love.

Beckett's relentless pursuit of a kind of pretentious intellectual sadism grows steadily more violent as his career progresses. The terrifying scenes between Lucky and Pozzo in *Waiting for Godot* are mild compared with the deliberate,

suppurating horror of the two old wrecks Nagg and Nell who exist in their dustbins in *Endgame*.

POZZO: Give me that! (*He snatches the hat from Vladimir, throws it on the ground, tramples on it.*) There's an end to his thinking!

VLADIMIR: But will he be able to walk?

POZZO: Walk or crawl! (*He kicks Lucky.*) Up pig!

ESTRAGON: Perhaps he's dead.

VLADIMIR: You'll kill him.

POZZO: Up scum! (*He jerks the rope.*) Help me!

VLADIMIR: How?

POZZO: Raise him up!
Vladimir and Estragon hoist Lucky to his feet, support him an instant, then let him go. He falls.

ESTRAGON: He's doing it on purpose!

POZZO: You must hold him. (*Pause.*) Come on, come on, raise him up!

ESTRAGON: To hell with him!

VLADIMIR: Come on, once more.

ESTRAGON: What does he take us for?
They raise Lucky, hold him up.

POZZO: Don't let him go! (*Vladimir and Estragon totter.*) Don't move! (*Pozzo fetches the bag and basket and brings them towards Lucky.*) Hold him tight! (*He puts the bag in Lucky's hand. Lucky drops it immediately.*) Don't let him go! (*He puts back the bag in Lucky's hand. Gradually, at the feel of the bag, Lucky recovers his senses and his fingers close round the handle.*) Hold him tight! (*As before with basket.*) Now! You can let him go. (*Vladimir and Estragon move away from Lucky, who totters, reels, sags, but succeeds in remaining on his feet, bag and basket in his hands. Pozzo steps back, cracks his whip.*) Forward! (*Lucky takes a step back.*) Turn! (*Lucky turns.*) Done it! He can walk.[9]

HAMM: Go and see is she dead.
Clov goes to bins, raises the lid of Nell's, stoops, looks into it. Pause.

CLOV: Looks like it.
He closes the lid, straightens up. Hamm raises his toque. Pause. He puts it on again.

HAMM: (*with his hand to his toque*) And Nagg?
Clov raises lid of Nagg's bin, stoops, looks into it. Pause.

CLOV: Doesn't look like it.
He closes the lid, straightens up.

HAMM: (*letting go his toque*) What's he doing?
Clov raises lid of Nagg's bin, stoops, looks into it. Pause.

CLOV: He's crying.
He closes the lid, straightens up.

HAMM: Then he's living. (*Pause.*) Did you ever have an instant of happiness?

CLOV: Not to my knowledge.[10]

In that vast monologue of Winnie in *Happy Days*—for the play is virtually a monologue—the degeneration seems to be greater because of the built-in contempt for everything that might make life purposeful or positive, and the equating of man with Pavlov's dogs is made the more sickening by the sniggering delight with which the author puts forward the proposition. And so through *Play*, through *All That Fall* through the later prose works *How It Is*, and the brief babble of *Not I*.

The creative minds of Beckett and Giacometti fed upon each other so that like the characters in a Beckett play Giacometti's figures often exist only above the waist or would seem to be only eyes immovable in an emaciated head. Similarly Beckett's characters gaze from the far side of their burnt-out lives as if through those staring eyeballs of Giacometti's sculptures. It is not surprising to discover that both of them were immensely impressed by the art of Francis Bacon.

When Giacometti saw the first major exhibition by Bacon he remarked that he felt almost like a dillettante, aware no doubt that the savage decadence of Bacon was even more implacable than his own. It is certainly not surprising that with Giacometti dead, Beckett's short play, *Not I*, should have as its sole visual aspect a great open babbling mouth—the screaming open mouth that is the symbol of Francis Bacon's most famous paintings. Confronted by the horror of the hysteria of the woman who is the voice of *Not I* speaking out of the darkness while that great mouth exists as the orifice for the idiot babble, it is not unreasonable, even when we are most shocked or seem momentarily to be most moved, to ask to what purpose are these extraordinary works put before us in the name of art and even more important to question why we, in the name of art, appear to embrace them with such a sick desire.

When Proust shut himself up in his cork-lined room he at least shut a large part of the world in with him; those Japanese paper flowers which he dropped into the glass of water by his bed blossomed, however artificially, in the silence of his room. But when Giacometti immured himself in his studio, pulling the curtains and allowing the dust to sift around him covering the furniture with grey powder so that he and the world in which he lived became as negative as that grey colourlessness which he finally exhibits in his paintings, he locked the

living, breathing world of mankind firmly outside the door. But perhaps it was in a way a heroic retreat into the stoic world of Camus the rebel. Beckett heaves maggot-like in his peculiar mixture of self-pity and self-disgust, recalling not so much the anger of the hero of Camus's *The Outsider* but the feeling of a sufferer from that horrifying affliction named by the hero of Sartre's first novel *Nausea*.

The first sight of Francis Bacon's *Pope I*, 1951, and the *Study after Velazquez's Portrait of Pope Innocent X* of 1953 set up strange tiny reverberations. Who is this? Where have we seen this face before? Is this a face we know? Is there a model? There are indeed many references and certainly one is reminded of a number of political orators of the past half-century and of Mussolini in particular, but there is also a curious residual likeness to Jean-Paul Sartre.

When Sartre sat for Giacometti he was astonished, so he tells us, when the artist detected in the head of the philosopher great strength, for Sartre had always thought his face to be rather flabby and soft. Whatever may be the reality of Sartre's face, or the reality of his philosophical being, there is no doubt that Giacometti exposed a certain rigorous forcefulness. But for all the shock tactics of Francis Bacon there is in his work a softness at the core. His images are invariably images of horror rather than terror, and within the semi-abstract areas of those rooms which produce a great deal of the total effect that so many of his canvases have on us, the figures contained in them are often depressingly deliquescent.

The work he produced in the 1930s is almost entirely decorative and related to applied art rather than to fine art, and it was not until 1945 that he exhibited the first of those canvases which, perhaps for the first time in history of painting, do not so much comment on the nature of pain and suffering as make visible before our eyes the very substance of pain itself. The three figures of *Three Studies for Figures at the Base of a Crucifixion* with their enigmatic part human, part animal, part vegetable shapes are pervaded with masochism. Whether these screams were the result and expression of an intense personal neurosis or whether they were indeed prophetic visions, it is certainly undeniable, as John Russell writes, that 'What once rang out like an individual cry of pain has been taken up, all over the world, as the first oboe's A natural is taken up by the whole orchestra.'[11] Whatever may be the case it is true that Bacon as a painter has been fortunate in being possessed by a gift and a vision which is absolutely appropriate, terrifyingly appropriate, we may say, to the experience of a large part of man's existence in the post-war world. The scream, the pain, the vulgarity of the flesh, the obscenity, seem all the more extraordinarily prophetic when the figures which express these emotions are confined within the thin lines of these cubes which cannot but recall the figure of Eichmann at his trial, protected within his glass box, or of various speech-making statesmen protected by glass

screens from the assassin's bullet. Removed however from such considerations, many of these devices, in especial the hanging tassel of the window blind in so many pictures, are neat intellectual tricks, intriguing, disquieting, but not absolutely integral to the real subject of the painting. The thin white lines of the cubes are all too often structures, arbitrarily imposed, hinting at a classical background within which a central subject wallows in its own romantic decadence. This is especially noticeable in *Seated Figure 1961* where there is a total absence of reason for the frame which surrounds the man in the chair and which bears no relation to the semi-naturalistic painting of the curtains and furniture.

The two most immediately observable influences appear to be those of Duchamp and Ingres—Ingres in the voluptuous nature of Bacon's approach to human flesh and early Duchamp in his attempt to show a body or a head in movement. Duchamp's paintings of the *Nude Descending a Staircase* for all their flickering brilliance seem to isolate each state of the movement in a series of overlapping images which are somehow devoid of rhythm. Similarly the attempt by Picasso to paint a portrait in profile and full-face at one and the same time, even when he is most successful, rarely produced an image that conveys the *shift* of the head, but shows merely two static positions imposed upon each other. Bacon does create in his many portraits of George Dyer, Isabel Rawsthorne and Lucian Freud, the very real impression of a head in the moment of turning, but he does so at considerable cost. The distortions are of a similar grotesqueness and while they may occasionally have about them a sense of imperiousness lacking in a great deal of modern portraiture, the emotional range is narrow and the sense of identification weak. Of course we have to accept that most major artists are obsessive, but we are in danger, when trying to assess the quality of twentieth-century art, of confusing the intensity and singleness of the obsession with the art itself, with the debilitating obsession with one's own personal neurosis.

There is a sensuality and voluptuousness about Bacon's painting of the nude that is made the more disturbing by the overwhelming sense of corruption with which he invests it. Like Antoine Roquentin, the protagonist of Sartre's first novel, Bacon seems only to emerge as a palpable and vibrant being at those moments when he is overcome by an emanation from the visible world of a sort of gross and pervasive sickness. 'Now I see; I remember better what I felt the other day on the sea shore when I was holding that pebble. It was a sort of sweet disgust. How unpleasant it was! And it came from the pebble, I'm sure of that, it passed from the pebble into my hands. That's it, that's exactly it: a sort of nausea in the hands.'[12]

'A sort of nausea in the hands.' And an intellectual determination to explore with aldoescent relish those aspects of man's nature which most usually cause revulsion. John Russell commenting on *Painting 1946* writes:

When Bacon painted the Museum of Modern Art's picture he produced as if in an echo chamber a scene which was many things in one. It was painted at a time in which Europe was one vast charnel house, France, Germany and Italy were like the field in front of Troy at the end of Troilus and Cressida, desolate places in which corpses were towed away like bulls at the end of a Corrida and Pandarus and Thersites were left alone to carry on as before. All over Europe Thersites' great cry held true, on the Unter den Linden, along the Naples waterfront and where accounts were settled in France, he had the essence of it 'Lechery, lechery; still wars and lechery; nothing else holds fashion.[13]

But it is not to Bacon that we could go for such a parallel but to Goya. The great cry of Goya was a cry of rage against such conditions. Bacon merely enters into the wound; he searches the wound out. He enjoys it—or so it seems. One of his earliest paintings is entitled *Wound for a Crucifixion* and many of his most powerful images arise from his study of a manual of diseases of the mouth. No, it is not Troilus and Cressida, those two sorry figures, to whom we should turn if we want a literary equation, but to Philoctetes whose tragedy was to suffer the horror of an unhealing wound, the stench of which was so great that even his friends could bear it no longer but abandoned him on an uninhabited island.

Although the late Herbert Read was one of the first critics to appreciate the extraordinary power of Francis Bacon's work and although as a critic and philosopher Read was constantly on guard against art's being tainted by considerations of the lowest common morality of a particular society at any given time, some words from his essay 'Art and Life' seem not inappropriate when considering the works of a painter like Bacon or a writer like Beckett:

Whether we are scientists or artists, our aim is what Wordsworth called 'Joy in widest commonality spread'; a society rid of its neurosis, a civilization rid of the threat of annihilating war. This aim will never be achieved by political legislation or by any form of totalitarian coercion. The change must come about organically, and must correspond to those vital laws which from the moment of birth determine the physical and psychological equilibrium of unfolding life.

These laws are known. It remains only to magnify them to the scale of our social problem, to animate them with that faith in life which is the final sanction of all human endeavour, life in its intimate recesses is intelligence, is creative, is art. But how shall we penetrate to these recesses and ensure that life's creative forces are liberated ?'[14]

This is not a plea for prettiness; it is not a plea for conventional beauty; it is not

a plea for decoration, or for the 'splendours of baroque'. But it is certainly a plea for a growth away from violence, and exploitation of violence in society, and it is a plea, taken in its context, for a renewal of the Tolstoyan artistic ethic. 'The task of art is enormous. Through the influence of real art, aided by science, guided by religion, that peaceful co-operation of man which is now maintained by external means—by our law courts, police, charitable institutions, factory inspection, and so forth,—should be obtained by man's free and joyous activity.'[15]

It is the life-giving celebratory quality that is almost entirely lacking from the work of Bacon, magnificent though certain aspects of the actual painting might be. Far from helping to produce 'a society rid of its neuroses' it helps to feed those neuroses. Its power is not that of the visionary seeing beyond the drab conformity and orthodoxy of most people's lives to a possible future irradiated by wisdom and love—the ecstatic vision perhaps of a St Augustine—but the reverse nightmare that the extreme obsessive modern artist often seems to wish upon the despised bourgeoisie. The most compulsive expression of this rejection of the so-called valueless life of little ordinary men and women is projected in the last astonishing visionary, decadent, passage in Sartre's *Nausea*:

How far away from them I feel, up on this hill. It seems to me that I belong to another species. They come out of their offices after the day's work, they look at the houses and the squares with a satisfied expression, they think that it is *their* town. A 'good solid town'. They aren't afraid, they feel at home. They have never seen anything but the tamed water which runs out of the taps, the light which pours from the bulbs when they turn the switch, the half-breed, bastard trees which are held up with crutches. They are given proof, a hundred times a day, that everything is done mechanically, that the world obeys fixed, unchangeable laws. Bodies released in a vacuum all fall at the same speed, the municipal park is closed every day at four p.m. in winter, at six p.m. in summer, lead melts at 335° C., the last tram leaves the Town Hall at 11.05 p.m. They are peaceable, a little morose, they think about Tomorrow, in other words simply about another today; towns have only one day at their disposal which comes back exactly the same every morning. They barely tidy it up a little on Sundays. The idiots. It horrifies me to think that I am going to see their thick, self-satisfied faces again. They make laws, they write Populist novels, they get married, they commit the supreme folly of having children. And meanwhile, vast vague Nature has slipped into their town, it has infiltrated everywhere, into their houses, into their offices, into themselves. It doesn't move, it lies low, and they are right inside it, they breathe it, and they don't see it, they imagine that it is outside,

fifty miles away. I *see* it, that Nature, I *see* it . . . I know that its submissiveness is laziness. I know that it has no laws, that what they consider its constancy doesn't exist. It has nothing but habits and it may change those tomorrow.

What if something were to happen? What if all of a sudden it started palpitating? Then they would notice that it was there and they would think that their hearts were going to burst. What use would their dykes and ramparts and power-houses and furnaces and pile-drivers be to them then? That may happen at any time, straight away perhaps: the omens are there. For example, the father of a family may go for a walk, and he will see a red rag coming towards him across the street, as if the wind were blowing it. And when the rag gets close to him, he will see that it is a quarter of rotten meat covered with dust, crawling and hopping along, a piece of tortured flesh rolling in the gutters and spasmodically shooting out jets of blood. Or else a mother may look at her child's cheek and ask him: 'What's that—a pimple?' And she will see the flesh puff up slightly, crack and split open, and at the bottom of the split a third eye, a laughing eye, will appear. Or else they will feel something gently brushing against their bodies, like the caresses reeds give swimmers in a river. And they will realize that their clothes have become living things. And somebody else will feel something scratching inside his mouth. And he will go to a mirror, open his mouth: and his tongue will have become a huge living centipede, rubbing its legs together and scraping his palate. He will try to spit it out, but the centipede will be part of himself and he will have to tear it out with his hands. And hosts of things will appear for which people will have to find new names—a stone-eye, a big three-cornered arm, a toe-crutch, a spider-jaw, and somebody who has gone to sleep in his comfortable bed, in his quiet, warm bedroom, will wake up naked on a bluish patch of earth, in a forest of rustling pricks, rising all red and white towards the sky like the chimneys of Jouxtebouville, with big testicles half way out of the ground, hairy and bulbous, like onions. And birds will flutter around these pricks and peck at them with their beaks and make them bleed. Sperm will flow slowly, gently, from these wounds, sperm mingled with blood, warm and vitreous with little bubbles. Or else nothing like that will happen, no appreciable change will take place, but one morning when people open their blinds they will be surprised by a sort of horrible feeling brooding heavily over things and giving the impression of waiting. Just that: but if it lasts a little while, there will be hundreds of suicides. Well, yes, let things change a little, just to see, I ask for nothing better. Then we shall see other people suddenly plunged into solitude. Men all alone, entirely alone, with

horrible monstrosities, will run through the streets, will go clumsily past me, their eyes staring, fleeing from their ills and carrying them with them, open-mouthed, with their tongue-insect beating its wings. Then I shall burst out laughing, even if my own body is covered with filthy, suspicious-looking scabs blossoming into fleshy flowers, violets and buttercups. I shall lean against a wall and as they go by I shall shout to them: 'What have you done with your science? What have you done with your humanism? Where is your dignity as a thinking reed?' I shan't be afraid —or at least no more than I am now. Won't it still be existence, variations on existence? All those eyes which will slowly eat up a face—no doubt they will be superfluous, but no more superfluous than the first two. Existence is what I am afraid of.[16]

There is a sense in which the paintings of Bacon are existentialist after the manner of Sartre's particular formulation of existentialism. But man has a choice of conditioning his existence; of modifying it. If society is stricken by plague he has the possibility of battling against it. He does not need to embrace it, to seek out the buboes and contaminate the healthy bodies so far fortunately escaped. The spectacular production at the National Theatre of Ted Hughes's black and subjugating translation of Seneca's *Oedipus* used appropriately enough an image straight out of Francis Bacon for the setting of its most terrifying moments. A small confining gold box within which an individual, hypnotized by the horror of his predicament, spewed out the words of plague into the waiting auditorium. Few moments in the modern theatre can have been more disquieting than that in which the figure of Creon, stumbling round in ever more frenzied circles within those confines, stammered and howled forth to Oedipus his appalling picture of the summoning up of King Laius from the great hole of death:

> I saw things in the darkness moving many pale
> masks lifted and sinking I saw dark rivers and
> marshes I saw writhing things
> I could hear human voices and the screeching and
> laughing of mouths that were never on earth I heard
> sobbing deeper than anything on earth
> I saw every disease I knew their faces I heard them
> and knew their voices I saw every torment every
> injury every horror spinning like flames and shadows
> sickening forms faces mouths reaching up clutching
> towards us and crying
> I saw the plague of this city bloated blood
> oozing from every orifice grinning up on a

sliding mountain of corpses
the roaring of dog's voices screams jabbering groans
indescribable laughter erupting as if the earth
were crammed splitting with it[17]

More monstrous than this vision however was the concluding tableau of the production in which the people of Thebes, having been at last released from the plague did not join in a great orgy of sexual rebirth and renewal, but, having dragged the great golden phallus on to the stage, indulged merely in trivial cavortings, leaving the theatre, and the minds of those in the theatre, still locked within their self-induced leprosy. Francis Bacon and Samuel Beckett do not so much indicate that the plague must be endured as suggest that the plague should be welcomed. They are both artists at the extreme edge of neurotic obsession, both to a large extent outsiders and rebels.

It is to a different plague and to a different outsider and a different rebel that we need to turn to examine another curious development in the progress of art in our times.

CAMUS DUCHAMP CAGE

Since culture fell away from the cult and made a cult of itself, it has become nothing else than a falling away.

Thomas Mann, *Dr Faustus*.

The plague for Camus has to be suffered and endured in order to be understood, but it also has to be rejected and defeated. Camus could never accept the degradation of man and despite the unnerving character of most of his fiction and plays and the unrelieved density both of literary style and philosophical speculation, there is about his work a quality of heroic optimism and purposefulness that distinguishes him from most of the political and philosophical writers of his generation, as the heroic stance of Giacometti defies the nihilism of Beckett. It is surprising therefore that one of the most significant comments that he makes through his writing is capable of being seen as a totally negative one and so often exploited in art, politics, science and social behaviour by the most trivial or in some cases the most pernicious practitioners. The electric current which makes his first novel, *The Outsider*, throb with such power beneath its calm surface is directed with exact skill to the proposition that gesture in itself is significant. It is this statement that seems to have caused so much misconception about the nature of his philosophy in the minds of many profound writers on his nature and his work. Philip Thody, for instance, says in his impressive study

> It was with the publication in 1942 of *L'Etranger* and *Le Mythe de Sisyphe*, that Albert Camus changed quite suddenly from a little-known provincial essayist into one of the best-known French literary figures. This success is easily accounted for. His automatic assumption that life had no meaning, his denunciation of hope, his determined refusal of any comforting transcendence exactly fitted the mood of the time.[1]

Of course Thody develops a very complex exploration of Camus's surgical, critical humanism and later considerably modifies this charge of 'hopelessness'. 'It is the fact that Meursault really has something to live for—unlike Antigone

(Anhouilh), Sartre's Roquentin or Malraux's Garine, who live only in their ideas and their refusal—that distinguishes him from them.' But as is so often the case where artists are concerned we remember the shock of their arrival on the scene more the profounder thoughts which often accompany their maturity, and despite all the modifications Camus was to make within his philosophical structures it is perhaps the impact of the ideas expressed in *The Outsider* and *The Myth of Sisyphus* that lodge irresistibly within our minds today.

Until the publication of *The Outsider* in 1942 Camus's writing was not particularly distinguished either in thought or in method from that of the average intellectual French writer of the period, but there are fascinating insights into his mind locked within the literary diary that he kept from 1939 until his death. What strikes one most forcibly is that constant preoccupation with three things: freedom, discipline, and the misery of 'work'.

What sordid misery there is in the condition of a man who works and in a civilization based on men who work.

But we must hang on and not let go. The natural reaction is always to scatter one's talents outside work, to make people admire you the easy way, to create an audience and an excuse for cowardice and play-acting (most marriages are organized on this basis). Another inevitable reaction is to try to be clever about it. Besides, the two things fit in very well together, if you let yourself go physically, neglect your body, and let your will-power slacken.

The first thing to do is to keep silent—to abolish audiences and learn to be your own judge. To keep a balance between an active concern for the body and an attentive awareness of being alive. To give up all feeling that the world owes you a living and devote yourself to achieving two kinds of freedom: freedom from money, and freedom from your own vanity and cowardice. To have rules and stick to them. Two years is not too long a time to spend thinking about one single point. You must wipe out all earlier stages, and concentrate all your strength first of all on forgetting nothing and then on waiting patiently.

If this price is paid, then there is one chance in ten of escaping from the most sordid and miserable of conditions: that of the man who works.[2]

Most of the commentaries on *The Outsider* deal with the nature of the main character, Meursault, and attempt to discover within the curious ambiguities of his personality some symbolical significance or attempt to identify him with a historical or mythical figure or combination of a number of mythical figures. The concern is most usually to place Meursault within the philosophical concept of the idea of the absurd and to show how Camus presented the possibility of life's

being endured within this modern absurdity. Conor Cruise O'Brien closes his chapter on *The Outsider* with the following paragraph:

> The real significance, and the source of the appeal, of the work of this period (1941) is not one of revolt but of affirmation. To a generation which saw no reason for hope, it offered hope without reason. It offered a category—the absurd—in which logical, psychological, philosophical and even social and political difficulties could be encapsulated and it allowed the joy of being alive, in the presence of death, to emerge. It was neither a revolutionary method nor a specially moral one; but it was a singularly sweet and exhilarating message to a whole generation who were also pleased to think of it as revolutionary and moral. I belonged to that generation and if I scrutinize that message now with the wary eyes of middle age, I am no less grateful for having received it in my youth.[3]

He may well be right in that many intellectuals received *The Outsider* in this way, but what is disquieting is not so much the background out of which the novel is constructed as the extraordinarily percipient discovery on the part of Camus of a condition that was growing at an alarming rate within certain types of individual in the second quarter of the twentieth century.

There are in *The Outsider* only two really positive and significant moments; the first is the murder which produces the situation that is to form the centre-piece of the novel. The murder, which comes at the end of part one, is not necessarily purposeless but it is motiveless and it is this terrifying dependence upon motiveless violence that is the cause of so much of the chaos in present day society and indeed in much that we still dignify with the name of art. Meursault himself admits even before his action that it need not be committed.

> Then everything began to reel before my eyes, a fiery gust came from the sea, while the sky cracked in two, from end to end, and a great sheet of flame poured down through the rift. Every nerve in my body was a steel spring, and my grip closed on the revolver. The trigger gave, and the smooth underbelly of the butt jogged my palm. And so, with that crisp, whip-crack sound, it all began. I shook off my sweat and the clinging veil of light. I knew I'd shattered the balance of the day, the spacious calm of this beach on which I had been happy. But I fired four shots more into the inert body, on which they left no visible trace. And each successive shot was another loud, fateful rap on the door of my undoing.[4]

In a curious way the description of the shooting seems negative rather than positive. Meursault does not pull the trigger of the gun: 'the trigger gave, and the smooth underbelly of the butt jogged my palm'; it is as if the character were

trapped in an action that he did not so much condition as undergo. The book has slowly moved up to this position where an unpremeditated and totally pointless murder is committed, a murder in which the reader can scarcely discover guilt on the part of the murderer. It is such a trivial action. So the significant and pivotal action in the book is motiveless. Despite the remarkable conversation between Meursault and the priest in prison at the end of the novel, it is again a very small section, and that at the very end, which jolts us so savagely into an awareness of a feature of our present existence. The novel concludes with Meursault's thinking 'For all to be accomplished, for me to feel less lonely, all that remained was to hope that on the day of my execution there should be a huge crowd of spectators and that they should greet me with howls of execration.' From a motiveless action we move to a purposeless gesture.

Gesture whether significant or not has become one of the terrifying possessions at the command of modern man. To be noticed is the important thing. It does not matter why one is noticed. In Camus's fiction the character of Meursault points to this condition more powerfully any other of his creations. In his plays it is the historical figure of Caligula who exhibits the same wantonness.

Caligula is not the most important of the plays of Camus; indeed it is fair to say that it is not an important play at all. It is tragically flawed because the actions of Caligula himself too often seem absurd rather than dramatic or if not absurd then certainly excessively melodramatic. Also, the philosophical ideas that are expressed throughout the play seem to be imposed from the outside rather than to arise spontaneously from the characters who are bodying them forth. What is important is the comment made in the very last speech of Caligula.

(*CALIGULA rises, picks up a stool and returns to the mirror, breathing heavily. He contemplates himself, makes a slight leap forward and, watching the symmetrical movement of his reflected self, hurls the stool at it, screaming*): To history, Caligula! Go down to history:[5]

Once again we see the insistence on the power of the gesture irrespective of the worth of the gesture—the memorableness of the action utterly divorced from the quality of the action. In recent years we have seen the horrifying spectacle of a man like Charles Manson becoming almost a figure of heroic importance in the bloodthirsty eyes of the world watching his trial, as we have seen the happy smiles and cavortings of his followers who we may suppose had the distinction so seemingly necessary of at last being in the public eye. The meaningless gestures of Caligula and Meursault are neatly balanced by the purposeless action of Sisyphus as treated by Camus in his brilliant essay. *The Myth of Sisyphus* is of course an elaborate essay on the idea of suicide set within an examination of the nature of the absurd. 'The gods had condemned Sisyphus to ceaselessly rolling

a rock to the top of a mountain, when the stone would fall back of its own weight. They had thought with some reason that there is no more dreadful punishment than futile and hopeless labour.'[6] The statement is bald and to the point, as was the labour imposed by the gods upon the poor wretch himself. It is his utterly pointless action that makes him so superbly suited to the role of the absurd hero, as indeed Camus comments: 'You have already grasped that Sisyphus is the absurd hero. He *is*, as much through his passions as through his torture. His scorn of the Gods, his hatred of death, and his passion for life won him that unspeakable penalty in which the whole being is exerted towards accomplishing nothing.' At the end of the essay Camus writes the simple sentence 'One must imagine Sisyphus happy.' But more important than that honest proposition—for it is honest and not ironic—are a few perhaps rather more pertinent words 'There is no fate that cannot be surmounted by scorn.'

Scorn and contempt, pointless activity and meaningless gesture, have captured large areas of the artistic consciousness of our time and play a huge role within the progress or decline of modern art, a process leading finally to betrayal. Many years before Camus discussed these ideas with such brilliance in a handful of books which are likely to remain among the most important published during the last thirty-five years, a painter more iconoclastic than Whistler (who was after all only accused of flinging a pot of paint in the face of the public), was to exhibit in an art gallery in Paris a bicycle wheel and a public urinal. His name was Marcel Duchamp.

Duchamp did not grow into extravagance; he was always extravagant. His earliest paintings though they may seem to us now to be comparatively orthodox were very much a part of the modern movement of the time and from the very beginning he resisted the influence of his academic masters. He would never accept the fact that because a thing exists at a particular time it must necessarily exist for all time; he could see no reason at all why a set of rules could not be superseded by another set of rules, or why one system of aesthetics should not be replaced by a different system of aesthetics, or why many systems should not exist side by side. His mind was to a large extent more like the mind of a scientist or perhaps a sportsman than that of the orthodox painter. He always delighted in problems and especially those arising from premises which were arbitrarily difficult or unreasonable. The activity of painting or sculpture was a chosen method of playing a complicated game or solving a particular problem rather than any attempt to produce works that were satisfying or self-sufficient in themselves. He was the sort of man more interested in trying to discover questions than in finding answers. We are reminded of the final utterance of Gertrude Stein who is reputed, on her death bed, to have raised herself up and asked 'What is the answer?' but then immediately to have corrected herself with 'No. What

is the question?' Certainly he has caused us to rethink many of our ideas about art but as Auden has very pertinently put it, 'To ask the hard question is easy.'

The earliest paintings of Duchamp offer a variety of elaborations upon the fashionable styles of the time, Cézanne, Matisse, Picasso, the early Bonnard. They are alive with colour and show a considerable command of technique. One of the very earliest paintings, the *Landscape at Blainville* of 1902, has all the luminosity and sense of lightness of a Corot. The first decade of the century shows Duchamp as a painter with the possibility of taking many paths. It is not until 1911 that he starts to create the small group of paintings from which we instantly recognize him in his most famous and most painterly phase—indeed his last painterly phase. They are of course the various works concerned with figures in movement. The paintings are *Sad Young Man on a Train* and the two notorious works *Nude Descending a Staircase no. 1* of December 1911 and *Nude Descending a Staircase no. 2* of January 1912. But by the end of 1912 Duchamp virtually discarded painting. If the world as it was came to an end in 1914, painting as it was for Duchamp also stopped. Perhaps up to the end of the Edwardian period there was a sense in which the artist had always been the scapegoat of society. At the beginning of that first terrible holocaust and certainly after it we may begin to suspect that for the first time in history society is becoming the scapegoat of the artist. We are inevitably reminded of the horrifying turning of the tables in the grotesque tales of Edgar Allan Poe.

If the leap taken by Mondrian from such exquisite painting of the natural scene to that severity of abstraction is astonishing and perhaps in the long run distressing, it pales into insignificance when compared with the virtual abandonment of painting by Marcel Duchamp. He was, it is true, already engaged on the first sketches for the huge work that was to occupy his attention throughout the remainder of his life and which was to be left unfinished at his death: *The Large Glass*, or *The Bride Stripped Bare by her Bachelors, Even*. But while making those early attempts toward that work he produced his 'readymades'. It is difficult to say whether it is to his credit or not but at least he did make a statement about the readymades: 'A point that I want very much to establish is that the choice of these readymades was never dictated by an aesthetic delectation. The choice was based on a reaction of visual *indifference*, with at the same time a total absence of good or bad taste, in fact, a complete anaesthesia.' And so, out of such an attitude the world of art was presented with a bicycle wheel painted black and mounted on a kitchen stool painted white. The original was lost (tragically?), but it has been reconstructed! The extent to which these early readymades have been discussed and acclaimed may in time be seen as one of the more astonishing aberrations of art criticism in the twentieth century.

The readymades of Duchamp differ from works of this kind exhibited by

many artists around about that period in that they are the objects pure and simple and not in any way made to represent something else. As William S. Rubin points out in *Dada and Surrealist Art*,

> Readymades like *Bicycle Wheel* are, however, essentially different from what appear at first to be related objects: for example, Picasso's *Bull's Head* which was created by joining together the seat and handlebars of a bicycle. The Picasso work has to do not primarily with a new revelation of meaning in the object but with the metamorphosis of its shape. The transformation from bicycle to bull's head is in the interest of *plasticity*, and though the result has a kind of surreal poetic quality (which it lost when later cast in bronze), it attests rather to the activity of the artist as manipulator than to the passive though incantatory insight of the 'Seer'.[7]

It is in the last word of that sentence that we detect an attempt to change the roles played by the artist and society. The idea is made concrete in a further comment by the same author about the same readymades:

> His Readymades have become monuments of the enigma of seeing; reminders that visual meaning cannot be defined in plastic terms alone or within the cumulative conventions of any art. In a world of competing artistic programmes, he argues the transcendence of creative seeing—that genius lies in the eye and mind, and not in the hand, of the artist.[8]

It is only one stage further to the proposition 'I am a genius because I think I am.'

If art is unnecessary and to a large extent undesirable, is not any activity connected with art equally undesirable and unnecessary? At least when Rimbaud abandoned poetry because he was either afraid of it or bored with it or merely because of lack of inspiration he went to North Africa and took up gun-running. He did not pretend that his gun-running was an artistic activity, nor have critics yet decided to elevate either the spent bullets or live bullets from those guns into poems more remarkable and far-reaching than the extraordinary and cataclysmic real poems of his youth. We are in danger of doing just that with our preoccupations with the late non-artistic works of Duchamp. Duchamp has, in fact, told us quite frankly that he became bored by retinal art. Apart from his preoccupation with the painting of *The Bride Stripped Bare by her Bachelors, Even* (which is as much an exercise in optical metaphysics as a painting proper) the works he produced after 1914 are not strictly within the field of art at all. They are in the field of metaphysics of a curiously shabby kind.

Just as Duchamp exhibited readymades and said, they are not works of art in themselves but I make them so by signing them—by pointing at them—by making the gesture—Duchamp is not in his maturity an artist at all but we make

him so by pointing at him. The magic lies entirely in the name. The bicycle wheel is ordinary as a bicycle wheel; exhibited in an art gallery and called a 'Duchamp' it becomes meaningful. Duchamp as a man walking about in a crowd is made significant when we hang on to him that magic name itself: Duchamp.

There have been many such sacred cows in history.

It is necessary to remember however that the contemporary adulation showered upon Duchamp is scarcely the fault of the artist. His world-wide reputation and fame outside the confines of the more rarefied art circles did not happen until the 1960s and for thirty years he was a comparatively little known figure. But a part of our immediately contemporary world disillusioned with the philosophies of the past, antagonistic toward the grotesque economic imbalance of most Western societies and brought up against a background of almost perpetual war and despoliation found in his special kind of nihilism a sense both of release and relief. But the disadvantage of overthrowing classical or romantic cultures is that too often nothing is put in their place.

In 1919 Duchamp produced perhaps the most notorious of his readymades—a 'rectified readymade'. This was *L.H.O.O.Q.* It is a reproduction of the Mona Lisa to which Duchamp has added a moustache and a beard in pencil. The letters of the title when pronounced phonetically in French become 'Elle a chaud au cul.' Duchamp tells us that a loose translation of the title would be 'There is fire down below', it also, or so we are told by William S. Rubin, can contain the scurrilous colloquial translation, 'She has hot pants.' In 1965 on the occasion of the preview of the Mary Sisler collection at the Cordier and Extron Gallery in New York, Duchamp issued one hundred examples of a reproduction of the Mona Lisa pasted on an invitation card but this time minus the moustache and beard and succinctly called *L.H.O.O.Q. Shaved*. It was of course signed by Duchamp. It may be that Leonardo's Mona Lisa will yet have the final smile.

It is to John Cage and his followers perhaps more than to any one else within the last ten years that the musical world owes the considerable revival of the work of Erik Satie, and it is easy to see why Cage was so drawn to the miniscule works of that curious composer. They have much in common, for most of the teachers of Satie thought him very untalented as a pupil, applying himself laboriously to his self-imposed problems (never particularly complicated ones) and equally clumsy as a performer. Though the most famous set of piano pieces, the *Three Pieces in the Shape of a Pear*, are comparatively simple from the technical point of view, Satie was unable to play them satisfactorily. His personality was equally clumsy in that it was a mixture of extravagant exhibitionism, considerable bitterness that expressed itself in a tart wit and, perhaps more significant, a

self-conscious determination to cling to the nature of the innocence of childhood for as long as possible. But the idea of the innocence of children has long since been exploded!

So too, the fantastic character John Cage. Schoenberg is reported to have found him not especially interesting as a composer but fascinating for his philosophical ideas. As an exhibitionist—or at any rate the manipulator of many exhibitions—he is certainly more extravagant that Satie, and this exuberance is allied to the cultivation of a sort of innocent child-like playfulness. He is a perpetual golden boy of American art. It would perhaps be fairer to say that too often he is like a precocious spoilt child whose silliness is unfortunately exceeded by his audacity so as to hypnotize us and to make us acquiesce in the situation he creates.

As Satie and Cage are very close, so also is Cage very close to Duchamp. Again we see that it is not the significance of what is being created that matters but merely the gesture that holds us in thrall. Fascinated as are so many composers of the present time by the music of certain Eastern societies and by the philosophy of those societies—in particular by Zen Buddhism—Cage has for the most part produced comparatively short works, even though when performed in sequence they may take a considerable length of time. The most elaborate of these and in some ways the most satisfactory, is the collection *Sonatas and Interludes*, produced between 1946 and 1948 for the prepared piano, which are more gracefully boring than his later effusions. The prepared piano itself is one of those notorious inventions so often created by the dilettante and it is astonishing that so many people have hailed it as a great advance or at least an important development in the history of music. We are told that even so remarkable a composer for the orthodox piano as Messiaen has expressed admiration for this clever toy.

Cage's growing preoccupation with percussion perhaps inevitably led him to desire an instrument that could be played like a piano with all the flexibility which that instrument allows but which would produce 'percussive' as opposed to 'musical' sounds. But whatever absorption and seriousness (the absorption and seriousness indeed of a child at play) is required to modify the sounds created by a piano by inserting between the strings various nuts, bolts, rubbers, etc., calculated as to size and to exact position, it is still a long way removed from the work of the truly creative inventor. Or the truly creative composer. Cage might very well say why bother to create a new percussive instrument when one already exists that can be adapted for the purpose, but that is an evasion of responsibility. It is indeed the evasion of responsibility that is the disquieting factor of the art or music or philosophy produced at the moment by artists of Cage's persuasion. The action in itself is all. It is not surprising that Cage has

been so great an admirer of that other wonder boy of American sophistication Marshall McLuhan, whose dictum 'The medium is the message' has all the spurious significance of a well-told lie.

Cage differs from Duchamp in the significant fact that Duchamp's early work is related to various styles of the past which the painter deliberately abandoned. He differs from Schoenberg and the painter Paul Klee, who also wished to rid themselves of the weight of their classical inheritance. The difference lies simply in the fact that Schoenberg, Klee and Duchamp all possessed an immense awareness of that past and a genius within the exploitation of traditional styles. Cage, like Satie, has never been at home in it and relies upon a chosen philosophy of behaviour to cover up the paucity of his artistic inspiration or craftsmanship.

The longer works, of which perhaps the most famous are the Concerto for prepared piano, *HPSCHD* and *Fontana Mix*, are the most revealing of his works, for they carry on long enough for the audience to become bored by the gesture. The earliest of these works, the Concerto for Prepared Piano is, as one might expect, closest to traditional methods of composition and it is a delicately innocuous piece which fulfils very well one of Satie's objectives—music which can be overheard without in any way intruding on whatever activity the listener might be engaged in at the time. There is of course a contradiction even here, since one is scarcely a 'listener' in the true sense of the word if one is busy doing something else. The word perhaps would be 'overhearer'. But once again these contradictions are inherent in the somewhat muddled philosophy of Cage who has said that he is disappointed if his music does not irritate the listener but also makes a great point of his acceptance of the idea that the function of music is to 'sober and quiet the mind'.

The Concerto for Prepared Piano of 1951 is separated by almost twenty years from the infinitely more complex (complex that is to say in relation to the paraphernalia required to perform it) of the work called *HPSCHD*. Cage apparently pronounces this word 'Harpsichord', and it is indicative of an inferiority in the work when related to works of exact human control and sensibility that the reason it is spelt *HPSCHD* is simply because the computer which produced the title could not spell the complete word 'Harpsichord'! This elaborate work might well be subtitled 'Homage to the God of Electronics', being composed for no less than fifty-one electronic sound tapes and seven solo compositions for harpsichord. The composition is exceptionally complicated in means, having been created by the most laborious process of a numerical system performed upon a computer but derived from the chance system of casting numbers of the *I Ching*, the great oracular book of ancient Chinese wisdom to which Cage frequently resorts, but from which he seems to have gained little in wisdom, humility, or reverence.

The elaboration required for its first performance is even more remarkable. Richard Costelanetz in his symposium on Cage describes the setting:

Flashing on the outside underwalls of the huge double saucer Assembly Hall, at the University of Illinois's Urbana campus, were an endless number of slides from fifty-two projectors; and, inside, between 7.00 p.m. and just after midnight Friday evening, May 16, 1969, was a John Cage–Lejarn Hiller collaboration, *HPSCHD* (1967–69), one of the great artistic environments of the decade. In the middle of the circular sports arena were suspended several parallel sheets of visquine, each 100 feet by 40 feet, and from both sides were projected numerous films and slides whose collaged imagery passed through several sheets. Running around a circular ceiling rim was a continuous 340 foot screen, and, from a hidden point inside, were projected slides with imagery as various as outer-space scenes, pages of Mozart music, computer instructions, and nonrepresentational blotches. Beams of light were shrewdly aimed across the interior roof, visually rearticulating the modulated concrete supports. In several upper locations were spinning mirrored balls reflecting dots of light in all directions—a device reminiscent of a discotheque or a planetarium; and the lights shining directly down upon the asphalt floor also changed colour from time to time. There was such an incredible abundance to see that the eye could scarcely focus on anything in particular; and no reporter could possibly write everything down.

He later on describes the audience:

Most of the audience milled about the floor while hundreds took seats in the bleachers. All over the place were people, some of them supine, their eyes closed, grooving on the multiple stereophony. A few people at times broke into dance, creating a show within a show that simply added more to the mix. Some painted their faces with Dayglo colours, while, off on the side, several students had a process for implanting on white shirt a red picture of Beethoven wearing a sweatshirt emblazoned with John Cage's smiling face.[9]

Whether intentionally or not he does then betray a tiny criticism when he writes 'in sum, then, above the microtonal din were references to Mozart, a favourite classic composer of Cage and Hiller.' 'Microtonal din' perhaps describes much of the work of Cage in its later manifestations.

What is disturbing is not however the microtonal din but the high seriousness with which the composer puts forward the philosophy out of which his creative works and his gestures spring. As early as 1937 he was very accurately foreseeing

that the future might very well lie in the manipulation of electronic sounds. He was also beginning to formulate his beliefs that music as something to be listened to and as something that might be conceived as meaningful would rapidly disappear and that the role of the composer—or in fairness the role of his particular kind of composer—was to wean people away from formalized music to which one listened to the discovery of the beauties of natural sounds with which we are constantly surrounded. He makes a telling point when he says that on entering an anechoic chamber, which is a room carefully conditioned to exclude every possibility of noise, indeed he heard two sounds, one extremely low. The engineer in charge pointed out that the high sound was the reaction of his nervous system and the low sound was the pulsing of his own blood. Cage commented that if that were so then he would surely possess music until he died.

It is from this desire to make us aware of the sounds by which we are surrounded that his most sensational gesture springs. This is the work entitled *4′ 33″*. It is gesture pure and simple and it is not surprising that in the present climate of experimental art it can be accepted as a work of art. It is, of course, the famous work written for a piano in which no note is played. Being in three movements the gesture is of manifold contempt. The performer merely sits in front of the instrument and by some gesture of his arms, or if he wishes through no specified gesture at all, though it is an advantage (!) to indicate where the movements begin and end, remains there for the duration of *4′ 33″*, during which time the audience is supposed to achieve a greater awareness of those sounds which enfold us at all times but of which we are scarcely aware. The awareness of these noises arises very early in Cage's philosophy. One of his very earliest collected public pieces is the essay 'The Future of Music: Credo', printed in *Silence*, of which the first paragraph is:

I BELIEVE THAT THE USE OF NOISE
Wherever we are, what we hear is mostly noise. When we ignore it, it disturbs us. When we listen to it, we find it fascinating. The sound of a truck at fifty miles per hour. Static between the stations. Rain. We want to capture and control these sounds, to use them not as sound effects but as musical instruments. Every film studio has a library of 'sound effects' recorded on film. With a film phonograph it is now possible to control the amplitude and frequency of any one of these sounds and to give to it rhythms within or beyond the reach of the imagination. Given four film phonographs, we can compose and perform a quartet for explosive motor, wind, heartbeat, and landslide.

TO MAKE MUSIC
If this word 'music' is

sacred and reserved for eighteenth- and-nineteenth-century instruments, we can substitute a more meaningful term: organisation of sound. WILL CONTINUE AND INCREASE UNTIL WE REACH A MUSIC PRODUCED THROUGH THE AID OF ELECTRICAL INSTRUMENTS.[10]

But if music is to be made through electrical instruments then it is not to the examples of Cage we should look for the proper exploitation and 'success' within the medium, but to Stockhausen whose works have about them an air of purpose and an authority lacking in Cage's enfeebled attempts.

One of the more disquieting features of Cage's approach to 'art' is that unlike previous artistic disciplines which produced maximum effects with (apparently) minimal effort, his works exhibit enormous effort for minimal effect. This is not only true of his 'sound' compositions with the enormous complications of their devices exposed in front of us, but also in his writings. His admiration for McLuhan leads him into exploiting the idea of the medium being the message. In this he goes to quite ludicrous lengths. It is possible that if his 'How to Improve the World'[11] contained a reasonable amount of good sense, or even originality, the curious method by which it is printed would be acceptable; though it is doubtful if a wise counsellor would be seduced by such tricks. As it is the typographical absurdity, which is neither beautiful nor purposeful, serves the more to demonstrate the inadequacy of most of the ideas expressed.

Cage can be very precise when he wants to be. He clearly states, in no-nonsense explicit prose, the method by which he produced the work:

This text was written for publication by Clark Coolidge in his magazine *Joglars*, Providence, R.I. (Vol. 1, No. 3, 1966). It is a mosaic of ideas, statements, words, and stories. It is also a diary. For each day, I determined by chance operations how many parts of the mosaic I would write and how many words there would be in each. The number of words per day was to equal, or, by the last statement written, to exceed one hundred words.

Since Coolidge's magazine was printed by photo-offset from typescripts, I used an IBM Selectric typewriter to print my text. I used twelve different typefaces, letting chance operations determine which face would be used for which statement. So, too, the left marginations were determined, the right marginations being the result of not hyphenating words and at the same time keeping the number of characters per line forty-three or less.

But these chance operations are not without a certain guile. In *Composition as Process*, for instance, the printed equivalent of the speech-pace and rhythm of the

lecture, on which it was based—which must by the nature of the English language itself have been variable—is of pages of four columns in which the text is printed in a constant four-syllable line but with none of the subtlety of a good syllabic poet.

Cage like Duchamp makes us aware of the gesture as Camus makes us aware of the gestures of Caligula or of Meursault. We are also aware of the absurdity. But the absurdity of Duchamp and Cage and the gestures of them both are far removed from the purposefulness of so rigorous and meaningful a thinker as Camus. The tragedy is that for too long we have been caught up in the superficial aspects of these two words and conditions and have forgotten the depths of significance that should lie behind them. It is time we focused once more not on the gesture but on the emptiness of the gesture, not on the absurdity of meaning but on the meaning of absurdity.

From his early studies in Paris and from a life undoubtedly devoted to many forms of art, Cage has shown an extraordinary singlemindedness and integrity of purpose in his pursuit of 'purposelessness', and we may perhaps best pay tribute to him by admitting that his achievement is the not inconsiderable one of making the Emperor's new clothes actually visible. But as Marianne Moore might pertinently have expressed it (though she was speaking in another context) 'I, too, dislike it: There are things that are important beyond all this fiddle.'

MOORE THOMAS TIPPETT WHITE

'More interesting phenomena', he responded, 'probably always have this double face of past and future, probably are always progressive and regressive in one. They display the equivocableness of life itself.'

'Reason and magic', said he, 'may meet and become one in that which one calls wisdom, initiation . . .'

Thomas Mann, *Dr Faustus*.

Hindemith concludes his book *A Composer's World* with the following paragraphs, which I feel have equal validity if the words which specify music and musicians are read as 'art' and 'artists'.

His choice is honest and hard work, and with this he turns our negative picture into its positive form, in which the arrangement of light and shadow is correct and artistically most satisfactory. If we then ask what the auspices of his work are, the answer will be: he has entered the inner circle of veritable artistic creation, and if his talent permits, he may well be on his way to producing a musical masterpiece.

We know this way. We have outlined it elaborately in our chapters on basic musical facts. In them beacons can be found that will lead our aspirant to truth and perfection. He will then know about musical inspiration and how to touch validly the intellectual and emotional depths of our soul. All the ethic power of music will be at his command and he will use it with a sense of severest moral responsibility. His further guides will be an inspiring creative ideal and the search for its realisation; an unshakable conviction in the loftiness of our art; a power to evoke convincing and exalting forms and to address us with the language of purity. A life following such rules is bound to exemplarily persuade others to become associated. This life in and with music, being essentially a victory over external forces and a final allegiance to spiritual sovereignty, can only be a life of humility, of giving one's best to one's fellow men. This gift will not be like the alms

passed on to the beggar: it will be the sharing of a man's every possession with his friend.

The ultimate reason for this humility will be the musician's conviction that beyond all the rational knowledge he has amassed and all his dexterity as a craftsman there is a region of visionary irrationality in which the veiled secrets of art dwell, sensed but not understood, implored but not commanded, imparting but not yielding. He cannot enter this region, he can only pray to be elected one of its messengers. If his prayers are granted and he, armed with wisdom and gifted with reverence for the unknowable, is the man whom heaven has blessed with the genius of creation, we may see in him the donor of the precious present we all long for: the great music of our time.[1]

It may be that the very nature of our society and the development of technological man is inimical to the production of the elevated works which Hindemith would seem to desire. Perhaps in the future, in a world dominated by electronics, and whose citizens are able to inhabit those areas of the solar system which are as yet only tentatively open to us, the problems which have confronted artists of the past and present will no longer apply. For if the very nature of man suffers a totally drastic and radical change then inevitably his response to art as to life itself will be altogether different. At the moment we are not in that state; we are still in that half-way world where we cannot become the animals that we know nor yet those gods or angels which we might still dimly imagine. What is perhaps lacking so far as art is concerned is any significant area of experience that can be elevated to the position of myth, or a form of belief, whether it is inspired by faith or by reason, to which might attach some kind of meaningful ritual.

Despite the beauty and elegance of so much of the purely abstract art of our time, pattern-making within Western culture lacks the power of tradition which makes it still relevant and meaningful within those cultures, such as Islam, in which the avoidance of 'image-making' has a profound significance. So too there is a similar lack in those totemistic sculptures produced by so many artists— including Giacometti Arp and Moore—from 1900 onward. Such totems are unsatisfactory in a sophisticated society which merely looks at them, doubtless obtains pleasure from them, but does not worship them; for if there is no belief in the power of the totem then it inevitably declines into an object merely of curiosity, often beautiful, often grotesque, but in the long run only peripheral to our deep psychological or spiritual needs. In music the extension of the intellectual concept from Webern to Boulez makes for a hermetic world of mystery which only the initiates may fully enter, yet in contradistinction to this the inchoate musical happenings with which we have been so often afflicted in

recent years appear more often than not to be merely the disruptive cavorting of hooligans. For it is essential to realize that hooliganism is not confined to the physical aspects of society but occurs also within intellectual discussion and artistic creation. People are savaged by poems, paintings, films, novels, theories, symphonies as bloodily in their minds and sensibilities as by the knives of maurauders in the streets. When so-called 'serious' artists betray 'the muse' in this way then it is not surprising if that same 'muse' turns and in revenge betrays mankind. When Plato in an attempt to construct a blueprint for a perfect society reluctantly concluded that poets would have to be excluded it was because he feared the consequences of the disruptive nature of the poet's vision. In the chaotic situation which prevails in Western civilization and which is mirrored in so much Western art in the second half of the twentieth century, he might well have considered it necessary to embrace in his ban artists of all callings.

But society as we know it inevitably exists within a huge framework of art, even if that framework is merely the corrupt one of packaging and advertising. In such a society the role of the artist should be one of especial concern. Simone Weil in her essay on 'The Responsibility of Writers' is very explicit. Again, for 'writers' we may read 'artists'. 'I believe in the responsibility of the writers of recent years for the disaster of our time. By that I don't mean only the defeat of France; the disaster of our time extends much further. It extends to the whole world, that is to say, to Europe, to America, and to the other continents in so far as Western influence has penetrated them.'

Later in the same essay she goes on: 'The essential characteristic of the first half of the Twentieth Century is the growing weakness, and almost the disappearance of the idea of value. This is one of those rare phenomena which seem, as far as one can tell, to be really new in human history, though it may be, of course, that it has occurred before during periods which have since vanished in oblivion, as may also happen to our own period.' Even more dramatically she continues:

Dadaism and Surrealism are extreme cases; they represented the intoxication of total licence, the intoxication in which the mind wallows when it has made a clean sweep of value and surrended to the immediate. The Good is the pole toward which the human spirit is necessarily oriented, not only in action but in every effort, including the effort of pure intelligence. The surrealists have set up non-oriented thought as a model; they have chosen the total absence of value as their supreme value. Men have always been intoxicated by license, which is why, throughout history, towns have been sacked. But there has not always been an artistic equivalent for the sacking of towns. Surrealism is such an equivalent.[2]

Simone Weil might perhaps have been indicating that the artist needs to be apprehensive of those unnameable essences which inform the structures and surfaces of the world in which he moves. Or perhaps, more simply, as Schweitzer suggested, what is always necessary is a reverence for life. This is not a plea for poets to rewrite *The Light of Asia*, nor for musicians to compose a latter-day *Elijah* or painters and sculptors to turn out gently persuasive madonnas. The apprehension and the bodying forth of the essence of things, perhaps in some way a twentieth-century equivalent of the Wordsworthian ideal, can be seen in the work of the poet Dylan Thomas (though his actual creations are far removed in style from those of Wordsworth, a poet he despised) the sculptor Henry Moore, the novelist Patrick White and the composer Michael Tippett.

Dylan Thomas prefaces his *Collected Poems 1934–52* with the following statement: 'I read somewhere of a shepherd who, when asked why he made, from within fairy rings, ritual observations to the moon to protect his flocks, replied: "I'd be a damn' fool if I didn't!" These poems, with all their crudities, doubts and confusions, are written for the love of Man and in praise of God, and I'd be a damn' fool if they weren't,'[3] Yes. Well, it is easy to find, as some critics have done, a kind of naïve portentousness in that, but it is not such a bad credo for any artist.

An attentive reading of the poems, and they cannot be appreciated without very close scrutiny indeed, forces one reluctantly to the conclusion that the work does not entirely justify Dylan Thomas's lofty claim. They exhibit on the one hand an exceptionally lush and romantic vocabulary and on the other an intellectual complexity that is at times almost stupefying in its impenetrability. It is as if far from writing for the love of man he is doing his utmost to prevent any ordinary reader from understanding him at all, and, far from praising God has, in inscrutability, left that august personage far behind. Where these two features are tempered by a moderating restraint and in particular when the poems seem to derive from a personal experience rather than from a generalized desire to 'write a poem' the result can be very moving indeed.

Even the earliest of the published poems present the reader with an extraordinarily mature use of language; a manipulation of words already distinct, already full of private nuances and meanings and for the most part organized in a syntactical manner that borders on the perverse. Compared with the simplicity of the prose writings and the directness of many of the radio scripts they inevitably expose themselves to the criticism that in his verse Dylan Thomas is being difficult for difficulty's sake. He would have denied this with all the rhetorical vehemence at his command but at the same time he was opposed to the idea that art, in principle, should be simple:

I admit that everything should be said as simply as possible, that meaning should never be smothered by conscious obscurity, that the most prized ornamentations of style and phrase have to go under when the meaning dictates it. But that all good poetry is necessarily simple seems to me very absurd. Because I can understand the English of Mrs. Beeton, there is no earthly reason why I should understand the English of Manley Hopkins— or W. H. Davies & W. H. Auden. I see no necessity why the greatest truths of the world, and the greatest variations of these truths, should be so simple that the most naïve mind can understand them. There are things, and valuable things, so complicated that even he who writes of them does not comprehend what he is writing.[4]

This is of course an early letter, written in 1933, and it shows the poet expressing much the same view as most artists in their formative years. But he muddles up the qualities of simplicity. If art does not communicate then we have to question its value. He is right when he says that there are some things so complex that to express them simply is impossible, but to communicate them as powerfully as possible demands at least a process toward, if not simplicity of expression, some comprehensibility of expression. The most naïve mind should not be *deliberately* excluded from the possibility of understanding. 'An art which arrogantly ignores the needs of the masses and glories in being understood only by a select few opens the floodgates for the rubbish produced by the entertainment industry. In proportion as artists and writers withdraw more and more from society, more and more barbaric trash is unloaded on to the public.'[5]

In the case of the best of Dylan Thomas however it is necessary to remind ourselves that the density of language and the obscurity of utterance was a fairly common style at his time of production, in opposition on the one hand to the esoteric intellectualism of T. S. Eliot and Ezra Pound, where the difficulties are for the most part those of recondite allusion, and on the other to the attempt to forge a new 'common' style as in the early work of W. H. Auden. The linguistic genius who could use the ordinary language of the time and imbue it with the overtones and far reaching relevance of 'poetry' was not then at hand, though he was seen to be required. As Pasternak said: 'The living language of our time is urban.'

In the short stories and especially in those which make up the autobiographical collection *Portrait of the Artist as a Young Dog*, Dylan Thomas re-creates a childhood as happy and sad or good and bad as that of most children swathed in the folds of a beautiful countryside. What he seems to try to do in so many of the poems is to dig more deeply back into his origins in order first to release a mythology related to childhood itself and then from this to create a mythology of

adolescence. Where in the prose works the innocent prevails he nevertheless keeps us usually aware of the fact of death, but at the same time, when, as in some of the stories in the collection *The Map of Love*, a tragic or terrifying element creeps in, that is tempered by a deeply held belief in essential goodness within which pain and horror may exist but which cannot finally be violated or over-thrown by such factors. The tragic nature of his own life in his later years and indeed a great deal of the much-publicized drunkenness and crudity of much of his adult public behaviour, which give an impression of deliberate grossness, has often concealed from the public at large the fact that for him nature was magical and that man is a spiritual being. He was possessed of an almost Keatsian idea of the nature of beauty as an indestructible absolute:

> Obviously one is born before one can be an artist, but after that it doesn't matter what happens. The artistic consciousness is there or it isn't. Suffering is not going to touch it. Consciousness of beauty—and what that elusive thing is I haven't the remotest idea; woman isn't because she dies. Nothing that dies is truly beautiful—is born with you or not at all. Suffer-ing is not going to create that consciousness, nor happiness, nor anything else you may experience. True beauty, I shall always believe, lies in that which is undestroyable, and logically therefore is very little. But it is there.[6]

Attempting to bring together the gross world of appearance and the spiritual essences pervading that gross world, while at the same time struggling to fuse into one similar process the apparently opposing poles of birth and death, he was forced in his poetry to try to imbue words with more meaning and significance than perhaps they can undertake if they are to communicate at all.

The two major poems of genesis in his first book are 'When Once The Twi-light Locks No Longer' and 'Before I Knocked'. In these, more clearly than in any other of his works, he shows not the simple idea of creation but the idea of a spirit becoming flesh, and the images used are remarkably powerful in project-ing his ideas of incarnation and discarnation. The provenance of birth is God; the provenance of death is man. Nevertheless the complexity of those poems is such as to make greater demands on the reader than is absolutely necessary and it is not for nothing that the most popular poem within his early work is 'The Force that through the Green Fuse Drives the Flower'. The language is simpler, the statement more direct and, because of that, more energy is released; the poem is allowed to escape from its own density.

As he moves into the middle-period poems, however, he often seems to get lost in a wilful intoxication of language, and the element of dream or nightmare, or at least a growing dislocation between image and meaning, comes close to surrealism, though when he was accused of this he protested:

I do appreciate the trouble you have taken to make your attitude towards these poems quite clear, and am glad that you value my work highly enough to condemn it when you find it—though wrongly I believe—to be influenced by such a pernicious experiment as surrealism . . . I am not, never have been, never will be, or could be for that matter, a surrealist, and for a number of reasons: I have very little idea of what surrealism is; until quite recently I had never heard of it; I have never, to my knowledge, read even a paragraph of surrealist literature . . .[7]

There is, of course a transparent error of logic in this comment. It is not necessary to know what surrealism is (it is merely the name given to a manner) in order to write in that manner.

But if the charge of surrealism does not stand he certainly cannot avoid the charge of being over-complex and at times almost impenetrably obscure. The poems become more private in language and themes are deployed in a contra-puntal fashion which almost defies unravelling. In this his style closely resembles the musical method of Michael Tippett, whose structures often almost choke themselves to death in their multitudinous and entangling lines. The language of the Elizabethans, of Milton, of the Metaphysical poets, to say nothing of the extravagant imagery of Swinburne and the astonishing linguistic feats of Gerard Manley Hopkins, all seem to come together in stanzas which sink under their own weight. Even for the most assiduous reader of poetry the puzzles are often too great. If we need a 'skeleton key to Finnegans Wake' then perhaps a skeleton key to the sonnet sequence *Altarwise by Owl-Light* would not come amiss. One does not have to be moronic to find the opening of the sequence pretty mind-boggling:

> Altarwise by owl-light in the half-way house
> The gentleman lay graveward with his furies;
> Abaddon in the hangnail cracked from Adam,
> And, from his fork, a dog among the fairies,
> The atlas-eater with a jaw for news,
> Bit out the mandrake with tomorrow's scream.[8]

Even in such a deeply moving poem as 'After the Funeral' he cannot resist being clever, or if not clever, then striving always to be extra-ordinary.

If the curious 'apocalyptic' vision was not in itself powerful enough to create a myth, it was the 'apocalyptic' happening of the Second World War (and in particular the air-raids on London—within which may possibly lie curled the seeds of a myth) that brought into focus the dispersing rays of his language and the unclear groping of his thought. Certain of the poems in *Deaths and Entrances*, and certain of the drawings of Henry Moore in his *Shelter Sketchbook*, together

with a musical oratorio like Tippett's *A Child of Our Time* capture that period but by the refinement of art also lift it out of the restrictions of time.

Dylan Thomas was aware of the importance in his career of the book of poems *Deaths and Entrances*. If his life of the poet, Constantine FitzGibbon writes:

> Like most established writers he pretended to be quite impervious to criticism and, again as with most writers, this was a defensive pose. He minded desperately what the reviewers said. It would take him years to forgive and forget an unkind or unfair notice, and even an appreciative one could arouse his scorn and ire if he felt that the writer had praised him for the wrong reasons. Furthermore *Deaths and Entrances* was, as he well knew, the book that must decide, one way or the other, his standing as a poet. Had he been a mere boy wonder, a shooting star that had burned itself out and fizzled into films or had he developed into a major poet? He himself could not be sure. Such questions are answered, in the short run, by the critics, though it is needless to say that they do not always get the answer right, but if they damn, then the chances of a later reappraisal are indeed slender.[9]

The answer was overwhelmingly in his favour. The reception of *Deaths and Entrances* might be summed up in the closing sentence of Norman Cameron's review, published by *Tribune*: 'Mr. Thomas, even in his earliest work, could do "magnificent things with words". Now he can do magnificent things with poems.'

The praise was indeed deserved. Complex as many of these poems are, they lack the wilful obscurity and allusiveness of the sonnet sequence in *Twenty-five Poems*, as well as their intellectual perversity, and they introduce a quality which had hitherto only been hinted at but never fully realized: it is that all too elusive quality of ecstasy. It is a quality which irradiates most of the poetry of Gerard Manley Hopkins, with which the poems in *Deaths and Entrances* have much in common. They are curiously radiant poems, as if to demonstrate a line in an earlier poem: 'Light breaks where no sun shines.' The child whose vision had been clouded over by the anxieties of adolescence re-emerges in the adult but transformed as if by a refining fire. As poems of experience they have about them something of the spiritual toughness, tenderness and glory of the works of Blake, a poet and mystic much admired by Thomas. It is in this book that his most famous poem was published: 'Fern Hill'. There are still those slightly annoying clevernesses—in the seventh line the phrase 'once below a time', which is the first line of that earlier poem 'Once Below a Time' and which is irritating in its somewhat gleeful inversion of 'once upon a time', but such irritations are dispelled by the astonishing evocation not so much of childhood as of man's in-

escapable ties with the earth. In the finest poems in *Deaths and Entrances*, and the handful of subsequent ones, Thomas seems almost to inhabit the role of Prospero who is himself the commanding father figure of Ariel and Caliban but who also cannot avoid sharing the opposing natures of both spirit and monster. Of Thomas's vision of the world it could never be said, as Wordsworth said of Peter Bell:

> A primrose by a river's brim
> A yellow primrose was to him,
> And nothing more.

The trees, the skies, the rivers, the hills, the valleys, the soil, the stones, flints, boulders and all the palpable substances of the world were living meaningful entities reaching far down into man's subconscious being. The world of appearances must be lived in but realized for what it is:

> You must *live* in the outer world, suffer in it and with it, enjoy its changes, despair at them, carry on ordinarily with money-making routines, fall in love, mate and die. You *have* to do that. Where the true artist differs from his fellows is that *that*, for him, is not the only world. He has the inner splendour (which sounds like a piece of D. H. Lawrence or a fribble of Dean Inge). The outer and inner worlds are not, I admit, entirely separate. Suffering colours the inner places, and probably adds beauty to them. So does happiness.[10]

It is in the capturing of this inner world and in making the reader aware of it that Dylan Thomas's true greatness lies. In spite of the astonishing success of works like *Under Milk Wood* which brought his name to a much wider public, and in spite of the effect of those public readings in that magnificent oracular voice, it is the calm at the heart of the tempest that affects us most, the still small voice out of the whirlwind, the prayer for the innocent, the pleas toward comfort, the deep flow of compassion; in the last resort the praise of God. In this he is a fitting companion of Michael Tippett and Patrick White; and also in his belief in the revivifying power of nature and the essential spirituality of men, of that unique sculptor Henry Moore.

Within the public consciousness Henry Moore is as a sculptor what Picasso is as a painter. He is the only sculptor of modern times whose work is known, liked, loathed or at least argued about, by people to whom the names of Giacometti, or Arp, or Brancusi, or Gabo, or Marini or Manzu are unknown; or if known then only as dim names remembered from some muddled past of newspaper cuttings or cocktail party conversations. It is heartening that in Moore's case this

recognition did not rely on any scandal in his private life nor on any notoriety produced by some 'shocking' exhibition's making headline news by being banned by officialdom. His work is often disturbing; never shocking.

Like that of Dylan Thomas, Henry Moore's inspiration is rooted in nature. This might seem something of an obvious statement in relation to a sculptor, but many sculptors, indeed most of the great classical masters, scarcely inhabit that world at all. Classical humanist sculpture from Praxiteles through Michelangelo to Rodin or even to Maillol produces works which almost transcend the very nature of the material from which they are carved. They have almost a total dedication to the truth of what is being portrayed. To look at Praxiteles' *Hermes* is to look at the perfect figure of a man carved in marble, not at a block of marble carved in the shape of the perfect figure of a man. Henry Moore is much more the kind of sculptor who realizes and helps to make manifest the potential forms imprisoned within his material. Nothing seems to escape from stone or wood or slate or bronze that in some strange way could not have been discovered curled in embryo within it. This kind of approach to sculpture has its very considerable dangers, and Moore, though not the originator of the phrase 'truth to material' has suffered from its use in connection with his work as Hindemith suffered from the phrase 'Gebrauchsmusik' and Brecht from 'alienation effects'. That Moore is true to his material is indisputable; but to be a great sculptor is to be more than that.

In much the same way as Bartók invigorated the classical German tradition of the string quartet by the incorporation of modes from outside the boundaries of that culture, so Moore, while being profoundly attached to the immense European sculptural tradition, infiltrated into it profoundly effective stylistic qualities derived from more remote and often primitive cultures—we may see this most clearly in certain early reclining figures in which the evidence of influence from Mexican art is immediately apparent. In the early works we discover in figures which are often of great 'abstract' beauty a slightly uneasy amalgamation of realism and formal abstraction. Often through the most limited means Moore will produce in a sculptural figure that is far from being 'representational' a sense of individual character more telling than that produced by many a purveyor of fashionable busts. This characteristic is also seen very clearly in many of the drawings.

Although Moore may seem sometimes to us to be such an original genius, John Russell in his book on the artist very properly points out:

Moore in his twenties had to puzzle things out more or less by himself, and to that extent it is reasonable to study him in isolation. But art is in the last resort a social activity, and no great work of art was ever produced in a

social vacuum. There is no such thing as a masterpiece that was executed without regard for what other artists were doing and had already done: or even to a lesser extent, without regard for what other human beings might one day want to see.[11]

This is as true for the poems of Dylan Thomas, which for all their 'uniqueness' demonstrate within themselves a distinguished traditional lineage.

The two most significant modern sculptors contributing to Moore's development must certainly be Brancusi and Arp. Brancusi in particular because of his extreme simplification of sculptural forms, his almost total banishment of decoration. Brancusi perhaps stripped away too much. There is an intellectual purity, almost a clinical barrenness about some of his works that denies the sensuous response that can be a part of the pleasure of the art. Arp, less severe than Brancusi and remaining closer to natural forms, tends to be too sensuous, too feminine—to be seduced by a maternal softness. Moore combines the masculinity and intellectual sinew of Brancusi with the gentler features and voluptuousness of Arp.

Many of the works produced in the mid-1930s inhabit fairly closely the world of middle-period Giacometti, though the surrealist element is never as great and the feeling of a relevance to nature is invariably present. But there is nevertheless something of that misguided element of the 'powerless totem'. It is in the reclining figures in various media that we see the major signs of his gathering up of that power which is to inform his later work and I think it is not altogether too fanciful to suppose that just as the wartime experiences of Dylan Thomas helped him to imbue the luxury of his language with a broader purposefulness and strength of meaning, to relate it more to the general human condition, so Moore seems to gain a dimension hitherto unsuspected. Much of this may have been due to his role as a 'war artist' recording the strange nocturnal life of those shelterers from the air-raids sleeping or wandering within the intestinal tunnels of the London underground system. Again John Russell very appositely writes:

> With the Shelter drawings Moore became what he has been ever since: one of the keepers of the public conscience. People were persuaded, when they saw these drawings, that a certain dogged grandeur attached to the life they were leading. The squalid and self-preservatory elements in that life dropped away, and what remained behind was on the scale of epic. (What epic, after all, is not without its *longueurs*?) And as Moore is not at all a hermetic or cerebral artist there is no doubt that he, likewise, was sustained and encouraged by this sudden contact with a large public.[12]

The only major sculpture of those early war years is that superb *Madonna and*

Child in Hornton stone which was commissioned for St Matthew's Church, Northampton, and which is undeniably one of the finest works for an ecclesiastical setting to be produced during the last half-century. It is, however, fairly isolated within Moore's development.

What is exciting about the wartime drawings and the subsequent sculpture is precisely what is so revelatory about the poems of Dylan Thomas; the feeling they convey for us that the natural world in which human beings move, and those very human beings themselves, are possessed of a relevance that lies deeper than their gross physical shapes and seemingly trivial usefulness. Perhaps this is merely that old pathetic fallacy raising its ugly head again; but I doubt it.

If the sculptures of Henry Moore do not proffer us a myth to which we can attach a name, they seem to insist on some kind of mythology of origin, and if the more hieratic figures such as the famous *King and Queen* do not inspire a particular ritual they go some way to reviving the belief that worship and ritual are valuable and, despite a society seemingly inimical to them, in some form or another deeply necessary.

The more disturbing and menacing bronze figures such as the series of *Helmet Heads*, though full of menace, are altogether free from the neurotic excesses which so disfigure the work of many younger artists. But perhaps the most intriguing development in Moore's carvings especially has been his manipulation of forms within forms. Those works in which a figure exists within another figure, not so much so as to exhibit the cleverness of a Chinese puzzle, but somehow to produce the idea of a child within a womb; of a life within a life. These explorations are particularly interesting when we remember that one of his great contributions to sculpture was first of all the opening up of form—the creation of the hole within and through the solid which is in itself a kind of liberation, a setting free; for this later development of the enclosing of the figure, in a mysteriously protective way, as a mother might a child, or in a menacing way as a society might imprison an individual, seems to bring his explorations full circle. More than this, though, it seems to me that this is related to his profound realization of the eternal flux of life and death: the *Deaths and Entrances* of Dylan Thomas. This sense of becoming, this curious apprehension of worlds within worlds, and, too, an overall sense of the positive capabilities of man, and the fecund growth processes for ever opposing the wilfully destructive and negative ones, culminate in Henry Moore's finest creations in a quality of ecstasy which is also the supreme manifestation of both the greatest poems of Dylan Thomas and the music of the composer Michael Tippett.

When the curtain went up at Covent Garden on the first performance of the *The Midsummer Marriage* the stage set was not by Henry Moore, who would have been the most appropriate designer, but by Barbara Hepworth. Tippett's choice

was not without perspicacity, for the work of Hepworth and Moore is fairly close in style, but for all Barbara Hepworth's devotion to and reliance upon shapes and forms drawn from the natural world there is a feminine elegance about it that lacks the grandeur to match Tippett's most marvellous creation. It is undoubtedly to Moore in the plastic arts that the mysterious and ecstatic vision of Tippett's musical imagination reaches, and never more dramatically than in the numinous majesty of *The Midsummer Marriage*.

If in the *Helmet Heads* and many of the small figures to be held in the hand Henry Moore, like Giacometti, exhibits the very powerful influence of the sculptural style of Mycenæ, it is perhaps not too fanciful to suggest that the poetry of Dylan Thomas inhabits a kind of post-Freudian Arcadia, while the world of Michael Tippett's music is that of a post-Jungian Arcadia. The darker areas of both these artists seem rarely to cast into the deepest shadow the radiant and spring-like innocence which appears to be its primal characteristic. What does too often obscure in the work of Thomas is too heavy a weight of abstruse sexual symbolism, and, in the operas and cantatas of Michael Tippett, too great an insistence on putting forward a very personal and private philosophy, and in the purely orchestral works a too constricting and elaborate intellectual contrivance.

Like the artistic development of Moore, Dylan Thomas and Patrick White, that of Michael Tippett has been entirely consistent and can be seen as a steady organic growth extending and developing from the first of his compositions, the String Quartet no. 1, through to the Third Symphony and the most recent of the operas *The Icebreak*. His peculiar sense of exuberance, which even in the more tragic works might almost be called a positive joy, is demonstrated in his first unquestionable masterpiece, which is one of the glories of modern string music: The Concerto for Double String Orchestra of 1938–9. This work at once not merely declares an individual musical idiom but proclaims with absolute sureness the philosophical/musical nature of the composer. The two orchestras are set not against each other but side by side and the musical themes are elaborated not by argument but through a discussion in which the questions and answers meet, overlap, merge, and resolve themselves in a final harmony not disrupted but enriched by their differences.

Even in such works as the opera *King Priam*, in which there is a considerable element of violence and in which the style employed is more fragmentary and episodic than in any of his other works with the possible exception of the Concerto for Orchestra, Tippett rarely introduces elements of vicious conflict and in this his musical style is very much in keeping with his individual personality. Like Dylan Thomas he was at pains to avoid participation in the Second World War and served three months imprisonment as a conscientious objector, a

curiously apposite fate for the composer of the oratorio *A Child of Our Time*, that still underrated, musically eloquent and deeply compassionate cry, opposing love to the increasing hatred of the past thirty years. The tragedy is illuminated by a quality of acceptance out of which hope may spring. Tippett's philosophy would not entirely embrace that of Yeats but there is a feature of it which in *A Child of Our Time*, *The Heart's Assurance* and *King Priam* recalls something of Yeats's words in the preface to the *Oxford Book of Modern Verse*: 'In all the great tragedies, tragedy is a joy to the man who dies; in Greece the tragic chorus danced. When man has withdrawn into the quicksilver at the back of the mirror no great event becomes luminous in his mind . . .'[13]

If Tippett, in his positive and joyous nature and also in the extreme complexity of much of his work, is very closely akin to Dylan Thomas, the two share an alikeness of style in the enormous arcs of their 'melodic' lines. One of the greatest difficulties in comprehending many of the more wilfully elaborate poems of Thomas lies precisely in the strain of encompassing poetic cadences which span parentheses and sub-clauses far in excess of those proffered by the majority of modern poets: more contorted often than the most entangled passages of Gerard Manley Hopkins. So, too, the widely thrown arcs of the melodies of Michael Tippett, which are in almost direct contrast to the succession of small fragments which so often make up the melodies of composers as different as Janáček, Bartók, Stravinsky and Schoenberg.

The most immediately appreciable evidence of this style is shown in the way in which he pursues and elaborates the nostalgically beautiful slow movement of the early Concerto for Double String Orchestra, and, in an even more convoluted manner in the cantata for voice and piano *Boyhood's End*. The choice of text for *Boyhood's End* is especially interesting when it is considered as the major vocal work to be composed after *A Child of Our Time*. In the oratorio the themes of imprisonment, deprivation, destruction, and indeed the denial of everything that should make life worthwhile, nevertheless carries as a kind of subterranean river a life-giving flow that points to growth in the future, and Tippett's own text offers as its final statement: 'Here is no final grieving, but an abiding hope. The moving waters renew the earth. It is spring.'

In *Boyhood's End* the trapped man of *A Child of Our Time* celebrates the fecundity of proliferating nature through the innocent eyes of W. H. Hudson. It is an unusual text for a work written for a tenor soloist and piano in that it is in prose, and yet it is perhaps precisely because of this that it requires of Tippett the extreme application of his personal, widely flung melodic gestures. Even the freest of verse forms, such as those employed by Walt Whitman or D. H. Lawrence, have a resolving cadence that is more mellifluous and encompassing as a vocal line than most passages in prose can be.

Delicately evocative and rapturous as Hudson's text undoubtedly is, it does not sing of itself, and the effect of those wing spans of melismatic joy are of necessity created almost entirely by the composer. The difference between the setting of such a prose passage and the more orthodox lyric fervour achieved by setting verse is clearly seen if *Boyhood's End* is contrasted with the song cycle *The Heart's Assurance* written in 1950–51 to poems by Sydney Keyes and Alun Lewis. In this work the vocal line is very much more straightforward and perhaps because of this the exceptional elaboration of much of the piano writing may at first seem altogether too extreme, though it is difficult not to be immediately captivated, perhaps overwhelmed is the right word, by the astonishing accompaniment given to the title song 'The Heart's Assurance' itself. After the tranquillity of *Boyhood's End* the poems in this cycle are very much more closely related to the sombre theme of *A Child of Our Time*, since they are poems by two young men who were tragically killed in the Second World War, and are full of an urgent foreboding. But even here Tippett pushes through the tragic statement to a final acceptance of the dark, brooding side of the world out of which a purposeful life must fructify and burgeon if humanity is to survive at all. He is not celebrating the idea of purification by grief or pain; nor acquiescing in the meritricious belief that suffering ennobles; merely accepting the tragic moment, enduring, and retaining a belief in the ultimate triumph of life.

The life-giving energies of nature that are so richly shown in *Boyhood's End* and the tragic world of human conflict and anxiety which is the basis of *The Heart's Assurance* merge in that miraculous and still grossly underrated opera *The Midsummer Marriage*, which must surely eventually be recognized as one of the most extraordinary musical masterpieces of our time. Tippett has himself repeated many times how its inception was in the nature of a vision, an inspiration, a visitation, unplanned, unexpected, unheralded. At its first performance it was considered exceptionally private and obscure both in its text, which is indeed clumsy and often laughable (but so is that of *The Magic Flute*) and also in its music, which many felt to be intricate in the extreme and weighed down by a proliferation of thematic and rhythmical devices which made its communication to an audience in an opera house virtually impossible. It is, of course, a composition of positive affirmation and because of this it may bewilder listeners in a world in which the destructive and negative elements are so much more easily assimilated and which assail us with degrading vigour at an alarming rate. It is indeed something of a shock to find a major work of our time propounding such a theme of ecstasy as that declared by Mark, the hero of the opera, in his first aria. Perhaps we feel we should shy away from such exaltation when he begins the florid melody of 'The summer morning dances in my heart.' But it is this dance within the heart that makes the music of Tippett so valuable in our time.

From the close of that aria through the opera in which we see both the simplicity of an ordinary love match between Bella and Jack and the complexity of a ritualistic love match and marriage between Mark and Jennifer embraced within a semi-mythological structure which seems to have its roots deeper than any known or imaginable history, we cannot but be aware of an abiding faith in the life-giving forces of the natural world. Such a faith and the pursuit of such a faith is no guarantee of the production of a work of art—often, alas, the result is sentimental and mawkish or dull. But in this work of Tippett perhaps more than in any other it produces an astonishing success. Even the text, which is often clumsy and inept, is appropriate and satisfactory at the most revelatory moment in the opera when Madame Sosostris the clairvoyant is summoned forth and propounds in a monologue of almost unnerving eloquence Tippett's never-wavering credo:

> You who consult me
> Should never doubt me.
> Clean let the heart be
> Of each seeker.
>
> Truth shall shine through me
> Once more endue me.
> Humble yourselves now,
> I speak as a seer.

It is salutary to note how, at this moment, much of the involution of Tippett's style is unravelled and a new simplicity shines through as it does in the finest poems of Dylan Thomas, to move us the more by an essential and grave rightness; a sense, almost, of innocence. But *The Midsummer Marriage* and the Piano Concerto which springs from the same ground of inspiration required, or seemed to require, a hard edge to oppose their lyric communings, and we see in the second opera *King Priam* a dampening down of the ecstatic musical flow and the introduction of a more fragmented and episodic style, a more elliptical utterance, a sparer texture and an altogether more cerebral manner of composition. It is the style perhaps of the *Helmet Heads* of Moore and certainly it bears a close relationship to the development of Moore's graphic style as displayed in his series of illustrations to Edward Sackville-West's radio drama *The Rescue*. The demands of these themes from classical Greek mythology conjure up, both in Moore and in Tippett, an energy which falls only a little short of savagery, and remarkable as both these works are they perhaps lack that overall sense of rightness to the individual creative being that we discover embedded in their other works. This may well be because both subjects interpose a considerable element of violence. The spikey themes of the opera are closely related to the intrusion of the sharp

fork-like element within the sculpture of Moore when he began to produce the various standing figures in the early 1950s. Something of the warmth of Moore's style is stripped away; something of the luxury of Tippett's is scraped away. As in the warrior figures of Moore produced between 1952 and 1957, the maternal nature of Tippett's work is partially replaced by a sterner masculinity. The lyrical impetuosity and the newly acquired dramatic strength come more purposefully to fruition in Tippett's opera *The Knot Garden* and in the cantata *The Vision of St Augustine*.

In *King Priam* it is possible to see Tippett attempting to overcome a significant weakness in his operatic thinking which is related more to the manipulation of the drama than to the deployment of the music. To a large extent in *King Priam* he eschews the symbolic extravagance that overlays so much of *The Midsummer Marriage*, though he is still concerned to write a work in which the drama is created more by the exposure of philosophical or psychological states of the characters than through the overt dramatic action. There is nevertheless a greater acceptance of the idea of an orthodox plot structure, and the actions are more 'reasonable'. In *The Knot Garden* he seems to have abandoned the struggle and the obscurities of the work are almost impenetrable away from the libretto and the score, though miraculously, as with Eliot's *Waste Land*, the emotional impact is so powerful that a great deal of the 'meaning' does filter through. But the difficulty is undoubtedly a barrier against complete success. Peter Heyworth perceptively sums up the problem:

> The failure to work out this imagery in terms of conventional 'plot', so that the discursive intellect is appeased and does not bar the way to what lies below, is why *The Midsummer Marriage* just fails to be one of the few really great operas of the twentieth century. Yet with all its weaknesses it carries an aura so potent that two or three bars suffice to sweep the addict back into an engulfing world. For me it has become a part of living itself.[14]

This is true enough of *The Midsummer Marriage* but how much more relevant is it to the almost wilful confusion of *The Knot Garden*. In this work it is as if Tippett was determined to confront the audience with a set of characters exhibiting and trying to resolve most of the neuroses stemming from rejection and sexual frustration that fill the case books of Kraft-Ebbing, Freud and Jung. But once again the music, for long stretches of time, makes up in sheer rhythmical vitality and melodic profusion what is lost through the imbalance and amateurishness of the text. An added complexity however arises in this work with the extension of Tippett's amazingly exploratory musical style. This is perhaps most clearly seen because the duration of the work is shorter, the effect more condensed, in *Songs for Dov*, the set of three songs partially drawn from the opera, but created as a

separate entity for concert performance. Here Tippett seems to be attempting to do just too much. The comparatively straightforward orthodox melodic structure in the tradition of European song merges somewhat uncertainly with speech-song and even less happily with the near-jazz elements which are introduced, and while this mixture of styles does mirror the nature of the fragmentary and allusive text itself, that text is largely unsatisfactory for the same reason. Once again in the hermetic world of these songs we are confronted with a symbolism that seems too personal and private and which is not made properly to cohere within a satisfactory 'plot' structure. This is the gravest weakness of the longer poems of Dylan Thomas, for undoubtedly the dense sexual imagery of the 'Ballad of the Long-Legged Bait' would be more rewarding if it rested upon a more comprehensible groundwork. The mysterious drama of *The Ancient Mariner*, even when Coleridge's imagination is acting at its most inspired wildness, works because the story-line is simple, obvious, and capable of holding the ballad as a whole firmly within its workaday world. But the language itself of Thomas plays the role of the music of Tippett and for a considerable time the reader is carried along by the melodic impetuousness and the gorgeous orchestration.

Tippett's attempt at the end of *The Knot Garden* to open out the opera to embrace the audience and, as it were, invite some kind of tentative audience participation seems totally misguided. There is little point in throwing out a beautiful welcome from the stage when one knows in advance that the people who are going to answer and respond are members of the operatic chorus placed at strategic positions within the auditorium.

Such difficulties as these which make *The Knot Garden* a very flawed opera are less damaging in the more hermetic cantata *The Vision of St Augustine*. It is possible that the very fact that this is a visionary work, that by its very nature it is hieratic and remote, works to its advantage. We are lifted instantly into a world of spiritual revelation and do not expect within that world to encounter simple directives to action within the sphere of our more mundane working lives. We accept the difficulties in much the same way as we might accept our participation in a liturgical ritual in which the total exposition is in Latin; which is indeed the language of Tippett's cantata.

Like most of Tippett's works it is undoubtedly overburdened with difficulties. The baritone soloist has an intensely exacting vocal line from the point of view of both the performer and the listener; the chorus sing in Latin throughout, the male voices often required to sing an altogether different text against that of the females, while the orchestral writing has all the multitudinous richness of Tippett's purely orchestral works.

Drawn from the *Confessions* of St Augustine himself, its intention is, at least in

its second section, to penetrate the mystery of time, and it is not without purpose that it bears at its head a quotation from T. S. Eliot's *Burnt Norton*: 'And all is always now.' It is a clue perhaps to the constant preoccupation of Tippett with illumining for us the ecstasy to which we could reach were we able to penetrate into the vibrant heart of each moment but which we scarcely apprehend because of our violent movement through moments in succession. He attempts to break open the pulsating core of each one. It is a spiritual and metaphysical exercise and discipline but it is also an attempt on the part of an adult saturated with experience to reclaim the purity and innocence of childhood (if such a state exists). It is this metaphysical quest and this belief in some primal Garden-of-Eden simplicity of childhood that links him so strongly with the poet Dylan Thomas on the one hand and the Australian novelist Patrick White on the other.

The artist who is the main protagonist of White's novel *The Vivisector* succinctly expresses it:

> Once he had recorded:
> God the Vivisector
> God the Artist
> God
> surrounding with thoughtful piecrust the statement he had never
> succeeded in completing. On the whole it didn't disturb him not to
> known what he believed in—beyond his own powers, the
> unalterable landscape of childhood, and the revelations of light.[15]

'The unalterable landscape of childhood and the revelations of light'—to make these palpable and vibrant within us would seem to be the purpose of the greater poems of Dylan Thomas and the finest compositions of Michael Tippett. We have only to recall Thomas's line: 'light breaks where no sun shines' and turn our hearing to those tremendous cries of the chorus in *The Vision of St Augustine* at the word 'fenestram', or the recurring line 'Diem Decoro lumine', to see the continuing significance in their work of their quest to illuminate for us the darkness through which we may stumble. In order to do this it is necessary for them to establish a world of essences and emanations. But the emanations are not to be those discovered by the hero of Sartre's *Nausea*. It is not nausea that is released from the pebbles, stones, fires, flowers, deserts, in the spiritualized landscape through which the characters in Patrick White's novels journey. White releases in his novels, as does Henry Moore from the innermost core of his tremendous creations, a quality that is not so much healing as redeeming. These two artists like Tippett and Thomas would seem not to enter into any conflict with nature, even in its most alien manifestations, but into a harmony within

which the nature of inorganic matter, or of strange vegetable life, and man as a being possessed of a spirit, may be capable of achieving a unity of purpose as yet only peripherally explored.

In Patrick White's first two novels, *Happy Valley* published in 1939 and *The Living and the Dead* published in 1941, there is little to indicate that he was to develop into such a powerful novelist within the grand classical tradition. *The Living and the Dead*, it is true, works as much through its undertones and over-tones, through what is implied rather than what is said, but its major character-istic is the somewhat unsatisfactory one of an aristocratic and pretentious gnomic style, particularly in its areas of conversation. The artifice of some of the more objectionable elements of Bloomsbury is too much to the fore, and this remains true of much of *The Aunt's Story*, though that fantastic novel is graced by a sense of humour and wit as well as carried forward in a much more relaxed style; it is in this third book that we begin to suspect that Patrick White is something rather out of the run of modern prose writers. The truth of these suspicions is magnifi-cently demonstrated in his epic novel *The Tree of Man* published in 1955, a novel which made many of the more fashionable writers of those years look trivial indeed, their sophistication covering up all to often their lack of anything worthwhile to say. But even that novel contains only to a small degree the element which is Patrick White's greatest claim to uniqueness among the ranks of contemporary writers: the investing of what might seem to be the common actions of man and the blunt obstinacies of the physical world within which he moves with a disquieting spiritual significance. Like Dylan Thomas he has about him something of the nature of that strange poet and painter of spirits and emanations, William Blake.

The Tree of Man has been described as the Australian Book of Genesis, and that is an apt and reasonable description; it has also been compared both in its scope and in its achievement with the epic novels of Tolstoy. In its length, in the leisurely way it unfolds, it is more akin to the nineteenth-century epic novel than to many of the more brilliant and iconoclastic novels of the twentieth century. In its weight and in the sureness of its development it is perhaps closer to the works of Thomas Mann than to most modern writers and like Thomas Mann Patrick White is rarely scintillating or superficially enjoyable. He digs deep and often makes the reader work hard for his revelations.

He has too a deep awareness of the emotional bond between people that reveals more than any actions or words can do, a quality found also in the finest passages of the novels of D. H. Lawrence. White however restrains the excess of romantic passion which Lawrence releases, offering in its place an often dis-quieting torrent of spiritual passion. It is in wonder, compassion, ecstasy and

love that he is most astonishingly successful, and it is this which links him so closely to the preoccupations of Dylan Thomas and Michael Tippett. Like them he is also ritualistic and like them he shows us the continuing extraordinariness of the ordinary. He shows, too, that although one may attempt to pursue a particular destiny, destiny for him, as for Goethe, as for Maeterlinck, as for Rilke, finally has to be acknowledged as that which is not willed.

His novels are for the most part curious conversations with God. He clearly indicates that intellect is not necessary for these conversations; and despite the metaphysical nature of his books there is rarely any truly metaphysical argument, for, for the most part, the characters would be incapable of sustaining it. Most of the revelations spring from the reflections of fairly simple people, or if through intelligent ones then at those moments when they are bereft of intellectual stamina and power.

The Tree of Man, however, is not especially concerned with such problems, though they cannot but help intrude from time to time. White perceives that perhaps uncomplicated beings are the more likely to be possessed not merely by uncomplicated thoughts but also by an uncontaminated spiritual innocence and wisdom. Wisdom, after all, has little to do with knowledge, and insight even less to do with education. When the simple woman Doll Quigley brings Amy Parker a tin of rock cakes Amy's husband reflects upon the action:

> But Stan Parker continued to think of Doll Quigley, her still, limpid presence that ignored the stronger muddier currents of time. It was through ignorance perhaps. Or else the purposes of God are made clear to some old women, and nuns, and idiots. At times Stan Parker was quite wooden in his thick bewilderment. Then for a moment he would be laid open, as he was by Doll Quigley's glance. He would begin then, watching his own hands as they did things, or he would remember the face of an old woman in a shattered church, or a tree that had been blasted, putting on its first, piercing leaves.[16]

Patrick White's concern is for the necessity of faith. Faith itself; not particularized faith. It is necessary merely to believe, not to be able to demonstrate or pass examinations in the nature or reality of one's belief. But not all belief, because of this, can be equal:

> To believe. The enviable word. It was not that she was without faith, only that there were different altitudes of inspiration. Wondering then, she looked round to see which face of these would be saved by implicit faith, the old woman who had the tumour, the man with the hair gummed down in strips, who had learned the gymnastics of ritual, several ugly people

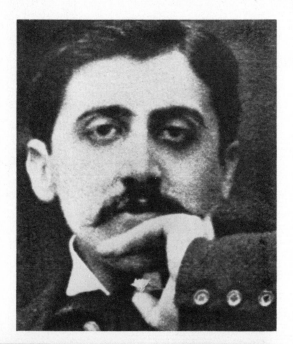

(LEFT) *Pelléas et Mélisande*. Royal Opera House, Covent Garden (1969). Photo: Donald Southern

(RIGHT) Marcel Proust. Mansell Collection

(BELOW) Claude Debussy. Portrait by Marcel André Baschet

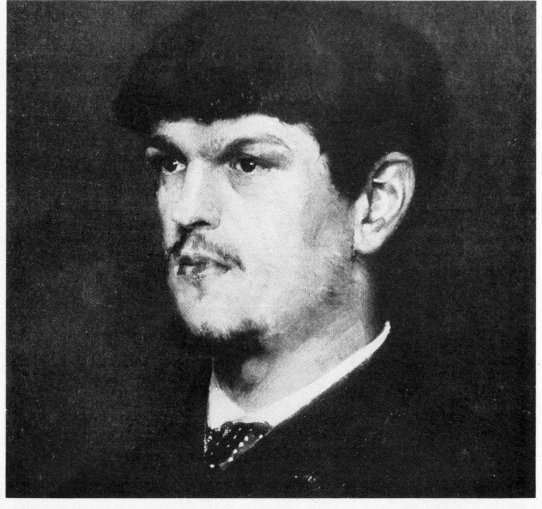

(RIGHT) Béla Bartók. Courtesy of Decca
Record Company

(FAR RIGHT) Arnold Schoenberg *Moses and
Aaron*. Royal Opera House, Covent Garden
(1966). Photo: Houston Rogers

(BELOW) W.B. Yeats by Augustus John
(1907). Reproduced by permission of The
National Portrait Gallery, London

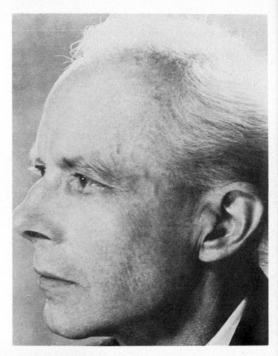

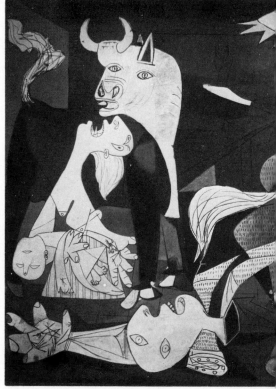

(ABOVE) T.S. Eliot. Film of *Murder in the Cathedral*. Courtesy of National Film Archive/Stills Library and Mr G. Hoellering

(ABOVE RIGHT) Igor Stravinsky *Oedipus Rex*. English National Opera (1960). Photo: Stuart Robinson

(RIGHT) Pablo Picasso *Guernica* (1937, May–early June). Oil on canvas, 11ft 5½ins × 25ft 5¾ins. Collection, The Museum of Modern Art, New York on extended loan from the artist's estate

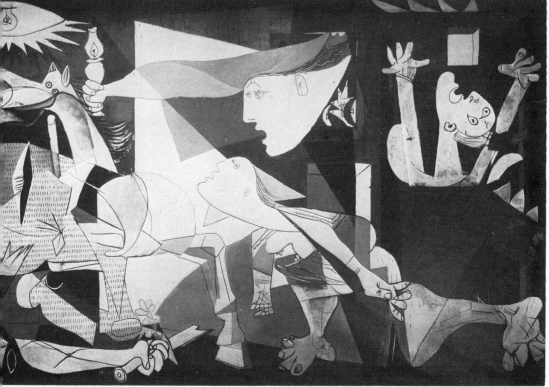

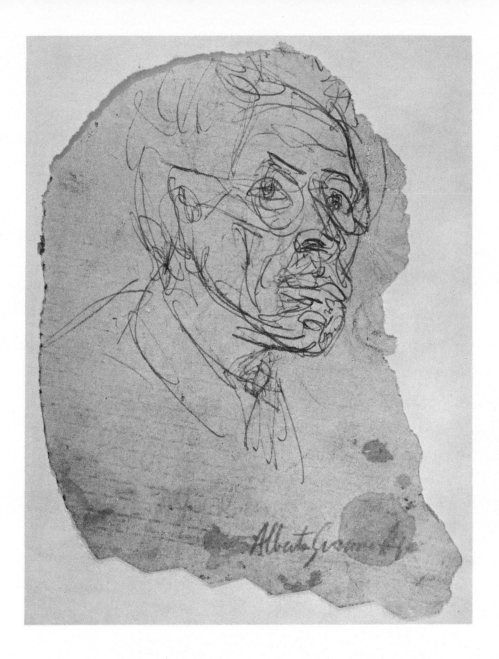

(ABOVE) Alberto Giacometti *Self-Portrait*
(1962). Ball point pen on paper napkin,
$7\frac{1}{4} \times 5$ins. Collection, The Museum of
Modern Art, New York

(LEFT) Paul Hindemith *Mathis der Maler*.
Hamburg State Opera (1967). Photo: Peyer

(ABOVE LEFT) Bertolt Brecht *The Life of
Galileo*. Mermaid Theatre, London (1963).
Photo: Andrew Cockrill

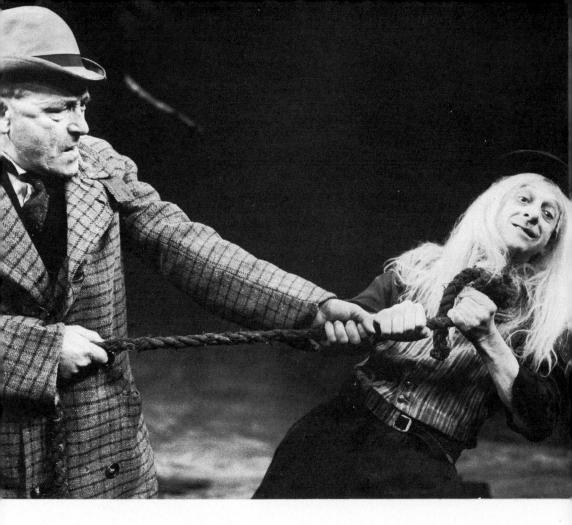

(ABOVE) Samuel Beckett *Waiting for Godot*. Royal Court Theatre production by Anthony Page (1964). Photo: Zoë Dominic

(ABOVE RIGHT) Marcel Duchamp, 1968. Photo: David Newell-Smith, Camera Press (OBS), London

(RIGHT) Francis Bacon. Photo: Dmitri Kasterine, Camera Press, London

(FAR RIGHT) John Cage. Photo: James Klosty

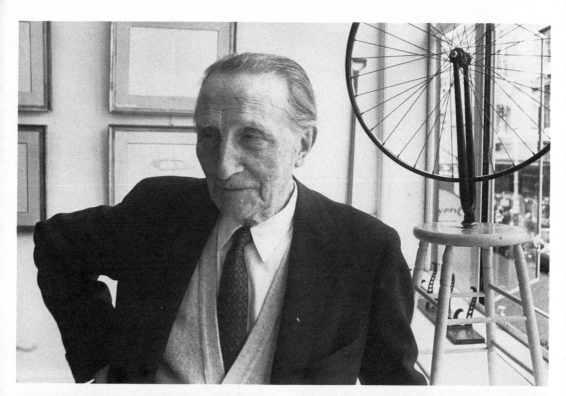

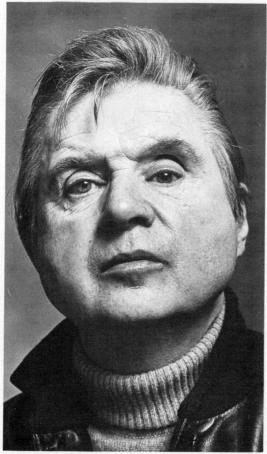

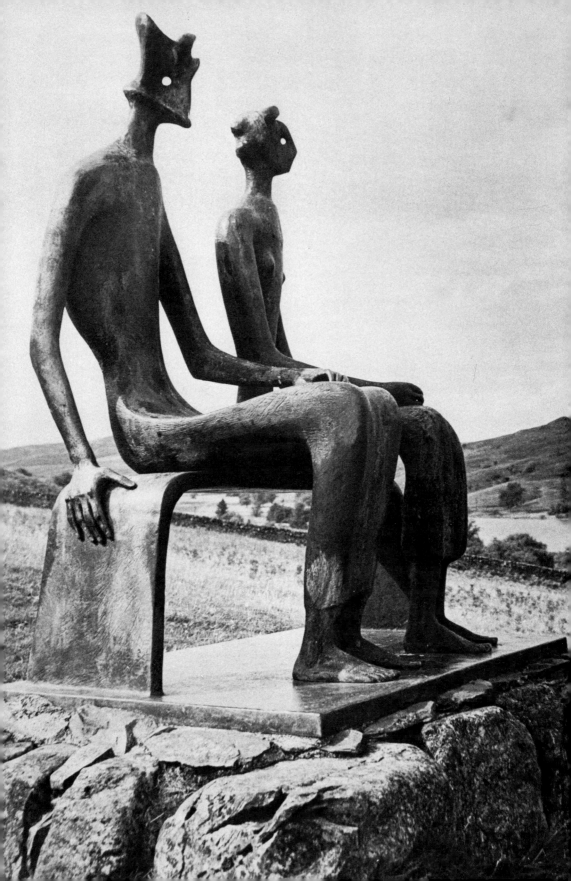

(ABOVE) Michael Tippett *The Midsummer Marriage*. Royal Opera House, Covent Garden
(1968). Photo: Mike Evans

(LEFT) Henry Moore *King and Queen*. Courtesy of the artist

(RIGHT) Patrick White. Courtesy Australian
Information Service

(BELOW) Dylan Thomas. Oil painting by
Rupert Shephard (1940). Reproduced by
permission of The National Portrait Gallery,
London

continent in which the spiritual and the physical commingle until it becomes almost impossible to tell them apart. The afflictions which beset, or the calamities which befall, the various characters in the novel are powerless to destroy them because, through no desire of their own, they are, as it were, the appointed of God. They have no need to understand their condition, they merely have to exist within it. This fact might seem to propose that Patrick White was writing a novel of extreme sophistication, a metaphysical prose work of great intellectual rarity, but this is far from the case. His chosen people are carefully selected so as to show the working out of the grace of God through disparate means. Miss Hare, the supposedly mad woman, living in her decaying mansion, is the recluse for whom inaction is the most significant action; Mrs Godbold is the ordinary simple woman whose righteous acts and disposition are not virtuous, because they are natural; the old Jew Himmelfarb is the man for whom knowledge and status have to be abandoned in order to grow into wisdom through faith; the aborigine painter Dubbo is the artist whose creative genius is released only when he has been transfixed at the core of affliction.

Whereas in *Voss* the characters are often required to propound thoughts of an audacity which would seem beyond them, and the total situation is of an exceptional nature, the four major characters in *Riders in the Chariot* are so compellingly created that their thoughts, words and deeds seem inevitable and proper to them.

The characters, though they all perceive that objects are imbued with spiritual power, do not suffer the delusion that such power will necessarily save them in their moments of trial. For the scapegoat as for the sacrificial animal nothing suffices in the end save death. Miss Hare enters into the nature of things. At their first meeting Himmelfarb ventures:

'You investigate nature very thoroughly,' the man said, and laughed.
'I do not have to investigate,' she answered. 'By now I know!'[19]

Toward the end of the book when Himmelfarb is dying, as his spirituality is reformed by an understanding of non-human beings, so Miss Hare's animality is made vibrant through spiritual radiance.

He was as content by now as he would ever have allowed himself to be in life. Children and chairs conversed with him intimately. Thanks to the texture of their skin, the language of animals was no longer a mystery, as, of course, the Baal Shem had always insisted.
So he breathed more gently, and resumed his journey.
So Miss Hare was translated. Her animal body became the least part of her, as breathing thoughts turned to being.[20]

But Miss Hare knows that the stones of the field, nor the trees on the hills, nor the water in the streams will save her, though they will, with their own precious magnanimity, accept her. Mrs Godbold, washing clothes or baking bread in the shed that is her primitive home, expects no mercy of the linen or the dough. Himmelfarb who acknowledges that God exists within his table is aware that the wooden object is powerless to save him from the Nazi hooligans; while Dubbo, the artist, perceives that the reds, blues and yellows of his oil pigments will devour him terribly before spitting him out on the far side of creation.

It is of no importance. They recognize the Chariot.

'The Chariot,' Miss Hare dared to disturb the silence which had been lowered purposely, like the thickest curtain, on the performance of a life.

She did tremble though, and pause, sensing she had violated what she had been taught to respect as one of the first principles of conversation: that subjects of personal interest, however vital, are of secondary importance.

'You know about the Chariot then,' she could not resist.

But whispered. But very slow and low.

It was as eventful as when a prototype has at last identified its kind. Yet pity restrained her from forcibly distracting attention to her own urgent situation, for her mouth was at the same time almost gummed together by all she had suffered in the course of her companion's life. And so, the word she had dared utter hung trembling on the air, like the vision itself, until, on recognition of that vision by a second mind, the two should be made one.

'If we see each other again.' The stone man had begun to stir and speak.

The knot of her hands and the pulses in her throat rejected any possibility that their meeting might be a casual one. But, of course, she could not explain, nor was her face of any more assistance than her tongue; in fact, as she herself knew, in moments of stress she could resemble a congested turkey.

'If we should continue to meet,' the Jew was saying, 'and I revert to the occasion when I betrayed my wife, and all of us, for that matter, you must forgive me. It is always at the back of my mind. Because a moment can become eternity, depending on what it contains. And so I still find myself running away, down the street, towards the asylum of my friends' house. I still reject what I do not always have the strength to suffer. When all of them had put their trust in me. It was I, you know, on whom they were depending to redeem their sins.'

'I do not altogether understand what people mean by sin,' Miss Hare

had to confess. 'We had an old servant who often tried to explain, but I would fail as often to grasp. Peg would insist that she had sinned, but I knew that she had not. Just as I know this tree is good; it cannot be guilty of more than a little bit of wormy fruit. Everything else is imagination. Often I imagine things myself. Oh, yes, I do! And it is good for me; it keeps me within bounds. But is gone by morning. There,' she said, indicating the gentle movement of the grass, 'how can we look out from under this tree, and now know that all is good?'

For the moment she even believed it herself. She was quite idiotic in her desire to console.

'Then how do you account for evil?' asked the Jew.

Her lips grew drier.

'Oh, yes, there is evil!' She hesitated. 'People are possessed by it. Some more than others!' she added with force. 'But it burns itself out. Some are even destroyed as it does.'

'Consumed by their own sin!' The Jew laughed.

'Oh, you can catch me out!' she shouted. 'I am not clever. But do know a certain amount.'

'And who will save us?'

'I know that grass grows again after fire.'

'That is an earthly consolation.'

'But the earth is wonderful. It is all we have. It has brought me back when, otherwise, I should have died.'

The Jew could not hide a look of kindly cunning.

'And at the end? When the earth can no longer raise you up?'

'I shall sink into it,' she said, 'and the grass will grow out of me.'

But she sounded sadder than she should have.

'And the Chariot,' he asked, 'that you wished to discuss at one stage? Will you not admit the possibility of redemption?'

'Oh, words, words!' she cried, brushing them off with her freckled hands. 'I do not understand what they mean.'

'But the Chariot', she conceded, 'does exist. I have seen it. Even if a certain person likes to hint that it was only because I happened to be sick. I have seen it. And Mrs Godbold has, whom I believe and trust. Even my poor father, whom I did not, and who was bad, *bad*, suspected some such secret was being kept hidden from him. And you, a very learned man, have found the Chariot in books, and understand more than you will tell.'

'But not the riders! I cannot visualize, I do not understand the riders!'

'Do you see everything at once? My own house is full of things waiting

to be seen. Even quite common objects are shown to us only when it is time for them to be.'

The Jew was so pleased he wriggled slightly inside his clothes.

'It is you who are the hidden *zaddik*!'

'The what?' she asked.

'In each generation, we say, there are thirty-six hidden *zaddikim*—holy men who go secretly about the world, healing, interpreting, doing their good deeds.'

She burned, a slow red, but did not speak, because his explanation, in spite of reaching her innermost being, did not altogether explain.

'It is even told', continued the Jew, stroking grass, 'how the creative light of God poured into the *zaddikim*. That *they* are the Chariot of God.'[21]

Who of the remarkable artists of the Twentieth Century are of the Chariot we cannot perhaps see. Our eyes are dazzled by the brilliance of their forms and our ears by the multitudinous cacophony of their sounds. It behoves us however to attempt to perceive them and to help make their recognition possible. Art, must entertain; yes. The greatest art entertains most profoundly. It is perhaps better to run the risk of portentousness than to escape into trivia. Art does not preach and should not moralize but its creation is essentially a moral activity. Art becomes nauseating if it assumes the role of specious religiosity and becomes holier than thou, but it is nevertheless a sacred charge.

Within these conditions are presented the dilemma of the arts; to ignore that dilemma is to acquiesce in the betrayal of art.

At the end of the third of the *Songs for Dov* Michael Tippett quotes Pasternak:

> 'Then why does the horizon weep in mist
> And the dung smell bitter?
> Surely it is my calling
> To see that the distances do not lose heart
> And that beyond the limits of the town
> The earth shall not feel lonely.'
> Sure, baby.

Yes.

NOTES

CHAPTER 1

1. Thomas Mann, *Dr Faustus*. Secker and Warburg, London, 1949; Knopf, New York, 1948.
2. Rainer Maria Rilke, 'The Book of Pilgrimage', *The Book of Hours*, in *Selected Works*, vol. 2. Hogarth Press, London, 1960; New Directions, New York, 1960.
3. Arnold Hauser, *Social History of Art*, vol. 4. Routledge and Kegan Paul, London, 1951; Random House, New York, 1958.
4. Charles Davy, *Words in the Mind*. Chatto and Windus, London, 1965; Harvard University Press, Cambridge, Mass., 1965.
5. Rilke, *The Lay of the Love and Death of Cornet Christoph Rilke*, in *Selected Works*, vol. 1. Hogarth Press, London, 1954; New Directions, New York, 1960.
6. Rilke, *The Rodin-Book*, in *Selected Works*, vol. 1.
7. Rilke, 'Ninth Duino Elegy', *Duino Elegies*, in *Selected Works*, vol. 2.
8. Rilke, 'Some Reflections on Dolls', in *Selected Works*, vol. 1.
9. A. Norman Jeffares, *W. B. Yeats, Man and Poet*. Routledge and Kegan Paul, London, 1949; Yale University Press, New Haven, 1949.
10. Rilke, 'Of the Monastic Life', *The Book of Hours* in *Selected Works*, vol. 2.
11. Rilke, 'Of the Monastic Life', *The Book of Hours*, in *Selected Works*, vol. 2.
12. José Ortega y Gasset, 'In Search of Goethe from Within', in *The Dehumanization of Art*. Princeton University Press, Princeton, N.J., 1969.
13. Rilke, *Notebook of Malte Laurids Brigge*. Hogarth Press, London, 1950; Capricorn Books, New York, 1958.
14. Rilke, *Brigge*.
15. Rilke, 'Archaic Torso of Apollo', *New Poems*, in *Selected Works*, vol. 2.
16. Rilke, 'Ninth Duino Elegy', *Duino Elegies*, in *Selected Works*, vol. 2.
17. Rilke, 'Orpheus. Eurydice. Hermes', *New Poems*, in *Selected Works*, vol. 2.
18. Rilke, 'Of the Monastic Life', *The Book of Hours*, in *Selected Works*, vol. 2.
19. Rilke, 'First Duino Elegy', *Duino Elegies*, in *Selected Works*, vol. 2.
20. Rilke, 'First Duino Elegy', *Duino Elegies*, in *Selected Works*, vol. 2.
21. Rilke, 'First Duino Elegy', *Duino Elegies*, in *Selected Works*, vol. 2.
22. Rilke, 'Second Duino Elegy', *Duino Elegies*, in *Selected Works*, vol. 2.
23. Rilke, 'Ninth Duino Elegy', *Duino Elegies*, in *Selected Works*, vol. 2.
24. Rilke, 'Sixth Duino Elegy', *Duino Elegies*, in *Selected Works*, vol. 2.
25. Rilke, *Sonnets to Orpheus*, in *Selected Works*, vol. 2.
26. Rilke, *Sonnets to Orpheus*, in *Selected Works*, vol. 2.
27. Bruno Walter, *Gustav Mahler*. Severn House, London, 1975; Knopf, New York, 1958.
28. Paul Valéry, *Aesthetics*. Routledge and Kegan Paul, London, 1964; Pantheon, New York, 1964.
29. Donald Mitchell, *Gustav Mahler; the Early Years*. Rockliff, London, 1958.
30. Rilke, 'Third Duino Elegy', *Duino Elegies*, in *Selected Works*, vol. 2.
31. Pierre Louÿs, letter to Debussy quoted in Edward Lockspeiser, *Debussy: His Life and Mind*. Cassell, London, 1962; McGraw-Hill, New York, 1972.
32. Walter, *Mahler*.

33. Li-Tai-Po, 'The Drinking song of the Sorrow of the Earth', trans. by Deryck Cooke. Universal Editions (London) Ltd.

34. Ernst Krenek, quoted in *Gustav Mahler; the Early Years* by Donald Mitchell.

35. Gustave Moreau, quoted in Pierre Courthion, *Rouault*. Thames and Hudson, London, 1962; Abrams, New York, 1977.

36. Moreau, in Courthion, *Rouault*.

37. Courthion, *Rouault*.

38. Georges Rouault, *Stella Vespertina*, quoted in Courthion, *Rouault*.

39. T. S. Eliot, *The Family Reunion*, in *Collected Plays*. Faber and Faber, London, 1962; Harcourt Brace Jovanich, New York, 1969.

CHAPTER 2

1. Mirbeau, review of *La Princesse Maleine* in *Figaro*, quoted in W. D. Halls, *Maurice Maeterlinck*. Clarendon Press, Oxford, 1960.

2. Maurice Maeterlinck, *The Sightless*. Walter Scott Publishing, London and New York, 1892.

3. Samuel Beckett, *Waiting for Godot*. Faber and Faber, London, 1956; Grove, New York, 1954.

4. Maeterlinck, *The Sightless*.

5. Halls, *Maeterlinck*.

6. José Ortega y Gasset, *The Dehumanization of Art*. Princeton University Press, Princeton, N.J., 1969.

7. Arnold Hauser, *Social History of Art*, vol. 4. Routledge and Kegan Paul, London, 1951; Random House, New York, 1958.

8. George D. Painter, *Marcel Proust*, vol. 1. Chatto and Windus, London, 1959; Little, Brown, Boston, 1959.

9. Marcel Proust, *Swann's Way*, Pt. I, *Remembrance of Things Past*. Chatto and Windus, London, 1957; Random House, New York, 1960.

10. Proust, letter to Antoine Bibesco, quoted in *Letters of Marcel Proust*, ed. Nina Curtis. Chatto and Windus, London, 1950.

11. Hauser, *Social History of Art*, vol. 4.

12. W. B. Yeats, 'For Anne Gregory', in *Collected Poems*. Macmillan, London and New York, 1933.

13. Proust, *The Sweet Cheat Gone, Remembrance of Things Past*.

14. Howard Moss, *The Magic Lantern of Marcel Proust*. Faber and Faber, London, 1963; Macmillan, New York, 1962.

15. Proust, letter to Marie Nordlinger, quoted in *Letters*.

16. Proust, *Time Regained, Remembrance of Things Past*.

17. Jacques Barzun, *Classic, Romantic and Modern*. Secker and Warburg, London, 1962; University of Chicago Press, Chicago, 1975.

CHAPTER 3

1. A. G. Stock, *W. B. Yeats: his poetry and thought*. Cambridge University Press, Cambridge, 1961.

2. W. B. Yeats, *The Wanderings of Oisin*, in *Collected Poems*. Macmillan, London and New York, 1933.

3. Yeats, 'The Second Coming', in *Collected Poems*.

4. Yeats, *The Countess Cathleen*, in *Collected Plays*. Macmillan, London, 1934; Macmillan, New York, 1953.

5. Yeats, *The Land of Heart's Desire*, in *Collected Plays*.
6. Yeats, *The Land of Heart's Desire*, in *Collected Plays*.
7. Yeats, *The Land of Heart's Desire*, in *Collected Plays*.
8. Yeats, *The Land of Heart's Desire*, in *Collected Plays*.
9. Yeats, *The Resurrection*, in *Collected Plays*.
10. Stephen Spender, *The Creative Element*. Hamish Hamilton, London, 1953; Books for Libraries Press, Freeport, N.Y., 1971.
11. Stock, *Yeats*.
12. T. S. Eliot, *The Use of Poetry and the Use of Criticism*. Faber and Faber, London, 1933; Harvard University Press, Cambridge, Mass., 1933.
13. Yeats, 'The Song of Wandering Aengus', in *Collected Poems*.
14. Herbert Read, 'The Later Yeats', in *A Coat of Many Colours*. Routledge and Kegan Paul, London, 1956; Horizon Press, New York, 1956.
15. Yeats, 'All Things Can Tempt Me', in *Collected Poems*.
16. Yeats, 'The Fascination of What's Difficult', in *Collected Poems*.
17. Yeats, 'A Coat', in *Collected Poems*.
18. Yeats, 'The Lake Isle of Innisfree', in *Collected Poems*.
19. Yeats, 'The Wild Swans at Coole', in *Collected Poems*.
20. Maud Bodkin, *Archetypal Patterns in Poetry*. Oxford University Press, London, 1963; Vintage Books, New York, 1961.
21. Yeats, Diary, quoted in A. Norman Jeffares, *W. B. Yeats, Man and Poet*. Routledge and Kegan Paul, London, 1949; Yale University Press, New Haven, 1949.
22. Yeats, 'Before the World Was Made', in *Collected Poems*.
23. The Divine Pymander of Hermes Trismegistus, by the Editors of The Shrine of Wisdom.
24. Frederick Grubb, 'Tragic Joy: W. B. Yeats', in *A Vision of Reality: a study of liberalism in twentieth-century verse*. Chatto and Windus, London, 1965; Barnes and Noble, New York, 1965.
25. Yeats, 'Easter 1916', in *Collected Poems*.
26. Yeats, 'The Second Coming', in *Collected Poems*.
27. Yeats, 'Coole and Ballylee', in *Collected Poems*.
28. Béla Bartók, letter to Irmy Jurkovics, quoted in Halsey Stevens, *The Life and Music of Béla Bartók*. Oxford University Press, London and New York, 1967.
29. Howard Hartog, *European Music in the Twentieth Century*. Routledge and Kegan Paul, London, 1957; Greenwood Press, Westport, Conn., 1976.
30. Stevens, *Bartók*.

CHAPTER 4

1. Arnold Schoenberg, 'Analysis of Chamber Symphony, op. 9', 1949.
2. Schoenberg, 'Chamber Symphony, op. 9'.
3. Arnold Schoenberg, letter to Fritz Stiedry quoted in Joseph Rufer, *The Works of Arnold Schoenberg*, translated by Dika Newlin, Faber and Faber, London, 1962.
4. Paul Klee quoted in Will Grohmann, *Paul Klee*. Lund Humphries, London, 1954; Abrams, New York, 1954.
5. Paul Valéry, *Aesthetics*. Routledge and Kegan Paul, London, 1964; Pantheon, New York, 1964.
6. Donald Mitchell, *The Language of Modern Music*. Faber and Faber, London, 1963; St Martin's Press, New York, 1963.
7. Schoenberg, 'Method of composing with twelve tones', lecture, 1934.

8. Schoenberg, letter to Karl Wiener quoted in *Arnold Schoenberg Letters*, ed. Erwin Stein. Faber and Faber, London, 1964; St Martin's Press, New York, 1958.

9. Paul Klee, quoted in Will Grohmann, *Paul Klee*.

10. Valéry, *Aesthetics*.

11. Schoenberg, letter to Emil Hertzka, quoted in *Arnold Schoenberg Letters*, ed. Erwin Stein.

12. Alban Berg, quoted in Willi Reich, *Alban Berg*. Thames and Hudson, London, 1965.

13. Paul Klee, letter to his parents, quoted in Grohmann, *Klee*.

14. Sidney Keyes, 'Paul Klee', in *Collected Poems*, ed. Michael Meyer. Routledge and Kegan Paul, London, 1945.

15. Paul Klee, *Diaries 1898–1918*, ed. Felix Klee. Peter Owen, London, 1965; University of California Press, Berkeley, Ca., 1964.

16. Klee, *Diaries*.

17. Klee, *Diaries*.

18. Klee, *Diaries*.

19. Wilfred Mellers, *Caliban Reborn*. Gollancz, London, 1968.

20. Mellers, *Caliban*.

CHAPTER 5

1. Patricia Hutchins, *Ezra Pound's Kensington*. Faber and Faber, London, 1965.

2. John Millington Synge, Preface to *Poems and Translations*. Allen and Unwin, London, 1908.

3. Ezra Pound, 'Villonaud for this Yule', in *Selected Poems*, intro. T. S. Eliot. Faber and Faber, London, 1928; New Directions, New York, 1957.

4. Pound, 'Aube of the West Dawn: Venetian June', in *A Lume Spento and Other Early Poems*. Faber and Faber, London, 1965.

5. Hutchins, *Ezra Pound's Kensington*.

6. Pound, 'Notes on Elizabethan Classicists', in *Literary Essays of Ezra Pound*, ed. T. S. Eliot, Faber and Faber, London, 1954; New Directions, New York, 1968.

7. Pound, 'Sestina: Altaforte', in *Selected Poems*.

8. Pound, 'Speech for Psyche in the Golden Book of Apuleius', in *Collected Shorter Poems*. Faber and Faber, London, 1968; *Personae*, New Directions, New York, 1926.

9. Pound, 'A Virginal', in *Collected Shorter Poems*.

10. Pound, 'The Return', in *Selected Poems*.

11. T. S. Eliot, introduction to *Selected Poems* of Pound.

12. Robert Graves, *The Common Asphodel*. Hamish Hamilton, London, 1949.

13. Pound, 'The Bath Tub', in *Collected Shorter Poems*.

14. Eliot, introduction to *Selected Poems* of Pound.

15. Witter Bynner, *The Jade Mountain: A Chinese Anthology*. Alfred A. Knopf, New York, 1920.

16. Pound, 'The River-Merchant's Wife: A Letter', in *Selected Poems*.

17. Donald Davie, *Ezra Pound, Poet as Sculptor*. Routledge and Kegan Paul, London, 1965.

18. Eliot, introduction to *Selected Poems* of Pound.

19. Allen Tate, 'Ezra Pound', in *The Man of Letters in the Modern World*. Thames and Hudson, London, 1955; Meridian Books, New York, 1955.

20. Pound, *The Cantos*. Faber and Faber, London, 1954; New Directions, New York, 1970.

21. Andrei Voznesensky, letter quoted in *The Times*.

22. Michael Roberts, introduction to *The Faber Book of Modern Verse*. Faber and Faber, London, 1960.
23. Pound, 'How to Read', in *Literary Essays*.
24. Pound, 'Canto C', in *The Cantos*.
25. Pound, introduction to *Ripostes*. Stephen Swift, London, 1912.
26. Pound, 'Canto II', in *The Cantos*.
27. Pound, 'Canto II', in *The Cantos*.
28. Pound, 'Canto III', in *The Cantos*.
29. Pound, 'Canto IV', in *The Cantos*.
30. Davie, *Pound, Poet as Sculptor*.
31. Pound, 'Arnaut Daniel', in *Literary Essays*.
32. Arthur Koestler, *Act of Creation*. Hutchinson, London, 1976; Macmillan, New York, 1964.
33. Pound, 'A Retrospect', in *Literary Essays*.

CHAPTER 6

1. The title of Eric Walter White's admirable book, *Stravinsky's Sacrifice to Apollo*. L. and V. Woolf, London, 1930; University of California Press, Berkeley, Ca., 1966.
2. Siegfried Sassoon, 'Concert Interpretation (Le Sacre du Printemps)', in *Collected Poems 1908–1956*. Faber and Faber, London, 1961; Viking Press, New York.
3. White, *Stravinsky: The Composer and His Works*. Faber and Faber, London, 1966; University of California Press, 1966.
4. Herbert Howarth, *Notes on Some Figures Behind T. S. Eliot*. Chatto and Windus, London, 1965; Houghton Mifflin, Boston, 1964.
5. Helen Gardner, *The Art of T. S. Eliot*. Cresset Press, London, 1949; Faber and Faber, London, 1968; Dutton, New York, 1950.
6. T. S. Eliot, *The Use of Poetry and the Use of Criticism*. Faber and Faber, London, 1933; Harvard University Press, Cambridge, Mass., 1933.
7. Eliot, 'The Love Song of J. Alfred Prufrock', in *Collected Poems*. Faber and Faber, London, 1963; Harcourt Brace Jovanich, New York, 1963.
8. Eliot, *Use of Poetry*.
9. Eliot, *Use of Poetry*.
10. Gardner, *Art of T. S. Eliot*.
11. Gardner, *Art of T. S. Eliot*.
12. Eliot, *Ash Wednesday*, in *Collected Poems*.
13. Wilfred Mellers, *Caliban Reborn*. Gollancz, London, 1968.
14. Pierre Daix and Georges Boudaille, *Picasso: the Blue and Rose Periods*. Evelyn, Adams and Mackay, London, 1967.
15. Daix and Boudaille, *Picasso*.
16. Anton Ehrenzweig, *The Hidden Order of Art*. Weidenfeld and Nicolson, London, 1967; University of California Press, Berkeley, Ca., 1976.
17. Donald Mitchell, *The Language of Modern Music*. Faber and Faber, London, 1966; St Martin's Press, New York, 1970.
18. Pierre Daix, *Picasso*. Thames and Hudson, London, 1965.
19. Pablo Picasso, in an interview with William Fifield, *Paris Review*, vol. 32, Summer/Fall, 1964.
20. Herbert Read, 'Picasso's Guernica', in *A Coat of Many Colours*. Routledge and Kegan Paul, London, 1956; Horizon Press, New York, 1956.

21. Read, 'The Triumph of Picasso', in *A Coat of Many Colours*.
22. T. S. Eliot, *The Family Reunion*, in *Collected Plays*. Faber and Faber, London, 1962; Harcourt Brace Jovanich, New York, 1969.

CHAPTER 7

1. Bence Szabolcsi, *History of Melody*. Barrie and Rockliff, London, 1965; St Martin's Press, New York, 1965.
2. Martin Esslin, *Brecht: A Choice of Evils*. Eyre and Spottiswoode, London, 1959; as *Brecht: the Man and his Work*, Doubleday, New York, 1960.
3. Paul Hindemith, *A Composer's World*. Harvard University Press, Cambridge, Mass., 1952.
4. Bertolt Brecht, *The Messingkauf Dialogues*. Eyre Methuen, London, 1974.
5. Brecht, *The Life of Galileo*, in *Collected Plays*. Methuen, London, 1970; Random House, New York, 1971.

CHAPTER 8

1. Samuel Beckett, *Watt*. Calder, London, 1963; Grove Press, New York, 1959.
2. Beckett, *More Pricks than Kicks*. Calder and Boyars, London, 1970; Grove Press, New York, 1970.
3. Beckett, *Murphy*. Calder and Boyars, London, 1969; Grove Press, New York, 1957.
4. Beckett, *Watt*.
5. Beckett, 'Proust', in *Proust and Three Dialogues with Georges Duthuit*. Calder, London, 1965; Grove Press, New York, 1957.
6. Beckett, *Molloy, Malone Dies, The Unnamable*. Calder and Boyars, London, 1971; Grove Press, New York, 1959.
7. Francis Doherty, *Samuel Beckett*. Hutchinson, London, 1971.
8. Gotthard Jedlicka, *Conversations with Giacometti*, quoted in Reinhold Hohl, *Giacometti: Sculpture, Painting, Drawing*. Thames and Hudson, London, 1972.
9. Beckett, *Waiting for Godot*. Faber and Faber, London, 1956; Grove Press, New York, 1970.
10. Beckett, *Endgame*. Faber and Faber, London, 1958; Grove Press, New York, 1958.
11. John Russell, *Francis Bacon*. Thames and Hudson, London, 1971.
12. Jean-Paul Sartre, *Nausea*. Hamish Hamilton, London, 1962; New Directions, New York, 1959.
13. John Russell, *Francis Bacon*.
14. Herbert Read, *Selected Writings*. Faber and Faber, London, 1963.
15. Tolstoy, 'What is Art?' quoted in Read, *Selected Writings*.
16. Sartre, *Nausea*.
17. Seneca, *Oedipus*, adapted by Ted Hughes. Faber and Faber, London, 1969; Doubleday, New York, 1972.

CHAPTER 9

1. Philip Thody, *Albert Camus—a study of his work*. Hamish Hamilton, London, 1957.
2. Albert Camus, *Carnets*. Hamish Hamilton, London, 1963: as *Notebooks*, Modern Library, New York, 1965.
3. Conor Cruise O'Brien, *Camus*. Fontana, London, 1970; Viking, New York, 1970.
4. Camus, *The Outsider*. Hamish Hamilton, London, 1960; as *The Stranger*, Random House, New York, 1954.
5. Camus, *Caligula*, in *Collected Plays*. Hamish Hamilton, London, 1965; Random House, New York, 1962.

6. Camus, *The Myth of Sisyphus*. Hamish Hamilton, London, 1955; Knopf, New York, 1955.
7. William S. Rubin, *Dada and Surrealist Art*. Thames and Hudson, London, 1969; Museum of Modern Art, New York, 1968.
8. Rubin, *Dada*.
9. Richard Kostelanetz, 'Environmental Abundance', in *John Cage*, ed. Kostelanetz. Allen Lane The Penguin Press, London, 1970; Praeger, New York, 1970.
10. John Cage, 'The Future of Music: Credo', in *Silence*. Calder and Boyars, London, 1968; Wesleyan University Press, Middletown, Conn., 1961.
11. Cage, 'Diary: How to Improve the World (You Will Only Make Matters Worse)', in *A Year from Monday*. Calder and Boyars, London, 1968; Wesleyan University Press, Middletown, Conn., 1967.

CHAPTER 10

1. Paul Hindemith, *A Composer's World*. Harvard University Press, Cambridge, Mass., 1952.
2. Simone Weil, 'The Responsibility of Writers', in *On Science, Necessity and the Love of God*, translated and edited by Sir Richard Rees. Oxford University Press, London and New York, 1968.
3. Dylan Thomas, *Collected Poems 1934–52*. Dent, London, 1952.
4. Thomas, letter to Pamela Hansford Johnson, in *Selected Letters of Dylan Thomas*, edited by Constantine FitzGibbon. Dent, London, 1966; New Directions, New York, 1967.
5. Ernst Fischer, *The Necessity of Art*. Penguin, Harmondsworth, 1963; Penguin, Baltimore, 1964.
6. Thomas, letter to Trevor Hughes, in *Selected Letters*.
7. Thomas, letter to Richard Church, in *Selected Letters*.
8. Thomas, *Altarwise by Owl-Light*, in *The Poems*, ed. Daniel Jones. Dent, London, 1971; New Directions, New York, 1971.
9. Constantine FitzGibbon, *The Life of Dylan Thomas*. Dent, London, 1965; Little, Brown, Boston, 1965.
10. Thomas, letter to Trevor Hughes, in *Selected Letters*.
11. John Russell, *Henry Moore*. Allen Lane The Penguin Press, London, 1968.
12. Russell, *Henry Moore*.
13. W. B. Yeats, introduction to *The Oxford Book of Modern Verse*. Oxford University Press, London, 1936.
14. Peter Heyworth, in *Michael Tippet: A Symposium on his Sixtieth Birthday*, ed. Ian Kemp. Faber and Faber, London, 1965.
15. Patrick White, *The Vivisector*. Jonathan Cape, London, 1970; Viking, New York, 1970.
16. White, *The Tree of Man*. Jonathan Cape, London, 1974; Viking, New York, 1955.
17. White, *Tree of Man*.
18. Roland Barthes, *Writing Degree Zero*. Jonathan Cape, London, 1967; Beacon Press, Boston, 1970.
19. White, *Riders in the Chariot*. Jonathan Cape, London, 1976; Viking, New York, 1961.
20. White, *Riders in the Chariot*.
21. White, *Riders in the Chariot*.

INDEX